The
COMPLEAT
SQUASH

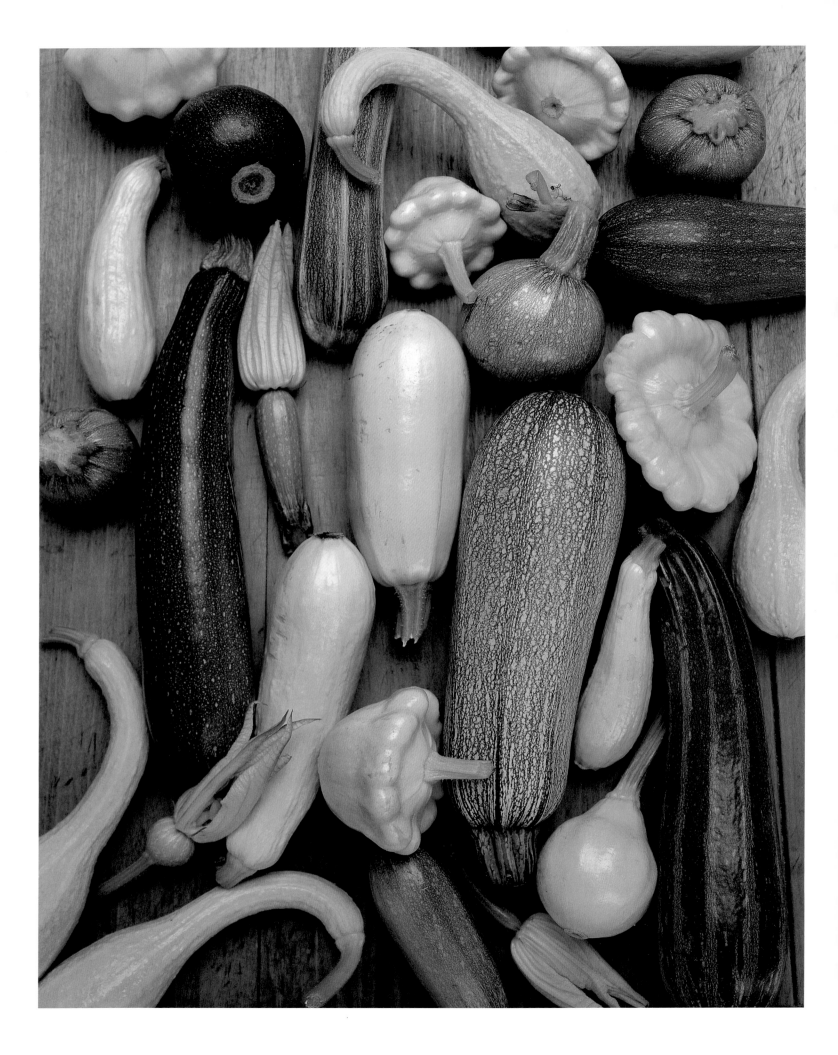

The

COMPLEAT

SQUASH

A Passionate Grower's Guide

to Pumpkins, Squashes, and Gourds

AMY GOLDMAN

PHOTOGRAPHS BY Victor Schrager FOREWORD BY Kent Whealy

ARTISAN

NEW YORK

For my daughter.
In memory of my parents.

CONTENTS

a.

FOREWORD

GARDENERS ARE SPECIAL PEOPLE and seed savers are special gardeners. In North America we are blessed with an immense cornucopia of food crops because seed-saving gardeners and farmers from every corner of the world often brought along their families' best seeds when they immigrated. Those precious seeds provided living remembrances of life in the old country and ensured continued enjoyment of beloved foods.

We also enjoy Native American crops that were grown before European contact, then saved by early settlers and passed down: squashes, corn, beans, potatoes, tomatoes, and peppers. Boston Marrow is a squash reportedly obtained from a tribe near Buffalo, New York. Sibley squash (also known as Pike's Peak), introduced in 1887, came from an elderly woman who had grown it for more than fifty years in Missouri and Iowa, but it apparently originated from Indian agriculture (see page 43). And the Arikara tribe in North Dakota grew a black heart-shaped squash almost identical in appearance to Table Queen and other Acorn squashes grown today (see page 121).

A century ago it was common practice for farmers to grow fields of squashes for livestock feed. Cattle love the sweetness of squashes and fatten well on them. Squashes were layered into loose hay in the barn to prevent freezing and these were fed together to cattle during the winter. Many were huge and of poor table quality. J.J.H. Gregory, a well-known and respected seedsman during the late 1800s in Marblehead, Massachusetts, describes some squashes as being "coarse and barbarous" and says that "to bring them, when prepared in any way, to the table is to rob the stock and wrong the family."

In *The Compleat Squash,* Amy Goldman presents a feast of the best-flavored, most beautiful, and most historic squashes. She is a connoisseur of the entire family of Cucurbitaceae who attends rare vegetable and fruit fairs in England, Belgium, France, and Australia. She plans her travels around visits to kitchen gardens and *potagers,* collecting squashes, melons, and watermelons. After one such trip to a pumpkin festival in Tranzault, France, Amy sent me a stunning photo of an oxcart tipped on end and spilling out a river of squashes. We created a replica using a restored covered wagon at Heritage Farm, headquarters of the Seed Savers Exchange, where we grow 650 varieties of squash. More people took photos of that beautiful flood of squashes than of any previous display or planting at Heritage Farm, a place widely considered paradise for horticultural photographers.

Jattepumpa *fig. 1a*
Cucurbita maxima
SIZE: 9" long by 18" wide
WEIGHT: 26 pounds
RIND COLOR: light vermilion
FLESH COLOR: toned-down brilliant orange
COLOR RATING: 2
FIBER: none
BEST USE: exhibition

Comes in a range of shapes.

A VERITABLE RAINBOW OF PUMPKINS. FROM TOP TO BOTTOM: SKY BLUE JARRAHDALE, COCOA BROWN MUSRUÉE DE PROVENCE, SCARLET ROUGE VIF D'ETAMPES, AND PEACHY PINK JATTEPUMPA.

Amy is a highly accomplished gardener who grows hundreds of heirloom and foreign vegetables each summer in the Hudson Valley of upstate New York, and she has helped make many rare horticultural treasures available to gardeners everywhere. Her previous book, *Melons for the Passionate Grower*, is the definitive book on the subject—the first book devoted to melons for the general public in nearly two hundred years. That extensively researched collection of one hundred melons and watermelons received the American Horticultural Society's Book Award in 2003.

In *The Compleat Squash*, award-winning photographer Victor Schrager's stunning portraits of cucurbits are the indisputable equals of the legendary Vilmorin paintings commissioned in Paris 150 years ago and the hauntingly beautiful photos taken by Charles Jones a century ago in England.

Working with Amy on these exciting and unique projects has been my great pleasure. We share a passion for horticultural diversity and genetic preservation, a devotion that is rapidly spreading throughout a worldwide network of like-minded gardeners and seed savers. Without such efforts, future generations might never have enjoyed growing and tasting these genetic treasures, many of which could have been lost forever to gardeners and plant breeders.

There has never been a more exciting time to be a gardener. Be careful, though, because the addictive fascination with horticultural diversity can easily lead to a compelling sense of stewardship that could change your life. There is nothing like the deep satisfaction of being down on your knees digging your hands into the warm, rich earth and planting seeds. Each spring I am profoundly aware of the immeasurable history hidden in the seeds I am planting. All seeds are living links in unbroken chains reaching back into antiquity. I often imagine that my intense feelings when planting connect me with all gardeners throughout time: from Native Americans intercropping the Three Sisters (squashes, corn, and beans), to Romans and Celts selecting primeval members of the cabbage family, all the way back to the beginning of agriculture when the first Stone Age gardener planted—instead of eating—seeds that had been gathered.

Kent Whealy
Executive Director
Seed Savers Exchange

VISIONS OF PUMPKINS AND SQUASHES

I'd like to coin a new term: "*Cucurbitacean* (kyoo-kûr-bit-ā'sē-en) n. A person who regards pumpkins or squashes with deep, often rapturous love. This love manifests in many ways, but is always characterized by a pervasive pattern of attachment and an abiding concern for the preservation of the species (*Cucurbita* spp.)." I invite you to join the club.

On the bulletin board above my desk, I keep a running tally of squashes: those I "Love" and those I "Like." I first became enchanted by a squash, displayed in a shop in New Zealand, on an autumn day fifteen years ago. That such art forms exist in nature! I'd never seen a blue squash before, let alone one with three convoluted lobes separated by deep fissures. It looked more like a three-cornered hat or even a punched-down plush pillow. Only after obtaining seeds and growing Triamble in my own garden the following summer did I discover that the flavor of its wall-to-wall orange flesh was outstanding—even when eaten raw like a carrot. Since then, scores of other squashes and pumpkins have captured my heart. I'm devoted to Marina di Chioggia, Winter Luxury Pie, Seminole, Buttercup, Hubbard . . . The list goes on.

Sometimes I don't know where pumpkins begin and I end. They consume me and I consume them. I crisscross the globe in search of "exotic germplasm" or seeds and am a regular at pumpkin festivals in France and farmers' markets from Salta, Argentina, to Venice. My house and barn are filled to the rafters with squashes, glorious squashes. They adorn the mantel, grace every countertop in my kitchen, and line the hallways, windowsills, and shelves in my basement. I have a dedicated freezer to store their seeds. By the way I collect these beauties, you'd think they were going out of style—and in a way, they are. Of the 150 varieties in this book, only about two dozen are widely grown.

Long before I knew the definition of agricultural biodiversity, I was in love with vegetables. My eyes glaze over when I look at flowers and perennials. From the time I had my first garden at the age of eighteen and realized that I could put food on the table, that I seemed to have a natural gift for kitchen gardening, I've had my hands in the soil. And a lot of soil is required to produce the hundreds of pumpkins I grow every summer. Unfortunately, my land in the Hudson Valley is less than ideal for agriculture. The upland hardscrabble land, heavily wooded and with just a scattering of open meadows, is full of rock outcroppings and water, water everywhere. The property has been labeled "bad" for the last 250 years.

It has taken me a long time into turn bad to good, and I'm still not done. Whenever I set foot in either of my two vegetable gardens, one an acre in size and the other only forty feet by sixty feet, I step softly over the natural springs that well up here and there. I've tried to enrich the soil by adding pond muck and leaf mold, and for the most part these efforts have been successful, with a couple of

notable exceptions. I'll never forget the disaster that struck ten years ago when, not exactly a horticultural genius, I added forty yards of hot, phytotoxic compost, and my entire squash crop wilted and died overnight. I was inconsolable.

Back then, visions of pumpkins and squashes had already begun to dance in my head, but *Cucurbita*s (members of the genus *Cucurbita*) were merely a means to an end: winning blue ribbons at the Dutchess County Fair in Rhinebeck, New York. Learning how to win, and to win big, was for me the equivalent of earning another doctoral degree. It meant producing blameless, blemishless specimens for the third Monday in August every year. And this feat had to be accomplished seventy times over, since there were that many horticultural classes. I grew thousands of varieties of vegetables in the hope of wowing fairgoers and judges.

I knew that in order to take home the grand champion rosette in vegetables, I'd have to master the *Cucurbita*s. Squashes and pumpkins make up the largest competitive category—it's even larger than tomatoes or potatoes. I wrote on my 1991 fair premium book, "Squashes R Essential." Judges graded *Cucurbita*s for uniformity, table quality, and bigness. Taste tests never entered into the official reckoning; these contests were all about form over flavor.

I eventually won the grand championship with thirty-eight blue ribbons. Ingenuity and sacrifice were the royal road to the winner's circle. Apparently, no one else was meshugge enough to grow Zucchinis and Straightneck squashes into plastic bags to preserve their pristine complexions. Or spend hours matching up pairs of Summer Crooknecks with just the right arch of triumph. Acorn squashes had to be heart-shaped and deeply furrowed; Hubbards tapered at each end were preferred. And forget about eating these until after the fair; the competition was stiff. I sometimes think about all the delicious meals I missed, and I'll always regret prematurely harvesting the biggest pumpkin I had ever grown (440 pounds), just to exhibit it in August for an appreciative audience. Who knows what weight it might have attained if it had been left on the vine until October?

A funny thing happened on the way to that grand championship. To paraphrase horticulture expert Liberty Hyde Bailey, I became aware that I grew miracles. I fell in love with heirloom vegetables—treasures from the past, handed down. I learned that squashes like Triamble lead a tenuous life, available from only one or two small seed companies that could fold at any time. Thousands of good old-fashioned vegetables are dead and gone, victims of a wave of consolidation in the seed industry, market forces, and the advent of first-generation (F1) hybrids. In the aggregate, these open-pollinated, standard varieties represent agricultural biodiversity—which is necessary to our very survival. Since the early 1990s, I've been a card-carrying seed saver, collector, and advocate.

By the time I had committed myself to the heirloom seed movement and won three grand championships in vegetables at various fairs, my conversion to squash was nearly complete. But I still gagged over the smell of raw pumpkin gut when I carved jack-o'-lanterns and threw up my hands in despair over stringy, watery pumpkin flesh while trying to make pie without resorting to

cans of Libby's. I didn't realize that these punky orange pumpkin heads are more fit for livestock than as pie stock.

Clearly, I still needed a few lessons from Glenn Drowns, the squash curator for the Seed Savers Exchange. Seed Savers's mission is to preserve our vanishing vegetable heritage, and it maintains a huge collection of squashes in danger of extinction. Glenn loves the Cucurbitaceae family of plants and, in particular, squashes: the edible members of any or all of the five domesticated species of *Cucurbita,* a New World genus that contains twelve or thirteen species or species groups. Pumpkins are included: They're simply edible, round-fruited *Cucurbita*s. Ornamental gourds are the decorative, unpalatable forms of *Cucurbita pepo*.

Before Glenn began to educate me, I was just a *keed,* in the parlance of fellow cucurbitacean Harry Paris, of the Department of Vegetable Crops and Plant Genetics, Newe Ya'ar Research Center, Israel. Glenn can tell the species of a squash just by looking at its leaf, stem, or seed. He has devoted his life to rescuing hundreds of squash varieties and rare fowl. I learned at the feet of a master gardener. When it came time for me to choose which varieties to grow for this book, Glenn alerted me to some of the most worthy, historic, and endangered.

Glenn also set me straight on the meaning of "table quality"; taste matters. It is not just how lovely a squash looks on a paper plate, set on a banquette in an exhibition hall, under fluorescent lights. We've got blinders on if all we see are round orange balls (pumpkins of *Cucurbita pepo*) and mediocre, immature Acorns and Butternuts. Far better to set a table with the starchy, dry, thick, flaky, floury, melting, nutty, and fine-textured winter squashes (mature fruits) of *C. maxima* and *C. moschata* (and some of the better *C. pepos*). You can even find some of these, such as Hubbard and Buttercup, in your neighborhood grocery store.

The Compleat Squash is where food, art, and gardening meet. My aim in writing the book was to catalog these marvels before they disappear, to describe my beloved squashes, to make them unforgettable, so that visions of them would dance in your head as they do in mine. You will read stories that I hope will forever change your conception of pumpkins and squashes, and you will learn how to cook them and grow them and preserve them. They total 150 heirloom varieties—all grown by me in my garden over the course of two summers and evaluated in the field and kitchen. Some are less old and rare than others, but all are standard, open-pollinated varieties and have in common the ability to reproduce themselves true to type from seed. Victor Schrager has captured their essence on film, and I have tried to capture their essence in words.

Growing Miracles

HOW TO GROW
PUMPKINS AND SQUASHES

GROWING PUMPKINS AND SQUASHES is not for the minimalist. The vines may not grow as tall as Jack's beanstalk, but they surely cover more territory at a faster clip. *Cucurbita* plants are rank growers and rank feeders. Their culture is similar to that of melons (*Cucumis melo*), but they are not nearly as finicky. In Liberty Hyde Bailey's words, "The plants are prompt, giving results speedily. They take care of themselves, requiring no great skill on the part of the grower." This is largely true if certain conditions are met and a few simple rules are followed. Even the beginning gardener can grow any of the four major domesticated squash species (*Cucurbita maxima, moschata, pepo,* and *argyrosperma*) in most places in the United States.

Pumpkins and squashes can never have too much compost and manure. Like Audrey II, the voracious plant in *The Little Shop of Horrors,* they practically scream "Feed me! Feed me!" The best kind of pumpkin patch has soil that, in addition to being warm, is penetrable to the roots (well drained) and fertile or high in organic matter. Compacted clay soil, accompanied by ponding or waterlogging, is not a happy medium. I'm a fan of soil amendments because they add nutrients, improve soil structure and tilth, and reduce erosion and weed pressure.

Any kind of soil–sandy or clay–can be improved by the addition of compost and animal as well as green manures (cover crops). Well-rotted manure, leaf mold, and finished compost are best added by the cubic yard in fall; a shovelful or two of aged cow manure in the planting hole come spring is also welcome. I always plant a fall cover-crop mixture of hairy vetch and rye and plow it under a month before spring planting. Alternatively, fast-growing spring or summer cover crops, such as buckwheat, can be tilled in before the first fall frost. Keeping soil slightly acid, with a pH in the range of 6.0 to 6.8, will ensure that nutrients are readily available for crop uptake. Synthetic fertilizers that are high in nitrogen or phosphorus should be used sparingly, since they may actually lower both yield and quality of fruit.

Squashes are fair-weather friends. They cannot tolerate cold–much less freezing–temperatures. *Cucurbita*s need blue skies and sunshine (high light intensity) and warm weather. Bright sunny days in the eighties and nights in the sixties are ideal. It's best to wait until the weather is settled and warm in the spring before sowing seeds. James J. H. Gregory, author of *Squashes: How to Grow Them,* observed in 1867, "If the soil be wet and cold, the growth of the vine is much retarded, and not only is the crop much lessened in size and weight, but at times this singular result is seen–the squash loses its normal form."

Summer squashes, such as Zucchini or Cocozelle, eaten immature and soft-rinded, require as little as forty frost-free days from sowing to bear fruit, making them prime candidates for northerly or short-season areas. These mostly bush or compact plants, the vast majority of which belong to *Cucurbita pepo,* will continue to produce for weeks if fruits are picked young and regularly; successive crops can be sown if time allows. On the other hand, winter squashes, such as Buttercup or Queensland Blue, eaten mature and hard-rinded, require as much as three to five frost-free months from sowing to reach

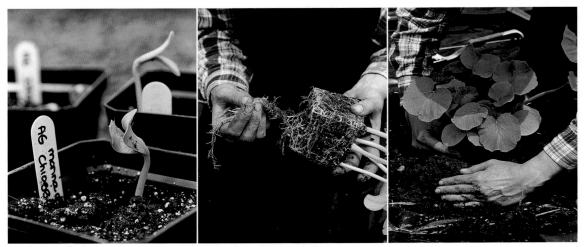

LEFT TO RIGHT: NEWLY HATCHED SEEDLINGS IN THE GREENHOUSE. LOOSENING ROOTS BEFORE TRANSPLANTING. CREATING A SMALL WELL TO RETAIN WATER AT PLANTING TIME.

maturity. Most winter squashes have trailing or vining habits, are less prolific than summer squashes, and have a long storage or postharvest life. Winter squashes that have a shorter shelf life are sometimes referred to as fall squashes.

Planting time for both summer and winter squashes depends on where you live and whether you intend to sow seeds directly into the ground or transplant seedlings that have been started inside. Direct seeding was once the norm, but using transplants makes germination more reliable. Indoor sprouting gives a head start in areas where seed can easily rot in cold wet soil or be gobbled up by squirrels and field mice. The main disadvantage is that transplants have shallower root systems, which may necessitate supplementary irrigation. As a general rule, start transplants three weeks in advance of setting them out after the danger of frost has passed. Plant seeds outside only when the soil temperature (as measured by a soil thermometer) is in excess of seventy degrees Fahrenheit—at about the same time you'd sow lima beans. Summer squashes can be started a bit later than winter squashes.

When the time is right, sow seeds in the garden at a depth of one inch; if the soil is light (sandy) rather than heavy (clay) or if seeds are big, plant them more deeply and then water well. Plant extras to ensure good emergence and thin them later on. Seedlings should germinate within a week. You don't need a greenhouse if you go the transplant route, but grow lights rigged to a timer are important. I recommend sowing five or six seeds per four-inch-diameter pot filled with a well-moistened sterile potting mix. Place pots in large plastic storage bins and loosely cover them with a lid. If kept in the dark at seventy-five to eighty-five degrees Fahrenheit, plants will emerge in four or five days—even sooner if temperatures approach ninety degrees.

After germination, set seedlings under grow lights and provide sixteen hours of light daily, keeping plants two or three inches below the bulbs. Thin each pot to the three strongest seedlings and apply liquid fertilizer at half strength; later on in the garden, when runners begin to form, the number of plants can be further reduced to one or two by cutting off stems at the soil line. *Cucurbita*

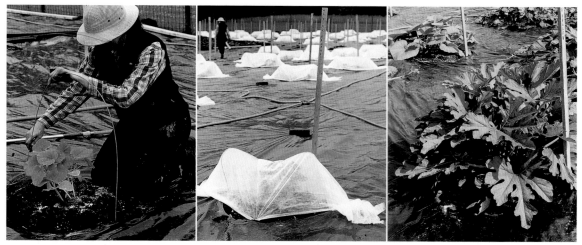

LEFT TO RIGHT: ERECTING FRAME FOR FLOATING ROW COVER; WHITE POWDER IS DIATOMACEOUS EARTH. SPUN POLYESTER COCOONS WARD OFF BAD BUGS AND ILL WINDS; SKY-HIGH LABELS PERMIT EASY ID AND MARK THE WATERING HOLE WHEN PLASTIC BECOMES A SEA OF GREEN; NOTE HOSE GRID. JUNE PLANTS BUSTING OUT ALL OVER.

seedlings are ready to transplant in half the time it takes a tomato. If at all possible, harden seedlings off for a few days by gradually reducing the temperature, water, and fertilizer, then set them in their garden spot in broad shallow wells, on a cool, cloudy late afternoon and give them a good dose of fish emulsion.

Timing is important, but it's not everything. Besides planting too soon, the biggest mistake growers make is crowding plants. If you are stingy with space, poor yields will follow. Increasing the plant density can boost melon yields, but it has the opposite effect on pumpkin and squash yields: Canopy overlap and shading of adjacent plants, reduced leaf area per fruit, and competition for food, water, and light will reduce the number of female flowers (as excessive nitrogen does) and thus the number of fruits, and the fruits that do form will be of poorer quality (lower soluble solids).

Squashes are usually planted in either hills or drills, but sometimes the distinction blurs. "Hills" refers to groupings of plants that may or may not be elevated above the field surface. I plant my seedlings in shallow saucerlike depressions and draw earth up around them for support as they grow; only when waterlogging or soil compaction is an issue should hills be elevated. "Drills" refers to a row of seeds or seedlings in a shallow trench or furrow, usually planted singly and equidistant, and often spaced somewhat closer than hills. Whichever method you use, I recommend ten to twelve feet in all directions between vining varieties and five to six feet between bush varieties. Pumpkins and squashes planted singly, at the appropriate distance, yield the biggest and best fruit. However, for added insurance against vine borers and cucumber beetles, I allow two plants per hill.

Black plastic mulch and spun polyester row covers are costly and optional for most growers, but I never forgo them. Together they amplify heat, protect against insect predators and soil-borne pathogens, and produce earlier and higher yields. Since black plastic suppresses weeds and conserves soil moisture and nutrients, using it prevents backbreaking weeding and watering. Covering a pumpkin patch with black plastic mulch ten days or so before planting (silver mulch is more effective but also more expensive) is a two-person job: Stake down the edges with earth staples (U-shaped pins),

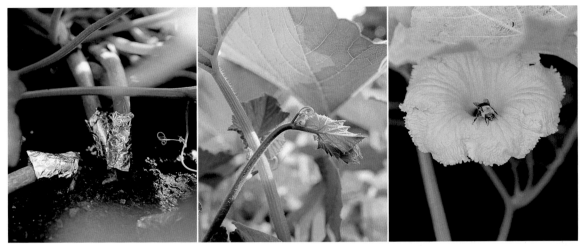

bricks, or stones, and then cut two-foot-diameter planting holes at regular intervals if using the hill method; long narrow rolls of plastic mulch, rather than wide sheets, can be used for rows or drills.

Enveloping newly planted seedlings with earth-stapled floating row covers draped over galvanized steel hoops will provide a degree of protection against desiccating winds, cold temperatures, and early onslaught by insects and other pests. Remove the row covers two to three weeks later to allow plants to flower and grow. Squash vines set adventitious roots at the nodes to anchor and feed the long runners; roots will not be able to push into the earth if plastic mulch is used, so these vines should be loosely secured with earth staples.

Weeds can quickly overrun an unmulched pumpkin patch and steal precious water, nutrients, and light from your plants; they can also harbor diseases. It behooves you to intervene early and defend your pumpkins with frequent shallow cultivation, hoeing, and hand weeding. Stop cultivating after vines sprawl to avoid uprooting or damaging your crop. Soon enough, pumpkin plants blanket the earth and suppress weed growth on their own. Cover-crop residues (often used in no-till systems), straw mulch, and even chopped switchgrass have been shown to smother weeds. With mechanisms such as these, the use of herbicides should not be necessary.

Irrigated pumpkins and squashes grow bigger and better than those that rely solely on the vagaries of rainfall. Soils high in silt, clay, or organic matter hold water longer than sandy ones; nevertheless, if you find the soil to be loose, powdery, hardpan, or cracked, you've waited too long to water, and plants will surely wilt and suffer a setback. Professional growers rely on tensiometers to monitor soil moisture; the home gardener must rely on his own best judgment. Plants will be thirstiest in midseason and may require as much as one to two inches of water weekly. If plants are mulched and widely spaced, and the weather is cool and humid, the need for water will be less insistent.

Transplants and plants grown on black plastic have much shallower roots than directly seeded plants or those grown in bare soil; they may require more frequent but lighter irrigation. There are any number of ways to water, but I prefer to run hoses in a grid throughout the pumpkin patch

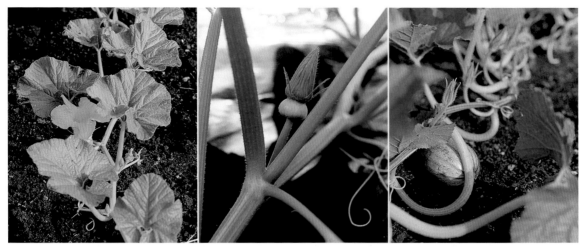

LEFT TO RIGHT: RUNNING VINES. FEMALE BLOSSOM SOON TO OPEN. A WINDBLOWN VINE LOOPING THE LOOP.

and dispense water when necessary. Sprinklers are cheap and easy, too, but they wet the leaves and can promote foliar diseases. Drip or trickle systems are costlier and higher-tech, but they deliver water more efficiently to the roots. If you have too much water in your garden, consider moving it to higher and drier ground or installing drainage.

Bees play a critical role by transferring pollen from male flowers to female flowers; fruits form from the fertilized ovary at the base of female flowers. Healthy plants produce high-quality fruit, but if too many squashes are allowed to grow, size and quality will suffer. It is best to prune off defective specimens (culls) and those that form too late in the season. I rarely prune vines, since reducing leaf area—whether by pruning or crowding—ultimately diminishes yield and quality. If you're trying to grow a world-class giant pumpkin, however, champion growers advocate aggressive pruning to reduce plant size. It's a good idea to manually position fruits so they are not strangled or marred by vines, but step gingerly among the squashes until harvest time. Use a cane or stick to lift leaves so you can see where to place your feet.

Pumpkins and squashes practically grow themselves, but they do it better under your watchful eye and helping hand. While weeds may be the enemy on the ground, a slew of hungry bugs, beetles, and borers, as well as fungal and bacterial diseases, can come out of left field and leave you pumpkinless. Whole books have been written about cucurbit maladies and disease management; their best advice is usually an arsenal of toxic chemicals. I have, in fact, used Rotenone and Pyrethrums—even Sevin in rare cases—but I prefer not to.

There are a number of more benign precautionary measures you can take to prevent insect and pest damage. By simply removing spent *Cucurbita* vines and debris at season's end, and rotating your squash crop to a new location yearly, you will reduce soil-borne diseases and hit the pests right where they live (overwintering in soil and debris). The Big Three are the vine borer (*Melittia cucurbitae*), squash bug (*Anasa tristis*), and cucumber beetles, striped (*Acalymma vittatum*) and spotted (*Diabrotica undecimpunctata howardi*).

In addition to field sanitation and rotation, erecting mechanical barriers between young plants and a dangerous world can stop problems before they start. James J. H. Gregory covered his young plants with glass cloches, frames with coarse cotton cloth on top, and ten-inch-high boxes with bottoms removed; more than one hundred years later, floating row covers and hot caps serve the same purpose. I have discovered that aluminum foil wrapped around the stem at the base of squash plants can prevent squash maggots or vine borer larvae from tunneling into stems and inflicting serious injury. Protect by coating plants, and the ground they stand on, with powders or dusts such as ground plaster or oyster shell, ashes, and diatomaceous earth (an organic pest control made from sea fossils) or the endotoxin spray *Bacillus thuringiensus* (*Bt*); be sure to reapply these substances after rain.

Trouble will soon find pumpkins, but traps can be set for it in the garden. Bad bugs that congregate overnight under shingles or boards laid alongside plants can be collected the next morning and quickly dispatched. Poison bait and sticky yellow traps leave no escape route, either. If you're not too squeamish, slitting stems and spearing vine borers, crushing squash bug egg cases on the underside of leaves with your bare hands—or simply using scissors to cut the adults in two—can be strangely satisfying. If you are bothered by woodchucks and all other remedies fail, follow Gregory's advice and offer a monetary reward for the skin of a woodchuck that "has commenced depredations in your squash field."

I have at this stage developed a certain tolerance for pests and diseases. I know they will live and thrive despite my best efforts to eradicate them. Henry David Thoreau once said that orange pumpkins in the field are a sight that belongs to autumn. If old Hank had surveyed the field more closely, he would surely have seen the swarming, scuttling squash bugs and other constant companions of pumpkins. They belong, too. Happily, in my own fields, I can usually extract my pound of pumpkin flesh in a good season—especially if I harvest fruits just a little early and cure them well.

HARVESTING
PUMPKINS AND SQUASHES

IT'S SIMPLE TO TELL WHEN pumpkins and winter squashes are ready to harvest, yet many gardeners, unsure how to gauge maturity, leave their fruits on the vine too long. They flirt with frost, overmaturity, and the relentless onslaught of pests and diseases. I'd much rather harvest a few days early and let pumpkins mature off the vine in my curing shed or barn. Pick winter squashes when they attain their maximum size and weight and their rinds harden and change color. Use the "Thumbnail Test" to determine maturity: A winter squash is ready to harvest when it resists puncture by a thumbnail. Fruit maturity is also often accompanied by dulling of rinds, browning of stems, and yellowing or withering of vines.

Winter squashes are thick-skinned but not impervious to harm. I cringe whenever I see someone pick up a pumpkin by its stem or "handle." Be careful during harvest and handling to minimize stem or pedicel injury, since a damaged or missing stem is an open invitation to pathogens—and it's an ugly sight as well. Cut the fruit from the vine using a sharp knife, garden shears, or scissors and leave a small piece of vine attached to the stem. Discard immature or defective fruits or use them for livestock feed. Don't leave harvested pumpkins outside, exposed to cold rains or scalding sun; bring them inside right away. Dropping, throwing, or stacking pumpkins can bruise them, so lay them down gently and treat them as if they were eggs. If you are kind to your pumpkins, they will reward you with long shelf life.

Curing pumpkins and winter squashes for two or three weeks in a well-ventilated place out of direct sunlight can promote healing of wounds and toughening of rinds and thereby enhance storage potential. An outbuilding or garage with open windows and doors makes a good curing shed. My setup includes sawhorses with plywood tabletops and fans to circulate air. When pumpkins arrive at "Squash Central" (aka my barn), they must first be cleaned and bathed in 10 percent chlorine bleach solution to reduce surface contaminants. Some experts recommend curing at high temperatures (eighty to eighty-five degrees Fahrenheit), and this is certainly beneficial when ripening or coloring up green or slightly immature specimens. In some instances, however, high-temperature curing has been shown to increase weight loss and shorten shelf life.

Once the curing process is complete, the best way to lengthen the postharvest life of pumpkins and winter squashes is to store them at a happy medium between 50 and 60 degrees Fahrenheit, with a relative humidity of 50 to 70 percent. These conditions, often found in basements, keep respiration and loss through shrinkage to a minimum and preserve color and quality. Well-matured and -cured squashes will store in good condition for three to six months or longer before processes of senescence bring decay. Winter squashes are bulky and require sturdy shelving (I use bakers' racks); place fruits in single layers with ample breathing space around them. Lining the shelves with cardboard or newspaper can make cleanup easy when squashes dissolve into puddles of protoplasm.

Summer squashes grow and self-destruct faster than winter squashes. They are, by definition, short-lived and are meant to be harvested immature (within a few days of flowering, when they are

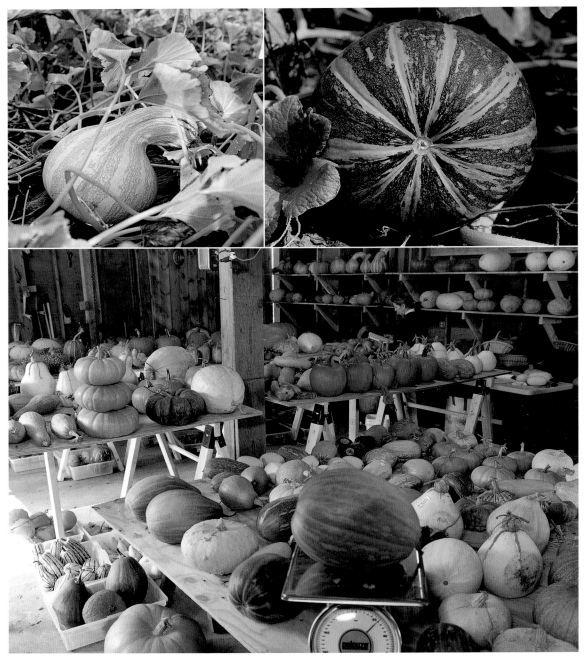

CLOCKWISE FROM UPPER LEFT: COCHITA PUEBLO PLANT DIES BACK TO REVEAL RIPENING FRUIT. TOURS PUMPKIN SAYING, "PICK ME." THIS IS SQUASH CENTRAL: AFTER BEING HARVESTED FROM MY GARDEN FIFTY YARDS AWAY, SQUASHES AWAIT GRADING, SORTING, CLEANING—AND MY SCRUTINY; VICTOR SCHRAGER SET UP HIS PHOTO STUDIO IN A CORNER OF THIS BARN.

still shiny) and enjoyed in summer. Summer squashes usually grow closely spaced on bush plants with prickly foliage. Harvesting them is akin to playing pickup sticks: You need to maneuver in tight spaces with a steady hand–one false move and both you and the fruit will be scratched by stiff foliar trichomes. Summer squashes, with their thin epidermis and partially formed epicuticular wax, are very susceptible to handling injuries of all kinds and shriveling due to moisture loss. Within three hours of harvest, wash squashes gently with a damp sponge, pat them dry with a paper towel, and then refrigerate them in plastic bags for up to two weeks.

Both summer and winter squashes can be harmed by cold and freezing temperatures. Frost on the pumpkin can be fatal: Freezing stops respiration, causes intercellular ice to form, and destroys tissue. Squashes with freezing injuries are "always unreliable property," according to James Gregory. Pumpkins and squashes can also be damaged by cold temperatures above freezing. Chilling injury is cumulative; it increases in severity with the number of hours a squash is exposed to temperatures of fifty degrees Fahrenheit or lower. Symptoms include necrosis (localized death of tissue) and premature breakdown. Some chilling injuries can, however, be reversed at high temperatures (above seventy degrees Fahrenheit) if the damage is slight. Keep a temperature gauge in your storage area and provide heat if there's too much of a chill in the air.

Winter squashes go through many physiological changes during storage. In the prime of their lives, they are starchy vegetables that can keep you well satisfied. Freshly harvested *Cucurbita maxima*s and some *moschata*s are perfect for processing, canning, and freezing because of their high starch levels, consistency, and mild flavor. As winter squashes age, enzymes convert starches back to sugars, making older squashes sweeter. Squashes too heavy or thick in consistency at harvest are improved by the "waiting-room effect": Let them sit a month or two. To improve the flavor of varieties that are low in starch to begin with, add a spoonful or so of sugar when you cook them.

I've known winter squashes to last as long as two years postharvest, but they were mere shells of their former selves. Ninety percent water at the outset, winter squashes gradually lose moisture and weight due to drying. Hollowneck is an example of a storage disorder in Butternut squashes that is caused by desiccation. The low calorie count of squashes (thirty-seven calories per hundred grams of fresh winter squash; twenty calories per hundred grams of summer squash) reflects their high water content. Apart from elevated levels of vitamin A precursors (carotenoids) associated with deep orange flesh, and fatty protein-rich seeds, pumpkins and winter squashes are generally not very nutritious. But they are "good carbs"–delicious, filling, and versatile.

You'll know stored pumpkins and winter squashes are on their way out when their skin color changes, because of a breakdown in chlorophyll and other pigments, and their texture softens. This is your signal to get busy in the kitchen. Make batches of frozen puree–the basic ingredient in Pumpkin Crème Brûlée and James J. H. Gregory's 1873 Squash Pudding (see pages 191 and 184). If you wait too long, fruits will develop off-flavors and -aromas from fermentation. Spoilage, caused by the pumpkin's own enzymes and infection by microbes, will eventually claim your pumpkins and render them inedible.

IT TAKES TWO. LEFT: MALE BLOSSOMS. **RIGHT:** FEMALE BLOSSOMS.

HAND
POLLINATION

HAND POLLINATING SQUASH is one of my greatest pleasures. There's nothing else I'd rather be doing on a day in early summer when the plants are literally in the first bloom of youth. For the moment, there are no signs of bacterial wilt or mosaic virus. As I get down on my hands and knees and prepare to transfer pollen, I am entranced by the scent of newly opened squash blossoms, so much like magnolia; squash nectar tastes even better than honeysuckle. Bees know a good thing and I do, too.

Take matters into your own hands when you absolutely, positively must have pure squash seed. Hand pollinate when you want to grow more than one variety in a species, or you want to grow both *Cucurbita argyrosperma* and *Cucurbita moschata,* to seed in the same pumpkin patch (see Saving Seeds, page 29). It's really quite straightforward and far easier than working with tiny, fragile melon blossoms. By transferring pollen from the male flower to the female flower of the same variety, preempting bees carrying pollen from other varieties, you will control pollination and maximize seed purity.

Spend a little time in the squash patch examining the behavior of flowers. Squashes have a monoecious flowering pattern, with separate staminate (male) and pistillate (female) blooms. Males are recognizable by their straight simple stems; females have an immature ovary at the base of each flower, which will become the squash. The fruit is botanically a fleshy berry called a pepo. The staminate flowers arrive on the scene earlier in the season than do the pistillate flowers. If the weather is too hot or too cold, the females delay their performance until the weather settles. Squash blossoms are as ephemeral as some Broadway shows—they open and close on the same day. Even though new blossoms open daily, try to pollinate your flowers early in the season and early in the morning for better fruit set.

Follow these simple steps, and I can almost guarantee you a very high success rate. Make sure to have on hand a roll of three-quarter-inch masking tape, twist ties, cotton balls, surveyor's or pollination flags in two colors, surveyor's tape, and a book for monitoring progress.

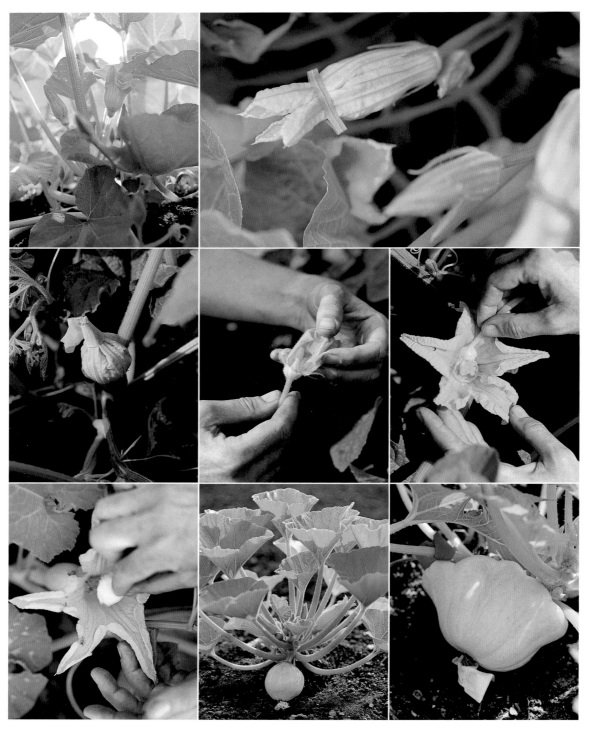

LEFT TO RIGHT. **TOP ROW:** ON BENDED KNEE, SEARCHING FOR BLOSSOMS. MALE SECURED. **MIDDLE ROW:** RECEPTIVE FEMALE. READY, SET . . . GO: TRANSFER POLLEN. **BOTTOM ROW:** PROTECTING STIGMA. SWELLING FRUIT, SUCCESSFULLY HAND POLLINATED, ON A BUSH PLANT. GELBER WITH PURE SEED INSIDE; TAPE ADHERENT TO BLOSSOM END.

1. Remove any fruits that have already set.
2. Identify male and female blossoms from the same plant ("selfing") or plants of the same variety ("sibbing") that appear likely to open the following morning: The buds will be somewhat orange and the petals may be slightly opened. Try to find two or more males for every female. Disregard dried, faded, or open flowers.
3. To close buds securely, use tape or twist ties, but apply them carefully to avoid damaging the petals, pollen-bearing anthers of the male, or the stigma (where the pollen lands) of the female blossom.
4. Blossoms tend to disappear from view, so stake pollination (surveyor's) flags next to closed blossoms to make them easier to find the next morning when pollen is actually transferred. Use one color for staminate blossoms and another for pistillates.

EARLY MORNING—DAY TWO

1. Find the male blossoms that were closed the previous day and pick them with their stems intact for easier manipulation. Discard any that might have opened in the interim.
2. Position yourself next to the first closed female blossom and carefully peel away all the petals from at least one, if not two, male blossoms, exposing the dehisced, pollen-covered anthers. Set these down and protect them from bees by placing their petals on top.
3. Remove the tape or tie from the female blossom; the petals should slowly expand, indicating the female is receptive.
4. Keeping an eye out for bees, quickly apply the loose pollen from the males onto the stigma of the female, using a rolling movement. Try to achieve full coverage without damaging the tender organs.
5. Carefully close the pollinated female flower using either fresh tape or a twist tie. Placing a protective cotton ball over the stigma before closing the flower is optional.
6. Loosely tie a piece of surveyor's tape around the vine adjacent to the pollinated flower and keep the pollination flag in place for easy retrieval.
7. Repeat this process if other female blossoms were closed. If hand pollination was successful, the ovary at the base of the pistillate flowers will swell and develop into fruits whose seeds are pure.

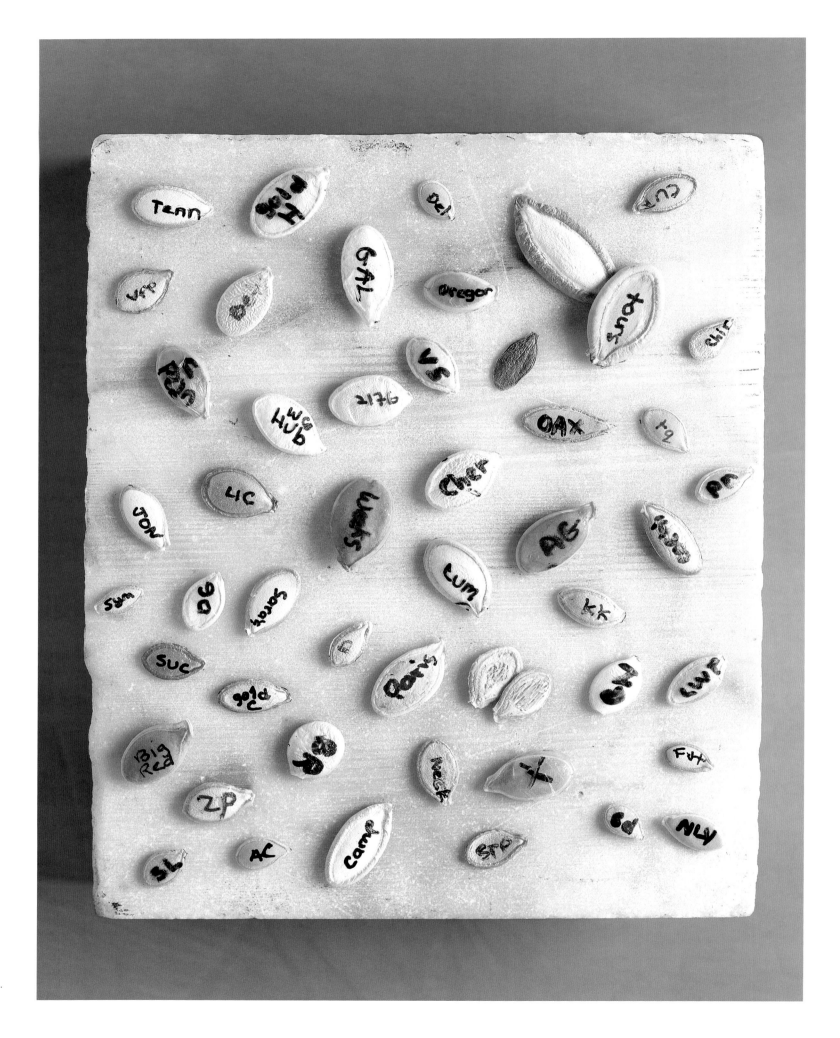

SAVING
SEEDS

IF YOU WANT TO SAVE PURE SEED, you need to know that squash plants are basically outbreeders that rely on insect pollinators to produce both fruit and the seed contained within. Bees flit from male to female blossoms and leave traces of foreign pollen behind. As in the case of humans, the identity of the mother (the fertilized female flower or ovary) is readily apparent, but paternity (the pollen parent) can be a mystery. Most people are under the mistaken impression that when varieties cross, changes will instantaneously be seen in the fruit. But the fruit is maternal tissue, and there is no xenia, or immediate effect of crossing, in squash fruit (crossing is visible in corn kernels, though). It is only the seeds, holding the next generation in embryo form, that are crossed.

Your mission, should you decide to accept it, will be to thwart the bees and ensure that like breeds with like. Seeds must be taken only from standard squashes (not F1 hybrids) that have either been isolated by distance (one-half mile) from other varieties with which they could cross, or have been pollinated by people and not bees (see "Hand Pollination," page 25). Let me reassure you, for starters, that—at least in nature, if not in the lab—squashes won't mix (crossbreed) with melons or cucumbers. Squashes that belong to the same species do cross with one another if given the chance. Of the four domesticated squash species included in this book, only *C. argyrosperma* and *C. moschata* will cross—and that apparently only when *C. argyrosperma* is the female and *C. moschata* is the male parent (not the reciprocal cross). The beginning seed saver can, therefore, grow one variety each of *C. pepo* and *C. maxima*, and one variety of either *C. moschata* or *C. argyrosperma* in the same garden plot, in good conscience. Information about which cultivars belong to which species is available in two Seed Savers Exchange publications: *Garden Seed Inventory* and *Seed to Seed*.

In order to harvest viable pure seed, not only must squashes (summer and winter) be grown until they are fully mature, but they must be stored for at least one month postharvest to ripen still further. Save seed from your best fruit, those that are characteristic of the variety as a whole. Cut the squash open and extract the seeds, pulling them away from the fleshy fruit and stringy attachments. You can have your winter squash seed and eat the flesh, too, but not so summer squash, which makes for singularly unpleasant eating at this stage of the game. Place the seeds in a colander and rinse them under a stream of tepid water. Shake the colander a little and blot the underside with paper towels to remove excess moisture. Lay the plump, glistening seeds out, one layer deep, on absorbent paper plates labeled with the variety name. Allow them to dry at room temperature in a well-ventilated place out of direct sunlight for several weeks. The seeds are dry enough for long-term storage when they snap in two instead of bending. Resist the temptation to salt and roast the seeds, and place them in an air-tight container in your refrigerator or freezer, where they will remain viable for six or more years.

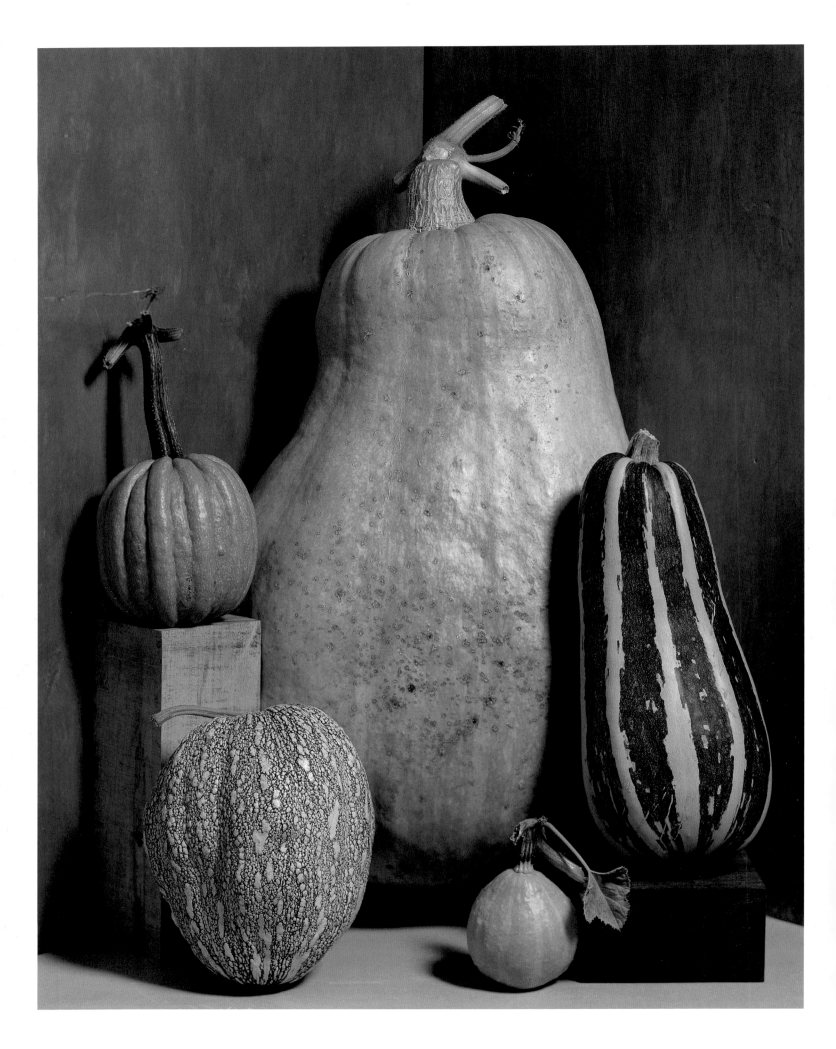

Squashes, Glorious Squashes

ABOUT THE SQUASHES

Here you will find squashes in all their glory, organized by species. In addition to the photographs and verbal portraits, this section contains vital statistics and descriptive information: names and synonyms, genus and species (and, in many cases, horticultural groups), size and weight, colors and color ratings, amount of fiber, best uses, dates of introduction, anecdotes, and seed sources. Seeds for a majority of varieties are available from domestic seed suppliers. First find the abbreviated seed source codes, then locate the full names, addresses, and contact information for commercial sources on page 198.

Flesh and rind samples are matched to standard colors with commonly accepted names. Flesh color and color ratings of flesh are not recorded for summer squashes because most are yellowish or whiter shades of pale. Flesh color for winter squash is rated on a scale from 1 to 5, with 5 being the deepest orange, which is associated with good table quality and high carotenoids. Freedom from fiber is another important quality component of squash; I used taste tests to determine the presence of fiber and whether the level was acceptable or not. I also used my own best judgment to determine the squash's highest and best use: livestock feed, exhibition, table vegetable (good eating), or ornamental.

It's almost impossible to describe the taste of something (summer squash) that has none—until it is sautéed in garlic and olive oil; only distinctive tastes and textures are noted. The highest and best use of ornamental gourds is . . . well, ornamental. Their flesh fiber is, with rare exceptions, unacceptable and their flavors are bitter or bland, never sugary.

A TURK'S TURBAN FIT FOR A SULTAN.

CUCURBITA
MAXIMA

MY FAVORITE SQUASHES. If all you've ever known is Acorn (*C. pepo*) or Butternut (*C. moschata*), then you will flip your lid when you taste the likes of Buttercup, Delicious, or Sibley. *Maxima*s have a quartet of virtues that other species lack: mild flavor, high solids (starches and sugars), freedom from fibers, and brilliant orange flesh. Choosy canners choose *maxima*s. The largest pumpkins and squashes (Atlantic Giant is the world's largest fruit) and some of the most beautiful–Iran, Galeuse d'Eysines, Queensland Blue, Strawberry Crown, and Triamble–are members of this species.

The soft-stemmed squash, *Cucurbita maxima*, arrived from South America after 1492, and although we have yet to fully embrace it–possibly because we're stuck on our native *Cucurbita pepo*–the Japanese have not hesitated. *Maxima* was domesticated by indigenes from the wild progenitor *Cucurbita maxima* ssp. *andreana*, in Argentina, Bolivia, or Uruguay. It is now widely dispersed. Most members of this species grow on long vines and are consumed mature as winter squashes; shorter-vined forms exist and some fruits are eaten immature as summer squashes, especially in South America. *Maxima*s are tolerant of cool temperatures but not squash bugs or vine borers.

For the sake of convenience, the *maxima*s in this book have been sorted into eight horticultural groups (five of which derive from Dr. Charles Jeffrey) based on fruit shape, color, or size.

AUSTRALIAN BLUE: blue-rinded squashes with a long postharvest life, popular Down Under
BANANA: elongated types, in several colors, usually tapered at the stem and blossom ends
BUTTERCUP: small drum-shape pumpkins with an "acorn," not prominent, at the blossom end
HUBBARD: big and bulky bruisers, smooth-rinded or warted, of excellent table quality, in blue, red, or green
MAMMOTH: exhibition squashes weighing one hundred pounds or more
TURBAN: not strictly ornamental; similar to Buttercups, but the acorn is more prominent
ZAPALLITO: petite fruits grown on short-running vines or bushy plants
MISCELLANEOUS: unclassified *maxima*s

THREE IRANS.

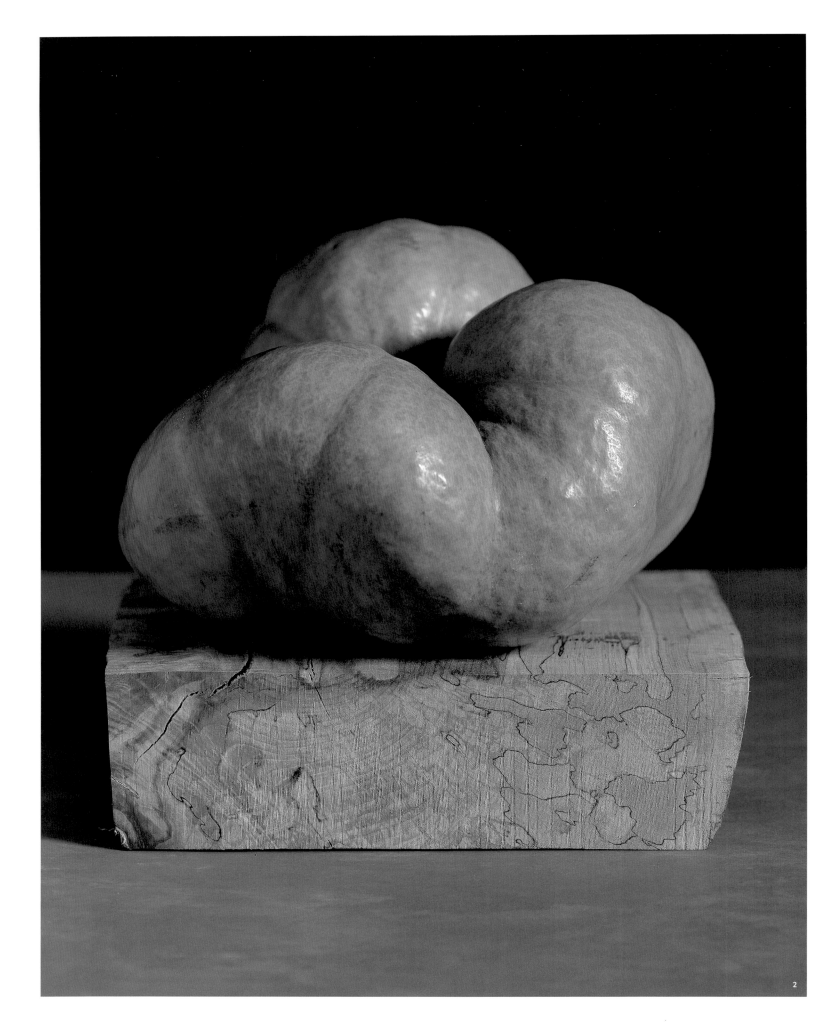

Australian Blue Group *Cucurbita maxima*

IMAGINE AN AUTUMN LANDSCAPE strewn with blue, not orange, pumpkins. That's par for the course in topsy-turvy Australia–the land that gave a berth to the blues. *Cucurbita maxima* pumpkins apparently arrived in Australia sometime after the first British settlement in 1788 (perhaps with farmer Elizabeth Macarthur in 1790); there the *maxima*s now live and thrive in the Blue Belt, at the same latitude as their native Uruguay and Argentina. (They thrive for the same reason in South Africa.) Down Under, nearly all the squash are blue, including the rounded sorts and the elongated Blue Hubbard and Blue Banana. Aussies also grow "grammas," which are tan *moschata* Crooknecks and Straightnecks, and some Japanese types.

None of the Australian Blues–including Queensland Blue, Crown, Triamble, Jarrahdale, and Ironbark–has achieved fame in the United States; all are well-loved in Australia. With the exception of Jarrahdale, they have meaty, sugary, brilliant orange flesh. If primitive pumpkins are little more than seed bags, then the Aussie Blues, with their dense abundant flesh (there's no hole, or seed cavity, in these pumpkins), are about the most highly evolved pumpkins on the planet.

Australia, in the best English and Irish tradition, has always been a meat-and-potatoes kind of place; it's no wonder that pumpkin has achieved near parity on the menu with potato. Sunday dinner typically consists of a joint of beef or mutton roasted alongside pumpkin, potato, and some third lucky vegetable. Queensland Blue scones at teatime are also a favorite, especially served warm with feijoa or pineapple guava (*Feijoa sellowiana*) jelly. Grabben Gullen Pie, once favored by early English settlers, is made by hollowing out a pumpkin, filling it with joints of possum, and baking it in a bed of hot coals.

Not only do Australian Blues look good and taste good, but they do so for a remarkably long time. A shelf life of up to two years is not unheard of: The Triamble pumpkin pictured here is two years old and even survived being cast in a rubber mold for a bronze sculpture. Part of these pumpkins' longevity can be attributed to their very thin but hard shells, which in nearly all cases are not terribly difficult to cut open. The Blues grow on extremely vigorous vines up to thirty feet in length, and they require a long growing season (four or five months) to mature. It is perhaps for this last reason, as well as ignorance, that American gardeners have steered clear of them. Most of these varieties have not even been offered in the American seed trade until recent years.

Queensland Blue, Crown, and Triamble, described in *The Vegetables of New York* (1937) as the most common Australian pumpkins in 1929, were directly imported into the United States from Arthur Yates and Company of Sydney, Australia.

Triamble *fig. 2*

Cucurbita maxima Australian Blue Group
SIZE: 7" long by 9$\frac{1}{2}$" wide
WEIGHT: 8$\frac{1}{2}$ pounds
RIND COLOR: toned-down vermilion
FLESH COLOR: brilliant medium orange
COLOR RATING: 3
FIBER: none
DATE OF INTRODUCTION: 1932
BEST USES: decorative, table vegetable
SYNONYMS: Shamrock, Triangle, Tri-Star
SEED SOURCES: Hud, Sse

I adore Triamble for every reason in the book. Listed as early as 1918 by Anderson & Co. of Sydney. Reputed by one source to be of French origin, but that seems unlikely; the French got it from the Vavilov Institute in St. Petersburg, Russia, in 1964. Listed in 1985 by Gleckler's Seedsmen, Metamora, Ohio. Trilocular; the carpels apparently develop separately instead of being fused, according to Dr. Brent Loy.

Queensland Blue *fig.3*

Cucurbita maxima Australian
Blue Group

SIZE: 6" long by 8" wide

WEIGHT: 7 pounds

RIND COLOR: intense vermilion green

FLESH COLOR: intense brilliant orange

COLOR RATING: 4

FIBER: none

DATE OF INTRODUCTION: Imported from
Australia in 1932; evaluated at the
New York State Agricultural
Experiment Station

BEST USES: decorative, table vegetable

SYNONYMS: Australian Blue,
Beaudesert Blue

SEED SOURCES: Bake, Ers, Heir, Hud,
Lej, Sky, Sse

Splendiferous. Cinched waist, darkest
blue rind, striking gray foliage.

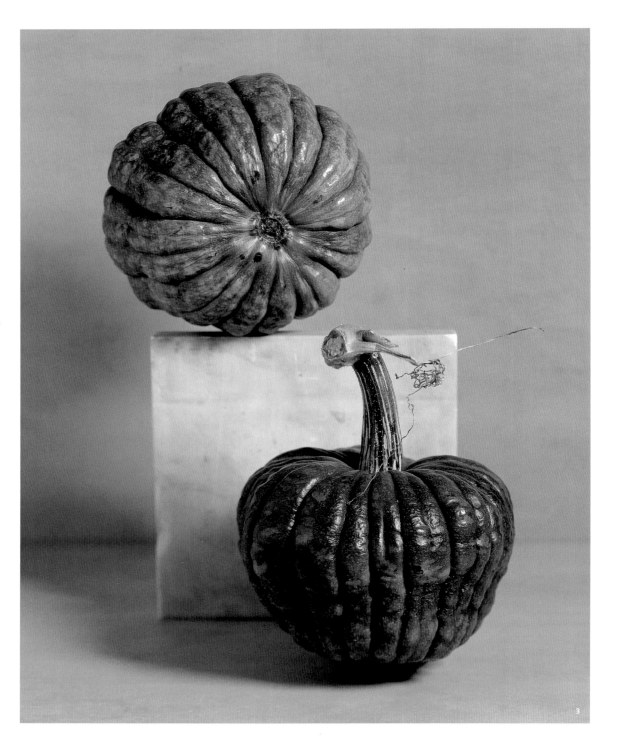

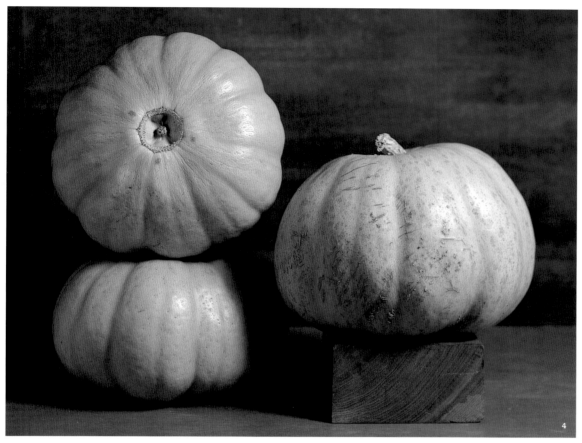

Crown *fig.4*

Cucurbita maxima Australian Blue Group

SIZE: 5½" long by 10½" wide

WEIGHT: 11 pounds

RIND COLOR: toned-down vermilion

FLESH COLOR: dense brilliant orange

COLOR RATING: 4

FIBER: none

DATE OF INTRODUCTION: Imported from Australia in 1932 and grown in Geneva, New York

BEST USE: table vegetable

SYNONYMS: Crown Prince, Improved Crown, Select Crown

SEED SOURCE: Bake

Very sweet. Documented by Vilmorin (1883) as Gris de Boulogne. Could be the same as Vert d'Australie described earlier by Vilmorin (1856). Not the same as Whangaparoa Crown from New Zealand. Seed industry now changing rapidly in Australia, putting Aussie Blues in peril.

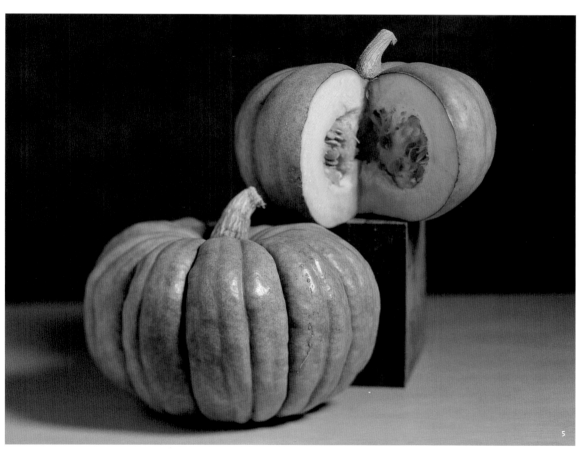

Jarrahdale *fig. 5*

Cucurbita maxima Australian Blue Group

SIZE: 5½" long by 8" wide

WEIGHT: 6 pounds

RIND COLOR: toned-down vermilion

FLESH COLOR: toned-down brilliant orange

COLOR RATING: 2

FIBER: none

DATE OF INTRODUCTION: Listed in 1991 by Bountiful Gardens, Willits, California

BEST USE: table vegetable

SYNONYMS: Australian Pumpkin, Jarradale, West Australian Grey

SEED SOURCES: Bake, Bou, Burpee, Com, Ers, Fed, John, Jor, Lej, Park, Rev, Sand, Sky, Und

A popular market type in Australia. Table quality is not nearly as good as Crown, Queensland Blue, or Triamble.

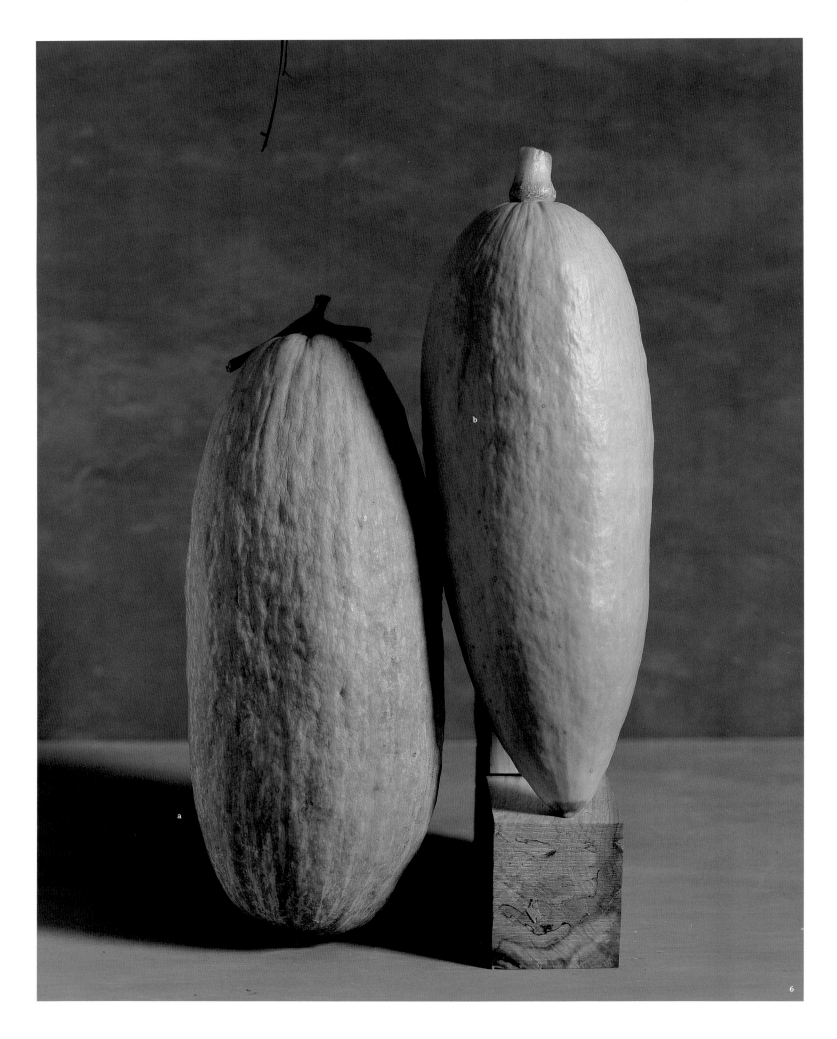

Banana Group *Cucurbita maxima*

WAKE UP TO THE GOODNESS of the *Cucurbita maxima*s. The Bananas, as a horticultural group, are top tier. Incorporate them into your meal plan, pronto, and don't be put off by their outrageous appearance and sometimes gigundo size. Blue Banana, first known as Shumway's Mexican Banana, was introduced by R. H. Shumway, circa 1893. By 1901, only three seed houses were carrying stock (R. H. Shumway, W. Atlee Burpee, and Jos. F. Dickmann), yet the varieties were already becoming popular on the West Coast. Shumway's 1895 catalog indicates that the company did not derive Banana directly from Mexico, but originated it by "crossing imported varieties."

This isn't surprising. Mexico is replete with *pepo*s and *argyrosperma*s, *moschata*s and *ficifolia*s. *Maxima*s come from south of the border, too—a little farther south. Eight-hundred-year-old archaeological seeds, uncovered from a burial site along the desert coast of Peru, at San Nicolás, have been found to match those of the very distinctive modern cultivar Banana.

Those in the know, like Iowa seed merchants Glenn Drowns and Henry Field before him, think Blue Banana is tops. Powdery, rich Blue Banana makes my heart sing, too. Pink Banana pales in comparison—in fact, when it comes to Bananas, the harder-rinded blues win out over the pinks every time. The champion, though, has to be Sibley, or Pike's Peak, which surpasses even Blue Banana in sweetness, texture, and flavor. Kindred spirit James J. H. Gregory found Sibley simply "magnificent."

So where have all the Bananas gone? They've gone to seed savers and have rarely surfaced in the marketplace. I don't believe, as Henry Field did, that seedsmen have dropped Bananas from commercial production because they make "but very little seed." I think, rather, that round pumpkins simply became more fashionable. Frieda Caplan, however, head of Frieda's, the nation's premier distributor and marketer of specialty produce, located in Los Alamitos, California, has single-handedly reintroduced the Pink Banana squash into commerce, branded with her label. I'm hoping she'll reintroduce the Blue, too, and do for Banana squash what United Fruit did for bananas with their blue paper seals.

Blue Banana *fig. 6a*

Cucurbita maxima Banana Group
SIZE: $18^{1}/_{2}$" long by 5" wide
WEIGHT: 5 pounds
RIND COLOR: transparent vermilion green
FLESH COLOR: transparent golden ocher
COLOR RATING: 3
FIBER: none
DATE OF INTRODUCTION: circa 1893; R. H. Shumway
BEST USE: table vegetable
SYNONYMS: Mexican Banana, Plymouth Rock
SEED SOURCE: Bake

Followed quickly on the heels of the similar Sibley (1887). Higher sugar levels in stored fruit (90 to 120 days) than the norm.

Pink Banana *fig. 6b*

Cucurbita maxima Banana Group
SIZE: 17" long by 5" wide
WEIGHT: 6 pounds
RIND COLOR: dense golden ocher
FLESH COLOR: intense golden yellow
COLOR RATING: 4
FIBER: none
DATE OF INTRODUCTION: circa 1900
BEST USE: table vegetable
SYNONYM: Jumbo Pink Banana
SEED SOURCES: Bake, Bunt, Green, Kil, Lan, Pine, Shaf

H. L. Musser of Aggeler & Musser Co., Los Angeles, separated the pinks from the blues. Though the pinks aren't shabby, I'll take the blues anytime. Jumbo Pink can be monstrous (up to 130 pounds). Most popular on the West Coast.

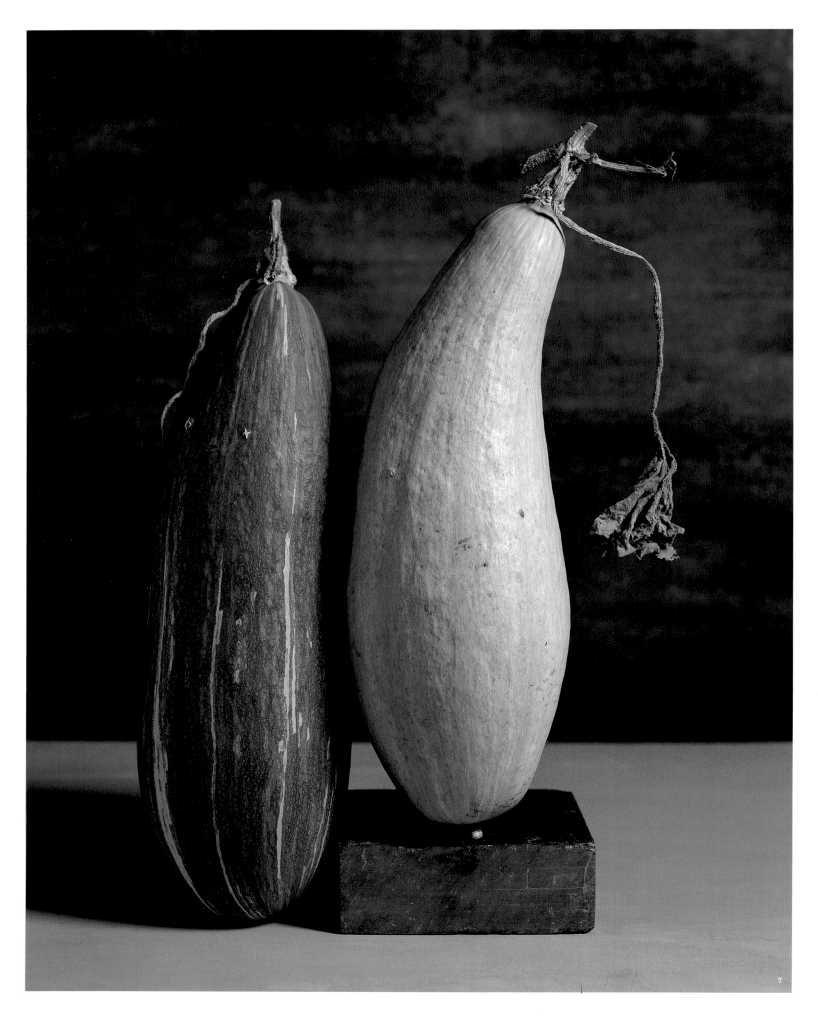

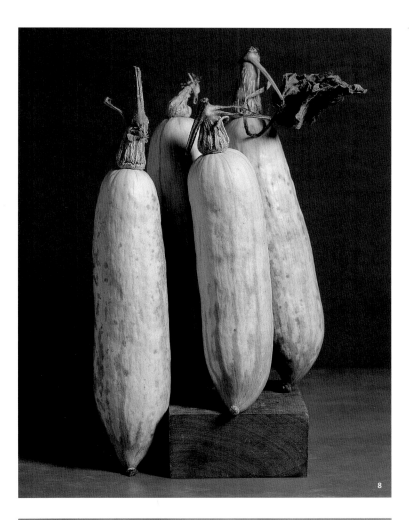

Rainbow *fig. 8*

Cucurbita maxima Banana Group
SIZE: 12" long by 3½" wide
WEIGHT: 2½ pounds
RIND COLORS: light permanent orange and medium vermilion green
FLESH COLOR: intense brilliant orange
COLOR RATING: 4
FIBER: acceptable
DATE OF INTRODUCTION: 1947; Farmer Seed & Nursery Co., Faribault, Minnesota
BEST USES: decorative, table vegetable
SEED SOURCES: Horus, Sand

A small Banana, adapted to 45th parallel, created at the Minnesota Agricultural Experiment Station–the place that brought us Kitchenette (1921), New Brighton Hubbard (1932), and Greengold (1939). Parents: Greengold × Banana. Sweet and potatoey but thin fleshed; good for stuffing as banana boats.

Guatemala Blue *fig. 7*

Cucurbita maxima Banana Group
SIZE: 15½" long by 5½" wide
WEIGHT: 5½ pounds
RIND COLOR: light vermilion green
FLESH COLOR: intense golden yellow
COLOR RATING: 4
FIBER: none
BEST USE: table vegetable
SYNONYM: Guatemalan Blue
SEED SOURCES: Bake, Sand, Yum

Throws off an occasional very dark blue fruit, as shown here.

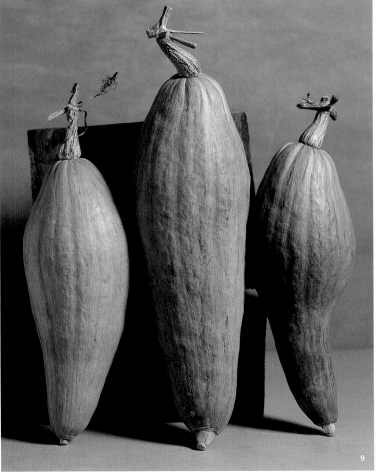

Sibley *fig. 9*

Cucurbita maxima Banana Group
SIZE: 18" long by 5½" wide
WEIGHT: 6½ pounds
RIND COLOR: light vermilion green
FLESH COLOR: intense golden yellow
COLOR RATING: 4
FIBER: none
DATE OF INTRODUCTION: 1887; Hiram Sibley & Co., Rochester, New York
BEST USE: table vegetable
SYNONYMS: New Sibley, Pike's Peak
SEED SOURCES: Bake, Hud, Sse

Best of the Bananas. Obpyriform (inversely pear shaped), reminiscent of Hubbard. Discovered in the hands of an old lady from Van Dinam, Iowa, who'd grown it for more than fifty years in Missouri. Peter Henderson & Co. was very favorably impressed in 1887 trials; it found Sibley entirely new and distinct and possessed of rare edible qualities, being dry, with a rich delicate flavor peculiarly its own.

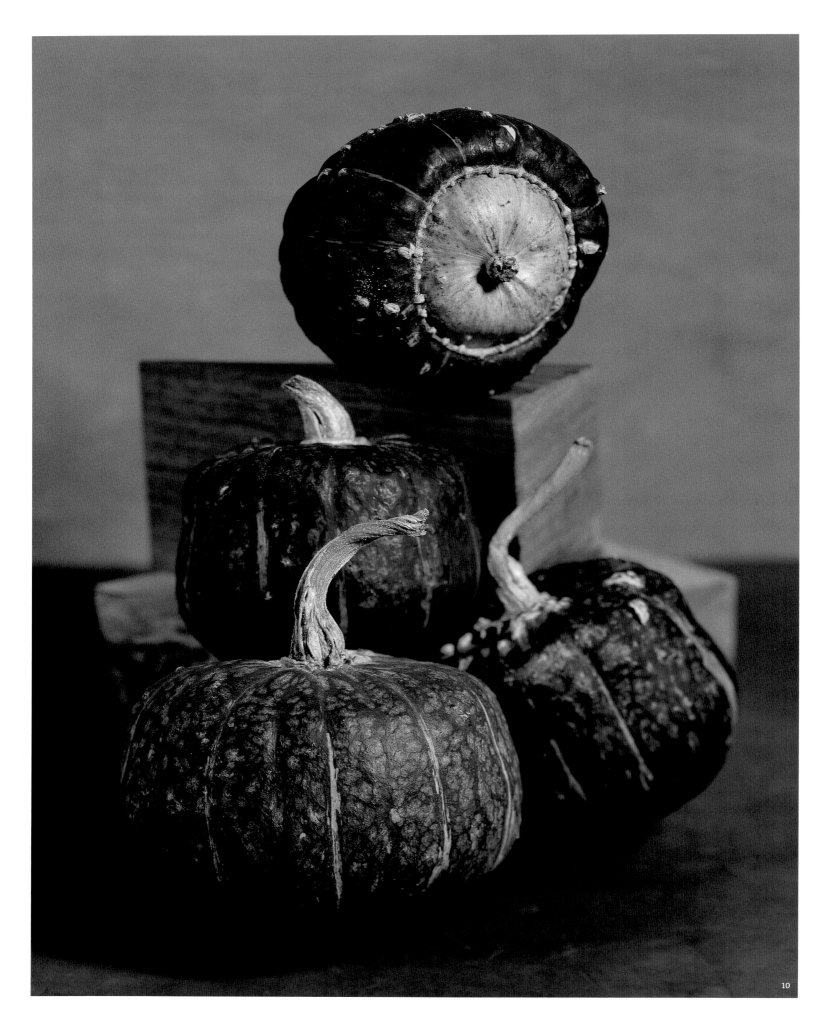

Buttercup Group *Cucurbita maxima*

BUTTERCUP IS A SQUASH with aspirations. It wants to be a sweet potato, and in the minds of many, including me, it very nearly succeeds. Don't overlook it because it's homely or commonplace nowadays. In the wide world of squash, Buttercup is a benchmark. Inside it is brilliant orange, dry, and sweet-meated, without a whisper of fiber. It even succeeds where sweet potatoes fail, in North Dakota.

Buttercup was developed at the North Dakota Agricultural Experiment Station in the late 1920s and early '30s by Albert Yaeger, a man who knew how to cook and had his priorities straight. He wanted a sweet-potato substitute for the benefit of the northern housewife, one that would leave no leftovers and was easy to cut or peel. Ever wonder how to negotiate the turban of a Buttercup (akin to the navel on an orange) at the blossom end or downside? Just carve it out. "Nothing is more delicious than baked squash with plenty of fresh butter," Yaeger proclaimed, though he was partial to baked Buttercup stuffed with sausage, too.

Yaeger began working with the Hubbard in 1922, but abandoned that avenue when something better came along three years later in a patch of Quality squash. This "Buttercup in formation" was distinctive in appearance and extraordinarily tasty. The saved seed, replanted in 1926, yielded plants with fruits varying in color and shape, indicating that Essex Hybrid (shown on page 46) was the probable pollen parent. Selection and "selfing," or self-pollination, continued until the variety was named and released in 1931. In the late 1920s, extensive baking tests were performed under the auspices of Miss E. Latzke in the Department of Home Economics at the North Dakota College of Agriculture. A trained panel of judges rated texture, flavor, color, sweetness, and depth of flesh on a scale from 0 to 100 and comparisons were also made with standard varieties. The Agricultural Chemistry Department got in on the act, too, by calculating dry matter content. No squash in history had ever been subjected to such scrutiny. Buttercup emerged on top.

Buttercup is American royalty. Of the 134 different squash cultivars evaluated by the authors of *The Vegetables of New York* (1937), only five merited the mark of excellence. Those five were Buttercup and, as it turns out, four of its parents or grandparents. Quality (introduced by the Joseph Harris Company of Coldwater, New York, in 1914) was the mother and Essex Hybrid the putative father. Beyond that, Delicious was the maternal grandmother, Hubbard the purported paternal grandfather, and American Turban the paternal grandmother. American Turban probably didn't make the grade of "excellent" because it throws off an occasional lemon. When it's good, though, it's very, very good: the driest, sweetest, finest-grained, and richest flavored of all fall squashes, according to guru James J. H. Gregory of the seed company that bore his name.

Buttercup *fig. 10*

Cucurbita maxima Buttercup Group
SIZE: $3^{1}/_{2}$" long by 5" wide
WEIGHT: $1^{1}/_{2}$ pounds
RIND COLOR: permanent deep olive green
FLESH COLOR: dense brilliant orange
COLOR RATING: 4
FIBER: none
DATE OF INTRODUCTION: 1931; Oscar H. Will & Co., Bismarck, North Dakota
BEST USE: table vegetable
SEED SOURCES: Allen, Bake, Berl, Burpee, Cros, Dan, Farm, Field, Ger, Green, Gurn, Har, Heir, Landis, Lej, Loc, Mel, Mes, Pea, Peace, Pine, Rev, Ros, Soc, Sow, Syn, Ter, Tur

Hard to beat. Many named varieties exist.

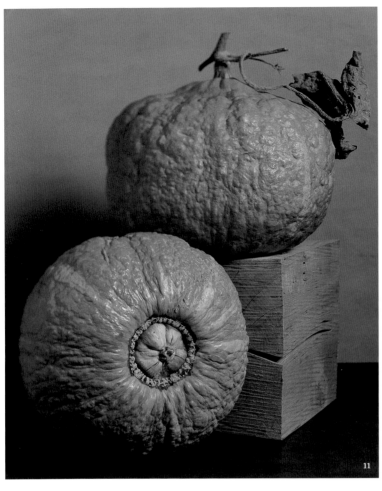

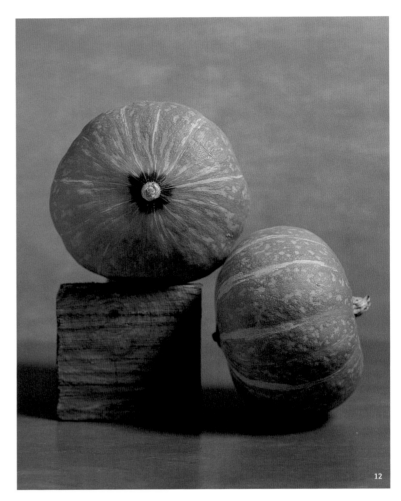

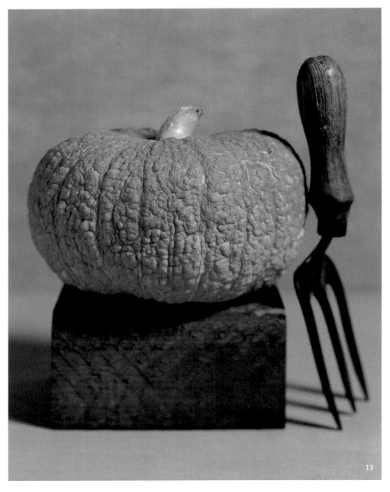

Essex Hybrid *fig. 11*

Cucurbita maxima Turban Group

SIZE: 9" long by 11" wide

WEIGHT: 14 pounds

RIND COLOR: intense raw sienna

FLESH COLOR: deep golden yellow

COLOR RATING: 4

FIBER: none

DATE OF INTRODUCTION: 1883; by Burpee, Ferry, Gregory, Sibley, and Vick

BEST USE: table vegetable

SYNONYMS: Essex, Essex Hardshell, Essex Turban, Improved American Turban, Low's Premium

SEED SOURCE: East

A treasure. Found in a field of American Turban by Aaron Low (introducer of Bay State); Hubbard said to be the likely outcross donor parent. Color of Campbell's cream of tomato soup. A comfort food.

Warren *fig. 13*

Cucurbita maxima Turban Group

SIZE: 4¹/₂" long by 7¹/₂" wide

WEIGHT: 4 pounds

RIND COLOR: dense golden ocher

FLESH COLOR: dense brilliant orange

COLOR RATING: 4

FIBER: none

DATE OF INTRODUCTION: 1890; James J. H. Gregory & Sons, Marblehead, Massachusetts

BEST USES: decorative, table vegetable

SYNONYM: Red Warren

SEED SOURCE: East

Very good quality and texture. The specimen pictured here is a mere shadow of the usual larger and more robustly warted Warren. Original squash found by Mr. David Warren of Marblehead, Massachusetts, in 1889, in a field of Essex Hybrid, and Gregory named it for him. It is not true that the squash was named for one of Gregory's adopted sons or even his grandson (who was most likely named for David Warren).

Greengold *fig. 12*

Cucurbita maxima Buttercup Group

SIZE: 5¹/₂" long by 7" wide

WEIGHT: 4 pounds

RIND COLOR: dense permanent orange

FLESH COLOR: intense brilliant orange

COLOR RATING: 4

FIBER: none

DATE OF INTRODUCTION: 1939; commercialized by Farmer Seed & Nursery Co., Faribault, Minnesota

BEST USE: table vegetable

SYNONYM: Green Gold

Originated at the Minnesota Agricultural Experiment Station, St. Paul, Minnesota. Parent was an inbred selection from Buttercup. Sweet, dense, and potatoey.

Kindred *fig. 14*

Cucurbita maxima Buttercup Group

SIZE: 4" long by 6¹/₂" wide

WEIGHT: 3 pounds

RIND COLOR: intense yellow ocher

FLESH COLOR: medium cadmium orange

COLOR RATING: 4

FIBER: none

DATE OF INTRODUCTION: 1969 All America Selection (AAS); offered by Northrup, King & Co.

BEST USE: table vegetable

SYNONYMS: Kindred Buttercup, Kindred Turban, Orange Buttercup

SEED SOURCES: Sand, Tur

Very sweet, even raw. One of the best. Semivining. Developed by Ben Gilbertson of Kindred, North Dakota.

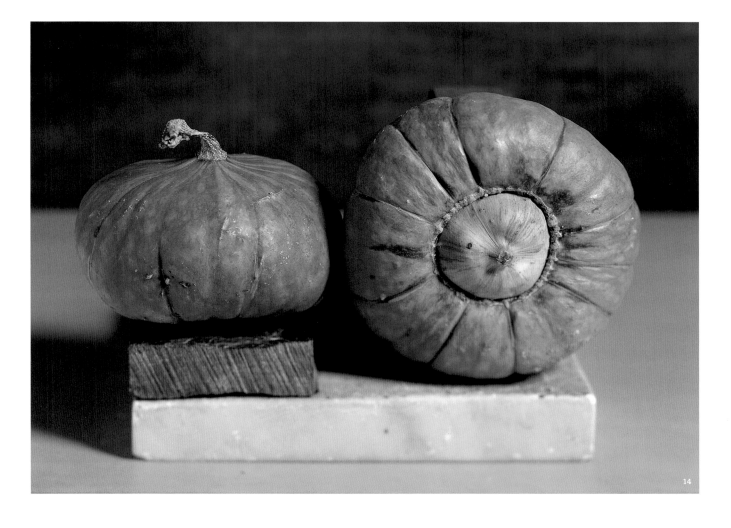

14

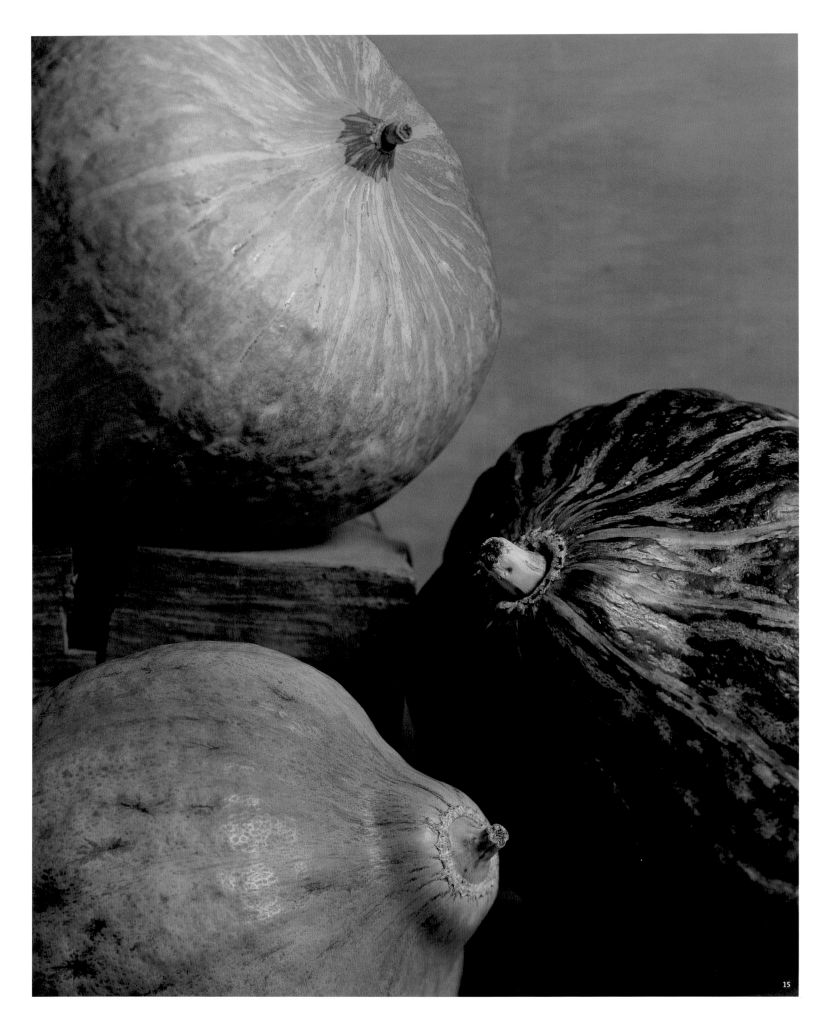

Hubbard Group *Cucurbita Maxima*

DON'T THESE SQUASHES make you chuckle? They've got personality. You don't have to look too closely to see the anatomy and physiognomy of headless chickens, talking heads, gigantesque breasts, or cavorting sea lions. But consider their more serious side, for the Hubbards are, as James J. H. Gregory attested, "the acme of perfection in squashdom."

We should all get down on our hands and knees and thank Gregory for introducing the original green Hubbard to the American public in the 1840s and '50s (through noncommercial and later commercial channels). This man did the world a great service. Until his time, the woody-stemmed pumpkins (*Cucurbita pepo* and *Cucurbita moschata*), fibrous and flavorless, held sway in North America. As a seedsman and a prolific writer, Gregory, whose *Squashes: How to Grow Them* (1867) is classic, sang the praises of the "soft-stemmed" *Cucurbita maxima*s. *Maxima*s originated in South America and were domesticated there by indigenes from a wild progenitor, *Cucurbita andreana,* which is native to Uruguay and Argentina and possibly Bolivia. *Maxima*s apparently first arrived in North America (at Marblehead, Massachusetts, Gregory's hometown and the "birthplace of the American Navy") in the 1700s aboard sailing ships from the West Indies.

In attempting to trace the history of the Hubbard, Mr. Gregory unwittingly landed himself in controversy. He was accused of fabricating his account of the Hubbard's origins; critics pointed to seeming inconsistencies in his various renditions of the story. Some implied he'd given a new name to the old variety Sweet Potato, which, while similar in shape to green Hubbard, was blue. Autumnal Marrow, or Boston Marrow, shared certain Hubbard features as well, but was red-rinded. Thus, there was a class of squash that was "Hubbardy," making confusion rampant. Fearing Burr Jr., the author of *The Field and Garden Vegetables of America* (1863), believed Gregory was a man of the highest integrity. I've reached the same conclusion. *No one* knew squashes better than Gregory did.

I pieced together the history of the Hubbard from three of Gregory's accounts. An elderly woman told Gregory that a market man named Green brought the first Hubbard to Marblehead around 1798. She remembered, from her childhood, tasting that first specimen, which was upturned "like a Chinese shoe"–a more poetic way of saying the fruit was "falcate-fusiform." In 1842 or 1843, Elizabeth Hubbard gave the famous seeds to Gregory, which eventually launched him in the seed business. Her seeds had come from Captain Knott Martin, who had gotten his seeds from an unnamed woman gardener. "Ma'am Hubbard" was the Gregorys' old washerwoman, "faithful in her narrow sphere in her day and

CLOCKWISE FROM TOP: GOLDEN HUBBARD, HUBBARD, GILL'S BLUE HUBBARD.

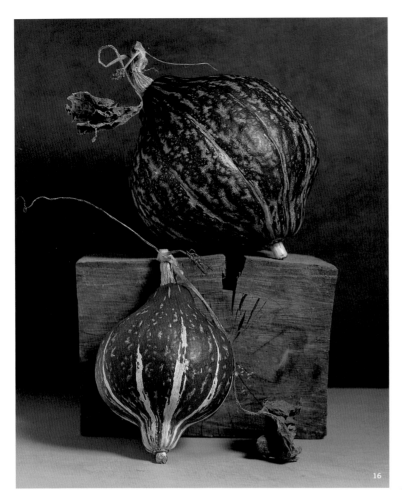

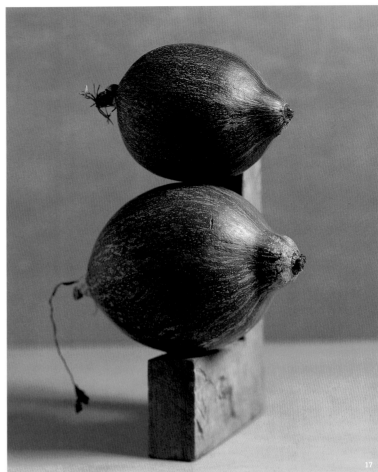

generation, a good, humble soul, and it pleases me to think that the name of such a one has become, without any intent of hers, famous." James and his father gratefully named the variety for their servant.

In recent years, information has surfaced that adds another dimension to the story and fills in a blank. Louise Martin Cutler, a Marblehead historian, claimed in 1981 that it was actually her great-aunt, Sarah Martin (sister to Captain Knott Martin) who "developed" the Hubbard squash. Louise Martin Cutler, ninety-three years old, told me that her great-aunts Sarah and Martha were well known in Marblehead as "the Mayflower" and "the Puritan." Often attired in hoop skirts, they, like the ships, followed each other in quick succession down narrow pathways. Sarah was quite bashful; if she hadn't been so timid about approaching the Gregorys, the seed she entrusted to her friend, Mrs. Elizabeth Hubbard, might now be known as the Martin squash.

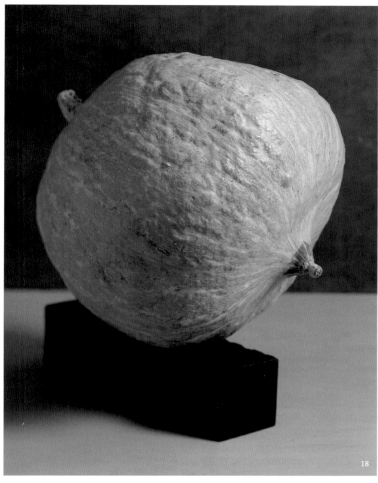

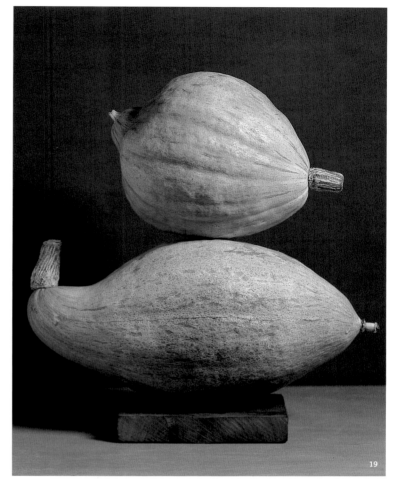

Hubbard *fig. 16*
Cucurbita maxima Hubbard Group
SIZE: 13" long by 11" wide
WEIGHT: 18 pounds
RIND COLOR: wet permanent olive green with streaks of subdued olive green
FLESH COLOR: intense golden yellow
COLOR RATING: 4
FIBER: none
DATE OF INTRODUCTION: circa 1850; James J. H. Gregory of Marblehead, Massachusetts
BEST USE: table vegetable
SYNONYMS: Green Hubbard, Green Mountain, Improved Hubbard, Mammoth Hubbard, New Sweet Hubbard, Smooth Hubbard, Warted Green Hubbard, Winter
SEED SOURCES: Bou, Burr, Dan, Deb, Ers, Horus, Lan, Loc, Mey, Ros, Sand, Sew, Shaf, Silv, Soc, Sow, Vesey, Wet

Most popular winter squash a century ago. Thick, rich flesh; one of my favorites. Don't be intimidated–it's easier to work with than it looks.

Olive Vert *fig. 17*
Cucurbita maxima Hubbard Group
SIZE: 8" long by 6" wide
WEIGHT: 4½ pounds
RIND COLORS: dense permanent olive green and dense burnt umber
FLESH COLOR: brilliant dense orange
COLOR RATING: 4
FIBER: none
DATE OF INTRODUCTION: Listed by W. Atlee Burpee in 1884 and James J. H. Gregory in 1885
BEST USE: table vegetable
SYNONYMS: Courge Olive Verte, French Olive, Green Olive, New Olive
SEED SOURCE: Sed

"Exactly resembles an unripe olive magnified one hundred times," according to Vilmorin (1885). Very dry, sweet, and well flavored.

Golden Hubbard *figs. 18, 24b*
Cucurbita maxima Hubbard Group
SIZE: 13" long by 12" wide
WEIGHT: 14 pounds
RIND COLOR: toned-down vermilion
FLESH COLOR: dense brilliant orange
COLOR RATING: 4
FIBER: none
DATE OF INTRODUCTION: 1898; D. M. Ferry
BEST USE: table vegetable
SYNONYMS: Genesee Red Hubbard, Golden Warted Hubbard, New Red Hubbard, Red Hubbard
SEED SOURCES: Deb, Ers, Field, Fish, Horus, Jor, Lan, Loc, Mor, Pine, Rev, Rohr, Shaf, Shum, Silv, Sky, Sse, Sto, Twi, Vict

Originated by J. J. Harrison of the Storrs & Harrison Co., Painesville, Ohio. Similar to Boston Marrow or Autumnal Marrow (introduced in 1831) but smaller, curved, and blotched green at the blossom end. As good as they get.

Gill's Blue Hubbard *fig. 19*
Cucurbita maxima Hubbard Group
SIZE: 23" long by 11" wide
WEIGHT: 16 pounds
RIND COLOR: subdued brilliant green
FLESH COLOR: toned-down yellow ocher
COLOR RATING: 2
FIBER: none
DATE OF INTRODUCTION: 1954; Gill Brothers Seed Co., Portland, Oregon
BEST USE: table vegetable
SYNONYM: Blue Hubbard

A smooth-rinded version of Blue Hubbard. A cross of Sweet Meat and True Hubbard. Excellent table quality. Shapes vary among Gill's, Golden, and other Hubbards.

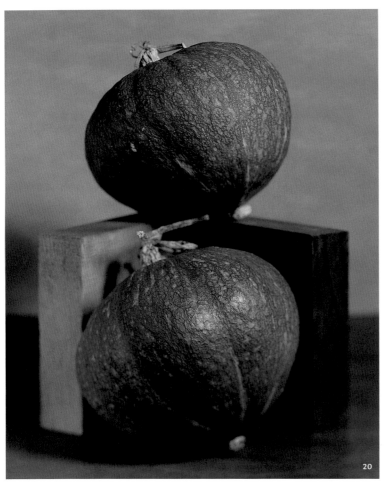

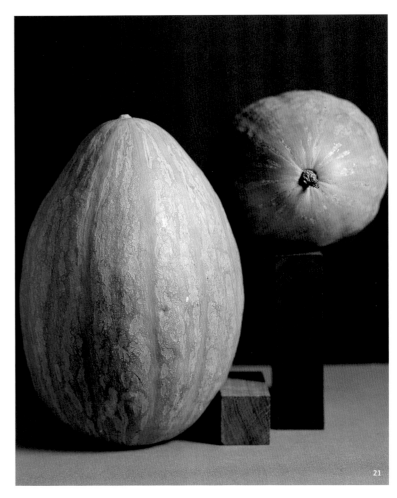

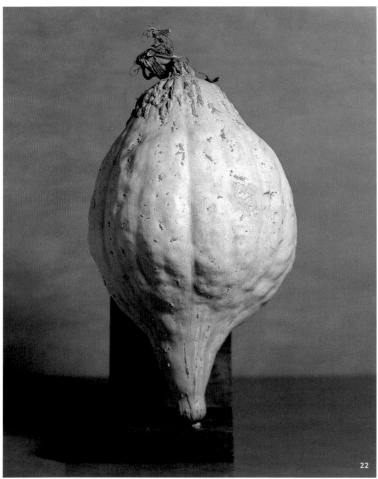

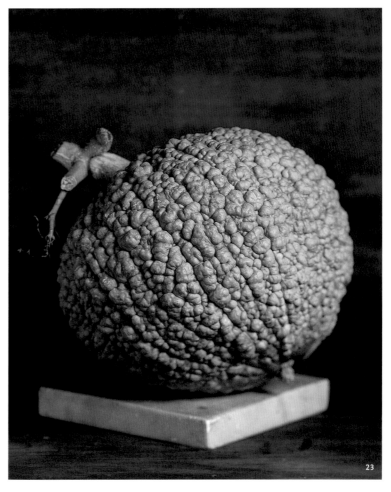

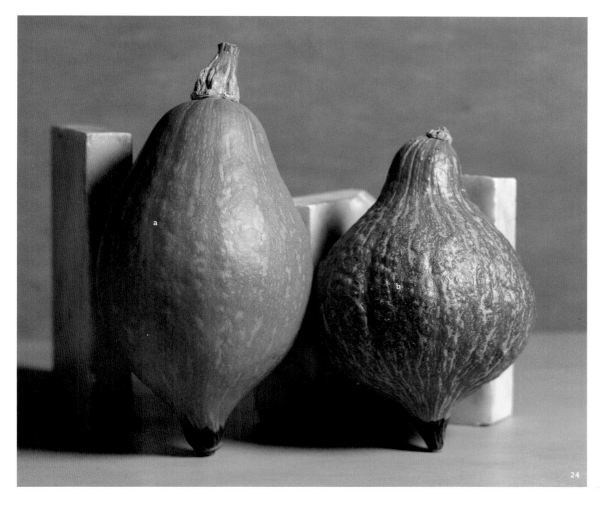

Oregon *fig. 24a*

Cucurbita maxima Hubbard Group
SIZE: 11" long by 7" wide
WEIGHT: 7 pounds
RIND COLOR: intense golden ocher
FLESH COLOR: intense brilliant orange
COLOR RATING: 4
FIBER: none
BEST USE: table vegetable
SYNONYM: Oregon Banana

Gorgeous orange flesh. Like a yam. Sometimes rind is mottled with green. From Lars Olov Rosenstrom, Ekero, Sweden.

Victor *fig. 23*

Cucurbita maxima Hubbard Group
SIZE: 13" long by 15" wide
WEIGHT: 24 pounds
RIND COLOR: intense permanent orange
FLESH COLOR: intense brilliant orange
COLOR RATING: 4
FIBER: none
DATE OF INTRODUCTION: 1897; James J. H. Gregory & Sons, Marblehead, Massachusetts; reintroduced in 2000 by Rupp Seeds, Wauseon, Ohio
BEST USES: decorative, table vegetable
SYNONYM: Red Warty Thing
SEED SOURCES: Bake, Rupp

A sight to behold—good eating, too. Roger Rupp, a man who knows quality squash, recently brought Victor out of U.S.D.A. dry dock, where it was inaccurately labeled Essex Turban. Everyone who saw it on display wondered, "What is that red warty thing?" Conforms exactly to Gregory's 1897 illustration and catalog copy, except that this one, offered by Rupp, is bigger. Gregory first saw the squash on exhibit at agricultural fairs, adorned by blue ribbons; he took it home and grew it in isolation, selected for uniformity, over eight years, and named it for the champ that it was. Victor tended to sport (it still does), showing its parentage, a cross between American Turban and Hubbard. Gregory introduced it anyway: "It is entirely too good and distinct a variety to be kept back from the public longer."

Delicious *fig. 20*

Cucurbita maxima Hubbard Group .
SIZE: 7" long by 8¾" wide
WEIGHT: 8 pounds
RIND COLOR: wet permanent olive green
FLESH COLOR: wet golden yellow
COLOR RATING: 4
FIBER: none
DATE OF INTRODUCTION: 1903; James J. H. Gregory & Sons, Marblehead, Massachusetts
BEST USE: table vegetable
SYNONYM: Delicious Green
SEED SOURCE: Rev

Earns its name. Sweet, thick, earthy, and hard rinded. Parent to Delicious Golden (Boston Marrow × Delicious) developed by Gill Brothers Seed Co. of Portland, Oregon, in 1926. The orange form is favored by the canning industry.

Marblehead *fig. 21*

Cucurbita maxima Hubbard Group
SIZE: 15" long; circumference 28½"
WEIGHT: 13 pounds
RIND COLOR: toned-down vermilion to dark permanent olive green
FLESH COLOR: light golden yellow
COLOR RATING: 2
FIBER: none
DATE OF INTRODUCTION: 1873; James J. H. Gregory named it for his hometown
BEST USE: table vegetable
SYNONYM: Yakima Marblehead
SEED SOURCE: Sed

First-rate. Has a "greater specific gravity" than Hubbard, according to Gregory. Resembles Courge de Valparaiso. Not the same as Umatilla Marblehead, a strain selected by the Eastern Oregon Experiment Station for resistance to blight, and cataloged by Gill Brothers of Portland in 1947.

Betolatti *fig. 22*

Cucurbita maxima Hubbard Group
SIZE: 15" long by 8" wide
WEIGHT: 10 pounds
RIND COLOR: subdued olive green
FLESH COLOR: medium yellow ocher
COLOR RATING: 4
FIBER: none
DATE OF INTRODUCTION: Listed in Seed Savers 1991 yearbook
BEST USE: table vegetable

One of the best, from Charles Betolatti, Danbury, Connecticut. Hard shell and pronounced snout.

FIGURE 24, A PAIR OF HUBBARDS: **a.** GOLDEN HUBBARD; **b.** OREGON.

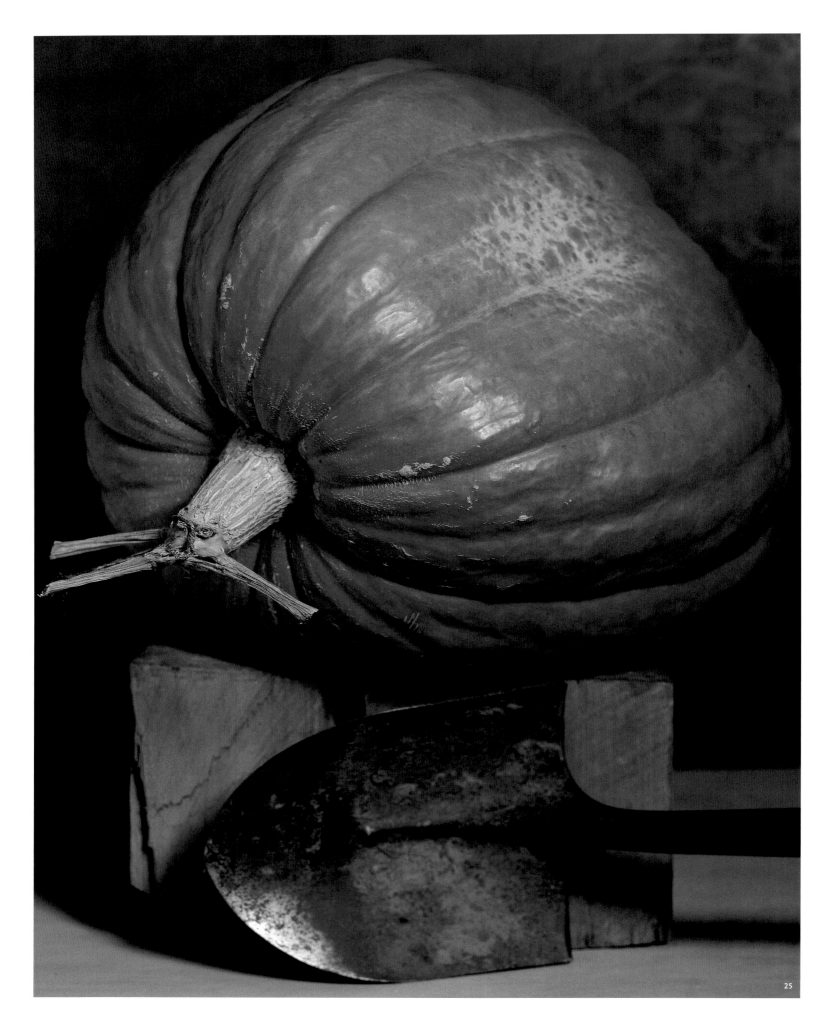

25

Mammoth Group *Cucurbita maxima*

THE MAMMOTHS ARE A NATURAL WONDER. Not only are they the biggest fruits on earth, but they materialize in a flash, almost like magic. They're not fit for human consumption, but that doesn't matter—we have grown them mainly because they bring joy. That is all changing, unfortunately, as pumpkin size and prize money escalate. The World Pumpkin Confederation has offered $100,000 to anyone, in any corner, weighing in with a pumpkin more than fifteen hundred pounds. The sight of beached pumpkin carcasses, all in a row on the official weigh-in day the first Saturday in October, is freakish. Giant pumpkins have become the new Fat Lady in the circus, complete with stretch marks, dill rings (internal fissures—not pickles), and pedicel cracks. At weights of more than a thousand pounds, pumpkins are literally busting a gut, and like rubberneckers at the scene of an accident, we can't seem to avert our eyes.

Even if you fed growth hormones—or milk—to the familiar orange pie and field pumpkins of *Cucurbita pepo*, they could never compete, when it comes to size, with the garden behemoths of *Cucurbita maxima*. The *maxima*s simply derive from bigger stock than the *pepo*s and so beget bigger stock. The first *maxima*s, Acorn (most likely a turban type), Valparaiso, French Turban, and Autumnal Marrow, began to appear in seed lists in the late 1820s. The name "Mammoth" appeared in trade lists as early as 1834; it may or may not correspond to the Mammoth that was wildly popular in the second half of the nineteenth century.

The giant pumpkins of today are direct descendants of Jaune Gros de Paris, or Large Yellow Paris, still popular in France. Transcendentalist Henry David Thoreau (1817–1862) was, as far as I can determine, among the first to grow the variety in the United States. In 1857, with seeds he had procured from the U.S. Patent Office, Thoreau, to his great astonishment, produced five pumpkins totaling 310 pounds of Potiron Jaune Gros. His pride and joy was the 123½ pounder, which took a premium at the Middlesex Show (Massachusetts) that fall. He attributed his success to a little abracadabra-presto-chango hoeing and manuring, plus "perfect alchemists I keep who can transmute substances without end, and thus the corner of my garden is an inexhaustible treasure chest. Here you can dig not gold, but the value which gold merely represents."

The French Potiron Jaune Gros is synonymous with the American Mammoth pumpkin. It must have been renamed and entered into trade in the United States shortly after Thoreau grew it; by the 1870s the seed had been widely dispersed. Testimonials in 1875 by customers of James J. H. Gregory who grew the Mammoth French Squash bore witness to the pumpkin fever that already raged from Red

Atlantic Giant *fig. 25*

Cucurbita maxima Mammoth Group
SIZE: 18½" long by 22" wide
WEIGHT: 90 pounds
RIND COLOR: deep yellow ocher
FLESH COLOR: toned-down yellow ocher
COLOR RATING: 2
FIBER: unacceptable
DATE OF INTRODUCTION: 1978; Howard Dill of Windsor, Nova Scotia; Burgess Seed Co. was first to carry it in the United States
BEST USE: exhibition
SEED SOURCES: Burr, Clif, Com, Deat, Ers, Fox, Heir, Hume, Irish, Mor, Pap, Rev, Sed, Thomp, Vesey, Vict

Similar to Dill's Atlantic Giant (PVP) but is generally smaller. Current world's record set by Steve Daletas, Pleasant Hill, Oregon, on October 4, 2003: 1,385 pounds. My specimen is a 90-pound weakling.

Bank, New Jersey, to Waterloo, Iowa. Mr. James Rister of Bethany, Missouri, wrote: "I must brag a little, for I believe from the seed I had of you I raised the largest Squash in the world; it weighed over 300 pounds!" Of course, pumpkin folly raged across the Atlantic, as well. Jaune Groses, with weights in excess of 100 pounds, were a common sight in the Central Market in Paris and on farms throughout France. Every September at the pumpkin festival in Paris, King Pumpkin was decked out and hoisted about–and all paid homage.

When William Warnock of Goderich, Ontario, produced a record-breaking four-hundred-pound pumpkin in 1900–shipped to France for display at the World's Fair in Paris–he gave new meaning to the word *avoirdupois*. Warnock set the bar three pounds higher three years later and established a record for giant pumpkins that would hold until 1979. Warnock's pumpkin was undoubtedly a Mammoth, but over the years different strains were developed and it acquired more than three dozen synonyms, including Genuine Mammoth, Hundred Weight, Mammoth Fifty Dollar Pumpkin, True Potiron, and my favorite, Landreth's Yellow Monster. Warnock may well have been using stock obtained from the prominent seed firm William Rennie of Toronto; Rennie carried Mammoth, with the synonyms Jumbo and Tours, at the turn of the century.

One hundred years later, Howard Dill of Windsor, Nova Scotia, is the "Pumpkin King." This remarkable man created the Atlantic Giant, which is the ultimate in pumpkins. "Moby Dill," as he is affectionately known, recognized early in life that giant pumpkins have "the power to make people happy." Like his father before him, William "Moby Dick" Dill, young Howard proudly displayed his pumpkins at the local county fair. In his decades-long quest to produce a bigger and better pumpkin, this amateur breeder crossed his father's Genuine Mammoth with what he believed to be the Goderich Giant–William Warnock's Mammoth strain, bought up by Rennie in 1904 for $40.00. Over the years, Dill selected for wall thickness and weight, form, and color and developed a pumpkin-growing regimen guaranteed to break records. Only the pumpkins themselves will tell us when to stop.

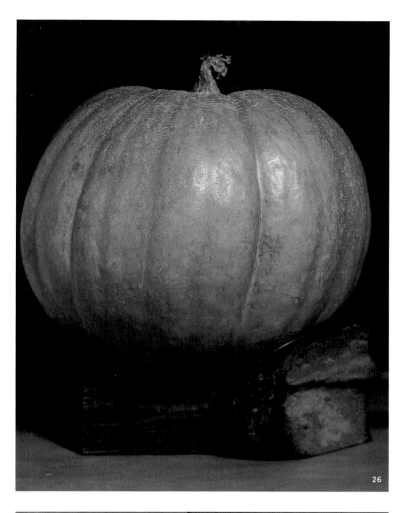

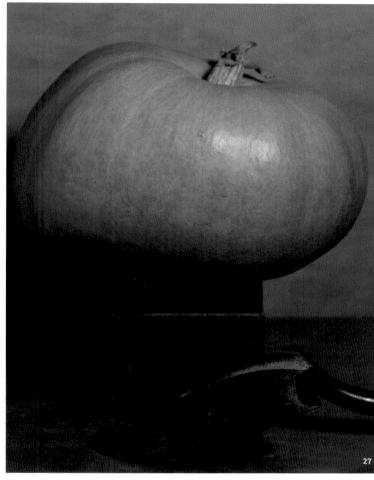

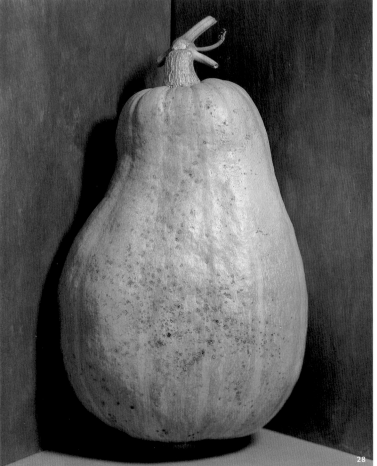

Weeks North Carolina Giant Squash *fig. 26*

Cucurbita maxima Mammoth Group
SIZE: 17" long by 21½" wide
WEIGHT: 92 pounds
RIND COLOR: intense raw sienna
FLESH COLOR: toned-down yellow ocher
COLOR RATING: 3
FIBER: unacceptable
BEST USE: exhibition

An attractive fellow. My heavyweight. From Weeks Seed Company, Greenville, North Carolina, but no longer available commercially.

Big Red *fig. 28*

Cucurbita maxima Mammoth Group
SIZE: 24" long by 14" wide
WEIGHT: 20 pounds
RIND COLOR: intense yellow ocher
FLESH COLOR: dense golden yellow
COLOR RATING: 3
FIBER: acceptable
BEST USE: exhibition

Often more than 100 pounds. Susceptible to insect damage. Once carried by Nichols Garden Nursery, Albany, Oregon.

Jaune Gros de Paris *fig. 27*

Cucurbita maxima Mammoth Group
SIZE: 12" long by 18" wide
WEIGHT: 42 pounds
RIND COLOR: dense yellow ocher
FLESH COLOR: light yellow ocher
COLOR RATING: 3
FIBER: unacceptable
DATE OF INTRODUCTION: Cited in Vilmorin (1856); obtained from the U.S. Patent Office by Henry David Thoreau in 1857
BEST USE: exhibition
SYNONYMS: Large Yellow Paris, Mammoth
SEED SOURCE: Bake

Well known in France. Can be ribbed or smooth; varies in color, too, from yellow to salmon.

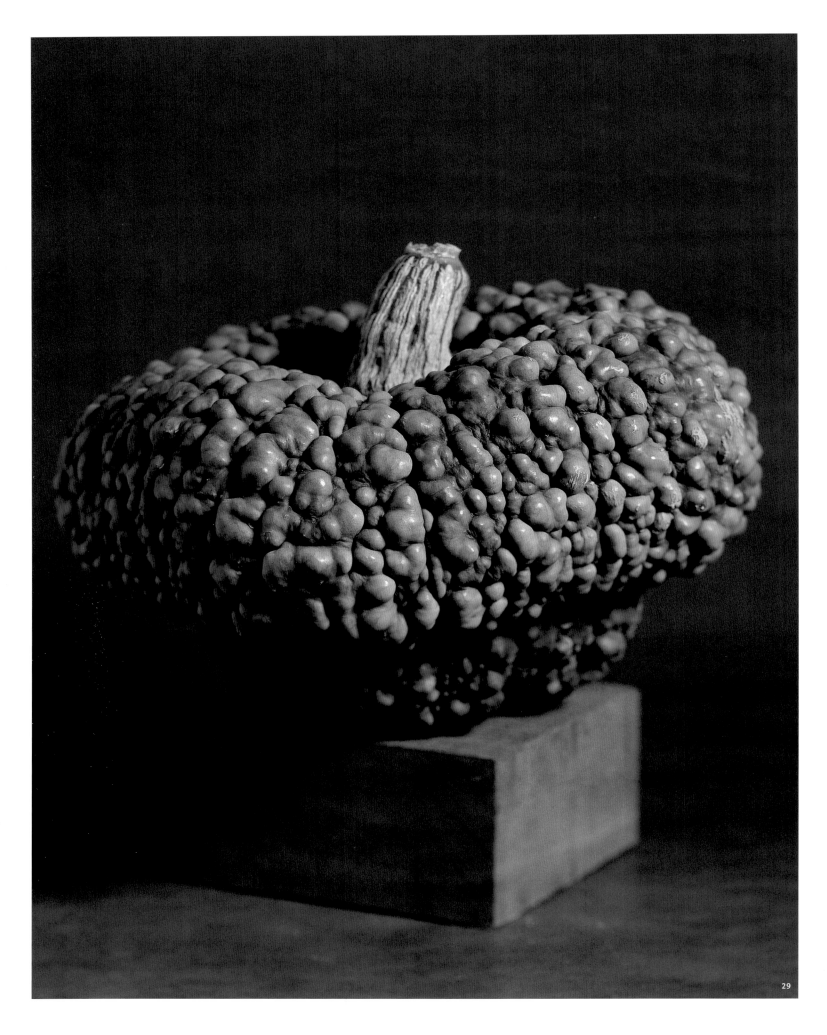

Turban Group *Cucurbita maxima*

MARINA DI CHIOGGIA

SHOW ME A SQUASH with warts and boils, and I'll show you the way to my heart. I've been gaga over Marina di Chioggia for over a dozen years now. Her blue-green armament of blistery bubbles simply does things to me. Not a morsel of Marina had passed my lips until this book came along and I got to know her, *really* know her, in the culinary sense. What I found was a revelation: This excrescent, bump-rinded turban squash is not only oddball, it is *deliziosa*. Marina was born to be gnocchi and ravioli.

Marina di Chioggia belongs to the ages and to the Italians, although like any *maxima* squash, her point of origin is South America. Marina lives and thrives in the salt air and sandy soils of Chioggia, an Adriatic port famed for its vegetables and fish market, located at the southern tip of Venice's lagoon. The marine environment of the Veneto also nourishes other delicacies, including the slightly bitter, much vaunted radicchios (di Chiogga, di Treviso, di Verona, and di Castelfranco).

Marina di Chioggia, or Chioggia Sea Pumpkin, is known in Venice by the nicknames Zucca Santa and Zucca Barucca. Both translate as "holy pumpkin," but the epithet Zucca Barucca is a play on two words: the Italian *verruca*, meaning "wart" and the Hebrew word *baruch*, for "sainted" or "blessed." Who else but the Italians and the Jews would call a squash holy? I understand this mentality perfectly—as a Jew and as an honorary Italian: My father was *proprietario* of Goldman's Italian-American Grocery in Brooklyn.

Italian Jews, over thousands of years, even while living within the confines of the ghetto, made a lasting imprint on *la cucina italiana*. Jewish merchants, many of whom originally came from the Levant, imported exotica such as fennel and eggplant, theretofore unknown to the Venetians. Dozens of recipes for beloved dishes, from *carciofi alla giuda* (fried artichokes, Jewish style) to *fiori di zucca fritti* (fried squash blossoms), are credited to the Jews. Marina di Chioggia's delicate orange blossoms, stuffed with ricotta and herbs, would be a "religious experience."

Marina di Chioggia *fig. 29*
Cucurbita maxima Turban Group
SIZE: 7" long by 11" wide
WEIGHT: 11 pounds
RIND COLOR: dense vermilion green
FLESH COLOR: toned-down golden ocher
COLOR RATING: 3
FIBER: none
BEST USES: decorative, table vegetable
SYNONYMS: Chioggia Sea Pumpkin, Zucca Barucca, Zucca Santa
SEED SOURCES: Bake, Com, Cook, Hud, Sit

Looks like a geode when cut in cross-section and scooped out. Great for minestrone and risotto as well as ravioli. Unripe fruits can be used in relishes.

Bonnet Rouge *fig. 30*

Cucurbita maxima Turban Group

SIZE: 5" long by 6" wide

WEIGHT: 2 pounds

RIND COLOR: raw deep sienna

FLESH COLOR: raw light sienna

COLOR RATING: 2

FIBER: none

BEST USE: decorative

SYNONYMS: Mini Red Turban, Red Bonnet, Turban, Turk's Turban

SEED SOURCES: Bake, Bunt, Burr, Clif, Com, Deat, Deb, Ers, Fed, Gurn, Har, John, Jor, Jung, Lan, Loc, Mey, Mor, Nic, Old, Pepp, Pine, Rev, Rohr, Ros, Shaf, Shum, Silv, Sky, Sse, Sto, Thomp, Twi, Ver, Vict, Wet, Will

Decorative but not delicious. A French turban. "Squash-within-a-squash," according to Liberty Hyde Bailey.

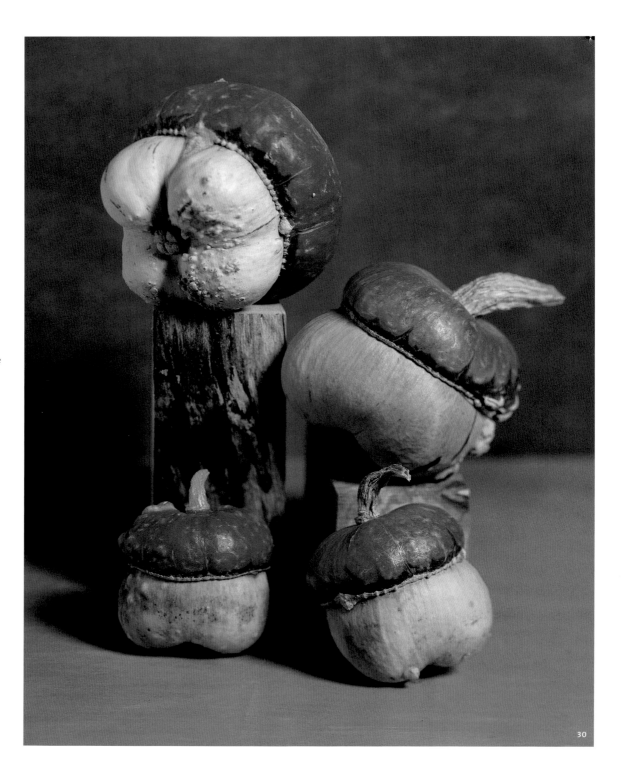

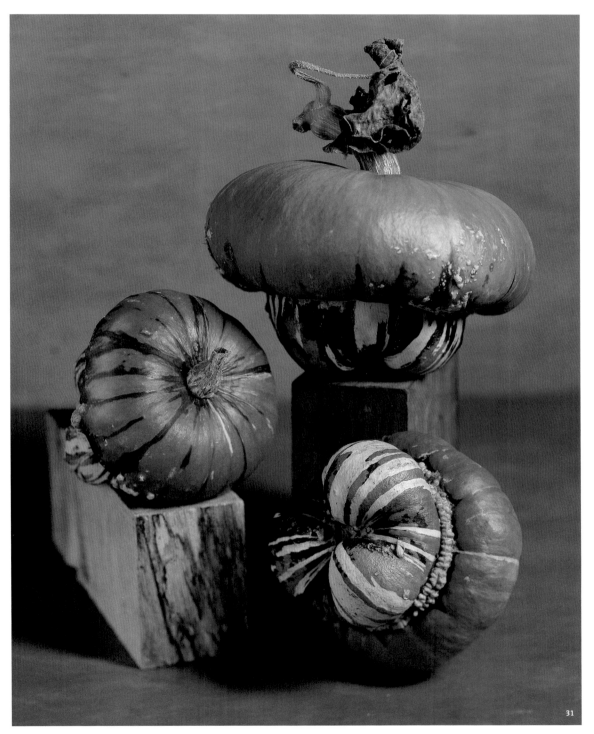

Turk's Turban *fig. 31*

Cucurbita maxima Turban Group
SIZE: $5^{1}/_{2}$" long by $8^{1}/_{2}$" wide
WEIGHT: 6 pounds
RIND COLOR: dense permanent orange
FLESH COLORS: brilliant light orange streaked with wet and thin olive green
COLOR RATING: 2
FIBER: none
DATE OF INTRODUCTION: predates 1820s
BEST USES: decorative, table vegetable
SYNONYMS: Acorn, Bonnet Turc, French Turban, Giraumon Turban, Squash Turban, Turban, Turbanet, Turk's Cap
SEED SOURCES: Bake, Bunt, Burr, Clif, Com, Deat, Deb, Ers, Fed, Gurn, Har, John, Jor, Jung, Lan, Loc, Mey, Mor, Nic, Old, Pepp, Pine, Rev, Rohr, Ros, Shaf, Shum, Silv, Sky, Sse, Sto, Thomp, Twi, Ver, Vict, Wet, Will

At its best: thick, floury, and mildly sweet, though flesh is irregularly distributed. A nearly infinite number of forms; some "plant monstrosities," according to Tapley et al. (1937).

French Turban may be the ancestral form of American Turban; selections after 1850 eliminated extreme turban or acorn shapes in favor of a well-marked but nonprotruding crown. James J. H. Gregory compared the two in 1875 and found the French sorts "showy but worthless." I feel more kindly toward them. To increase the shelf life of Turk's Turban, lay it on its side—not the acorn end—to prevent injury and decay.

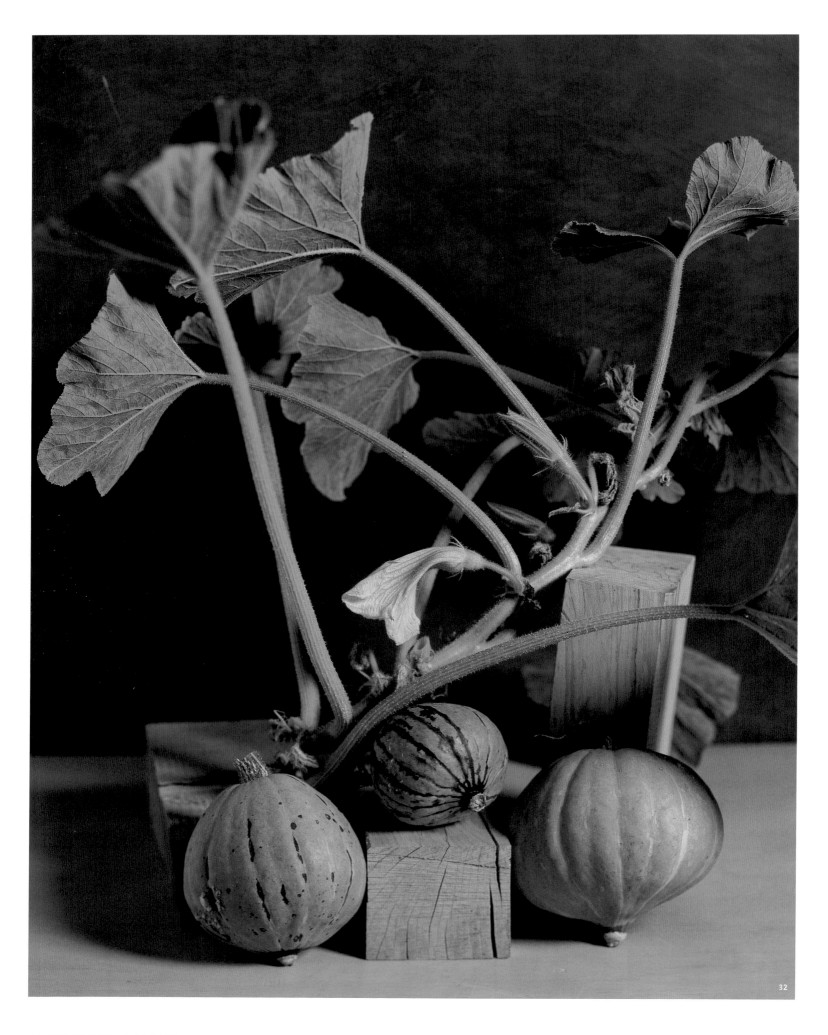

Zapallito Group *Cucurbita maxima*

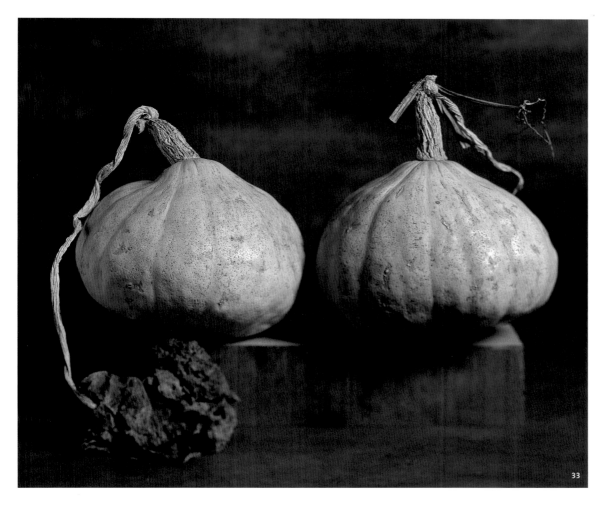

Silver Bell *fig. 33*
Cucurbita maxima Zapallito Group
SIZE: 5" long by 7" wide
WEIGHT: 4 pounds
RIND COLOR: thin vermilion green
FLESH COLOR: light cadmium orange
COLOR RATING: 3
FIBER: none
DATE OF INTRODUCTION: 1956; bred and introduced by Ferry-Morse Seed Co.
BEST USE: table vegetable
SEED SOURCE: Sse

Great. A selection from Blue Banana. Would love to lay my hands on Boston Bell, which is Boston Marrow × Silver Bell.

Gold Nugget *fig. 32*
Cucurbita maxima Zapallito Group
SIZE: 6" long by 5" wide
WEIGHT: 2 pounds
RIND COLOR: toned-down vermilion
FLESH COLOR: intense brilliant orange
COLOR RATING: 4
FIBER: none
DATE OF INTRODUCTION: 1966 All America Selection (AAS)
BEST USE: table vegetable
SYNONYM: Golden Nugget
SEED SOURCES: Cook, Fish, Horus, Irish, Jor, Pete, Set, Soc, Ter, Vesey

Bred by Dr. Holland at the North Dakota Agricultural Experiment Station, Fargo, North Dakota. Parents: (Tapley's Bush × Banquet) × Banquet. Parents of Banquet were Buttercup × Gilmore. Lovely miniature *maxima*. Starchy.

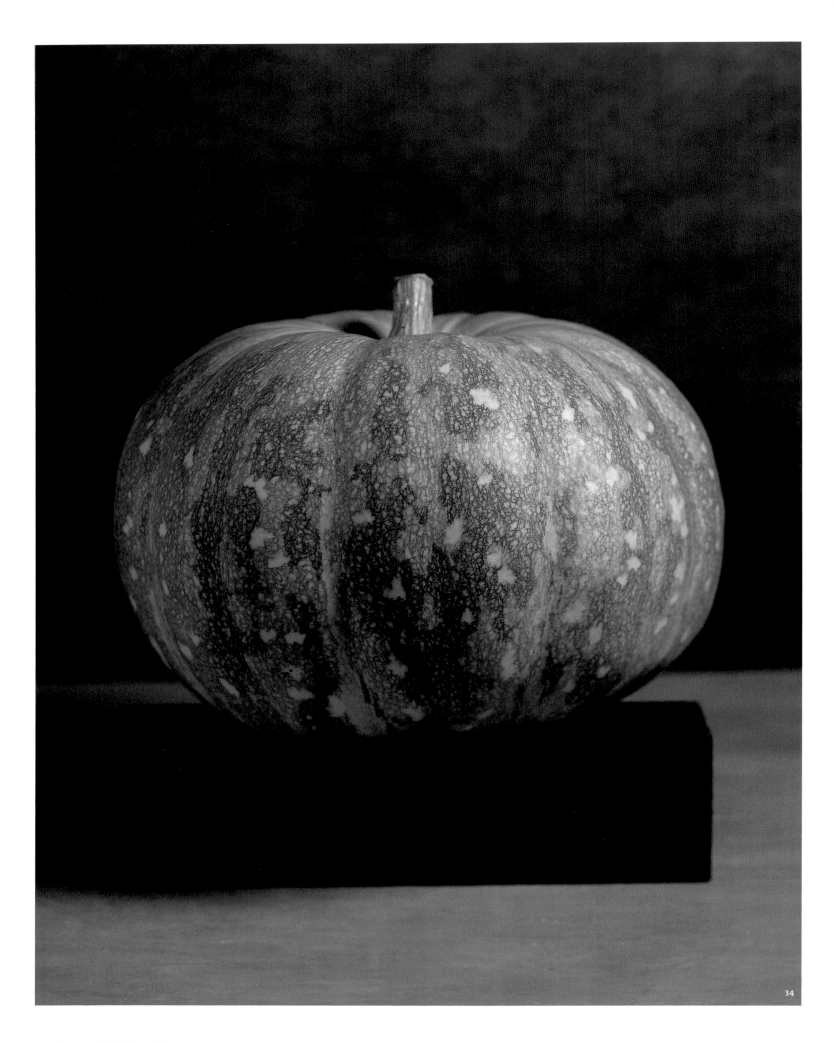

34

Miscellaneous Maximas *Cucurbita maxima*

IRAN

HANGING IN THE "DUTCH" PARLOR of my 1788 farmhouse, with its wide doors, massive paneled fireplace, and twelve-over-twelve windows, is an old botanical print of an Iran. The mezzotint folding plate N. 444 depicts a staid bottle gourd completely upstaged by a rainbow phantasm looming larger than life. Only the botanical epithet *Cucurbita marmorea maxima* ("marbled" *maxima* squash) betrays its terrestrial origin.

The artist, Georg Dionysius Ehret, was clearly as enamored of this variety as I am. Ehret produced the first five hundred designs out of an eventual 1,025 plates included in Johann Wilhelm Weinmann's (1683–1741) lifework, *Phytanthoza iconographia,* published in Germany in half-yearly installments until its completion in 1748, after Weinmann's death. Weinmann was an apothecary and the owner of Elefanten-Apotheke in Regensburg. His comprehensive iconography of four thousand garden plants was based on Weinmann's own collection of plants. *Phytanthoza iconographia* was the first, and perhaps finest, example of color-printed mezzotinting. The plates that are hand-tinted by Johann Jakob Haid, and marked with a telltale "H." in the corner as mine is, are regarded as the most subtle and unusual.

To the U.S.D.A., this pumpkin is best known as Plant Introduction (PI) No. 141638. To Glenn Drowns, who took it out of U.S.D.A. mothballs more than ten years ago, it goes by a place name, Iran. But to me, it is, and always will be, the stop-you-dead-in-your-tracks, eye-poppingly beautiful Empress of Persia. Even the best-informed squash purveyors have never laid eyes on such a rarity. But unless you're mad for boiled turnip pablum, Iran is best left sitting pretty on her throne, where she will remain *virgo intacta* for up to two years.

In 1898, the U.S.D.A. began to systematically hunt and gather crop germplasm from all over the world; PI No. 1 is a Russian cabbage variety. The collection of seeds and plant materials, now hovering at about a half-million accessions, is a national treasure of rare and endangered species, wild and weedy crop relatives, cultivars, and inbred parental lines. Not much is known about PI No. 141638 except that it was collected on September 11, 1940, in the city of Torbat-e-Heydariyeh in northeastern Iran; the U.S.D.A. took possession of it on April 9, 1941, under the alias *kadu,* which is Farsi for "pumpkin."

Iran *fig. 34*
Cucurbita maxima
SIZE: 9" long by 12" wide
WEIGHT: 20 pounds
RIND COLORS: medium permanent olive green and medium golden ocher
FLESH COLOR: subdued cadmium orange
COLOR RATING: 1
FIBER: none
DATE OF INTRODUCTION: Collected in Torbat-e-Heydariyeh, Iran, in 1940
BEST USE: decorative
SYNONYM: Empress of Persia
SEED SOURCE: Sse

My very favorite for looks. Global, maplike, with continents, lines of longitude, and foamy green seas. U.S.D.A. #141638. My seed came from Calvin Wait of Ethel, Missouri, who obtained it from Glenn Drowns of Calamus, Iowa.

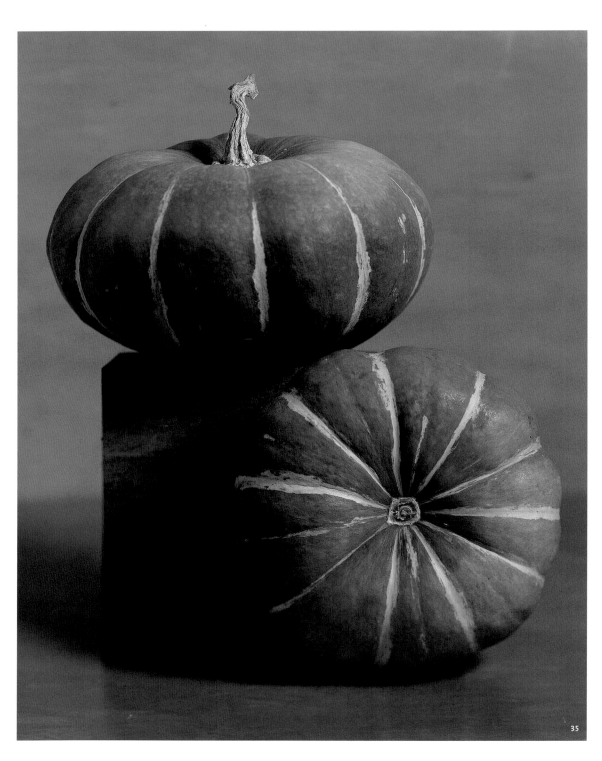

Strawberry Crown *fig. 35*

Cucurbita maxima

SIZE: 5" long by 7¹/₂" wide

WEIGHT: 6 pounds

RIND COLORS: intense burnt umber crowned by wet raw umber

FLESH COLOR: light golden ocher

COLOR RATING: 4

FIBER: none

BEST USES: decorative, table vegetable

I'm in love. Brown color is rare in the *maxima* world; so is the bicolor rind. Variety is aptly named for blush of salmon at the crown. Mary Schultz of Monroe, Washington, brought it back from a trip to Brazil in the late 1980s and gave it to Glenn Drowns.

Rouge Vif d'Etampes *fig. 36*

Cucurbita maxima

SIZE: 6" long by 15¹/₂" wide

WEIGHT: 19 pounds

RIND COLOR: wet vermilion

FLESH COLOR: dense brilliant orange

COLOR RATING: 4

FIBER: none

DATE OF INTRODUCTION: 1883; W. Atlee Burpee & Co., Philadelphia

BEST USE: decorative

SYNONYMS: Bright Red Etampes, Cinderella, Etampes, Mammoth Bright Red Etampes, Red Etampes

SEED SOURCES: Bake, Burpee, Cook, Deat, Eden, Fed, Gour, Heir, Horus, Hud, John, Jor, Jung, Lej, Loc, Mes, Nic, Peace, Pine, Rev, Rohr, Sand, Scheep, Sese, Shum, Soc, Sse, Ter, Twi, Ver, Will

Beloved by the French for more than a hundred years. Documented in 1883 by Vilmorin but not in Vilmorin's 1856 publication. Jean de La Quintinie (1692) grew pumpkins "*plate et jaune*" (flat and yellow) in the royal garden at Versailles. This one coasts on its looks alone, being insipid and watery. It's enchanting, but I wouldn't cook with it.

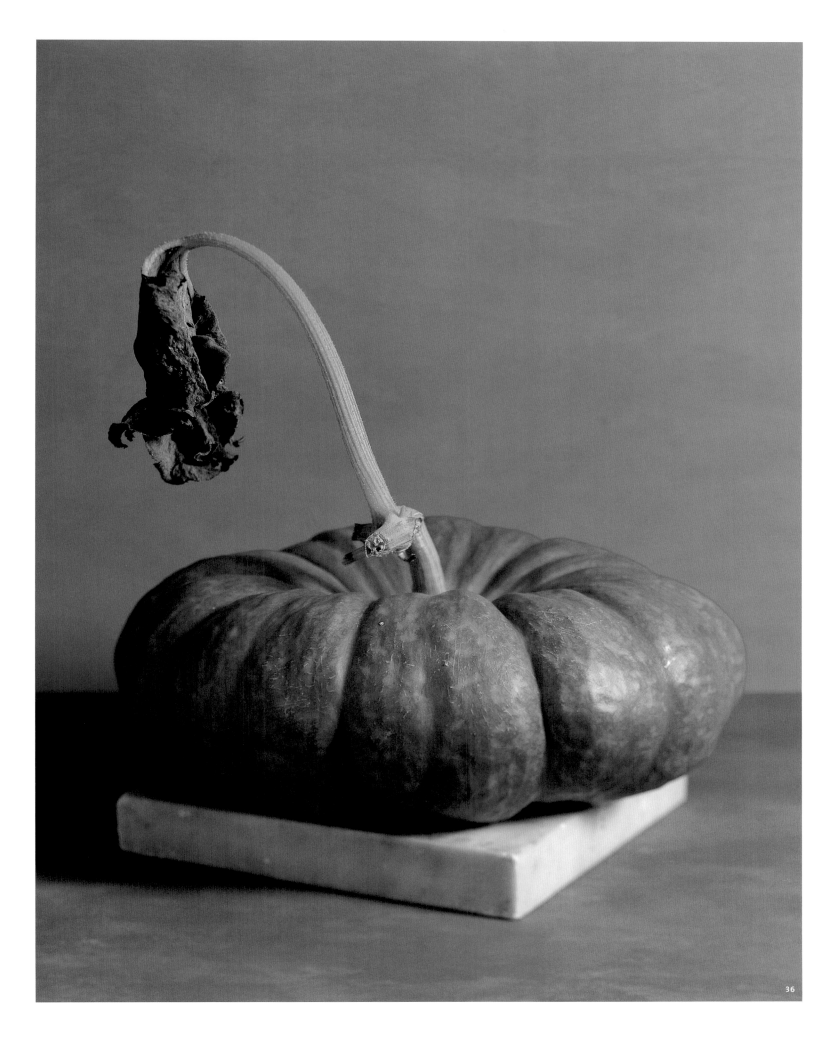

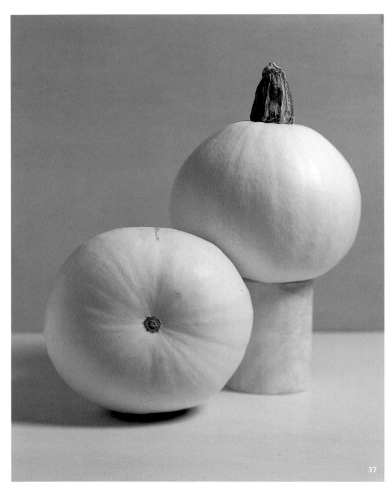

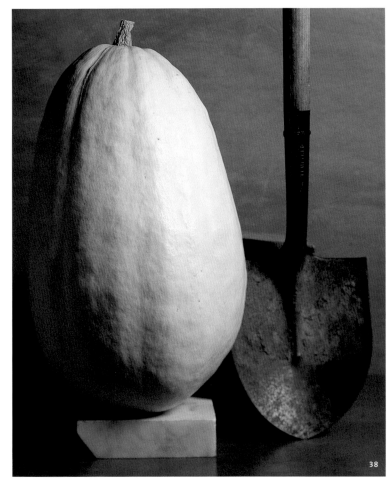

Fortna White *fig. 37*

Cucurbita maxima

SIZE: 7^1/$_2$" long by 6^1/$_2$" wide

WEIGHT: 3^1/$_2$ pounds

RIND COLOR: subdued golden yellow

FLESH COLOR: toned-down golden yellow

COLOR RATING: 2

FIBER: unacceptable

BEST USE: livestock feed

SEED SOURCES: Landis, Rohr

A spitter. From Fortna family
of Pennsylvania.

German Sweet Potato *fig. 38*

Cucurbita maxima

SIZE: 21" long by 11" wide

WEIGHT: 24 pounds

RIND COLOR: subdued golden yellow

FLESH COLOR: transparent golden yellow

COLOR RATING: 1

FIBER: none

BEST USE: exhibition

Great white whale. More ivory-
colored than Lumina. Jumps fences.

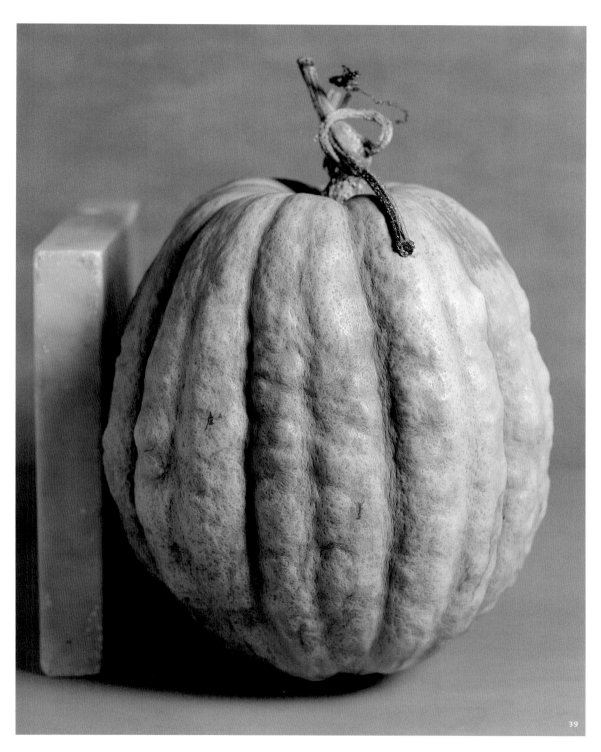

Valencia *fig. 39*

Cucurbita maxima

SIZE: 10$\frac{1}{2}$" long by 9$\frac{1}{2}$" wide

WEIGHT: 14$\frac{1}{2}$ pounds

RIND COLOR: light vermilion green

FLESH COLOR: dense brilliant orange

COLOR RATING: 4

FIBER: none

DATE OF INTRODUCTION: 1987; Peace Seeds, Corvallis, Oregon; dropped 1991

BEST USE: table vegetable

SYNONYMS: Bohemian Heirloom, Courge de Valence, Valencia Squash

Topnotch. A substitute for chestnuts. Need a butcher's chopper and a mallet to open.

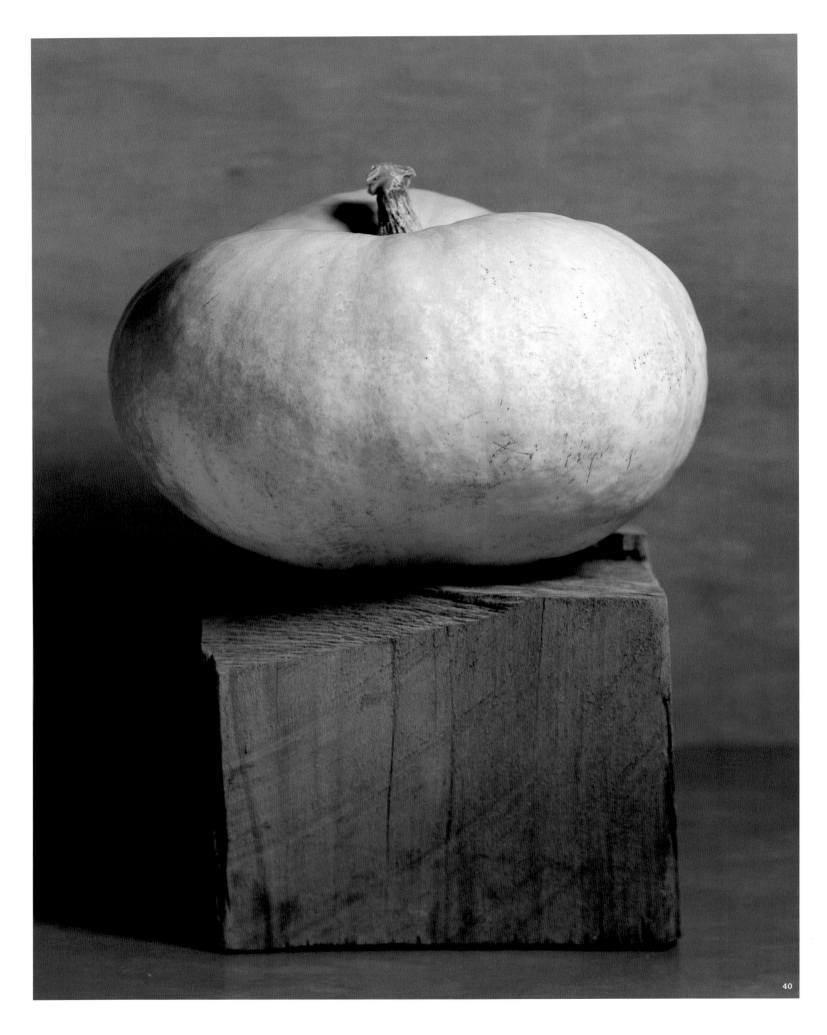

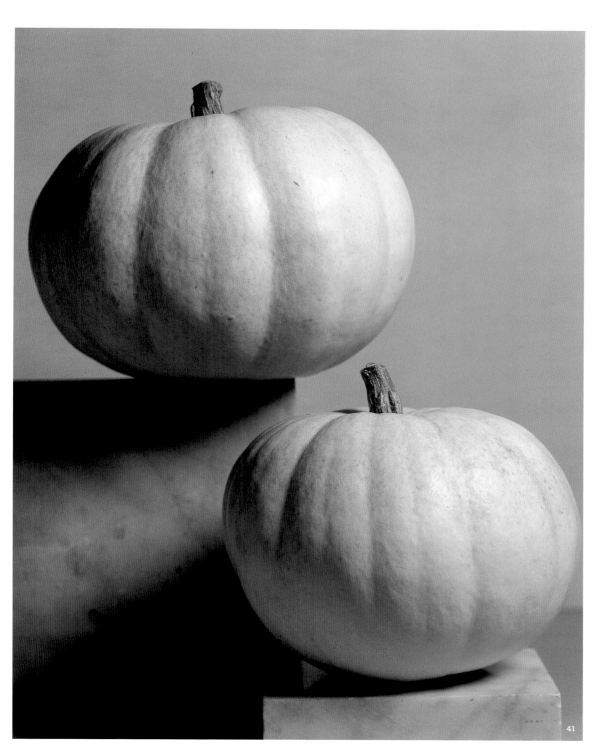

Lumina *fig. 41*

Cucurbita maxima

SIZE: 8½" long by 12" wide

WEIGHT: 14 pounds

RIND COLOR: thin golden yellow

FLESH COLOR: intense brilliant orange

COLOR RATING: 4

FIBER: unacceptable

DATE OF INTRODUCTION: PVP 1990

BEST USE: jack-o'-lanterns

SEED SOURCES: Bunt, Burg, Burpee, Burr, Clif, Com, Dan, Deat, Deb, Farm, Fed, Field, Green, Gurn, Har, Jor, Jung, Lan, Lej, Loc, Mel, Mor, Nic, Pine, Rohr, Ros, Shaf, Shum, Silv, Sky, Sto, Ter, Twi, Vesey, Wet, Will

The hardest of rinds: a banger and a spitter. Breeders: Hollar Seed Co. and George Perry & Sons.

Hungarian *fig. 40*

Cucurbita maxima

SIZE: 10" long by 15" wide

WEIGHT: 30 pounds

RIND COLORS: subdued chrome yellow with a touch of subdued vermilion green

FLESH COLOR: light golden yellow

COLOR RATING: 1

FIBER: acceptable

BEST USE: exhibition

SYNONYM: Hungarian Mammoth

More luminous than Lumina. Sun blushes it blue. Once carried by Stokes and Nichols but dropped from commerce in 1998.

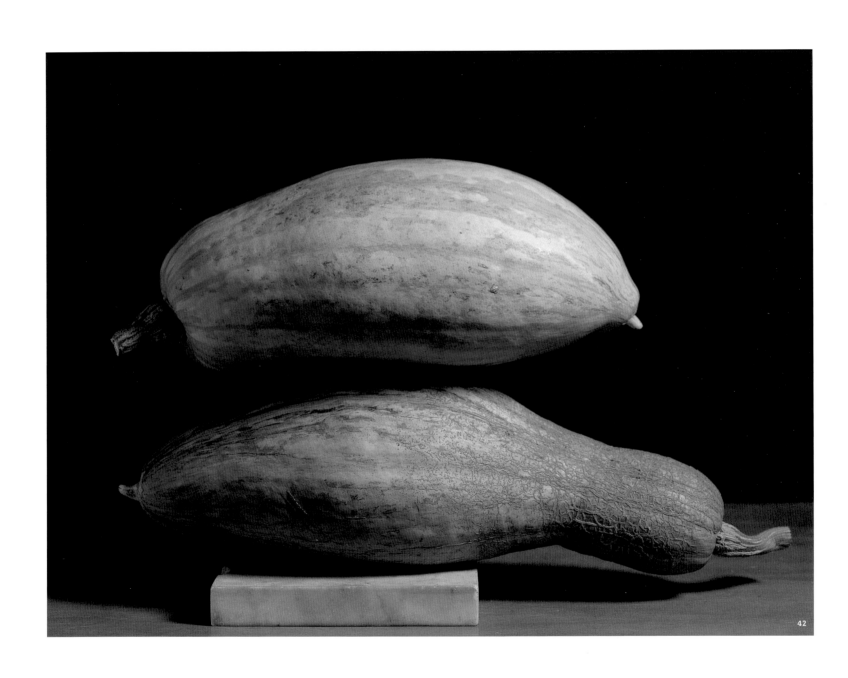

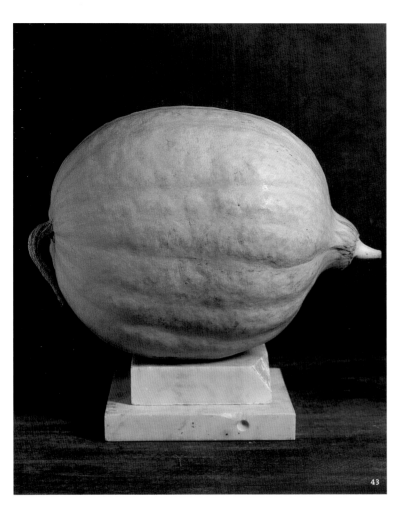

Candy Roaster *figs. 42, 43*

Cucurbita maxima

SIZE: long form: 27" long by 8½" wide; round form: 18" long by 14" wide
WEIGHT: long form: 15 pounds; round form: 34 pounds
RIND COLORS: permanent transparent orange and light olive green
FLESH COLOR: transparent golden ocher
COLOR RATING: 3
FIBER: acceptable
BEST USE: livestock feed
SEED SOURCES: Bake, Fed, Rev

Candy Roaster seems to be an Appalachian Mountain term for a big squash. Many strains (Francis Ballew, Friedman's, North Georgia, etc.); some *C. moschata*. Tom Knoche of Sardinia, Ohio, collects them.

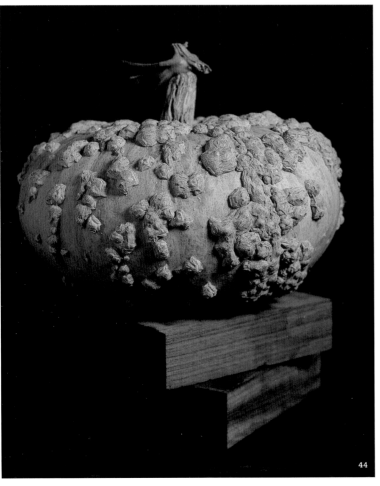

Galeuse d'Eysines *fig. 44*

Cucurbita maxima

SIZE: 6½" long by 11½" wide
WEIGHT: 18 pounds
RIND COLOR: light vermilion
FLESH COLOR: dense raw sienna
COLOR RATING: 4
FIBER: none
DATE OF INTRODUCTION: Noted in Vilmorin (1883)
BEST USE: decorative, table vegetable
SYNONYMS: Courge Brodée Galeuse, Galeux d'Eysines, Giraumon Galeux d'Eysines, Warted Sugar Marrow
SEED SOURCES: Bake, Rev, Sse

A warty thing from Eysines, France. Mealy and dense. The stuff of Garbure (see page 175); delicious when sautéed in butter; watery when steamed. A club-shaped version, Courge Brodée de Thoumain, existed in 1880.

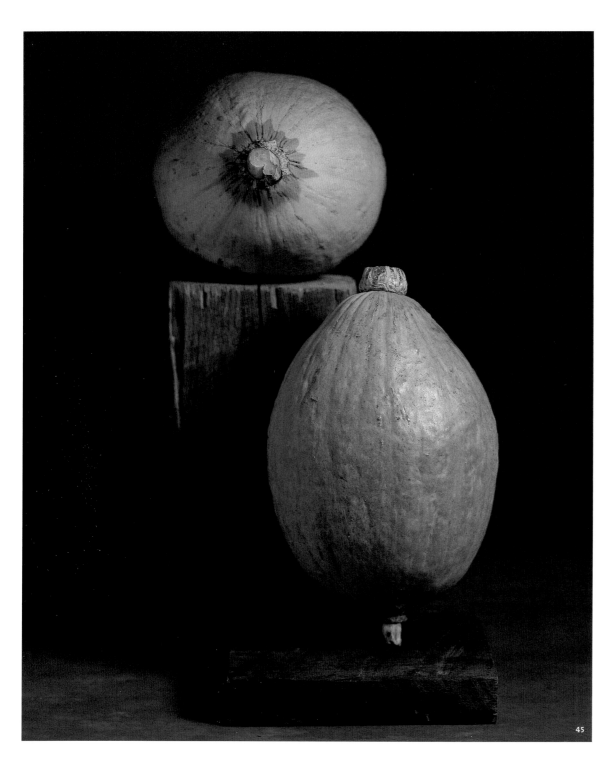

Arikara *fig. 45*

Cucurbita maxima

SIZE: 13" long by 7¼" wide
WEIGHT: 9 pounds
RIND COLOR: medium vermilion
FLESH COLOR: dense golden yellow
COLOR RATING: 3
FIBER: acceptable
DATE OF INTRODUCTION: 1920; Oscar H. Will & Co., Bismarck, North Dakota
BEST USE: livestock feed
SEED SOURCE: Sand

Grown by the Arikaras on the Fort Berthold Reservation; discovered by Dr. Melvin R. Gilmore of the University of Michigan. Adapted to Northern Plains. Early and productive. Quality poor.

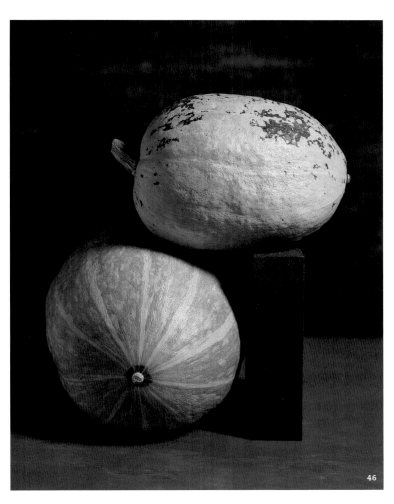

Cherokee Indian *fig. 46*

Cucurbita maxima

SIZE: 12" long by 10½" wide

WEIGHT: 18 pounds

RIND COLOR: toned-down vermilion green

FLESH COLOR: dense golden yellow

COLOR RATING: 3

FIBER: unacceptable

BEST USE: livestock feed

Doesn't wow me. Solid as a rock; very thick (2") flesh. From Dr. Wyche of Oklahoma. Similar to the Argentinian Forragero.

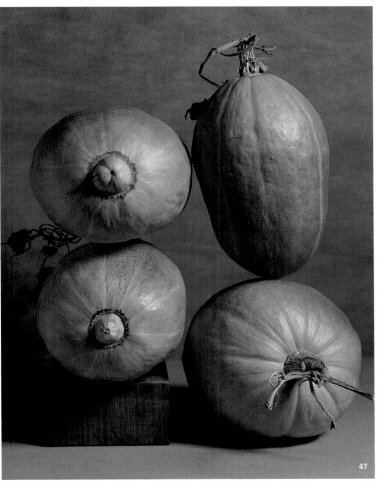

German *fig. 47*

Cucurbita maxima

SIZE: 11" long by 8½" wide

WEIGHT: 9 pounds

RIND COLOR: medium vermilion

FLESH COLOR: intense brilliant orange

COLOR RATING: 4

FIBER: unacceptable

BEST USE: livestock feed

SEED SOURCE: Sand

Mealy and mediocre.

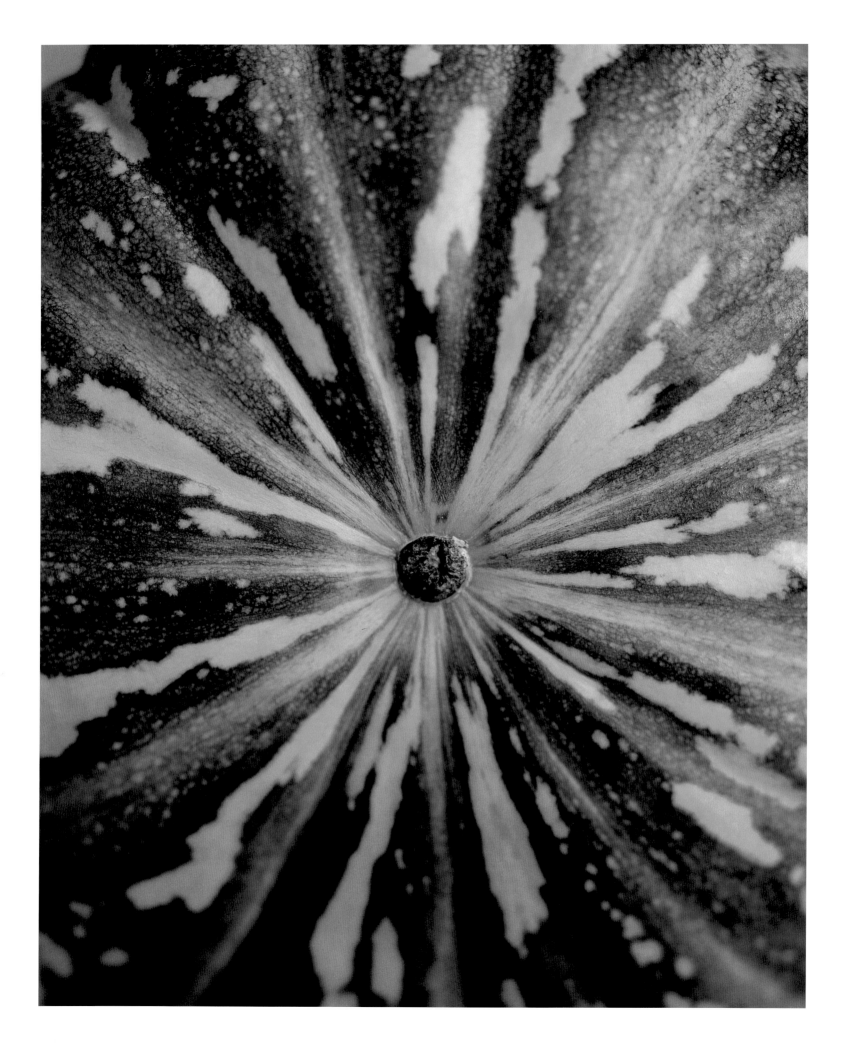

CUCURBITA
MOSCHATA

BLINDINGLY BRILLIANT ORANGE FLESH—high in carotenoids—is one of the most striking features of *Cucurbita moschata*. The best of the lot (Musquée de Provence, St. Petersburg, and Canada Crookneck) approach *Cucurbita maxima* in taste and texture, although many are stringy, coarse, or unpleasantly musky in flavor. Fortunately, these negatives are usually neutralized during the cooking process, especially if fruits are roasted rather than steamed; and the color and carotenoids do not wash out. *Moschata*, like any of the edible-fruited *Cucurbita*s, can be eaten immature (as the Chinese do), but Americans prefer it as long-lived winter squash.

Moschata is content in warm, damp, tropical environments and is the cultivated species most intolerant of cold, although varieties such as Seminole will thrive in the north in a wet summer. The best-known *moschata*s are buff-rinded with a white bloom, but others are green, yellow, piebald (spotted or patchy), or bicolor. Plants are viny and leaves are often mottled; *moschata*s have thin nonlignified (nonwoody) rinds and hard, smoothly angled stems that flare at the point of fruit attachment. Though the primitive ancestor of *moschata* is unknown, cucurbit expert Dr. Michael Nee suspects that northern Colombia (and not Central America) is the center of origin, given the great diversity of fruit types found there.

Dr. Donald N. Maynard suggests three cultivar groups for *moschata*, to which I add a fourth from Dr. Charles Jeffrey: Japonica.

NECK: curved- or straight-necked fruits with an enlarged blossom end (seed cavity); usually buff-rinded
CHEESE PUMPKIN: buff-colored field pumpkins and oblate sorts shaped like a wheel of cheese
TROPICAL PUMPKIN: round or irregularly shaped types, with buff, yellow, green, or piebald rinds
JAPONICA: bewitching, bluish-black, blistery varieties used in traditional Japanese cuisine, with finely grained and yellow flesh

BRAZIL UP CLOSE.

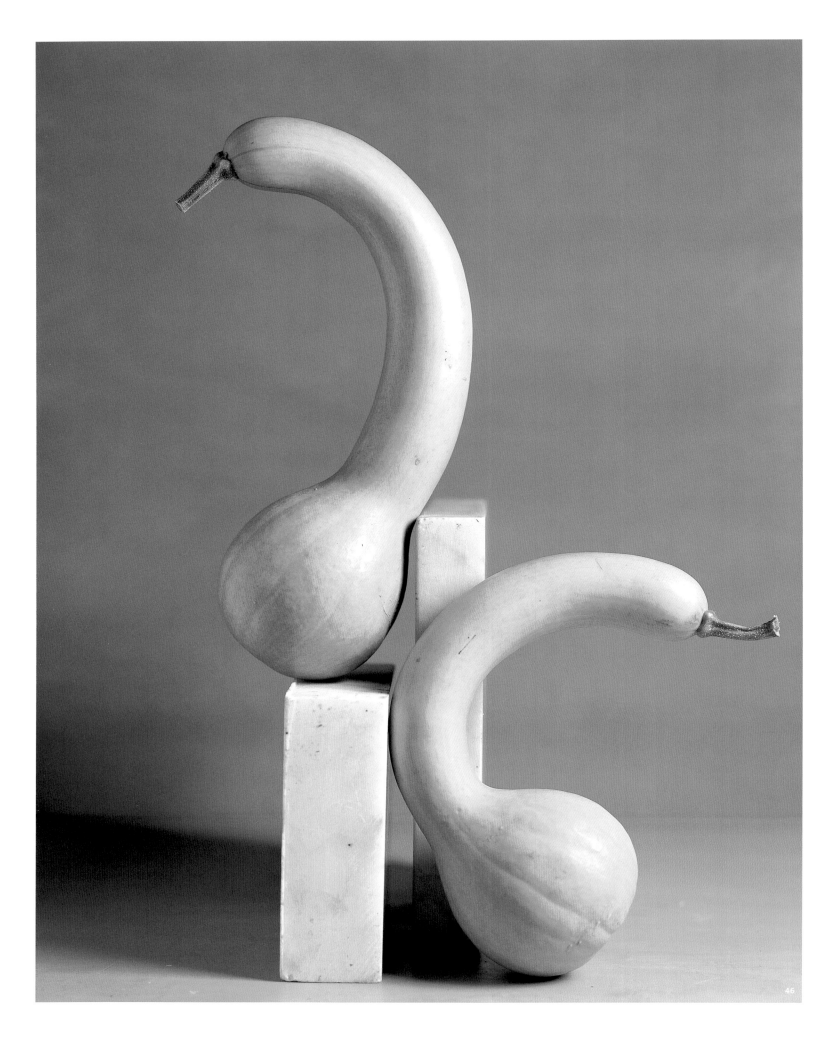

Neck Group *Cucurbita moschata*

CANADA CROOKNECK

THERE ARE TWO KINDS OF CUSHAWS, aka Crooknecks, in the winter squash world: the *Cucurbita argyrosperma*s (such as Green Striped Cushaw, Tennessee Sweet Potato, Japanese Pie, and White or Jonathan) and *Cucurbita moschata*s (including Neck or Winter Crookneck, Canada Crookneck, and Golden Cushaw). Canada Crookneck is, without a doubt, head–and dare I say "neck"–and shoulders above the rest. The texture and taste are similar to that of the *Cucurbita maxima*s; the long, slender, sweeping neck is not punky, but dense, sweet, and seedless. Use sliced rounds, lightly baked or sautéed with skins on, as a colorful and delicious base for canapés, or dice, toss with cinnamon sugar and butter, and roast.

The Canada was once America's sweetheart–New England's sweetheart in particular–but now Butternut occupies that exalted position. Listed by seedsmen as early as 1834, Canada Crookneck was "perfectly at home in the homestead" until the turn of the twentieth century, and could even be found swinging from the rafters! By 1894, James J. H. Gregory was exhorting his patrons to revive a custom "truly honored in the observance": As thrifty farmers did in times past, adorn the kitchen with choice Canada Crookneck specimens, suspended on the walls by narrow strips of wood. Gregory knew that Canadas are just plain fun. I love to throw them over my shoulder like a Continental soldier when I carry them upstairs from my pumpkin storehouse.

You can't suspend Butternuts in quite the same way, of course–nor can you tie them in a knot or tie them in a bow. In the old days, straight-necked variants were frowned upon. It didn't escape the eagle eyes of squash lovers such as Burr, Gregory, or Tapley that the Crooknecks mysteriously threw off more than the occasional straight fruit. As times changed and the shipping trade demanded more compact and stackable squashes, what was once a "rogue" came into vogue.

In the early 1930s, the Butternut prototype appeared in New England markets and seized the attention of Joseph Breck and Sons of Boston, who introduced it to the general public in 1936. The short, squat, and straight-necked Butternut, now commonplace in America, was apparently derived from Canada Crookneck either by mutation or natural outcrossing, and differed from its predecessor in shape only. Unfortunately–at least from the viewpoint of plant breeders and seed producers–Butternut's neck kept getting bent out of shape: This fickle fellow had an exasperating tendency to produce crookneck rogues, or tares, on the same or dimorphic plants, in much the same manner as unstable gene systems cause chimeras such as "rabbit ear" tares in garden peas, or even all-green gourds on Bicolor Pear plants.

Canada Crookneck *fig. 48*
Cucurbita moschata Neck Group
SIZE: 17" long by 4" wide
WEIGHT: 2 pounds
RIND COLOR: light brilliant orange
FLESH COLOR: dense brilliant orange
COLOR RATING: 4
FIBER: none
DATE OF INTRODUCTION: circa 1834; listed by Thorburn, Sinclair and Moore, and Hovey
BEST USE: table vegetable
SYNONYMS: Canada, Canadian Winter Crookneck, Courge Cou Tors du Canada
SEED SOURCE: East

More uniformly colored and finer grained than the larger crook-necked varieties.

Throwbacks in Butternut to Canada Crookneck have more or less been eliminated by zealous plant breeders in the intervening years. This feat, however, may come with a high price: diminution of flavor due to crossbreeding with less tasty varieties. Yeager and Meader crossed Taurukubi and Butternut to produce the stable, smaller New Hampshire Butternut in 1956. This was followed in 1968 by the ever-popular Waltham Butternut bred by Robert Young at the Waltham Agricultural Experiment Station; he crossed New Hampshire Butternut with a neckless *moschata* from Turkey and produced a larger, more stable and uniform, and blockier fruit. The medium-size Ponca, developed by Dermot P. Coyne at the University of Nebraska at Lincoln in 1976 (New Hampshire Butternut × Butternut 23) is also free of crookneck rogues but is, at least in my experience, quite variable, randomly throwing off both long and short forms.

Trombone *fig. 49*

Cucurbita moschata Neck Group

SIZE: 29" long by 6" wide; stem end 16" and blossom end 19" in circumference

WEIGHT: 12 pounds

RIND COLOR: light raw sienna

FLESH COLOR: dense golden yellow

COLOR RATING: 3

FIBER: none

BEST USE: table vegetable

SYNONYM: Queensland Gramma

SEED SOURCE: Sand

One in a long line of Crookneck types. A definite heavyweight. Almost bilobal. Very fine flavor. Sometimes referred to as Horse Collar because of its shape. A favorite for gramma (pumpkin) pie in Australia.

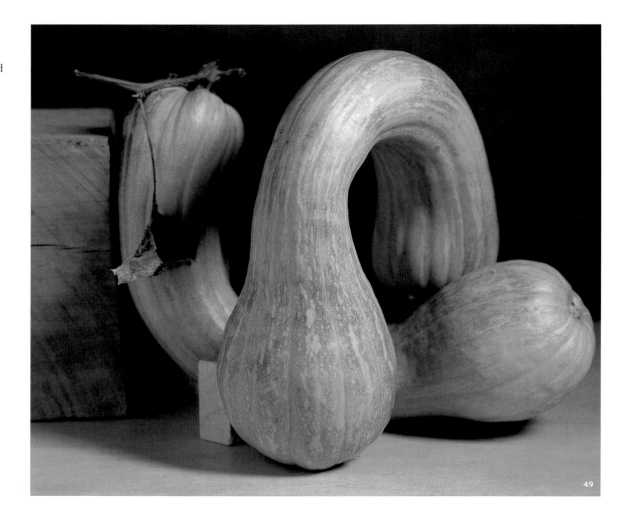

49

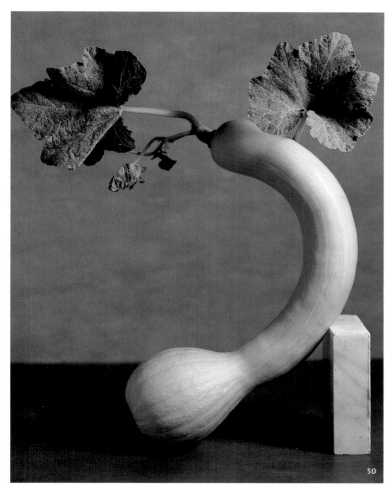

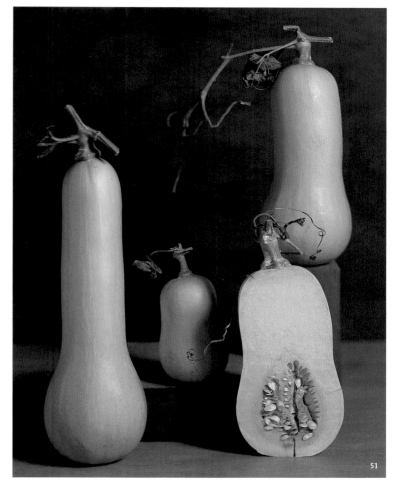

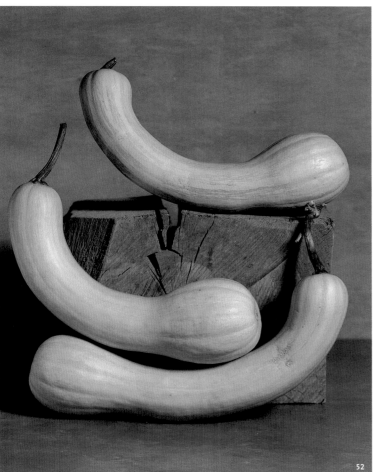

Neck *fig. 50*
Cucurbita moschata Neck Group
SIZE: 22¹/₂" long by 5¹/₂" wide
WEIGHT: 6¹/₂ pounds
RIND COLOR: transparent raw sienna
FLESH COLOR: dense brilliant orange
COLOR RATING: 4
FIBER: acceptable
BEST USE: table vegetable
SYNONYM: Winter Crookneck
SEED SOURCES: Bunt, Burpee, Fed, Har, Horus, Mor, Old, Rohr

The giraffe of the Neck group.

Brasiliera *fig. 52*
Cucurbita moschata Neck Group
SIZE: 23" long by 18" circumference
WEIGHT: 6 pounds
RIND COLOR: medium raw umber
FLESH COLOR: medium golden ocher
COLOR RATING: 5
FIBER: unacceptable
BEST USE: livestock feed

Lots of meat, but extremely fibrous and metallic tasting.

Ponca Butternut *fig. 51*
Cucurbita moschata Neck Group
SIZE: 7¹/₂" long by 3¹/₂" wide
WEIGHT: 1 pound
RIND COLOR: toned-down burnt sienna
FLESH COLOR: medium golden ocher
COLOR RATING: 5
FIBER: acceptable
DATE OF INTRODUCTION: 1976; Northrup, King & Co.
BEST USE: table vegetable
SYNONYM: Butternut
SEED SOURCES: Fed, High, Und

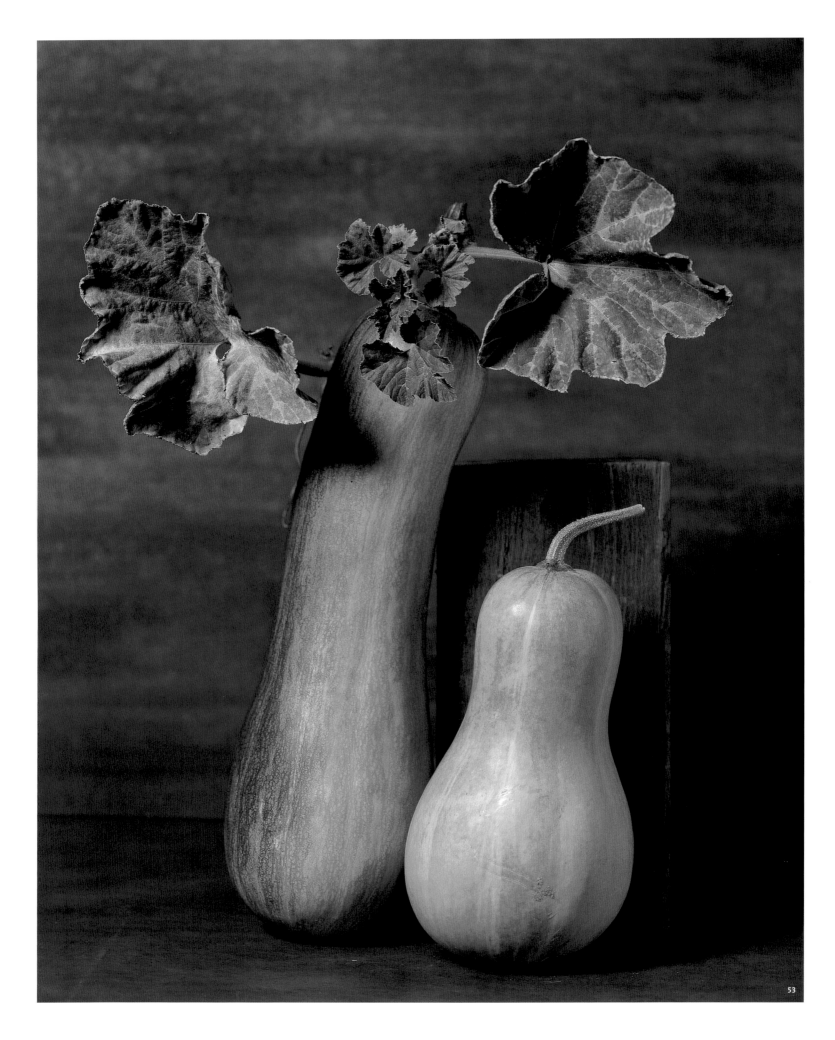

53

SUCRINE DU BERRY

I WILL NEVER FORGET THE SECOND SUNDAY in October ten years ago. That's when I first encountered Jacques Aubourg and the Sucrine du Berry squash with which he is inextricably linked. The occasion was the eighth annual Foire aux Potirons, or Pumpkin Festival, in Tranzault, France. I was expected: a pilgrim from New York in search of pumpkins. Jacques, the guiding light of the festival, warmly embraced me in the village square, introduced me to the mayor, and presented me with a Sucrine du Berry engraved with my name. Only when my head stopped spinning could I take in the spectacle surrounding us. There were mimes, acrobats, and oxcarts spilling over with pumpkins.

Tranzault, with its 320 inhabitants, is the proverbial center, the heartland of France. Immortalized by the writer George Sand, the aptly named Berry region is defined by its traditional food crops and cuisine. A simple study of place names is telling: Pommiers (Apple Trees), Pruniers (Plum Trees), Coings (Quinces), Le Noyer (Walnut Tree), and Cormier (Service Tree). The Sucrine du Berry may not have its own place name, but it has been a part of the landscape for decades. Sucrine is apparently the same as Courge Portemanteau Hâtive, the little sister to Courge Pleine de Naples (aka Lunga di Napoli, page 84), also widely grown in the Berry.

In Jacques Aubourg's Berrichon Pumpkin Pastry (page 171), a marvelous pastry filled with diced Sucrine, onion, and parsley, this squash achieves its platonic ideal. Although Sucrine is quite fibrous, it cooks up beautifully when roasted or baked. The flesh, deeply and intensely red-orange, is stunning. Sucrine du Berry, like many *moschata*s, has a very long shelf life, and the plant itself is prolific, producing enough squashes for every member of even the biggest family to inscribe his or her name *à la* Aubourg. Early in summer, while the fruits are still green, I carve my daughter's name on one of them; then after the scars have healed and the squash turns brown, it is up to her to find her personalized squash waiting in the pumpkin patch.

Jacques Aubourg might tell you that he is unimportant in the scheme of things, but I beg to differ. Probably no one else has done as much as he has to preserve the exceptional legacy of the Berrichon orchard, vineyard, and vegetable garden. Jacques adores cultivated plants, particularly wine grapes, because they embody the sacred bonds between people and plants. He follows in the grand tradition of his parents. Images of his father bleeding the pigs, sharpening sickles, threshing wheat, or harvesting grapes pepper his memory, as does his mother's cooking: Every dish was a gift—from her *petit pois à l'étouffée*, painstakingly prepared but once a year, to her *galette aux pommes de terre*, which I have been told makes men's eyebrows move ecstatically.

Sucrine du Berry *fig. 53*
Cucurbita moschata Neck Group
SIZE: 11" long by 6" wide
WEIGHT: 6 pounds
RIND COLOR: light permanent orange
FLESH COLOR: intense cadmium orange
COLOR RATING: 5
FIBER: acceptable
DATE OF INTRODUCTION: pre-1883
BEST USE: table vegetable
SYNONYMS: Courge Carabacette, Courge Portemanteau Hâtive, Früher Mantelsack-Kürbiss
SEED SOURCE: Bake

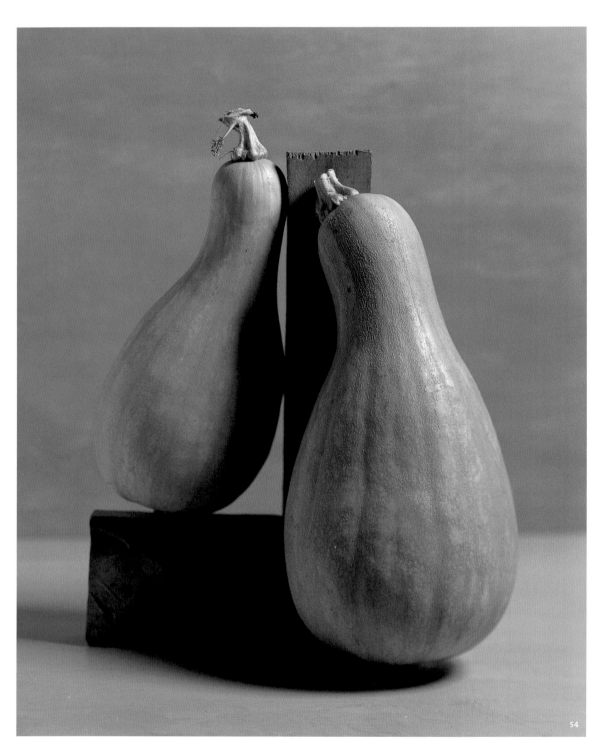

Golden Cushaw *fig. 54*

Cucurbita moschata Neck Group
SIZE: 12" long by 5" wide
WEIGHT: 2½ pounds
RIND COLOR: toned-down raw sienna
FLESH COLOR: medium cadmium orange
COLOR RATING: 4
FIBER: unacceptable
BEST USE: livestock feed
SYNONYMS: Cashew, Cushaw, Golden Yellow
SEED SOURCE: Shum

Sturtevant says the name derives from the Native American word *ecushaw;* Castetter says it was a Mr. Cushaw who first grew the Mammoth Golden Cushaw. Doesn't do well in the North.

Lunga di Napoli *fig. 55*

Cucurbita moschata Neck Group
SIZE: 29½" long by 9" wide
WEIGHT: 31 pounds
RIND COLOR: medium raw umber
FLESH COLOR: toned-down golden ocher
COLOR RATING: 5
FIBER: acceptable
DATE OF INTRODUCTION: Cited in Vilmorin 1856
BEST USES: decorative, table vegetable
SYNONYMS: Carpetbag Gourd, Courge des Bédouins, Courge Pleine d'Alger, Courge Pleine de Naples, Naples Gourd, Neapolitan, Piena di Napoli
SEED SOURCES: Bake, Red, Sand, Sit

Gigantic Butternut look-alike. Common in southern Italy and other Mediterranean areas.

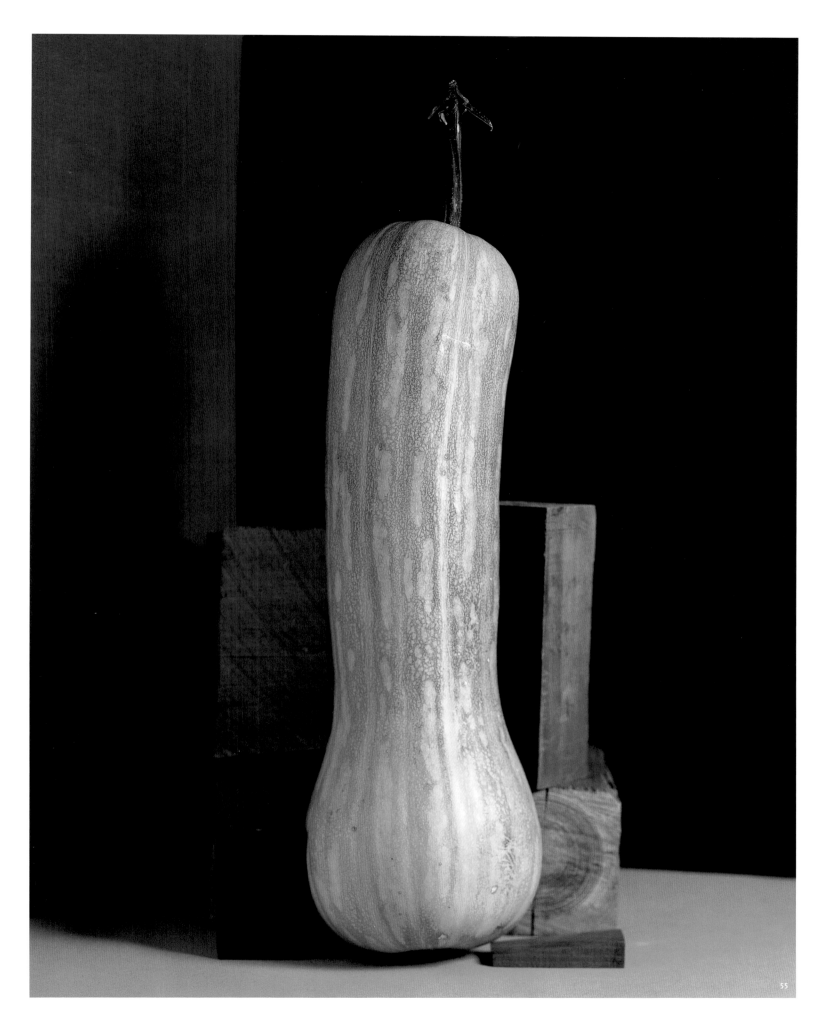

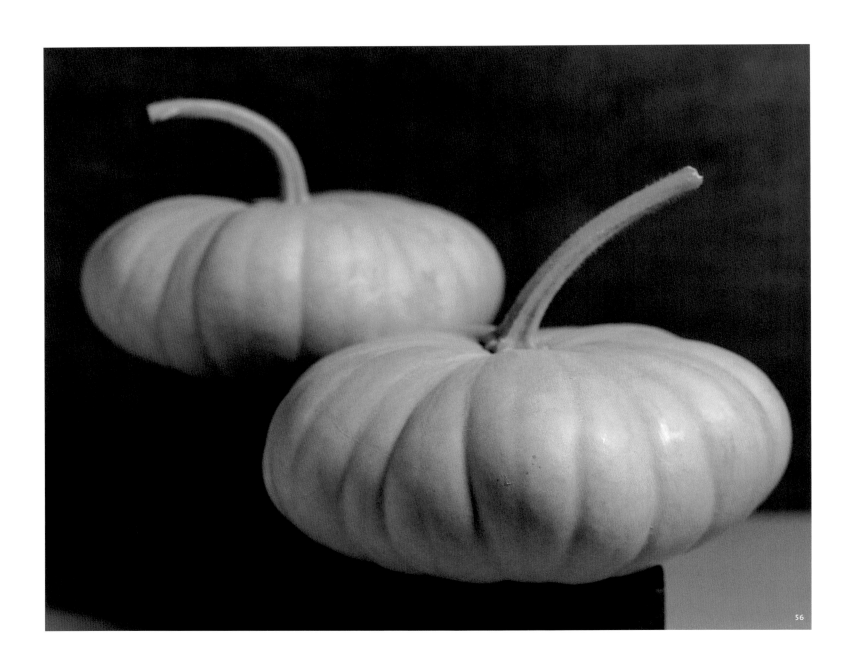

56

Cheese Pumpkin Group *Cucurbita moschata*

FOR SHEER ENDURANCE, Cheese Pumpkins are peerless. In the fall of the year, hundreds of squashes dwell on floor-to-ceiling stainless steel baker's racks in my pumpkin storehouse. Like the von Trapp Family Singers, in predictable order, they bid us adieu: *Cucurbita pepo*s, followed by *C. argyrosperma*s, *maxima*s, and *moschata*s. Some pumpkins implode and are reduced to puddles. Others simply shrivel up like shrunken heads and fade away. At the end of the day, still alive and well—and respiring to beat the band—the Cheese stands alone.

I urge you to grow the Cheese Pumpkin for its sheer long-lasting loveliness. Pumpkins aren't just globelike and orange, you know. This terra-cotta beauty, clearly resembling a wheel of cheese with a natural rind and parallel flat faces, is an antidote to the plague of sameness in the American pumpkin patch. Use it as a paperweight, a doorstop, or even a soup container. But whatever you do, *don't eat it*. Cheese Pumpkins are strictly bottom of the barrel, unsavory and coarse. Culpepper and Moon, in their classic comparative study, found Cheese sorely lacking in flavor, consistency, total sugars, and solids, with an unsatisfactory color when canned.

Tropical pumpkins (*Cucurbita moschata*) like Cheese thrive in the hot, humid lowlands of Central and South America. Before the arrival of Columbus, this kind of cultivated plant had migrated throughout the West Indies and Caribbean and had gained a foothold in the American Southwest. By the time of the American Revolution, Cheese Pumpkins were widely grown throughout the Middle Atlantic states. Soldiers returning from service introduced Cheese to Northeasterners, and by 1807 Bernard McMahon of Philadelphia was listing Large Cheese Pumpkin in his seed catalog. These days you can find Cheese Pumpkins flourishing from California to New York, but there's one part of the earth they will not inherit: the Far North. They're among the most cold intolerant of squashes.

Cutchogue Flat Cheese *fig. 56*

Cucurbita moschata Cheese Pumpkin Group
SIZE: $3^1/2$" long by 10" wide
WEIGHT: 6 pounds
RIND COLOR: light burnt sienna
FLESH COLOR: dense raw sienna
COLOR RATING: 5
FIBER: acceptable
BEST USE: decorative
SYNONYMS: Cheese, Cheese Pumpkin, Long Island Cheese
SEED SOURCES: Bake, Ers, Fed, Heir, John, Old, Sand, Sky, Sou, Vict

Very graceful lines; flattened like some Piaget watches. Smaller and flatter than its relative, Long Island Cheese.

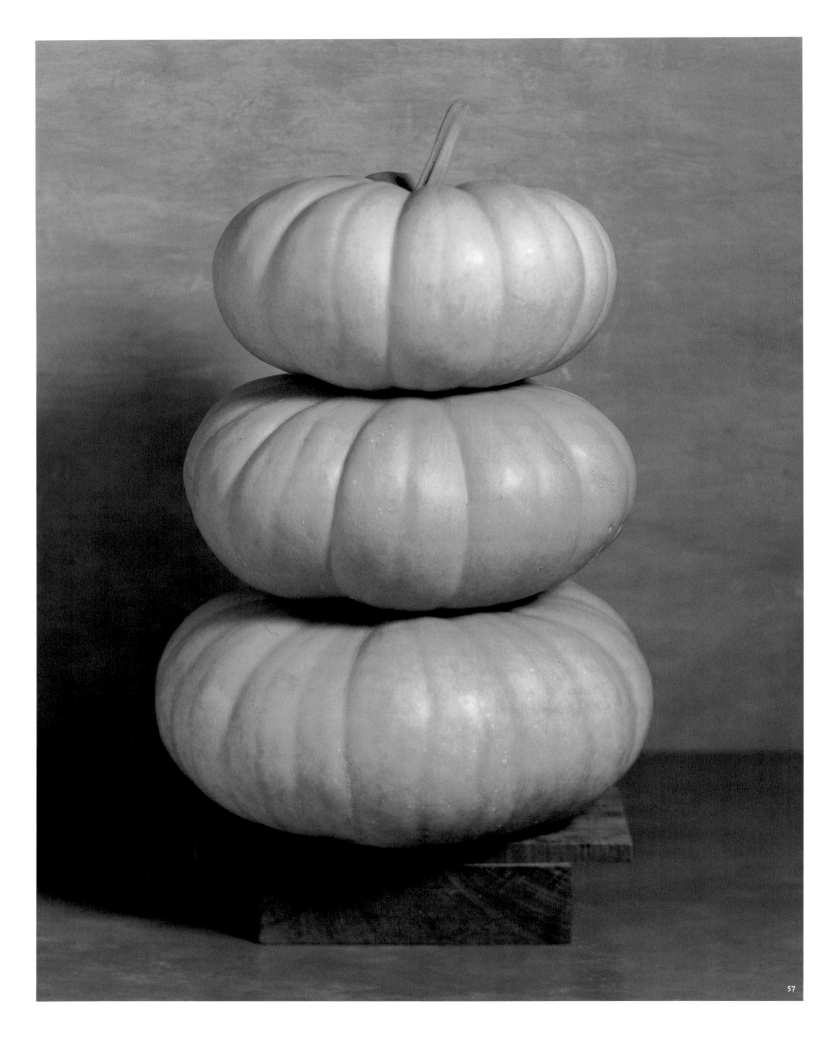

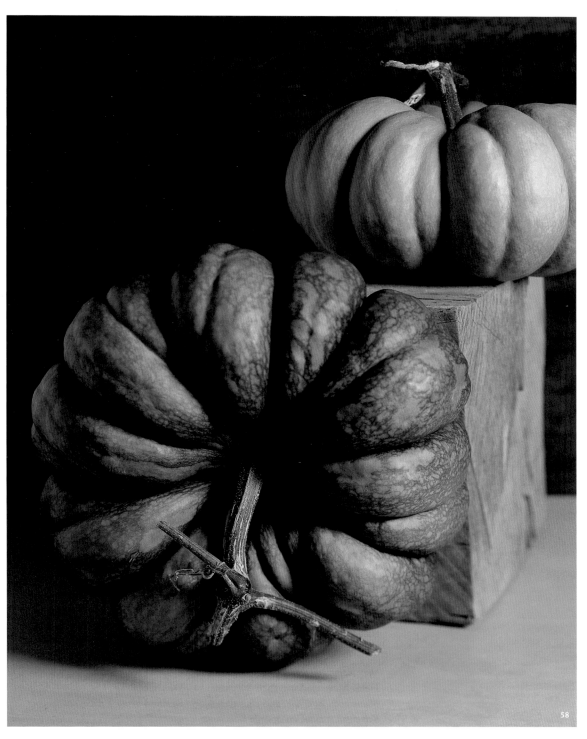

Musquée de Provence *fig. 58*

Cucurbita moschata Cheese Pumpkin
Group

SIZE: 6" long by 13" wide

WEIGHT: 13 pounds

RIND COLOR: dense burnt sienna

FLESH COLOR: intense cadmium orange

COLOR RATING: 5

FIBER: none

DATE OF INTRODUCTION: 1899; Vaughan's
Seed Store, Chicago

BEST USES: decorative, table vegetable

SYNONYMS: Bronze-Colored Montlhéry,
Fairytale, Potiron Bronze de
Montlhéry

SEED SOURCES: Bake, Clif, Har, Jor,
Orn, Sky, Ter

An absolute favorite. Color of milk
chocolate and just as addictive.
Corresponds to the Potiron Bronze
de Montlhéry cited in Vilmorin
(1890).

Long Island Cheese *fig. 57*

Cucurbita moschata Cheese Pumpkin
Group

SIZE: 6" long by 11¹/₂" wide

WEIGHT: 12 pounds

RIND COLOR: light burnt sienna

FLESH COLOR: dense raw sienna

COLOR RATING: 4

FIBER: unacceptable

DATE OF INTRODUCTION: 1807; Bernard
McMahon, Philadelphia

BEST USE: decorative

SYNONYMS: Cheese, Cheese Pumpkin,
Large Cheese Pumpkin

SEED SOURCES: Bake, Ers, Heir, John,
Old, Sky, Sou, Sse, Vict

Not near and dear to me, though
some people are fans. Somewhat
soapy.

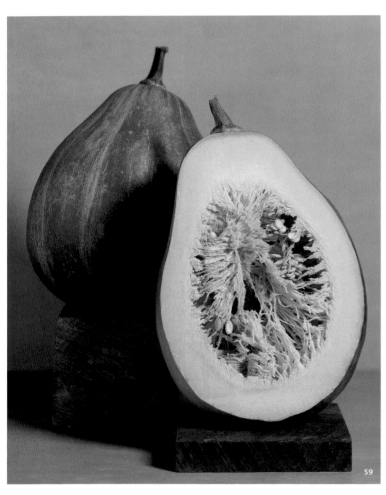

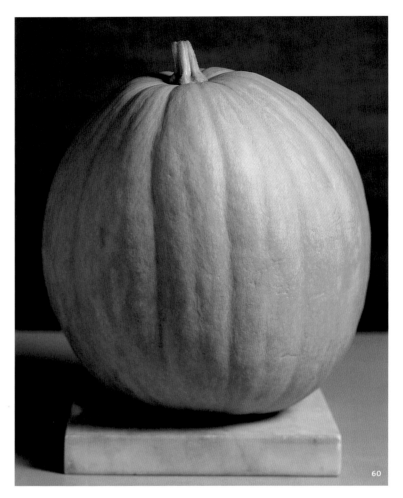

Virginia Mammoth *fig. 59*

Cucurbita moschata Cheese Pumpkin
Group
SIZE: 15" long by 10" wide
WEIGHT: 15 pounds
RIND COLOR: toned-down burnt sienna
FLESH COLOR: toned-down brilliant orange
COLOR RATING: 2
FIBER: unacceptable
DATE OF INTRODUCTION: 1895; T. W. Wood
& Sons, Richmond, Virginia
BEST USE: livestock feed
SYNONYMS: Jumbo, King of Mammoth,
Mammoth Gold
SEED SOURCES: Bunt, Clif, Ers, Lan, Sky,
Wet, Will

My preferred tan field pumpkin.
Beauty is skin deep in this case.
Matures later than Shakertown Field.

Shakertown Field *fig. 60*

Cucurbita moschata Cheese Pumpkin
Group
SIZE: 14" long by 14" wide
WEIGHT: 17 pounds
RIND COLOR: medium raw sienna
FLESH COLOR: medium cadmium orange
COLOR RATING: 4
FIBER: unacceptable
BEST USE: livestock feed

Very attractive and similar to Kentucky
Field. More uniform than Virginia
Mammoth in color, and rounder.
Beautiful inside: an orange fairyland
with gossamer strings.

Upper Ground Sweet Potato *fig. 61*

Cucurbita moschata Cheese Pumpkin
Group
SIZE: 8" long by 5" wide
WEIGHT: 3 pounds
RIND COLOR: medium raw umber
FLESH COLOR: medium cadmium orange
COLOR RATING: 4
FIBER: unacceptable
BEST USE: livestock feed

Disappointing. The Maoris of New
Zealand grow a different "upper
ground" pumpkin called Whatawhata.

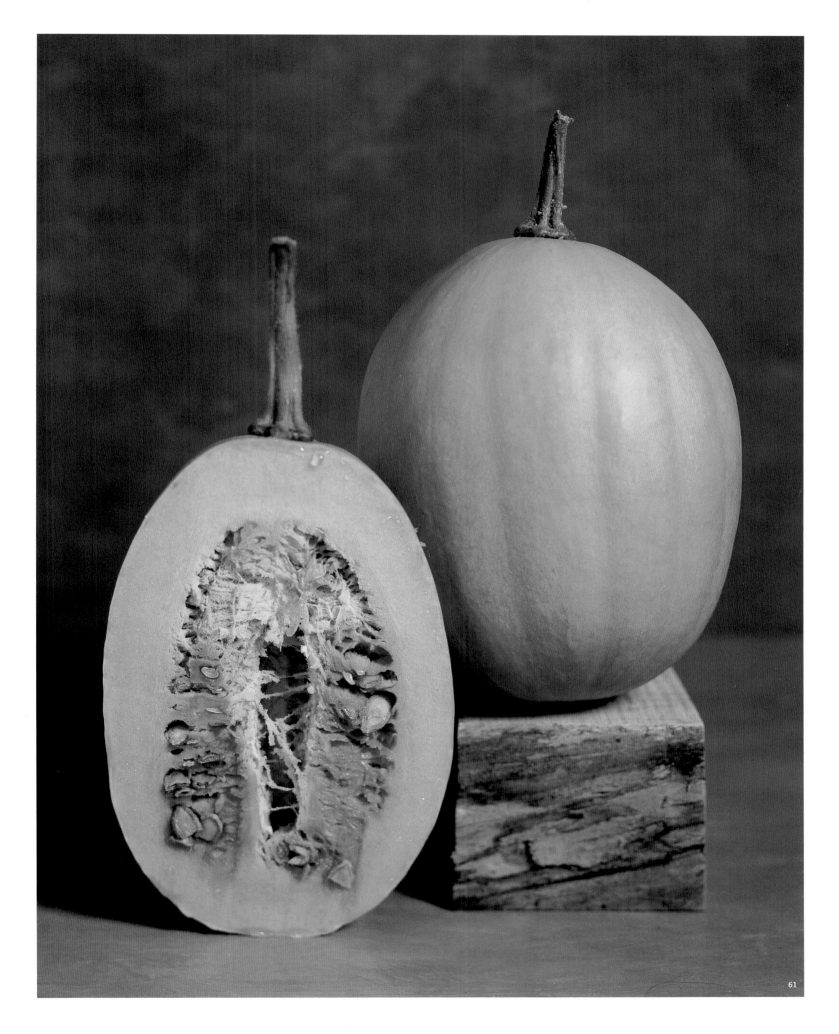

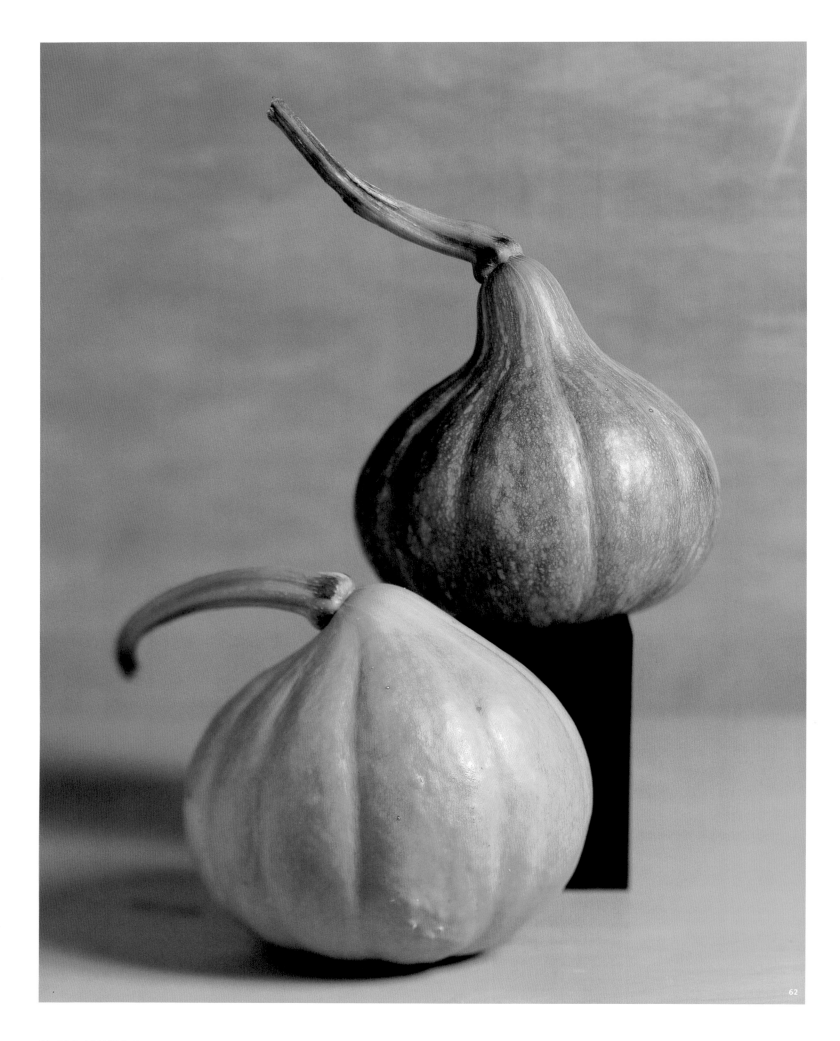

Tropical Group *Cucurbita moschata*

SEMINOLE

"IRREPRESSIBLE" IS NOT TOO STRONG A WORD for a vine that can maneuver around any obstacle, run over the river and through the woods, climb trees, and maybe even leap small buildings in a single bound. With vim and vigor, Seminole runners root at the nodes and go on and on seemingly ad infinitum. When other pumpkins were felled by rainstorms and an all-out assault by squash bugs in my garden, Seminole yielded a bumper crop borne on twenty-eight-foot vines. I've heard of one vine that grew in John DuPuis's father's Florida grapefruit grove and covered four acres with hundreds of pumpkins; Charles Pierce's Uncle Will planted Seminoles in 1873 on Hypoluxo Island (Florida), and ten years later the plants were still going strong. Believe it or not.

While we're in the realm of the improbable, who says pumpkins don't grow on trees? In Florida, they do. In the "land of the cypress and myrtle where the evergreen live oak and lofty magnolia dress the forest in a perpetual mantle of green" can be found *chassa-howitska*, the Creek term for "hanging pumpkin," which is used by the Creek-speaking Seminole as well as Hitchiti-speaking Miccosukee. There are at least two unrelated types of "arboreal" pumpkins in Florida: *Cucurbita okeechobeenis*, a wild green-and-white speckled hardball (brownish at maturity) about the size of a grapefruit, and the Seminole (*Cucurbita moschata*), which is pear shaped and deep gold. Early explorers were captivated by the sight of sky-high pumpkins; John Bartram, the noted Philadelphia botanist, found it exceedingly curious in 1774 "to behold the wild Squash climbing over the lofty limbs of the trees; its yellow fruit, somewhat of the size and figure of a large orange, pendant from the extremities of the limbs over the water."

The Seminole Indians, growers of the semidomesticated tropical pumpkin (*C. moschata*) that now bears their name, knew from experience to keep their pumpkins high and dry. Dr. John Gifford, a former forestry professor at the University of Miami, witnessed how, in the early 1900s, the Seminoles planted pumpkins at the base of trees they had deadened; the pumpkins then followed their natural inclination. Gifford was as shocked as I was to find out how phenomenal this pumpkin tastes, especially given its hard, lignified rind that must be cracked open, like a coconut, with heavy artillery, an ax, or machete. Its powdery orange flesh is almost as satisfying as a *maxima*'s. Halve a Seminole and bake it, face down, in a 425-degree Fahrenheit oven for a half hour or so, and you've got the treat of a lifetime. Seminole pumpkin bread, more like a fritter or empanada, is still served at Seminole and Miccosukee powwows and festivals.

This pumpkin is a legacy, its teardrop shape emblematic of the tragic story of a once glorious people decimated in an inglorious war. The name *Seminole*, derived

Seminole *fig. 62*
Cucurbita moschata Tropical Group
SIZE: 7" long by 6" wide; stem: 7"
WEIGHT: 3½ pounds
RIND COLOR: light permanent orange
FLESH COLOR: medium cadmium orange
COLOR RATING: 4
FIBER: none
DATE OF INTRODUCTION: 1916; listed by Aggeler & Musser Co., Los Angeles
BEST USE: table vegetable
SYNONYMS: Indian Pumpkin, Chassa-howitska
SEED SOURCES: Bake, Fed, Horus, Nat, Rev, Sese

Fruit shapes vary considerably. My seed came from Kit Condill of Revolution Seeds.

from the Creek word *simanoli*, meaning "exiles" or "wanderers," is doubly apt, since the Seminoles were not once but twice uprooted. First they were dispossessed by their own people, the Creeks, and banished to Florida, where they remained for just one hundred years or so. Then the Seminoles were forcibly marched—at the cost of thousands of lives and millions of dollars—to the Indian Frontier west of the Mississippi by government soldiers in the infamous Trail of Tears "removal." I was moved to tears by the accounts of the Seminoles' last days in Florida and the deathbed scene of Master Spirit and leader of the tribe, Osceola, "Moon of the Little Moon." Osceola died as much of a broken spirit as he did of malaria and tonsillitis on January 30, 1838, surrounded by Seminole chiefs, officers of the garrison, and his wives and children. The doctor took his head as a trophy.

Paw Paw *fig. 63*
Cucurbita moschata Tropical Group
SIZE: 6½" long by 5½" wide
WEIGHT: 2½ pounds
RIND COLOR: dense raw umber
FLESH COLOR: medium golden ocher
COLOR RATING: 5
FIBER: acceptable
BEST USE: table vegetable
SYNONYMS: Papaya, Papaya Golden
SEED SOURCE: Ever

A "gramma" Down Under. Common in Taiwan. Very sweet but thin fleshed.

Brazil *fig. 64*
Cucurbita moschata Tropical Group
SIZE: 5" long by 8½" wide
WEIGHT: 5 pounds
RIND COLOR: intense permanent olive green
FLESH COLOR: dense raw sienna
COLOR RATING: 5
FIBER: acceptable
BEST USE: table vegetable

A beauty. Very sweet sautéed in olive oil.

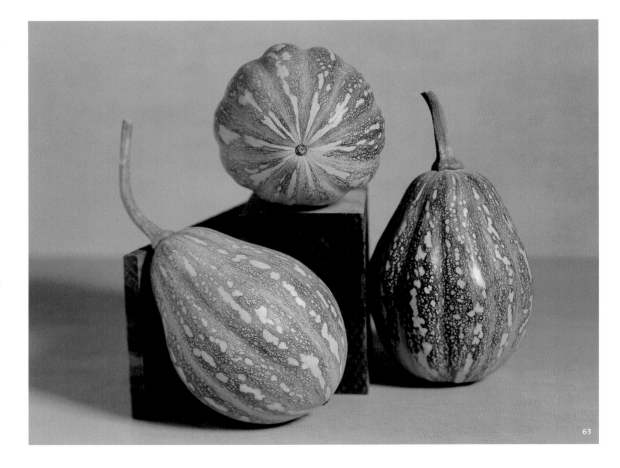

63

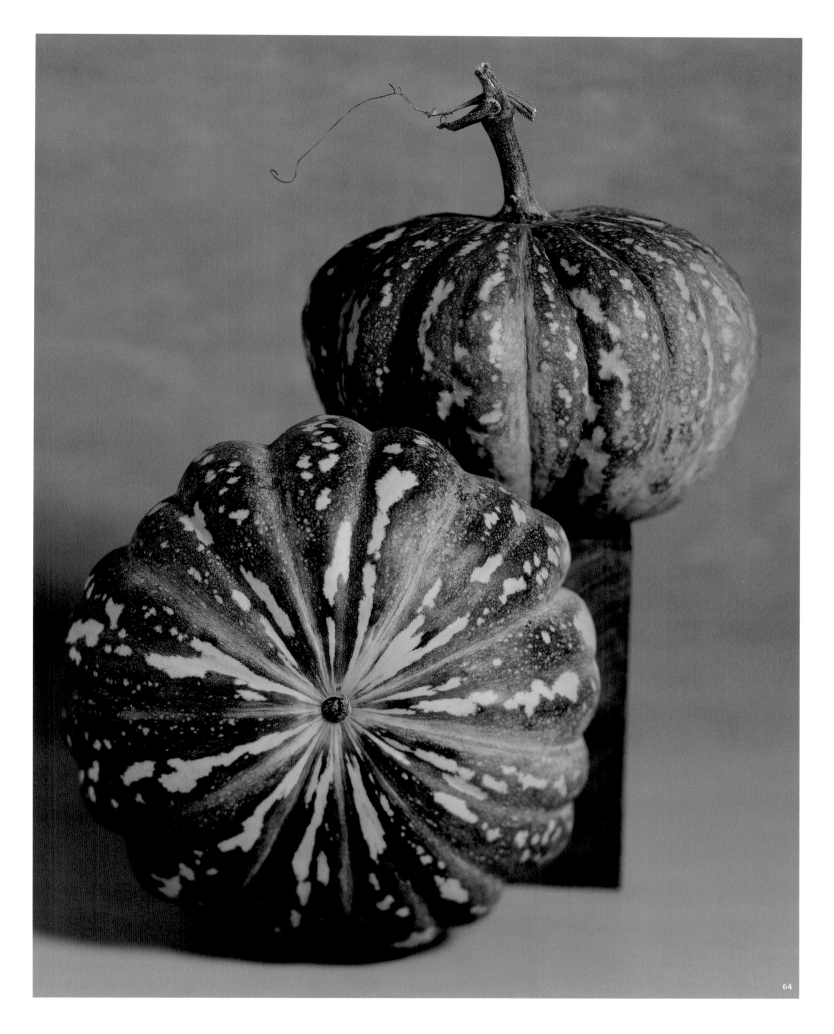

64

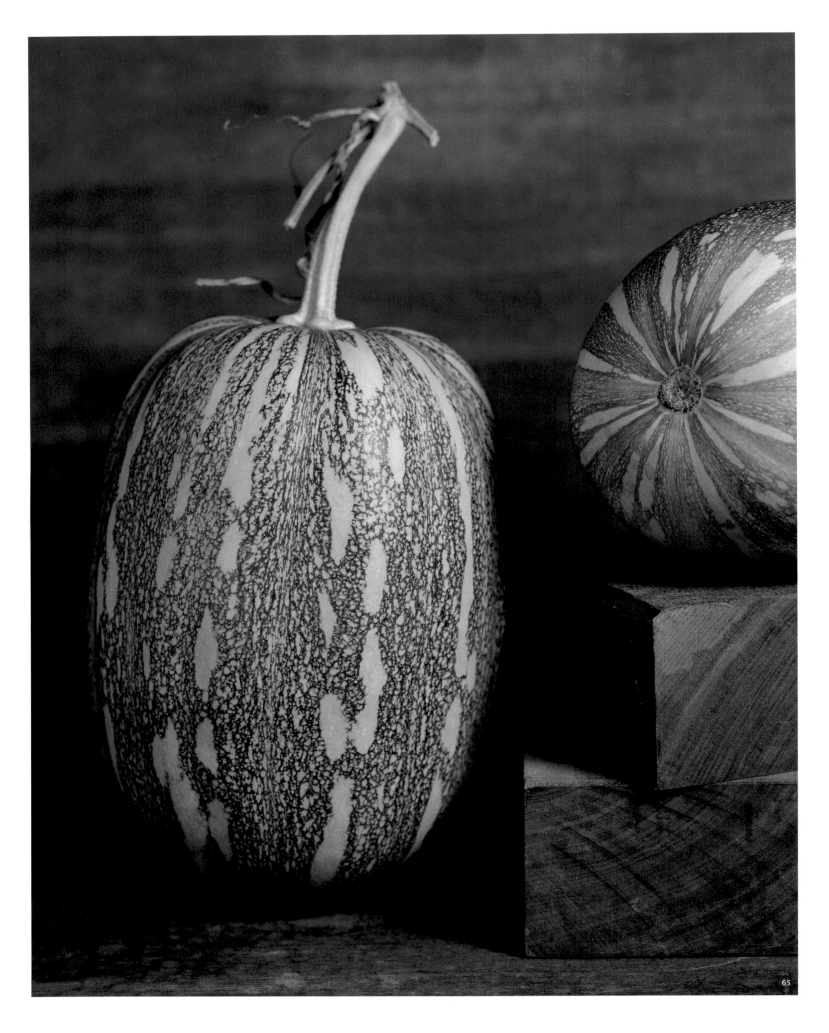

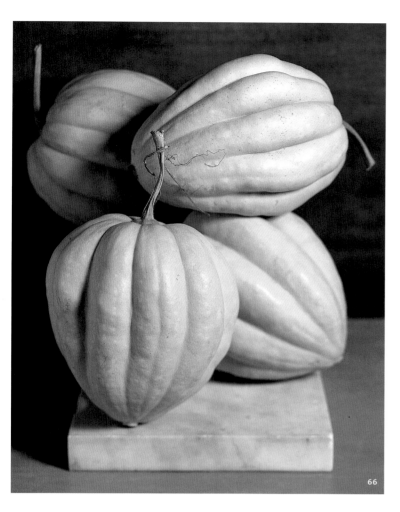

White Rind Sugar *fig. 66*

Cucurbita moschata Tropical Group

SIZE: 9" long by 7½" wide

WEIGHT: 6 pounds

RIND COLOR: subdued burnt sienna

FLESH COLOR: transparent yellow ocher

COLOR RATING: 1

FIBER: none

BEST USE: decorative

SEED SOURCE: Horus

Completely bland and thin fleshed; turns tan at maturity. Looks like a giant Acorn squash. Very long shelf life.

St. Petersburg *fig. 65*

Cucurbita moschata Tropical Group

SIZE: 14" long by 10" wide

WEIGHT: 18 pounds

RIND COLORS: dense raw umber and deep permanent olive green

FLESH COLOR: medium golden ocher

COLOR RATING: 5

FIBER: acceptable

BEST USES: decorative, table vegetable

This is heavenly. Unquestionably the sweetest *moschata*, even if somewhat coarse. Beta carotene must be off the charts. Collected by Ed Nute of San Rafael, California, at the Saint Petersburg (Russia) Flower Market in April of 1993, along with another squash called Aeronaut.

Galeux des Antilles *fig. 67*

Cucurbita moschata Tropical Group

SIZE: 8½" long by 7" wide

WEIGHT: 4 pounds

RIND COLORS: wet vermilion green and transparent brilliant orange

FLESH COLOR: intense brilliant orange

COLOR RATING: 4

FIBER: unacceptable

BEST USE: decorative

Stunning. Difficult to bring to fruition in my Zone 5 garden. Bears few seeds. Thin, disagreeable flesh.

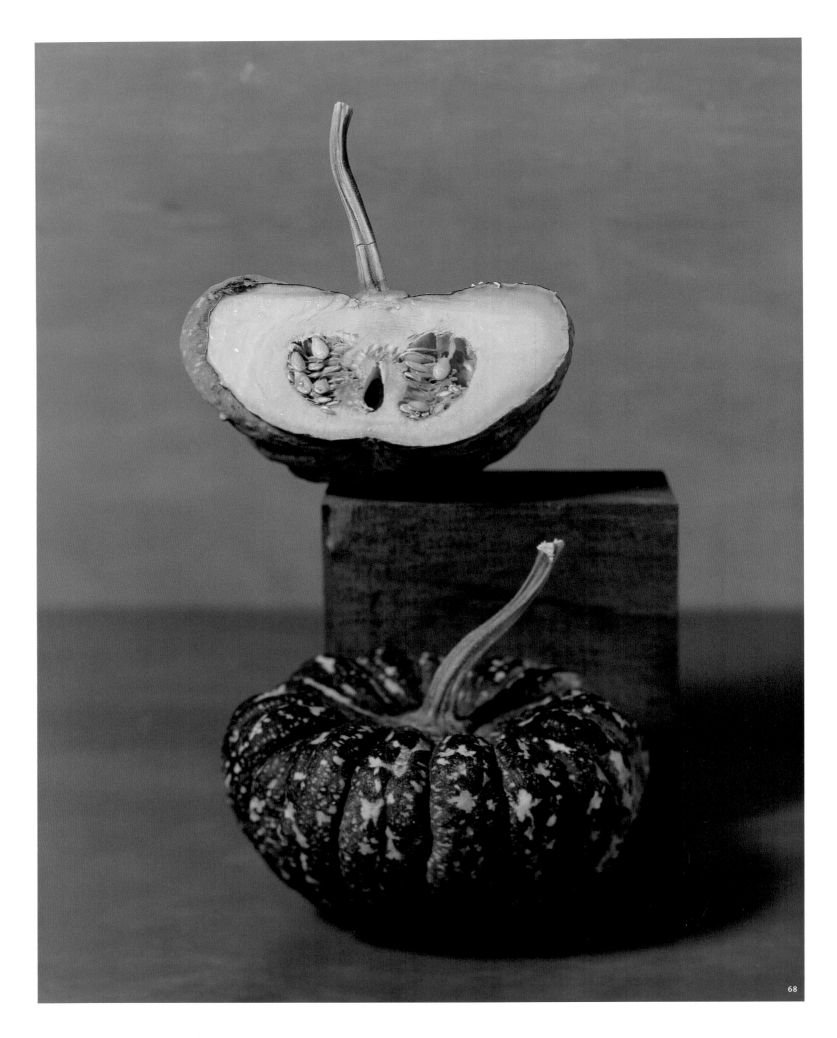

Japonica Group *Cucurbita moschata*

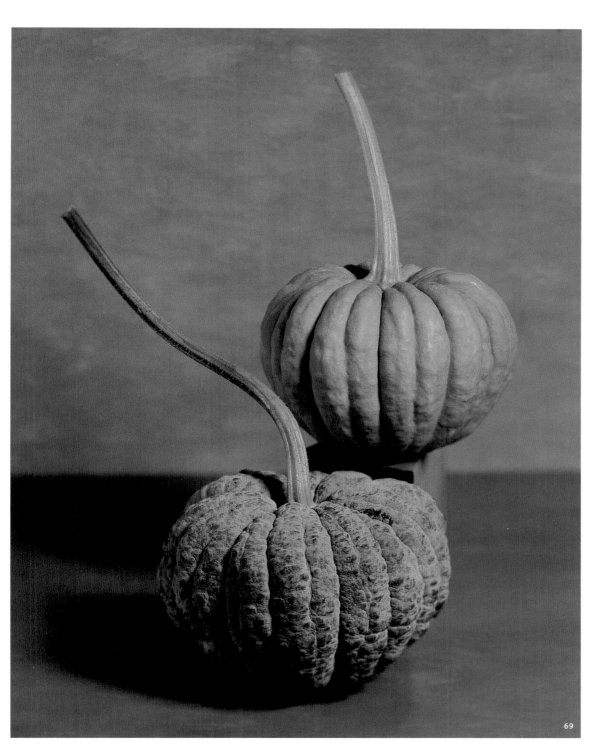

Chirimen *fig. 68*

Cucurbita moschata Japonica Group
SIZE: 2¹/2" long by 7" wide
WEIGHT: 3 pounds
RIND COLOR: medium bluish black
FLESH COLOR: toned-down yellow ocher
COLOR RATING: 2
FIBER: none
DATE OF INTRODUCTION: 1922; Aggeler
& Musser Co., Los Angeles
BEST USES: decorative, table vegetable
SYNONYMS: Bizen Chirimen, Chu
Chirimen
SEED SOURCE: Kit

Gorgeous little squash. Very good
quality. Popular in Edo period
(1603–1867); becoming less
common.

Futtsu *fig. 69*

Cucurbita moschata Japonica Group
SIZE: 4" long by 6" wide
WEIGHT: 3 pounds
RIND COLOR: intense raw umber
FLESH COLOR: dense golden yellow
COLOR RATING: 4
FIBER: none
BEST USES: decorative, table vegetable
SYNONYMS: Black Futtsu, Futtsu Black
Rinded, Futtsu Early Black
SEED SOURCES: Bake, Red, Sed

Becomes a shrunken head over time.
Nutty, sweet, and dry. Popular in
Tokyo in the Edo period (1603–1867).

Toonas Makino *fig. 70*

Cucurbita moschata Japonica Group
SIZE: 9" long by 4½" wide
WEIGHT: 2½ pounds
RIND COLOR: intense raw umber
FLESH COLOR: light cadmium orange
COLOR RATING: 3
FIBER: acceptable
BEST USE: decorative
SYNONYMS: Shishigatani, Tounasu
SEED SOURCE: Bake

What singular form! Use for inspiration only. According to Mr. Minoru Kanda, of the Kanda Seed Company in Japan, *tounasu* or *toonas* is the old word for traditional Japanese squashes grown in the Tokyo area; it also refers to squashes with bottle necks or hourglass shapes grown in the Kyoto region. Makino is a common family or place name. Toonas Makino is similar to the bottle-necked Shishigatani or Hyoutan Nankin grown near Kyoto.

Yokohama *fig. 71*

Cucurbita moschata Japonica Group
SIZE: 5" long by 8" wide
WEIGHT: 4½ pounds
RIND COLORS: deep Payne's gray and dense permanent orange
FLESH COLOR: medium golden yellow
COLOR RATING: 2
FIBER: none
DATE OF INTRODUCTION: 1860; disseminated by Mr. James Hogg
BEST USE: decorative
SEED SOURCE: Bake

Unfamiliar to cucurbit experts in Japan; probably the progenitor of the present-day Chirimen. Received in 1860 by Mr. James Hogg of Yorkville, New York, from his brother Thomas, then residing in Yokohama, Japan. Carried by seed vendors Bliss, Gregory, and others. Shell reminded Gregory of a toad's back; it looks and feels like elephant hide to me. Other Japonicas have better flavor.

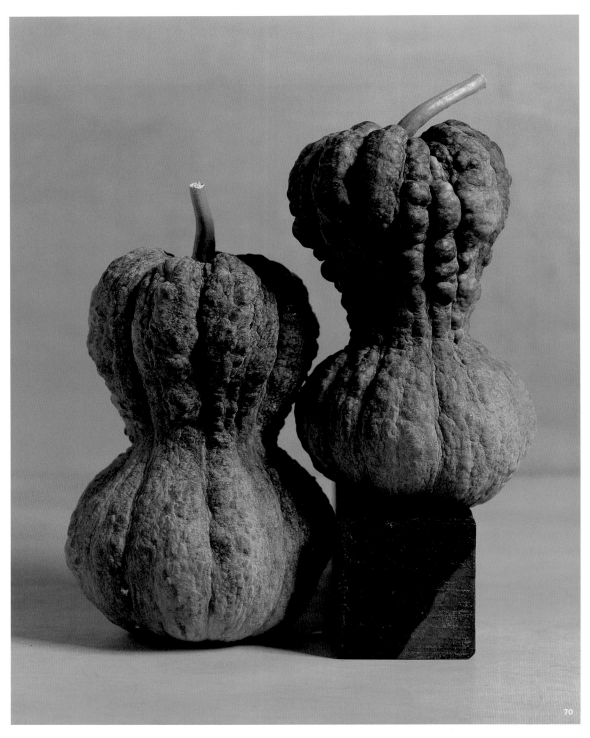

70

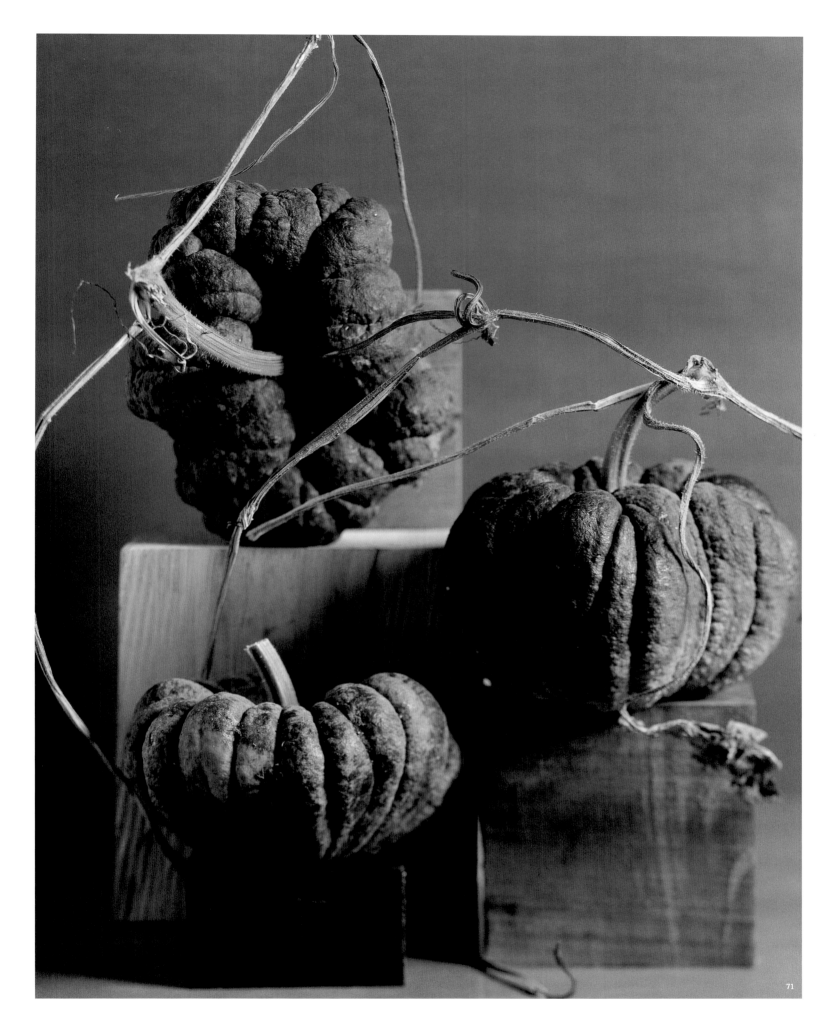

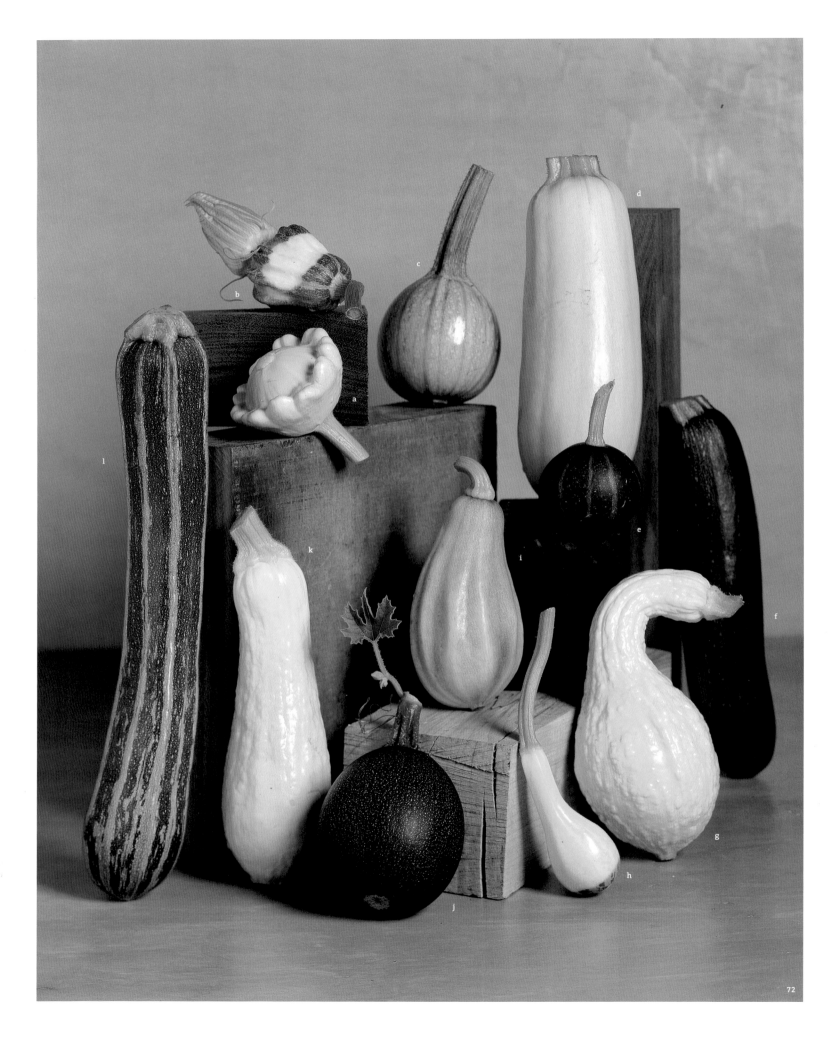

CUCURBITA
PEPO

CUCURBITA PEPO IS THE MOST POPULAR SPECIES of all—and the most diverse. It includes favorites such as Zucchini as well as the familiar Halloween jack-o'-lantern. This species is native to Mexico and the United States and performs well in temperate areas with cool climates. Native Americans domesticated the older forms (including Pumpkin, Acorn, and Scallop); some of the elongate-fruited forms (Cocozelle and Zucchini) were developed in recent centuries in Europe. Although the wild progenitor is up for grabs, two wild relatives have been identified: *C. pepo* ssp. *fraterna* (in Mexico) and *C. pepo* ssp. *texana* (in the United States). Domesticates have acutely and prominently lobed leaves, often spiny foliage, and fruit stalks or stems that are hard and strongly angled.

The following eight culinary and one ornamental gourd cultivar groups, based on fruit shape, are derived from Harry Paris's subspecific horticultural classification of *C. pepo*. The Pumpkins and Acorns, used almost exclusively as mature fruits, are defined by their roundness: a length-to-broadest-width ratio of 1:1. Fruits of the other culinary groups, consumed immature as summer squashes (within a week of flowering) and grown mainly on bushy (rather than viny) plants, tend to deviate strongly from roundness, being either flat (Scallop) or cylindrical (Crookneck, Straightneck, Vegetable Marrow, Cocozelle, and Zucchini).

PUMPKIN: round; probably the oldest and most diverse group. Can be smooth or warted, with or without longitudinal grooves, ribs, or furrows. Various colors. Includes oil pumpkins of Europe, grooved pumpkins of the United States and Canada, ribbed Mexican pumpkins, and summer pumpkins popular in France and Italy. Not lignified (hard shelled). Subspecies: *pepo*.

ACORN: turbinate (top-shaped) with ten deep furrows. White, orange, yellow, green, tan, or striped and blotched rinds. Individual (single or double serving) fall squashes, easy to cut and serve. I include the once-thought-extinct Fordhook group—long-lost cousins of Acorns, probably derived from them by chance outcrosses (promiscuity). Subspecies: *texana*.

SCALLOP: flattened disk shape with wavy, scalloped (usually equatorial) margins. There are at least three distinct forms and four colors. Also known as Pattypans (for their resemblance to crimped baking pans), custard and button squashes, cymlings or pâtissons. Hard woody (lignified) rinds when mature. Subspecies: *texana*.

CROOKNECK: long, narrow necks, slightly to very curved, depending upon the angle of the dangle on the plant; broad at the blossom end. Yellow varieties predominate and become intensely orange, lignified, and warty when mature. Green and pale yellow varieties exist, too. Popular in the southeastern United States. Subspecies: *texana*.

FIGURE 72, A PANORAMA OF *C. PEPOS*, ONLY A FEW DAYS OLD: **a.** EARLY WHITE BUSH SCALLOP; **b.** SHENOT CROWN OF THORNS; **c.** DAGESTAN; **d.** BEIRUT; **e.** MINIATURE BALL; **f.** NANO VERDE DI MILANO; **g.** SUMMER CROOKNECK; **h.** BICOLOR SPOON; **i.** CHESTNUT ACORN; **j.** ROLET; **k.** EARLY PROLIFIC STRAIGHTNECK; **l.** STRIATO D'ITALIA.

STRAIGHTNECK: shorter, straighter neck than Crookneck, from which it was recently derived; blossom end broad. Rind is always yellow. Less intensely orange and warted at maturity than Crookneck; lignified rind. Easier to box and pack than Crookneck. Popular in the United States. Subspecies: *texana*.

VEGETABLE MARROW: short and stubby, tapered, and cylindrical with a length-to-broadest-width ratio of 1.5 to 3.0. Traditionally eaten half-grown in England or grown monstrously big for exhibition; now very popular in the Middle East and North Africa, where it is stuffed with meat and rice. Horticulturally primitive group (spiny foliage and closed growth habit). Vegetable Spaghetti is the most popular vegetable marrow in the United States. Subspecies: *pepo*.

ZUCCHINI: uniformly cylindrical, with little or no taper. The most popular *C. pepo* and most modern cultivar group in its subspecies. Crunchiest texture. Developed in Italy; name comes from the plural in Italian for "summer squash." Most are various shades of green and some are intensely yellow. Length-to-broadest-width ratio is usually 3.5 to 4.5. Confusion is rampant about what constitutes a Zucchini: often mixed up with Cocozelle or Vegetable Marrow. Subspecies: *pepo*.

COCOZELLE: straight and narrow; longest-fruited forms of *C. pepo;* bulbous, with cylindrical, length-to-broadest-width ratio of 3.5 to 8.0 or more. Use very young, as it quickly becomes astringent or even grassy. Four subgroups: smooth striped, prominently ribbed and striped, smooth light green, and smooth pale Turkish or Yugoslavian sorts. Developed in Italy—sometimes referred to as Italian Vegetable Marrow. Name derives from *cocuzza*, the Sicilian word for *zucca*, "gourd." Subspecies: *pepo*.

ORNAMENTAL GOURDS: small decorative gourds of various shapes and colors. Most are bitter and inedible. These gourds may be subdivided into two groups (Orange and Ovifera) pending further research. Not the same as the white-flowered gourds (for example, bottle gourds) of *Lagenaria siceraria*.

Rolet *fig. 72j*

Cucurbita pepo Pumpkin Group
SIZE: $2^1/2$" long by $2^1/8$" wide
WEIGHT: $3^1/2$ ounces
RIND COLOR: deep vermilion green
SYNONYMS: African Gem, Rollet

South African origin. Tough rind, soft flesh, and seedy; nowhere near as good as Ronde de Nice. Must peel before using.

Pumpkin Group *Cucurbita pepo*

NAKED SEEDED PUMPKINS

ENTERING THE PUMPKIN PATCH is like walking into a nut store. *It's the snack course, only better*, and humanity has been munching on this natural, nutritious taste treat for thousands of years. Raw pumpkin flesh may not be my idea of a good time, but the seeds are. I find pumpkin seeds just as addictive as peanuts and sunflower seeds, the more popular American natives. In fact, I haven't met a pumpkin or squash whose ripe seeds I didn't like. Even the vilest, bitterest *Cucurbita pepo* gourds have edible seeds.

The naked seeds are sensational. Those gorgeous green seeds can go right from the pumpkin into your mouth (although they're better toasted than raw); no need to worry about shucking thick seed coats. You'd be misinformed, though, if you believed those titillating seeds are truly "naked" or hulless. The naked-seeded pumpkin, like the headless horseman, is mythical. Naked seeds are clothed in a thin seed coat, even though their epidermis is showing.

I'm obsessed with seeds. I squirrel them away and even find seed morphology fascinating. According to Dr. Herwig Teppner of the Institute of Botany at Karl-Franzens University in Graz, Austria, there are two basic types of *C. pepo* seed coats: the thick and the thin. The testa, or outer coat of a seed, has five layers (from the outside in): (1) epidermis, (2) hypodermis, (3) schlerenchyma, (4) aerenchyma, and (5) chlorenchyma. Most ripe, dry seeds are thick coated; their four outer layers are strongly lignified (woody). The testa (external coating) of ripe, dry, thin-coated seeds is not lignified at all, and during ripening, the second and third layers are destroyed and the fourth and fifth layers collapse. This, in addition to their protochlorophyll, is what gives thin-coated seeds their special green color.

The Austrians produce the most exquisite pumpkin seed oil from thin-coated pumpkin seeds. Once you've tasted delicate and strangely familiar Kurbis Kernl, also called *kürbiskernöl* or *ölkürbis*, drizzled on salads and steamed vegetables or used as part of a marinade or vinaigrette, you'll know why the Austrians of Styria have been making pumpkin seed oil for nearly three hundred years. The Styrians welcomed a thin-coated variant, which appeared out of nowhere circa 1870, because they no longer had to soak or peel seeds for oil production. The thin-coated types now largely predominate. This new type of pumpkin was a result of either mutation or genetic recombination derived from accidental crossing of two major kinds of pumpkins. The naked-seeded character, recessive to the thick-coated character, may be controlled by as many as six different genes.

One hundred years elapsed between discovery and commercialization of naked-seeded cultivars. Styrian Hulless or Gleisdorfer Olkurbis, introduced in 1970, was developed by breeders at Saatzucht Gleisdorf (in Gleisdorf, Austria)

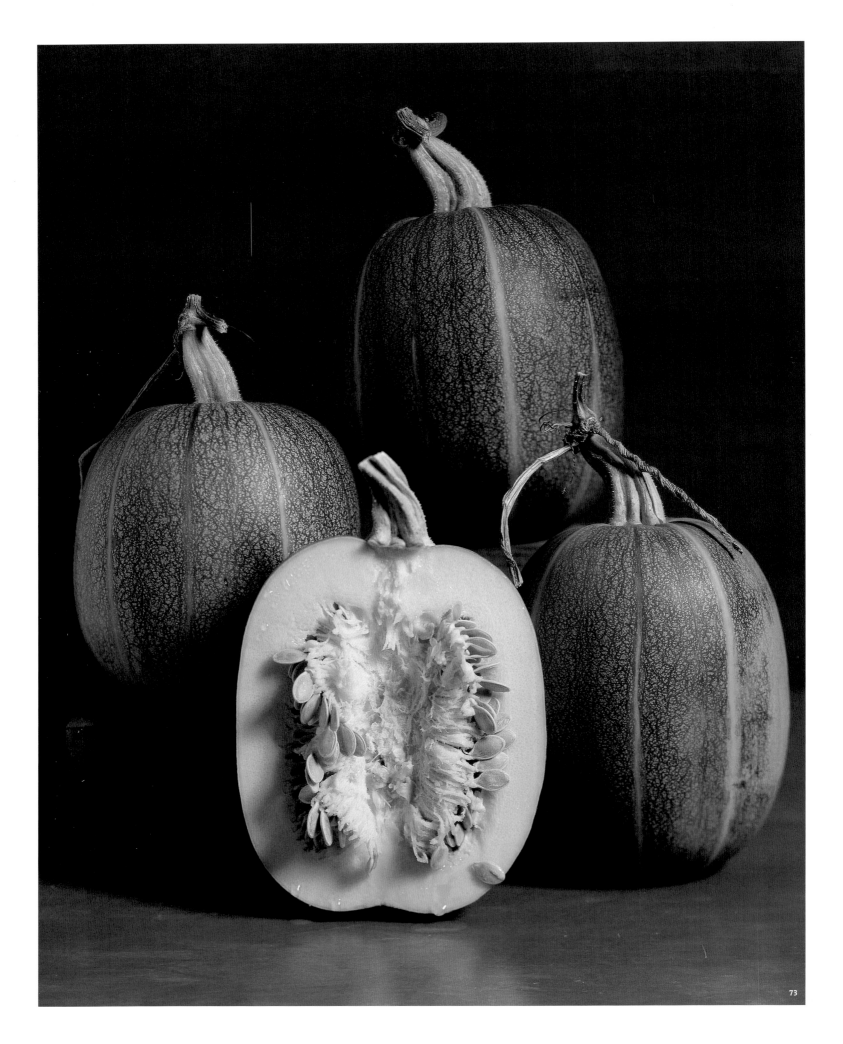

using thin-coated varieties collected from Styrian farmers ten years previously. Today this variety is the most popular oil seed pumpkin grown in Austria. Lady Godiva, introduced by the U.S.D.A.'s Agricultural Research Service two years later, was developed by Allan K. Stoner and touted as a snack food. It was derived from a cross between two naked seed lines: PI 267663 (developed by L. C. Curtis of the Connecticut Agricultural Experiment Station in the 1940s) and Beltsville Accession 102 (commercialized by Agway in 1965).

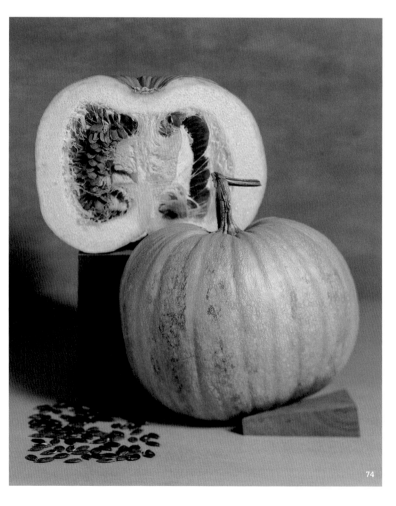

Styrian Hulless *fig. 74*

Cucurbita pepo Pumpkin Group

SIZE: 7$\frac{1}{2}$" long by 9$\frac{1}{2}$" wide

WEIGHT: 7 pounds

RIND COLOR: medium cadmium orange

FLESH COLOR: subdued cadmium orange

COLOR RATING: 1

FIBER: unacceptable

DATE OF INTRODUCTION: 1970; Saatzucht Gleisdorf, Gleisdorf, Austria

BEST USES: oil seed, livestock feed

SYNONYMS: Gleisdorfer Olkurbis, Styrian Oil Pumpkin

SEED SOURCES: Deat, Horus, Hud, Rev, Sand, Sed, Sou, Und

The original hulless oilseed pumpkin, with very dark green seeds. Other varieties are available, including Eat-All, Lady Godiva, Mini-Jack, Snack Jack, Trick-or-Treat, and Triple Treat.

Lady Godiva *fig. 73*

Cucurbita pepo Pumpkin Group

SIZE: 7$\frac{1}{2}$" long by 6" wide

WEIGHT: 3$\frac{1}{2}$ pounds

RIND COLOR: toned-down golden ocher

FLESH COLOR: transparent golden ocher

COLOR RATING: 2

FIBER: unacceptable

DATE OF INTRODUCTION: 1972; developed by Allan K. Stoner, U.S.D.A.

BEST USES: edible seed and oil seed

SYNONYMS: Naked Seeded, Hulless

SEED SOURCES: Horus, Sand, Sed, Soc

I harvest my Ladys green because they tend to sunscald, wrinkle, and rot in my garden.

75

Dagestan *fig. 72a, 75*

Cucurbita pepo Pumpkin Group
SIZE: $5^{1}/_{2}$" long by 6" wide
WEIGHT: 4 pounds
RIND COLORS: dense brilliant orange
and wet vermilion green
FLESH COLOR: medium chrome yellow
COLOR RATING: 2
FIBER: unacceptable
BEST USES: livestock feed, decorative

Adorable bicolor pumpkin. Shape
identical to mature Ronde de Nice.
From National Institute of Plant
Breeding, Russia.

Kumi Kumi *fig. 76c*

Cucurbita pepo Pumpkin Group
SIZE: $5^{3}/_{4}$" long by $5^{1}/_{2}$" wide
WEIGHT: 3 pounds
RIND COLOR: intense yellow ocher
FLESH COLOR: toned-down yellow ocher
COLOR RATING: 3
FIBER: none
BEST USES: decorative, table vegetable
SYNONYMS: American Pumpkin,
Kamo Kamo
SEED SOURCE: Bake

Prominent ribs and lignified rind.
Surprisingly tasty. Cultivated by
the Maoris in New Zealand.

Howden *fig. 76a*

Cucurbita pepo Pumpkin Group
SIZE: $9^{1}/_{2}$" long by $9^{1}/_{2}$" wide
WEIGHT: 9 pounds
RIND COLOR: dense burnt sienna
FLESH COLOR: light burnt sienna
COLOR RATING: 2
FIBER: unacceptable
DATE OF INTRODUCTION: 1973; Vendor:
Harris Moran
BEST USE: jack-o'-lanterns
SYNONYM: Howden's Field
SEED SOURCES: Allen, Berl, Bunt, Burg,
Burr, Clif, Com, Deat, Deb, Ers,
Farm, Fed, Field, Ger, Green, Har,
High, Hume, Irish, Jor, Jung, Lan,
Loc, Mel, Mey, Mor, Park, Peace,
Pine, Rohr, Ros, Shaf, Silv, Sit, Soc,
Sto, Ter, Twi, Ver, Will

Connecticut Field type bred by
John Howden, Howden Farm,
Sheffield, Massachusetts. The
industry standard for years. PVP
expired 1994. A larger version
exists: Howden Biggie (PVP 1996).
Adapted to the north.

FIGURE 76, ORANGE PUMPKINS OF *C. PEPO*
WITH ONE INTERLOPER—JACK BE LITTLE
(AN ACORN SQUASH): **a.** HOWDEN;
b. CONNECTICUT FIELD; **c.** KUMI KUMI;
d. JACK BE LITTLE; **e.** WINTER LUXURY PIE;
f. OMAHA.

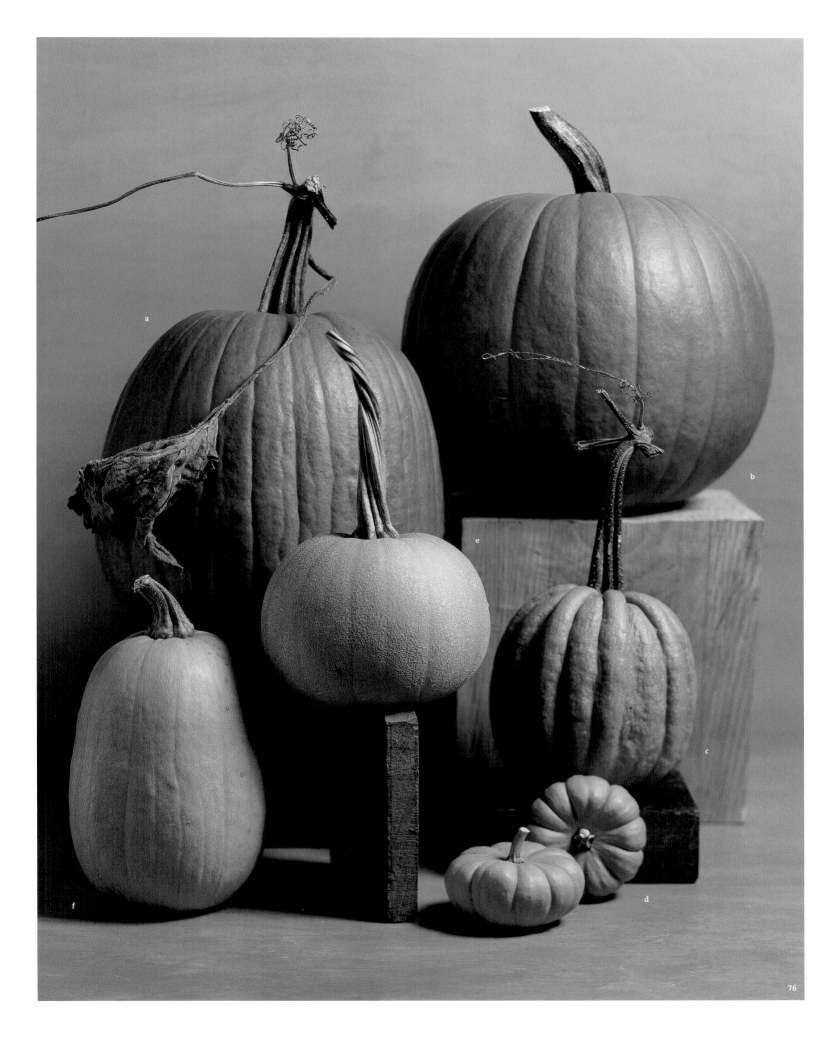

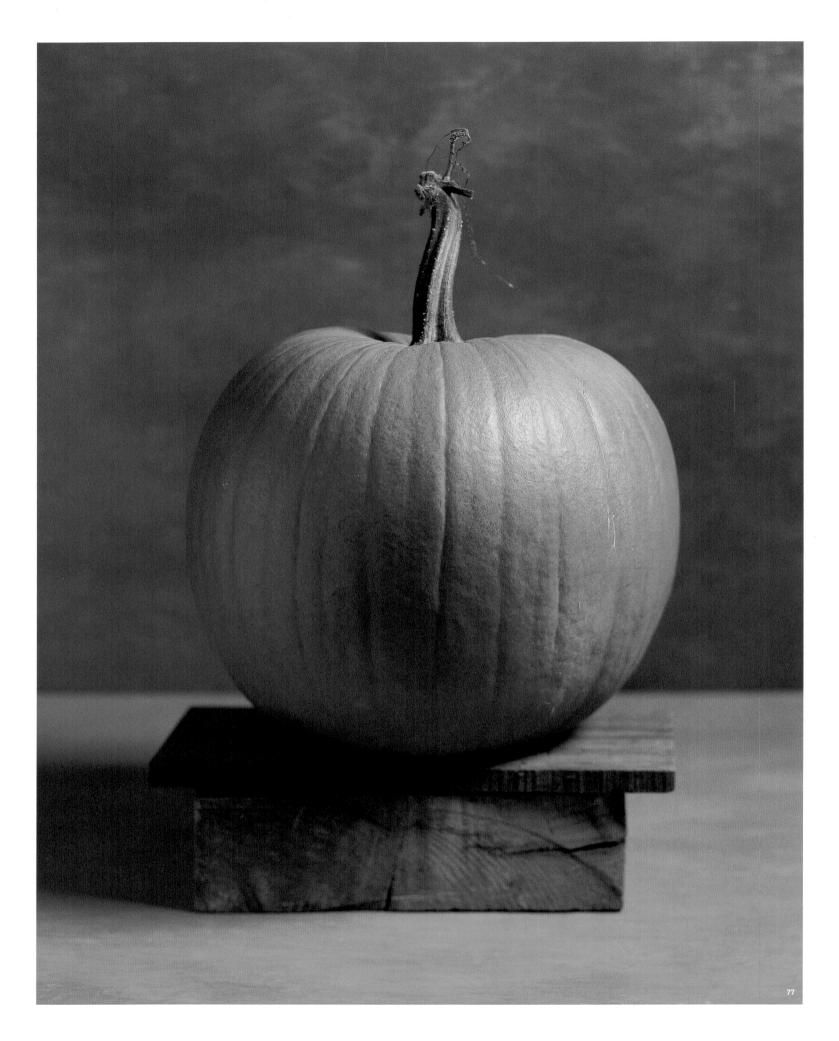

CONNECTICUT FIELD

BOTH ARE MADE IN AMERICA, but McDonald's Big Mac can't compare with the Connecticut Field pumpkin: Zillions and zillions have been sold. For hundreds of years, there's been a veritable monoculture of round orange pumpkins in American fields. I felt a bit of a warm glow when I read Henry David Thoreau's 1852 journal entry: "I see some yellow pumpkins afar in the field. . . . This sight belongs to the season." But nostalgia doesn't cut it for me when I cut the pumpkin. Connecticut Field is a "pumpkin interrupted," only halfway along the road to good eating. When it comes to the grooved orange pumpkins of eastern North America, size matters. The smaller, often more oblate, pie pumpkins are finer and sweeter.

Both pie and field pumpkins were very much in evidence as early as the mid-sixteenth century. Jacques Cartier saw *pompions* (pumpkins) and gourds in his travels among the natives of Hochelega (Montreal) in 1535. Decades after European explorers arrived in the Americas, pumpkins very similar to Small Sugar and Connecticut Field were being illustrated in Europe. Native Americans used pumpkins for medicinal and culinary purposes. Cherokees ate the seeds as an anthelmintic to counter intestinal worms, and the Iroquois and Menominee infused pumpkin seeds to make diuretics. Many tribes dried pumpkin strips for winter storage. Both fresh and dried pumpkin were used in corn bread, cake, pudding, relish, and sauces, and fresh pumpkin was often simply boiled or baked in ashes. The American Colonists were quick to adopt the pumpkin and the Native American know-how that went along with it.

The Native Americans taught us how to grow pumpkins by intercropping, or growing two or more different crops together in a single field. Fearing Burr Jr. observed that when corn or potatoes were grown with pumpkin, Native American style, a single acre could yield a very respectable ton of pumpkins. James J. H. Gregory agreed that such a yield was usually satisfactory to the farmer, but he thought pumpkins, grown as a single crop, could produce even more on half the acreage. Gregory was right: Connecticut Field, grown on the grounds of the Iowa Agricultural Station, yielded sixteen tons per acre, and even more (twenty tons per acre) in California, when well manured.

So what should be done with such providence? Make jack-o'-lanterns, of course. In all probability, pumpkin lanterns were derived from the English punkies: hollowed-out, illuminated turnips or rutabagas used as an apotropaic, a bane for evil spirits. This home remedy, as resourceful as the use of beetroot lanterns by wives leading pie-eyed husbands home from the tavern in the Middle Ages, is perhaps one of the more incongruous, but nonetheless brilliant, uses of a vegetable.

Connecticut Field *figs. 76b, 77*
Cucurbita pepo Pumpkin Group
SIZE: 10" long by 12" wide
WEIGHT: 14 pounds
RIND COLOR: intense yellow ocher
FLESH COLOR: transparent yellow ocher
COLOR RATING: 1
FIBER: unacceptable
BEST USES: jack-o'-lanterns, livestock feed
SYNONYMS: Big Tom, Canners Supreme, Common Field, Common Yellow, Connecticut Cornfield, Connecticut Yellow Field, Cow, Eastern Field, Georgia Field, Golden Field, Golden Marrow, Indiana Field, Jack O'Lantern, Lake Shore, Large Common Field, Large Connecticut Field, Large Connecticut Yellow Field, Large Cornfield, Large Field, Large Yellow, Mammoth Field, Michigan Mammoth, Pure Gold, Southern Field, Vermont Pumpkin, Western Field, Yankee, Yankee Field, Yellow Pie
SEED SOURCES: Allen, Bake, Berl, Burpee, Burr, But, Com, Cros, Deb, Down, Ers, Farm, Fed, Field, Fish, Ger, Green, Gurn, Heir, Hume, Jor, Jung, Kil, Lan, Lej, Loc, Mel, Mes, Mey, Mor, Old, Rev, Rohr, Ros, Sand, Sese, Shaf, Shum, Silv, Sky, Sow, Sto, Tom, Twi, Vesey, Vict, Wet, Will

One of the first varieties grown by American Colonists. As Fearing Burr Jr. (1863) observed, "The cultivation of the Common Yellow Field Pumpkin in this country is almost co-eval with its settlement."

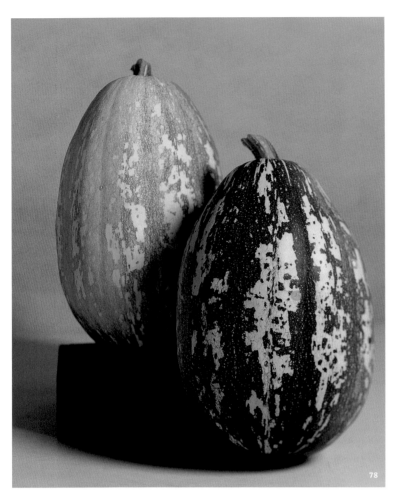

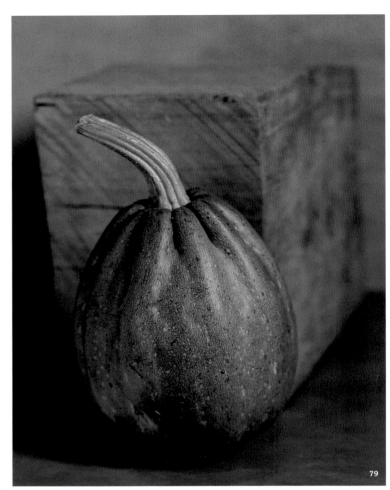

Pushchino *fig. 78*

Cucurbita pepo Pumpkin Group

SIZE: 11" long by 6½" wide

WEIGHT: 6 pounds

RIND COLORS: intense chrome yellow and deep golden yellow

FLESH COLOR: deep golden yellow

COLOR RATING: 3

FIBER: unacceptable

BEST USE: decorative

From Pushkino, Russia. Thin and tasteless.

Omaha *figs. 76f, 80*

Cucurbita pepo Pumpkin Group

SIZE: 7" long by 6" wide

WEIGHT: 3½ pounds

RIND COLOR: yellow ocher

FLESH COLOR: toned-down brilliant orange

COLOR RATING: 2

FIBER: unacceptable

DATE OF INTRODUCTION: 1924; Oscar H. Will & Co., Bismarck, North Dakota

BEST USE: decorative

SEED SOURCES: East, Sand

Very cute pumpkin but extremely stringy, coarse, and tasteless. Grown by the Omahas of Nebraska and collected by Dr. Melvin R. Gilmore. May have some precocious yellow traits.

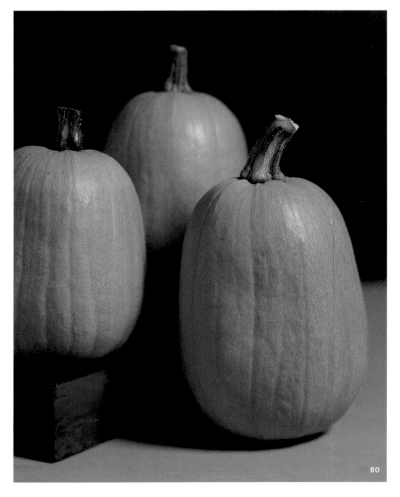

Oaxacan *fig. 79*

Cucurbita pepo Pumpkin Group
SIZE: 10" long by 8" wide
WEIGHT: 8 pounds
RIND COLOR: dense vermilion green
FLESH COLOR: subdued yellow ocher
COLOR RATING: 1
FIBER: acceptable
BEST USES: decorative, container

Found in a market in Oaxaca, Mexico. If you wanted to keep someone or something in a pumpkin shell, Oaxaca's lignified rind would be perfect. Barely edible. Plant produces a tremendous amount of foliage and few fruits, late in the season. Similar types pictured in seed catalogs in the 1890s under names such as Large Cheese and Nantucket Sugar. May be same as Huicha. Birds eat the flowers.

Tours *fig. 81*

Cucurbita pepo Pumpkin Group
SIZE: 14 1/2" long by 11" wide
WEIGHT: 17 pounds
RIND COLORS: dense golden yellow and intense olive green
FLESH COLOR: light golden yellow
COLOR RATING: 1
FIBER: unacceptable
DATE OF INTRODUCTION: circa 1863; Peter Henderson & Co., New York
BEST USES: decorative, jack-o'-lanterns
SYNONYMS: Citrouille de Touraine, French Tours, Large Touraine, Touraine

Tall, dark, and handsome field pumpkin with stripes. One of the largest-fruited *pepo*s, named for its place of origin in France and listed there by Vilmorin as early as 1856. Distinctive large oil seeds with wide margins once used in the preparation of sugar-coated pills and as a remedy for tapeworm.

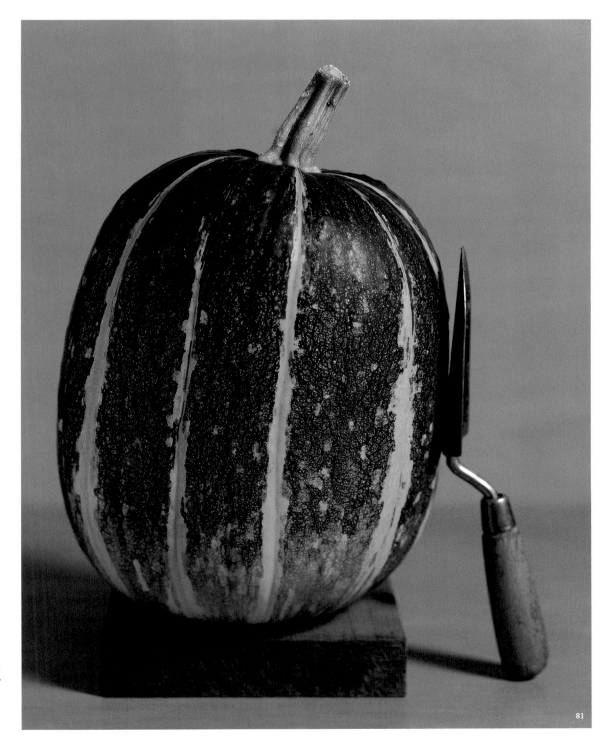

81

Mandan Yellow *fig. 82a*

Cucurbita pepo Pumpkin Group

SIZE: 4" long by 5" wide

WEIGHT: 2 pounds

RIND COLORS: medium chrome yellow with dense brilliant orange

FLESH COLOR: transparent brilliant orange

COLOR RATING: 2

FIBER: acceptable

BEST USE: decorative

SEED SOURCE: Sand

More attractive than Mandan. Mildly sweet, thin flesh. From Dan Zweiner.

Mandan *fig. 82b*

Cucurbita pepo Pumpkin Group

SIZE: 3³/4" long by 4¹/2" wide

WEIGHT: 12 ounces

RIND COLORS: deep vermilion green and thin vermilion green

FLESH COLOR: thin golden yellow

COLOR RATING: 1

FIBER: unacceptable

DATE OF INTRODUCTION: 1912; Oscar H. Will & Co., Bismarck, North Dakota

BEST USE: decorative

SYNONYMS: Early Mandan Squash, Mandan Strain No. 1

SEED SOURCES: East, Sand, Sed

Grown by the Mandans, who dried it in the fall for winter use. Oscar Will had good things to say about Mandan: It was the earliest squash in the world, the most valuable vine crop Will ever introduced, and was guaranteed to ripen almost anywhere–especially in the mountains of Montana. Nonetheless, I find it sorely lacking.

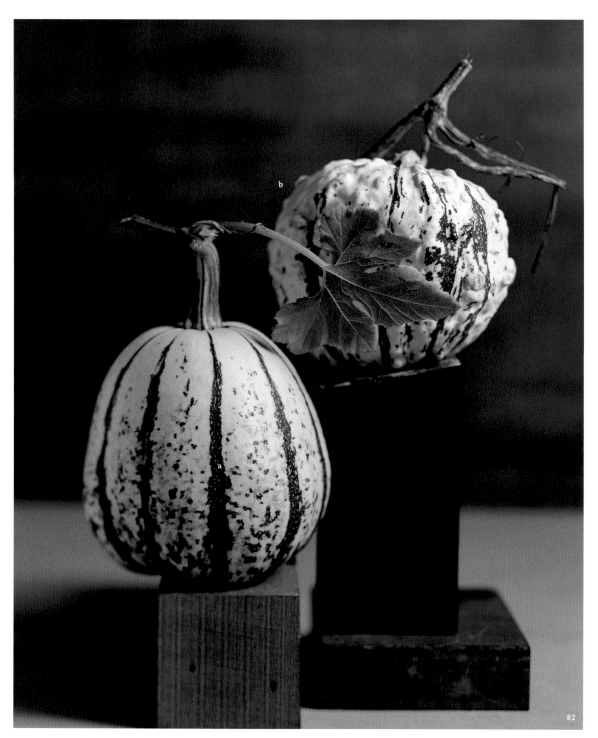

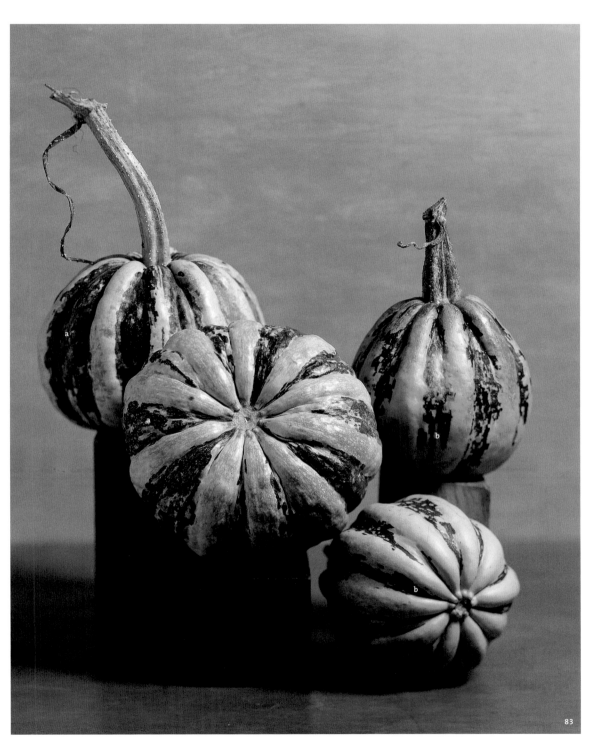

Mongogo du Guatemala
fig. 83a

Cucurbita pepo Pumpkin Group
SIZE: 5" long by 7" wide
WEIGHT: 4 pounds
RIND COLORS: medium golden yellow and wet vermilion green
FLESH COLOR: medium golden yellow
COLOR RATING: 2
FIBER: acceptable
BEST USE: decorative
SYNONYM: Southern Miner
SEED SOURCE: Sand

A ribbed Mexican pumpkin, very similar to Southern Miner but bigger and rounder. Fruit has a lignified rind, prickly stem, and dry, solid, lemony flesh. Can be consumed young as summer squash.

Southern Miner *fig. 83b*

Cucurbita pepo Pumpkin Group
SIZE: 4 1/2" long by 5 1/2" wide
WEIGHT: 2 pounds
RIND COLORS: dense golden yellow and wet vermilion green
FLESH COLOR: medium golden yellow
COLOR RATING: 2
FIBER: acceptable
BEST USE: decorative
SYNONYM: Mongogo du Guatemala
SEED SOURCE: Sand

Smaller than Mongogo du Guatemala and easier to cut. Very hard flesh. Ribbed Mexican pumpkin.

Ronde de Nice *fig. 84*

Cucurbita pepo Pumpkin Group

SIZE: 2" long by 2" wide

WEIGHT: 3 ounces

RIND COLOR: dense olive green

SYNONYMS: Eight Ball, Tondo Chiaro di Nizza

SEED SOURCES: Bake, Bou, Cook, Deat, Gour, Horus, Lej, Orn, Peace, Ren, Sand, Scheep, Sew, Sit, Soc, Syn, Tur, Ver

A summer pumpkin, not a Zucchini. Appears to be Vilmorin's *"Courge de Nice à fruit rond."* The Vilmorin-Andrieux catalog of 1902 says of it, *"en Provence, on la consomme demi-formée, au printemps"*; in Provence, it is eaten semiformed in spring. Can be grown as a fall pumpkin if space is at a premium, but the rind is not intensely orange. Gorgeous foliage plant with huge leaves mottled with silver.

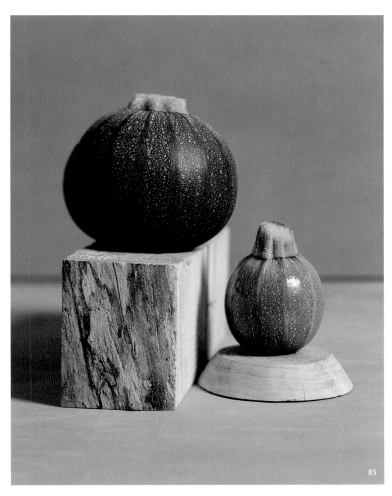

Tondo Scuro di Piacenza *fig. 85*

Cucurbita pepo Pumpkin Group
SIZE: 2" long by 2¹⁄₈" wide
WEIGHT: 3 ounces
RIND COLOR: deep olive green
SEED SOURCE: Bake

Similar to Ronde de Nice but darker green. Not a Zucchini. Harry Paris says Courgeron de Genève (Geneva Bush) as described by Vilmorin was the forerunner of Tondo Scuro di Piacenza, Tondo Chiaro di Toscana, and Ronde de Nice. Harvest when golf ball size.

Lemon *fig. 86*

Cucurbita pepo Pumpkin Group
SIZE: 3¹⁄₂" long by 2¹⁄₂" wide
WEIGHT: 8 ounces
RIND COLOR: medium chrome yellow
SEED SOURCES: Bake, Horus, Sky

Looks like a lemon, grows on a short vine, can be used as both summer and winter squash. Stems are bicolor—yellow near the fruit and green near the plant. Popular in Missouri. Good firm texture.

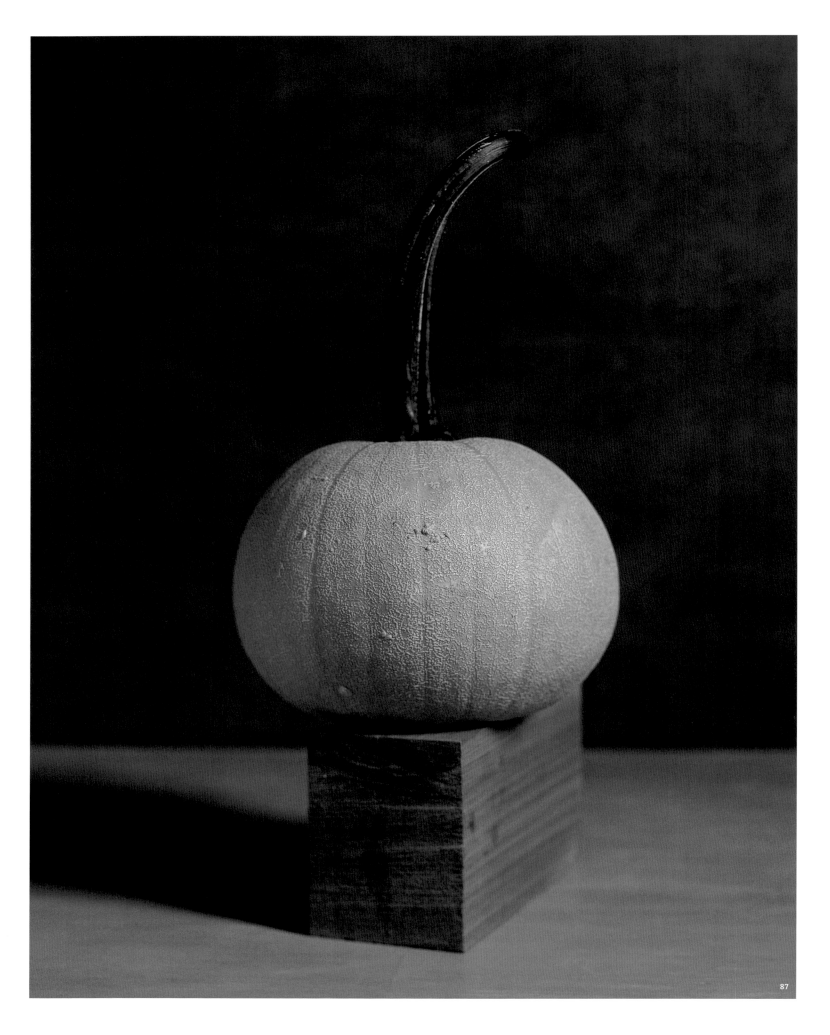

87

WINTER LUXURY PIE

WINTER LUXURY PIE IS MY FAVORITE orange pumpkin, and were she not the finest pie stock in the land, she still would be a knockout. That outrageous trophy fruit stalk is the perfect counterpoint to her modest and petite curvaceous form. She sits pretty, oh, so pretty, draped in exquisite lace. Though it breaks my heart to cut one open, I know the flavor will be as fabulous as her appearance.

Winter Luxury Pie was introduced to the general public in 1893 by Johnson & Stokes of Philadelphia. This special strain, apparently developed by an anonymous pumpkin farmer, was similar in many respects (even down to the occasional warts) to the still popular Sugar Pumpkin. Winter Luxury Pie, as introduced, was less prominently ribbed, yellower in color, and more finely netted than it is nowadays. By 1917, brothers Ray W. and Edward E. Gill, of the Gill Brothers Seed Company, Portland, Oregon, had bred Winter Luxury Pie up in size and changed the color back to orange orange from lemon yellow—and so it remains. Famed for breeding such wonders as the Golden Delicious squash on their own farms, Ray and Edward knew a thing or two about pumpkins: "Simply cook [Winter Luxury Pie] done and it is ready for use in making pies," requiring much less in the way of sugar and eggs than other varieties.

Winter Luxury Pie makes the smoothest and most velvety pumpkin pie I've ever had. When cut into a wedge on a plate, it holds its shape, color, and flavor long after the competition has keeled over and died. Ray and Edward didn't spell it out for you, so I will. Simply "cook it done" this way:

1. Winter Luxury Pie pumpkin should be baked whole, pierced for a few tiny vent holes, stem trimmed, at 350°F until it "slumps" and softens after an hour or so. If you wish, you can cut a lid, remove the gunk and seeds, and replace the lid loosely before baking (this method yields a drier pie).
2. The cooked pumpkin is hotter than hot potatoes: Be careful when you cut out or remove the lid. Seeds and strings, if left inside, come out easily. Take a large spoon and simply scoop the pumpkin out like ice cream. The flesh peels away from the desiccated rind without a shudder and leaves it flat.
3. Puree the flesh in a blender, adding liquid if needed. A 5-pound pumpkin yields approximately 2½ pounds or 4 cups of pulp, enough for two pies.
4. Insert your favorite pie recipe here.

Winter Luxury Pie *figs. 76e, 87*
Cucurbita pepo Pumpkin Group
SIZE: 6½" long by 8" wide
WEIGHT: 6½ pounds
RIND COLOR: toned-down golden ocher
FLESH COLOR: transparent golden ocher
COLOR RATING: 2
FIBER: none
DATE OF INTRODUCTION: 1893; Johnson & Stokes, Philadelphia
BEST USE: pie stock
SYNONYMS: Golden Russet, Improved Sugar, Livingston's Pie Squash, Luxury Pie, New Pie, New Winter Luxury Pie, Orange Winter Luxury, Queen, Queen Luxury, Standard Pie, Winter Queen
SEED SOURCES: Jung, Rev, Sand, Sed

Distinguished by its fine and close netting. Unequaled table quality: The proof is in the pie. Glenn and Linda Drowns like to stuff their Winter Luxury Pies with hamburger or beef stew, in the style of a carbonada criolla.

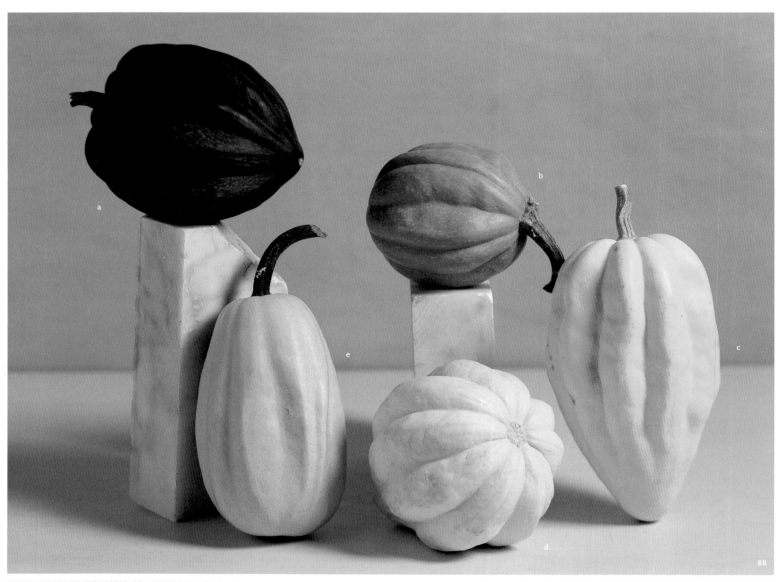

THERE IS MORE TO THE WORLD OF ACORNS THAN TABLE QUEEN: **a.** TABLE QUEEN; **b.** GILL'S GOLDEN PIPPIN; **c.** PAYDON'S HEIRLOOM (NOT FEATURED IN BOOK); **d.** THELMA SANDERS; **e.** FORDHOOK.

Acorn Group *Cucurbita pepo*

TABLE QUEEN

ACORN SQUASH IS MORE AMERICAN than apple pie and decidedly less fattening—even if halved, baked, and embellished with butter, brown sugar, honey, or maple syrup. Apples are a transplant from Eurasia, whereas the Acorns of *Cucurbita pepo* were domesticated by Native Americans from primitive indigenous forms. After 1492, the squashes made their way to Europe. Seventeenth-century European descriptions of the turbinate (top-shaped) macock or macocqwer squashes, grown by indigenes in Virginia, could apply to Table Queen. The illustration of *Pepo indicus minor angulosus* of Theodorus (1590), which surfaced later in Gerard (1597) under the name Cornered Indian Pompion, bears a striking resemblance to Table Queen, too.

Table Queen, introduced in 1913 by the Iowa Seed Company of Des Moines, was not the first Acorn squash to be entered into American commerce. It was preceded by the striped or bicolored Green Striped Bergen (circa 1841), Cocoanut Squash (circa 1869), and Golden Heart (1894). Other forms and colors existed in Europe but apparently were not commercialized. The heart-shaped Table Queen, diminutive, greenish black, and furrowed, sets the standard for Acorn squash today.

This Acorn squash arrived in Des Moines under mysterious circumstances. It could have come from as far away as Denmark or as near as North Dakota. A local lumberman supposedly brought the seed with him from Denmark, and in fact, the variety was known and grown under the name Danish Squash by Sestier Brothers and other market gardeners in the vicinity before its commercial debut. A similar variety was cultivated by the Arikara on the Fort Berthold Reservation, in North Dakota, although according to George F. Will, of the Oscar Will Seed Company of Bismarck, North Dakota, "It was not anywhere near equal to [Table Queen] in quality." A wily Wyoming seedsman tried to foist a new vegetable—a purported cross between Golden Bantam corn and Hubbard squash—on a gullible public in 1924; the vegetable was exposed as none other than our very own Table Queen.

This squash went through something of an adolescent identity crisis. Although it was introduced to the trade as Table Queen, the Iowa Seed Company later changed the name to Des Moines at the behest of the Des Moines Market Gardeners Association. When the Iowa Vegetable Growers Association tried to get in on the act in 1919 by urging a further name change to Des Moines Table Queen, the Iowa Seed Company balked: The name was "too long to be serviceable, so we have dropped the name Table Queen and now list it as Des Moines." The name Table Queen eventually prevailed, its association with Des Moines understood. As Henry Field, of the rival seed company that bears his name in Shenandoah, Iowa,

Table Queen *fig. 88a*
Cucurbita pepo Acorn Group
SIZE: $5^{1}/_{2}''$ long by $4^{1}/_{2}''$ wide
WEIGHT: 1 pound
RIND COLOR: deep vermilion green
FLESH COLOR: transparent golden ocher
COLOR RATING: 2
FIBER: acceptable
DATE OF INTRODUCTION: 1913; Iowa Seed Co., Des Moines
BEST USES: fall squash, table vegetable
SYNONYMS: Danish, Danish Table Queen, Des Moines, Des Moines Market, Individual, New Acorn, Queen Anne, Yama
SEED SOURCES: Allen, Bake, Bunt, Burpee, Burr, Com, Dan, Deb, Down, Fed, Field, Fox, Ger, Green, High, Hori, Jor, Jung, Kil, Lan, Loc, Mel, Mey, Mor, Nic, Rohr, Ros, Sese, Sew, Shaf, Silv, Sse, Vict, Wet, Will

Des Moines's claim to fame. Has countless descendants. Can be damaged by warm-temperature curing.

Gill's Golden Pippin *fig. 88b*
Cucurbita pepo Acorn Group
SIZE: $4^{1}/_{2}''$ long by $4''$ wide
WEIGHT: 1 pound
RIND COLOR: wet brilliant orange
FLESH COLOR: transparent golden ocher
COLOR RATING: 2
FIBER: acceptable
DATE OF INTRODUCTION: 1954; Gill Brothers Seed Co., Portland, Oregon
BEST USE: table vegetable
SYNONYM: Gill's Golden Table Queen

Similar to Gill's earlier Golden Table Queen. Becomes intensely orange in storage; not as regular and uniform as Table Queen, and a little harder to cut open, but tastes sweeter and nuttier. Prolific, vining.

acknowledged in 1923: The Table Queen is "well known and liked by people up there [in Des Moines] who are certainly good judges of squash."

The arrival of Table Queen was greeted with great enthusiasm partly because it tasted so great, and partly because its petite size and soft shell were welcome relief from the monstrous Hubbards and similar sorts. Table Queen started the rage for small, individual fall squashes. Henry Field summed it up in his singular way: "Table Queen is the finest little individual squash you ever saw, about as large as a quart cup . . . and makes a better pumpkin pie than a pumpkin." It's not surprising that, twenty years later, Table Queen reigned supreme in a bake-off with three dozen other squashes, having the highest total solids, soluble solids, sugars, and acids. Unfortunately, the Acorns flooding the market today—larger, more distinctly furrowed, and grown on bush or semibush plants and harvested underripe—are not nearly as good.

Thelma Sanders *figs. 88d, 89*

Cucurbita pepo Acorn Group
SIZE: 6" long by 4¾" wide
WEIGHT: 2 pounds
RIND COLOR: light raw umber
FLESH COLOR: light brilliant orange
COLOR RATING: 3
FIBER: none
DATE OF INTRODUCTION: 1988; Southern Exposure Seed Exchange
BEST USE: fall squash, table vegetable
SYNONYM: Thelma Sanders Sweet Potato
SEED SOURCES: Sese, Sse

The sweetest of the Acorn squashes in this collection. Chestnutty. Like a *moschata* in color. A family heirloom from Thelma Sanders in Adair County, Missouri. The seed was passed from neighbor Everett Pettit to Tom Knoche to Glenn Drowns. I would like to find the midget pea Ms. Sanders kept going, too.

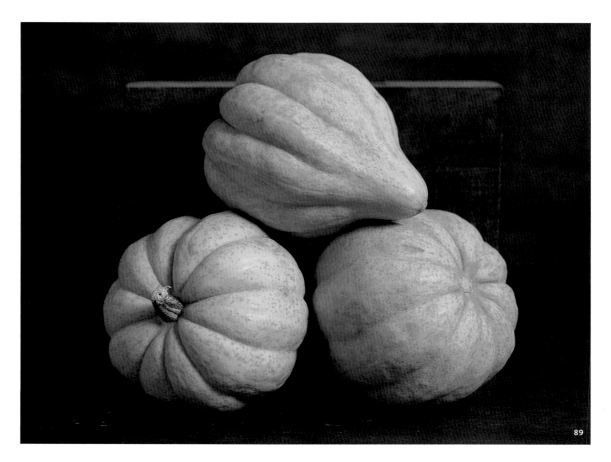

89

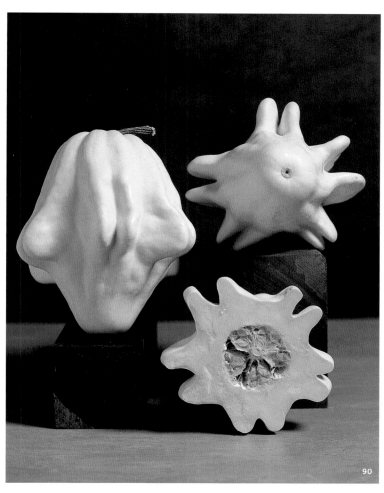

Pineapple *fig. 90*

Cucurbita pepo Acorn Group
SIZE: 7" long by 6¹/2" wide
WEIGHT: 3 pounds
RIND COLOR: toned-down chrome yellow
FLESH COLOR: transparent chrome yellow
COLOR RATING: 1
FIBER: acceptable
DATE OF INTRODUCTION: circa 1884; offered by Burpee, Gregory, and Landreth
BEST USE: decorative
SYNONYMS: Courge du Congo, Early Pineapple, White Pineapple, Yugoslavian Finger Fruit
SEED SOURCES: Bake, Hud, Rev

Extraordinary shape. Doesn't perform in the kitchen, but who cares? Always grown as a novelty. Not a Crown of Thorns, but perhaps derivative.

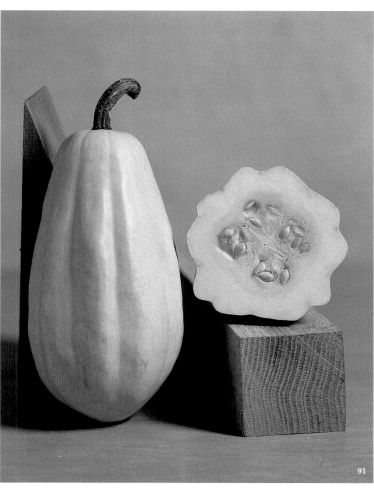

Fordhook *figs. 88e, 91*

Cucurbita pepo Acorn Group
SIZE: 7¹/2" long by 3¹/2" wide
WEIGHT: 1¹/2 pounds
RIND COLOR: light brilliant orange
FLESH COLOR: light golden yellow
COLOR RATING: 1
FIBER: acceptable
DATE OF INTRODUCTION: 1890; W. Atlee Burpee & Co., Philadelphia
BEST USE: table vegetable
SYNONYMS: Early Fordhook, Fordhook Marrow, Fordhook Oblong, Fordhook Vine
SEED SOURCES: Bake, Sse

Very handsome. Thought to be extinct. Fordhook group once consisted of Delicata, Fordhook Bush, Fordhook, Panama, Perfect Gem, Table Queen, and Winter Nut. Came from Chauncey P. Coy of Nebraska. Vining plant (bush type was introduced circa 1906); grainy but not coarse, mildly sweet. Long shelf life. Never very popular.

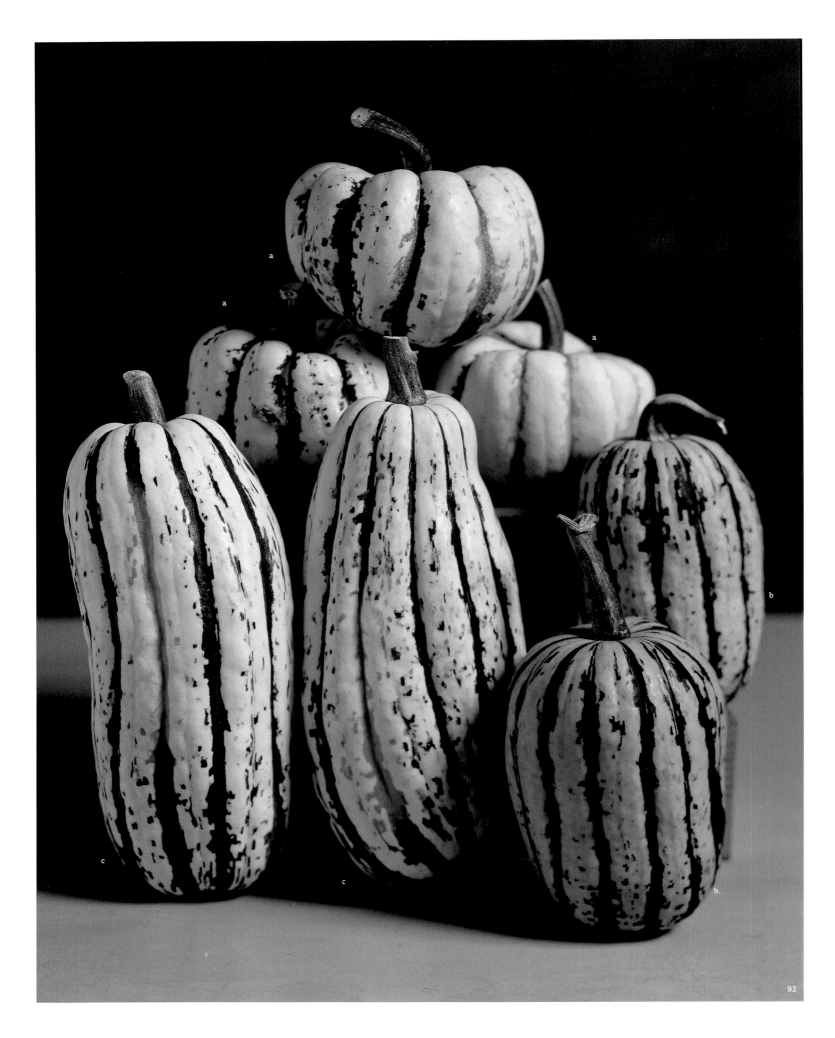

92

DELICATA

RIGHT OR WRONG, I SEE Delicata, Sweet Dumpling, and Sugar Loaf as a family. Just look at them and you'll know what I'm talking about: With furrows, green stripes, and a cream or brownish ground color, they share the same good looks and surely the same genes. We do know that Sugar Loaf is child to Delicata. All three are similar in looks and taste to the rounded, furrowed, and bicolor Cocoanut squash, offered for sale as "more ornamental for the parlor than the most beautiful of gourds" by James J. H. Gregory and Sons as early as 1875. The copy and illustration in Gregory's 1894 catalog bear this out: "The color is an admixture of cream and orange, while the bottom, over a circle of two or three inches in diameter, is of a rich grass green."

According to Harry Paris, at the Newe Ya'ar Research Center in Israel, what we have here is a case of reversed striping. Light stripes are usually narrow bands and are positioned over and immediately adjunct to the ten main carpellary (vascular) vein tracts, in the furrows. In Delicata, the dark stripes reverse that position, with narrow dark stripes occurring in the furrows. This phenomenon apparently has a relatively simple genetic basis.

Most *Cucurbita pepo*s are long on texture and short on flavor, but not Delicatas. Baked whole—or halved and stuffed with sweetmeats or savories—they are a *"delikat essen,"* or "good eat." And like Cocoanut, which itself is quite similar to the modern cultivar Carnival, the flesh is fine-grained, sweet, and dense. The Delicatas, thin-skinned fall squashes with a shorter shelf life than most winter squashes, are perfect for the Thanksgiving table—as centerpiece or vegetable entrée.

Delicata *fig. 92c*
Cucurbita pepo Acorn Group
SIZE: 8³/4" long by 4¹/2" wide
WEIGHT: 2¹/2 pounds
RIND COLORS: subdued cadmium orange and deep permanent olive green
FLESH COLOR: transparent golden ocher
COLOR RATING: 2
FIBER: none
DATE OF INTRODUCTION: 1894; Peter Henderson & Co., New York
BEST USES: fall squash, table vegetable
SYNONYMS: Bohemian, Henderson's Delicata, Sweet Potato, Ward's Individual
SEED SOURCES: Allen, Bake, Berl, Bou, Burpee, Burr, Cook, Deb, Ers, Ger, Green, Har, High, Hume, Irish, Jor, Jung, Lan, Loc, Mel, Mor, Orn, Peace, Pine, Plan, Rev, Rohr, Sese, Sew, Shum, Soc, Sou, Sow, Sto, Tur, Twi, Ver

Pleasantly sweet and starchy. Popular individual squash. Tons of seeds.

FIGURE 92: **a.** SWEET DUMPLING; **b.** SUGAR LOAF; **c.** DELICATA.

Sweet Dumpling *figs. 92a, 93*

Cucurbita pepo Acorn Group

SIZE: 3" long by 4" wide

WEIGHT: 1 pound

RIND COLORS: medium chrome yellow and light brilliant orange

FLESH COLOR: transparent golden ocher

COLOR RATING: 2

FIBER: none

DATE OF INTRODUCTION: 1976; Sakata Seed Corp., Yokohama

BEST USE: table vegetable

SYNONYM: Vegetable Gourd

SEED SOURCES: Bake, Berl, Bunt, Burpee, Ers, Fed, Field, Ger, Har, Hume, John, Jor, Lej, Loc, Mor, Pine, Rev, Ros, Sew, Shaf, Shum, Soc, Sow, Sto, Syn, Ter, Ver, Vesey

A dead ringer for a squash illustrated in the sixteenth century. Didn't go over well as Vegetable Gourd when first introduced in the U.S. but now very popular.

Sugar Loaf *figs. 92b, 94*

Cucurbita pepo Acorn Group

SIZE: 4½" long by 3¾" wide

WEIGHT: 1 pound

RIND COLORS: toned-down yellow ocher and deep permanent olive green

FLESH COLOR: transparent golden ocher

COLOR RATING: 2

FIBER: none

DATE OF INTRODUCTION: 1990; bred by Dr. James Baggett, Oregon State University, Corvallis

BEST USE: table vegetable

SYNONYM: Tan Delicata

SEED SOURCES: Bake, Burr, Heir, Jor, Nic, Pete, Sky

As sweet as true loaf sugar. Developed from a rind color mutant of Delicata found on an OSU farm in 1978. Has tan rather than cream background color.

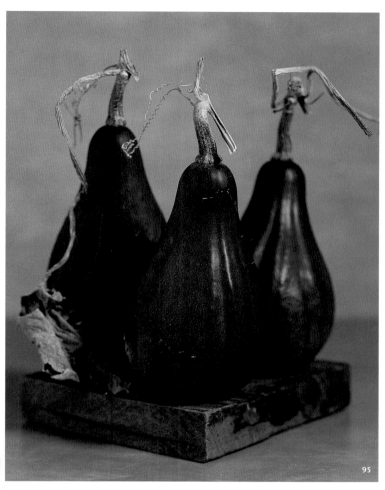

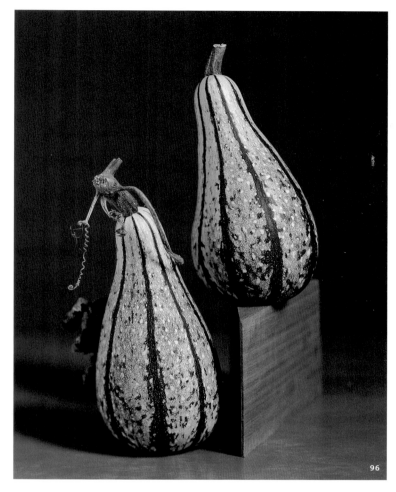

Chestnut Acorn *figs. 72i, 95*

Cucurbita pepo Acorn Group

SIZE: 8¹/₂" long by 4" wide

WEIGHT: 2 pounds

RIND COLOR: deep vermilion green

FLESH COLOR: transparent yellow ocher

COLOR RATING: 1

FIBER: acceptable

BEST USE: decorative

From Tom Knoche, Sardinia, Ohio. Elongated Acorn. No discernible sugar.

Bakery's *fig. 96*

Cucurbita pepo Acorn Group

SIZE: 8" long by 4" wide

WEIGHT: 1¹/₂ pounds

RIND COLORS: light yellow ocher and wet vermilion green

FLESH COLOR: subdued yellow ocher

COLOR RATING: 1

FIBER: acceptable

DATE OF INTRODUCTION: Emma Adkins's family heirloom donated to Seed Savers Exchange in 1994

BEST USE: decorative

SEED SOURCE: Horus

Looks like confetti effervescing. Similar in shape to Chestnut Acorn but smooth rinded. Only a vessel. From Emma Adkins, Van Lear, Kentucky; grown by her mother, Anna Wells, for as long as she can remember. Emma wrote: "I have never seen these in seed catalogs. I don't know where my mother got the seed. They are made like a bowling pin, yellow and green striped. Not very sweet. We always precooked them and then sprinkled sugar on them and baked them whole."

JACK BE LITTLE

THERE'S SOMETHING INNATELY SIMPLE and appealing about Jack Be Little. This palm-size pipsqueak is undeniably fanciful. My daughter adores it—as I do—because it seems to ask the question "Honey, who shrunk the pumpkin?" Perhaps we'd be better off thinking of Jack Be Little—JBL to its friends—not so much as a scaled-down version of Cinderella's coach, but as the Atlantic Giant of the dollhouse.

But don't be lulled into thinking JBL is a pumpkin, regardless of what promoters might say. Cucurbitologist Harry Paris says with conviction: "There is little doubt in my mind that Jack Be Little is an Acorn squash, even though the overall profile is similar to a flat Pumpkin or even a Scallop squash." The telltale sign is its ten deep radial furrows—in conjunction with its small size. By contrast, the pumpkins of the United States and Canada are "groovy" (with twenty grooves) but "shallow." Deep in my heart I know Harry's right: JBL *tastes* like an Acorn. If you want some comfort food along the lines of a flaky baked potato—with a bit of whimsy thrown in—bake one whole, cut a lid and scoop out the seeds, drop in some creamy butter and maple syrup, and you've got a splendid breakfast or after-school snack.

Over the centuries, many *Cucurbita pepo* forms have become obsolete and have disappeared, seemingly forever. Yet reincarnation and rediscovery happen. Harry Paris conjectures that Jack Be Little is one of those long-lost cultivars, or at least a cleaned-up version of one. JBL does have its precedents in some of the seventeenth-century botanical herbals. It is also quite similar in many respects to the old Perfect Gem squash pictured in *The Vegetables of New York*.

Jack Be Little surfaced suddenly and unheralded in the 1980s. "It was really quite strange," according to Larry Hollar of the Hollar Seed Company in Rocky Ford, Colorado. Nothing like it had been seen anywhere in Hollar's forty-five-county radius, until he received a phone call one day from Earl May Seed about a gardener in their office who had a cute little "pumpkin." With alacrity and prescience, Hollar bought the rights to it along with a bushel of fruit; he cleaned it up and removed the rogues so the seed would be true to type, and introduced Jack Be Little to the public in 1986—a year ahead of Harris Moran's introduction of the look-alike Munchkin. Hollar believes his gardener may have gotten his seed, not from China or Germany, as some have speculated, but from an Indiana grower who served as a wholesaler to the floral industry

One hundred fifty years ago, hefty pumpkins that could feed an army—or at least a large family—were the norm; small squashes, such as Apple, were left by the wayside. Today, small is back with a vengeance. The 1970s and 1980s saw the introduction of pumpkin cultivars that include Little Boo and Baby Pam—tinier

Jack Be Little *figs. 76d, 97*
Cucurbita pepo Acorn Group
SIZE: 2¼" long by 3¾" wide
WEIGHT: 9 ounces
RIND COLOR: intense brilliant orange
FLESH COLOR: toned-down brilliant orange
COLOR RATING: 2
FIBER: none
DATE OF INTRODUCTION: 1987; Hollar Seed Company, Rocky Ford, Colorado
BEST USE: decorative
SYNONYMS: Chinese Miniature, Little Sweetie, Munchkin, Sweetie Pie
SEED SOURCES: Allen, Berl, Burg, Burpee, Burr, Clif, Cook, Deb, Ers, Farm, Fed, Field, Fox, Gurn, Hume, Irish, John, Jor, Jung, Lan, Lej, Loc, Mel, Mes, Mey, Mor, Nic, Orn, Pine, Rohr, Ros, Sew, Shaf, Silv, Sto, Ter, Twi, Vesey, Wet, Will

Not strictly ornamental. Baby Boo (PVP) is the white version bred by John Jaunsen. Prolific.

than a toaster, and getting tinier. Soon even the classic Small Sugar, weighing in at five or six pounds, seemed oversized. Larry Hollar, with Jack Be Little, and Rob Johnston Jr. of Johnny's, with Baby Bear (1992), led the way. Welcome to the age of minis. According to Rob Johnston, as the trend in home fall decoration picked up steam in the 1980s, so, too, did pumpkin acreage. Now the use of "living products" for ornament is well accepted. As Harry Paris says, we have always derived an essential part of our holiday cheer from *Cucurbita pepo*. If pumpkins and squashes–big and small–are chic, then I'm in my glory. . . .

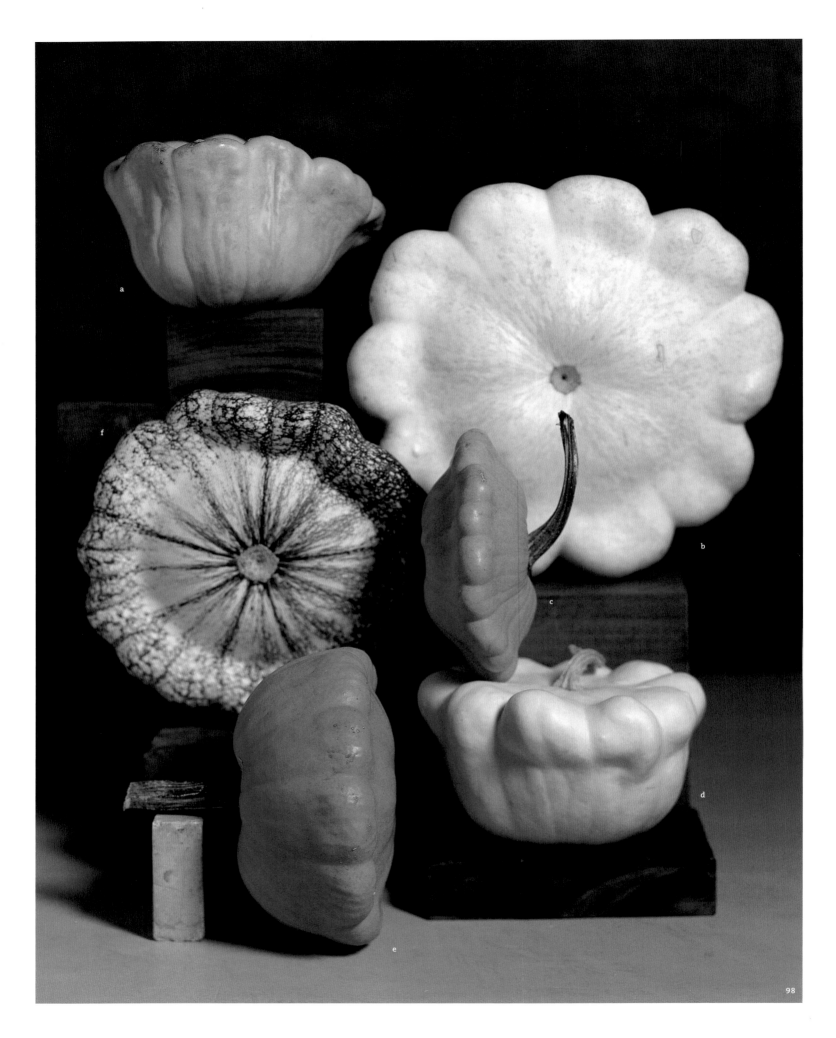

98

Scallop Group *Cucurbita pepo*

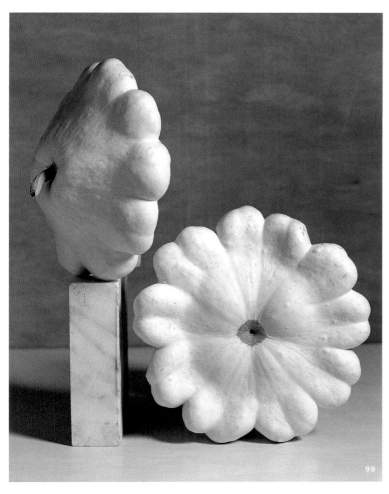

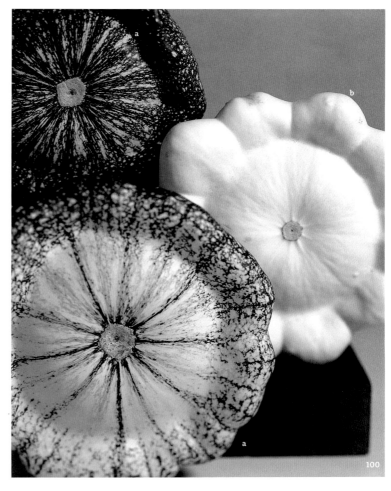

Patisson Orange *fig. 98c*

Cucurbita pepo Scallop Group

SIZE: 2¹/₂" long by 6" wide

WEIGHT: 1¹/₄ pounds

RIND COLOR: medium lemon yellow

SYNONYM: Yellow Scallop

SEED SOURCES: Deb, Horus, Lan, Shaf

Charming. Vividly orange.

FIGURE 98, PATTYPANS, DECORATIVE BUT
TOO OLD TO BE DELICIOUS: a. GELBER
ENGLISCHER CUSTARD; b. MAMMOTH
WHITE BUSH SCALLOP; c. PATISSON ORANGE;
d. WHITE BUSH SCALLOP; e. YELLOW BUSH
SCALLOP; f. RUSSIAN PATTYPAN.

White Bush Scallop

figs. 98d, 99, 100b

Cucurbita pepo Scallop Group

SIZE: 1¹/₂" long by 2¹/₄" wide

WEIGHT: 2 ounces

RIND COLOR: transparent olive green

SYNONYMS: Cymbling, Dwarf White
Bush, Earliest White Bush, Early
Bush Scallop, Jersey White Bush,
Silver Custard, White Patty Pan

SEED SOURCES: Bake, Ers, Field, Fish,
Horus, Hud, Hume, Lej, Shaf,
Wet, Will

Thought by Fearing Burr Jr. to be a
subvariety of Yellow Bush Scallop.
Matures earlier. Can be used as a
trap crop among melons because
cucumber beetles prefer squashes.

Russian Pattypan *figs. 98f, 100a*

Cucurbita pepo Scallop Group

SIZE: 3" long by 6¹/₄" wide

WEIGHT: 2 pounds

RIND COLORS: wet olive green and
thin olive green

SYNONYMS: Improved Variegated
Custard Marrow, Patisson Panaché,
Variegated Patty Pan

SEED SOURCE: Bake

From Alzbeta Kovacova-Pecarova,
Slovakia. May be the Variegated
Bush Scalloped documented in
The Vegetables of New York.

Mammoth White Bush Scallop *fig. 98b*

Cucurbita pepo Scallop Group

SIZE: 10" wide by 4¹/₂" long

WEIGHT: 5 ounces (dried)

RIND COLOR: transparent olive green

DATE OF INTRODUCTION: 1891; A. W.
Livingston's Sons, Columbus, Ohio

SYNONYMS: Early White Bush, Giant
White Bush, Large Patty Pan

SEED SOURCES: Bake, Bou, Ers, Field,
Fish, Heir, Horus, Hud, Hum, Lej,
Shaf, Sto, Wet, Will

More vigorous and distinctly larger
than White Bush Scallop. Popular
100 years ago.

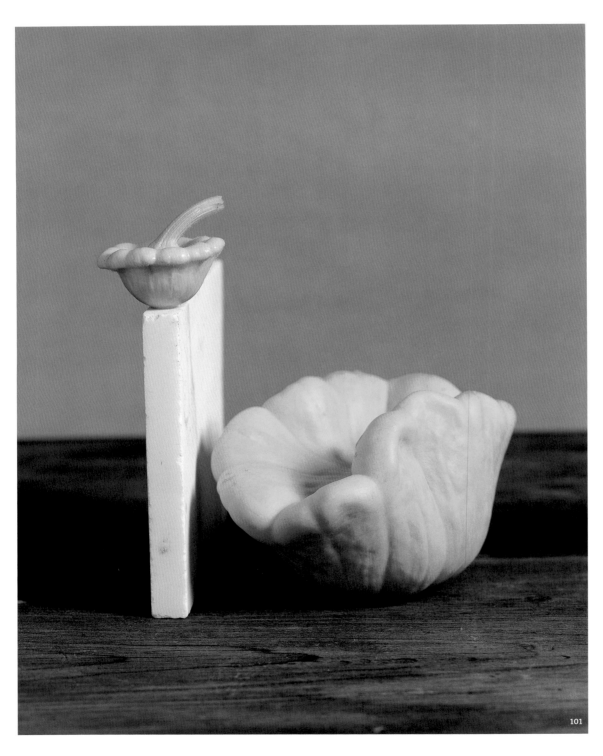

101

Gelber Englischer Custard *figs. 98a, 101*

Cucurbita pepo Scallop Group

SIZE: 4" long by 2¼" wide
WEIGHT: 7 ounces
RIND COLOR: medium lemon yellow

My favorite Pattypan. Outrageous shape. From the Institute for Plant Genetics and Crop Plant Research, Gatersleben, Germany. Similar to Green Custard. Dries beautifully.

Yellow Bush Scallop *fig. 98e*

Cucurbita pepo Scallop Group

SIZE: 1½" long by 2½" wide
WEIGHT: 2 ounces
RIND COLOR: medium lemon yellow
SYNONYMS: Custard Marrow, Custard Vegetable Marrow, Early Golden Bush, Golden Scallop, Yellow Elector's Cap, Yellow Patty Pan
SEED SOURCES: Deb, Heir, Horus, Lan, Lej, Sand, Shaf, Shum

Companion to White Bush Scallop but never as highly regarded. One of my favorite pattypans.

Benning's Green Tint *fig. 102a*

Cucurbita pepo Scallop Group

SIZE: 2¼" long by 3⅞" wide
WEIGHT: 8 ounces
RIND COLOR: subdued olive green
DATE OF INTRODUCTION: 1914; listed by F. W. Bolgiano & Co., Washington, DC
SYNONYMS: Farr's Benning White Bush, Farr's White Bush, Green Tinted White Bush, White Bush
SEED SOURCES: Bake, Clif, Fed, Fox, Horus, Jor, Lan, Loc, Mey, Orn, Pete, Sand, Sese, Shaf, Syn, Ter, Und, Wet

Green tinted in its youth, but turns creamy white later. Developed by Charles N. Farr. Hints of sweetness; gets seedy fast.

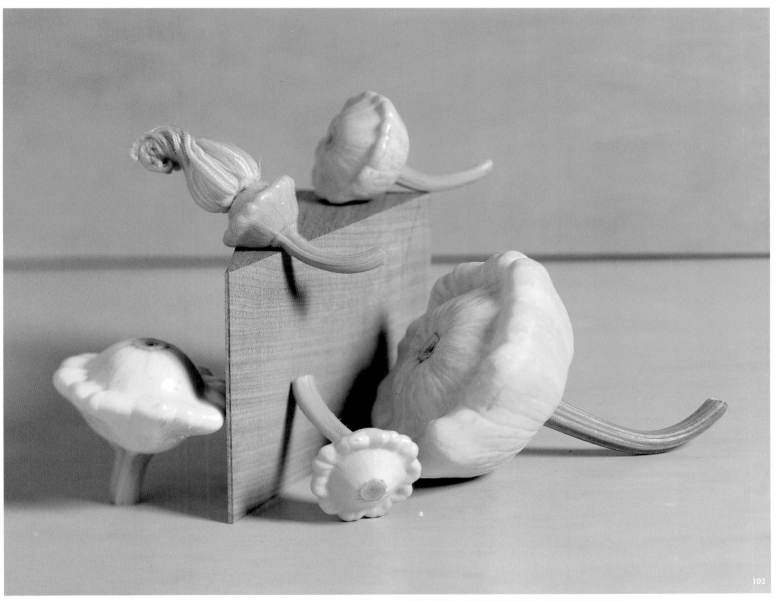

ASSORTED PATTYPANS AS TENDER YOUNG THINGS: **a.** BENNING'S GREEN TINT ALWAYS STANDS OUT IN A CROWD (ESPECIALLY IF THE OTHERS ARE WHITE).

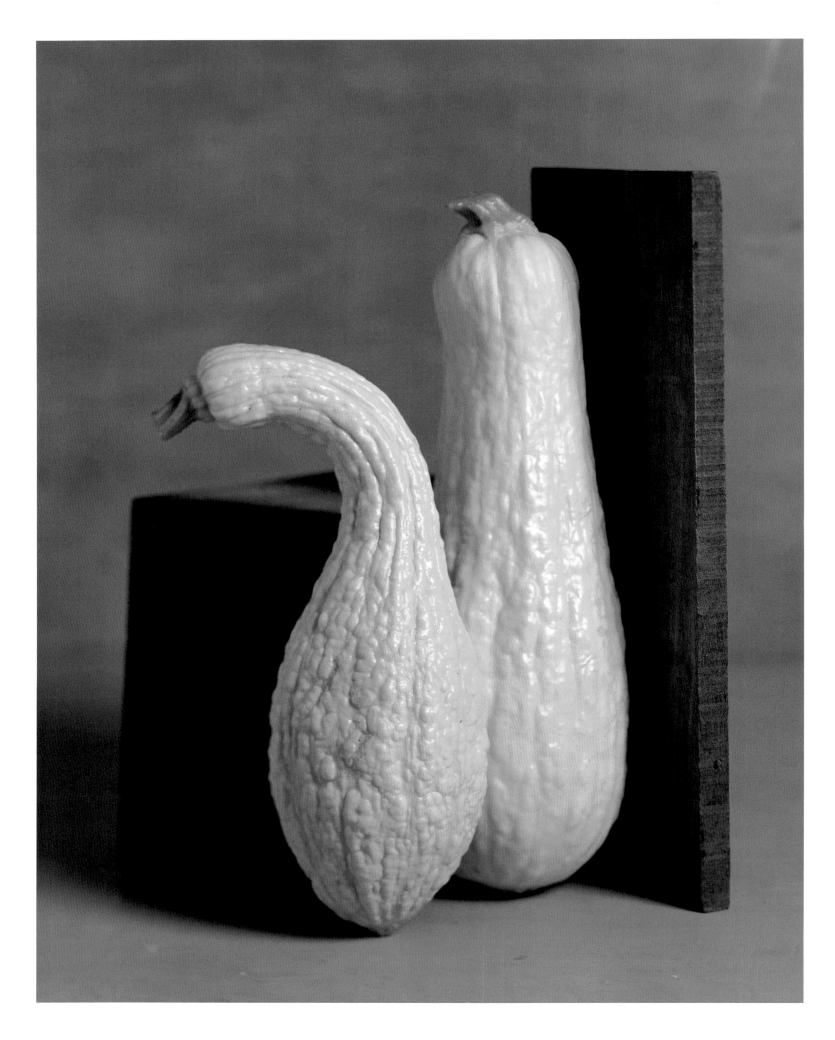

Crookneck and Straightneck Groups *Cucurbita pepo*

CROOKED OR STRAIGHT, these distinctive *Cucurbita pepo*s have much to recommend them. Unique among their edible-fruited squash peers, the Crookneck and Straightneck groups both carry the warted rind (Hr, Wt) and yellow immature fruit color (Y) genes (although Straightnecks are generally less warty and intensely orange). That's what gives them that razzle-dazzle corrugated look at maturity, which—at the risk of sounding vulgar—says "Cheez Doodles" (Crookneck) and "buttered popcorn" (Straightneck) to me.

Crooknecks and Straightnecks are a peculiarly North American institution, virtually unknown outside our borders. Some might say they are just plain peculiar: Outlanders look down their noses and hold these squashes at arm's length. I find them quite fetching. So, too, did millions of Americans, especially southerners, in the days before Zucchini ruled the roost. They were the sine qua non of summer squash.

Native North Americans domesticated the Crookneck long before the Pilgrims stepped ashore. Its highest and best uses were as tender young squashes and as warty old rattles or seedstores. The literature is rife with speculation about which explorers, Colonists, or botanists might have first caught sight of these squashes. Early written accounts are vague and European botanical illustrations were few and far between. It's clear, however, despite the existence of incipient Straightneck forms illustrated as early as 1770, that Crookneck gave birth to Straightneck in America in the late 1890s.

Dr. Harry Paris, a dominant figure in the field of *Cucurbita pepo* crop history and evolution, compared groups using DNA markers. Because the two horticultural groups differ in fruit shape, color, and wartiness, he strongly suspected that Straightneck was not derived by simple mutation and/or selection as had previously been thought, but was derived from Crookneck by outcrossing with an unknown parent. As Harry recently explained, "There was a big surprise in the results. The data suggest that it was an Acorn that did the cuckolding. The extant Straightneck cultivars are a result of this chance cross."

SUMMER: SUMMER CROOKNECK AND EARLY PROLIFIC STRAIGHTNECK.

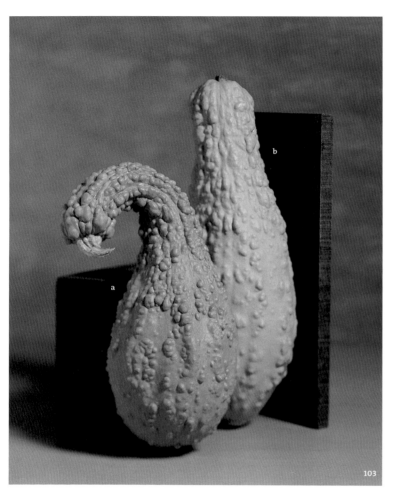

103

Summer Crookneck

figs. 72g, 103a

Cucurbita pepo Crookneck Group

SIZE: 11 1/2" long by 3 1/2" wide

WEIGHT: 1 1/2 pounds

RIND COLOR: toned-down cadmium yellow

FLESH COLOR: transparent cadmium yellow

SEED SOURCES: Allen, Bake, Bou, Bunt, Burpee, Burr, But, Com, Cros, Deb, Down, East, Eden, Ers, Fed, Field, Green, Heir, High, Irish, John, Jor, Lan, Loc, Mel, Mey, Mor, Old, Orn, Peace, Pete, Red, Rohr, Ros, Sed, Set, Shaf, Shum, Sky, Soc, Sop, Sou, Sow, Sse, Ter, Tur, Ver, Vict, Wet, Will

Listed in the earliest seed catalogs. Mentioned in a letter from T. Matlock to Thomas Jefferson in 1807: "The long crooked and warted squash–a native of New Jersey, which the Cooper family have preserved and cultivated for near a century. It is our best squash." I don't think any hybrid can improve on this. Cucumber beetles are supposedly less fond of Summer Crooknecks than Zucchinis. Be careful not to break young necks. Orange fleshed at maturity.

Early Prolific Straightneck *figs. 72k. 103b*

Cucurbita pepo Straightneck Group

SIZE: 5" long by 1 1/2" wide

WEIGHT: 4 ounces

RIND COLOR: dense golden yellow

DATE OF INTRODUCTION: 1938 All America Selection (AAS); Ferry-Morse Seed Co., Detroit

SYNONYM: Straightneck

SEED SOURCES: Allen, Bake, Berl, Bunt, Burpee, Burr, But, Com, Cros, Deb Ers, Field, Fish, Ger, Gurn, High, Irish, Jor, Kil, Lan, Loc, Mel, Mey, Mor, Rohr, Ros, Sand, Sese, Shaf, Shum, Sou, Vict, Wet

Brought to you by the makers of White Summer Crookneck (1895). New and improved, fewer warts, shorter straighter necks. Said to be derived from Summer Crookneck. The peak of perfection in summer squash according to Ferry-Morse.

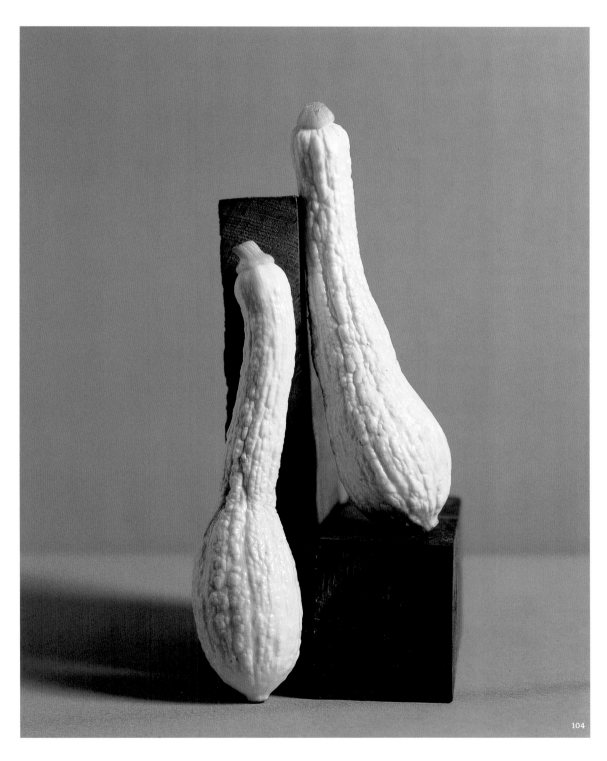

Bianco Friulano *fig. 104*

Cucurbita pepo Crookneck Group

SIZE: 11¹⁄₂" long

WEIGHT: 9 ounces

RIND COLOR: transparent chrome yellow

SYNONYM: White Friulano

Probably not the White Summer Crookneck (introduced by D. M. Ferry in 1895) reincarnated, since this one is more yellow. Has lighter stems and lighter-yellow fruits than other Crooknecks and does not turn intensely orange at maturity. Seems longer and thinner than most Crooknecks. Some fruits have broad, slightly more intense stripes–perhaps the result of outcrossing with a Cocozelle. These fruits did not "crook," for some reason.

104

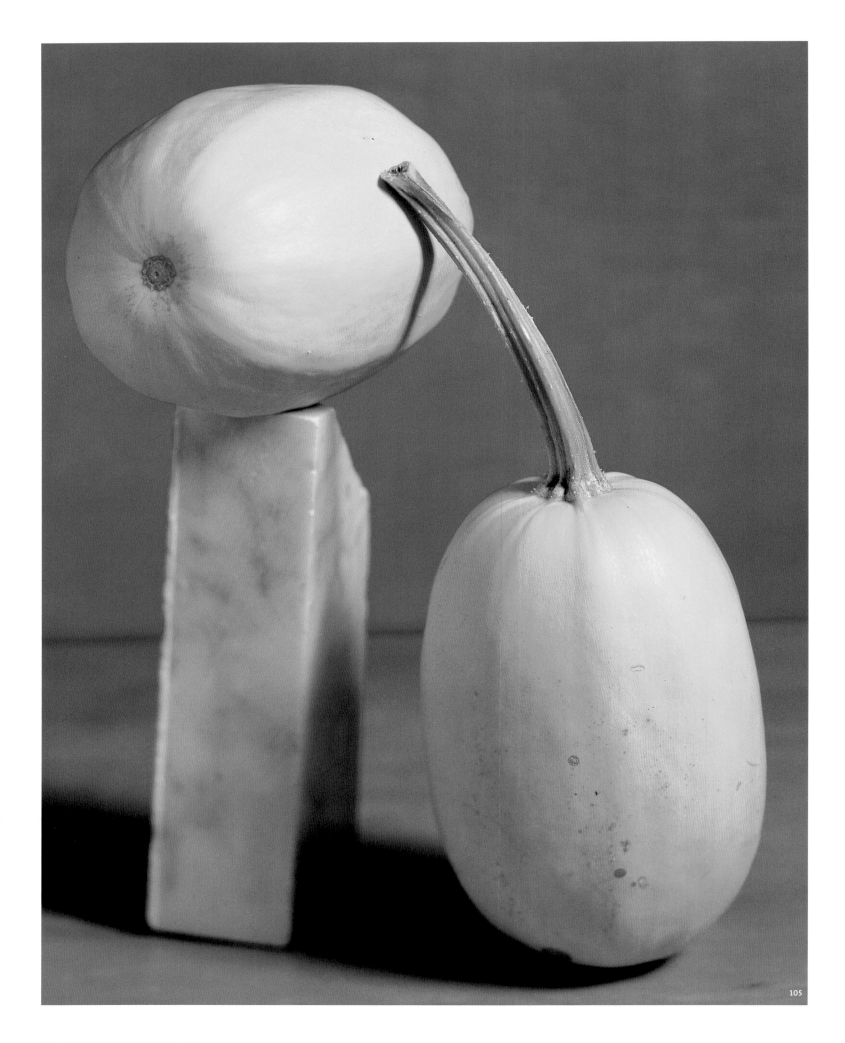

Vegetable Marrow *Cucurbita pepo*

VEGETABLE SPAGHETTI

WHAT KID, OR ADULT FOR THAT MATTER, hasn't dreamed about growing her own spaghetti and meatballs? I have no remedy for the meatballs, but I can help with the spaghetti: Vegetable Spaghetti is the closest thing to pasta since durum wheat. Until this squash came along in the 1930s and turned its stringiness into a virtue, vegetable marrows had never been popular in North America. Vegetable Spaghetti defies convention. It is sweet golden fiber, and we are lapping it up—with butter and cheese, pesto, alfredo, marinara, and, yes, meatballs. If the mere thought of eating squash has ever turned your stomach, if as a parent you've failed to find a vegetable your child will eat, then Vegetable Spaghetti is for you.

When this cultivar made its American debut, the squash-eating public was not alone in its fascination—and perplexity. The J. C. Robinson Seed Company of Waterloo, Nebraska, thought in 1937 that the new Spaghetti or Golden Macaroni was "probably not a true squash" but rather belonged to the lesser-known domesticated species *Cucurbita ficifolia*. A very educated guess, since mature *ficifolia* are the most fibrous and blandest squashes. In fact, the Aztecs used their boiled strands to make a special dish called angel's hair.

The short, squat, and cylindrical Spaghetti rightly belongs with the Vegetable Marrows (not the Cocozelles or Zucchinis), so popular in England over the last two hundred years. These marrows, as tender young things, have much to recommend them, but unhappily, their flesh quickly becomes unpleasant with advancing age. Spaghetti, by contrast, doesn't get older; it just gets better or stringier, a trait apparently conferred by a single gene, *fl*. The English, not known until recently for their culinary prowess, might be advised to jettison their marrow chutneys, gingered jams, and casseroles and confine their overgrown marrows to exhibition.

Vegetable Spaghetti originated in China. It was first commercialized by the Sakata Seed Company of Yokohama, Japan, in 1934 and brought to America by Burpee two years later. According to Mr. Minoru Kanda of the the Kanda Seed Company in Japan, Spaghetti squash or Somen Nankin was introduced to Japan from China in 1921 by the Aichi Prefectural Agricultural Research Station. Spaghetti marrows were apparently commonplace in northern Manchuria. Photos taken on August 29, 1925, by Mr. P. H. Dorsett of the U.S.D.A. during field explorations in this area are especially telling: They depict a woman, with a baby by her side, cutting long, thin strings in spirals from a vegetable marrow pierced by a pointed rod mounted on a sawhorse. The spaghettilike strands were gathered in bowls and hung on racks to dry in the sun, then plaited and stored for winter use, a common practice in the Manchurian countryside.

Vegetable Spaghetti *fig. 105*
Cucurbita pepo Vegetable Marrow Group
SIZE: 8" long by 5" wide
WEIGHT: 4 pounds
RIND COLOR: dense chrome yellow
FLESH COLOR: toned-down chrome yellow
COLOR RATING: 1
FIBER: acceptable
DATE OF INTRODUCTION: 1934; Sakata Seed Corp., Yokohama; introduced to North America by W. Atlee Burpee & Co. in 1936.
BEST USE: table vegetable
SYNONYMS: Golden Macaroni, Spaghetti Marrow, Spaghetti Squash
SEED SOURCES: Allen, Bake, Berl, Bou, Bunt, Burpee, Burr, But, Clif, Com, Dan, Dea, Deb, Ear, Ers, Fed, Field, Fish, Fox, Ger, Green, Gurn, Har, Heir, Hum, John, Jor, Kil, Kit, Lan, Lej, Loc, Mel, Mey, Mor, Nic, Pine, Red, Rev, Rohr, Ros, Sese, Set, Shaf, Shum, Silv, Sky, Soc, Sto, Ter, Tur, Twi, Vesey, Vict, Wet, Will

Self-shredding flesh is a spaghetti substitute. Harvest when the rind is bright yellow. F1 hybrids include Hasta-La-Pasta, Orangetti, and Stripetti. Dr. Harry Paris created Orangetti (introduced in 1986) by crossing Vegetable Spaghetti with Oved Shifriss's Precocious Fordhook Zucchini. Orangetti has intense orange flesh and a very high carotenoid content.

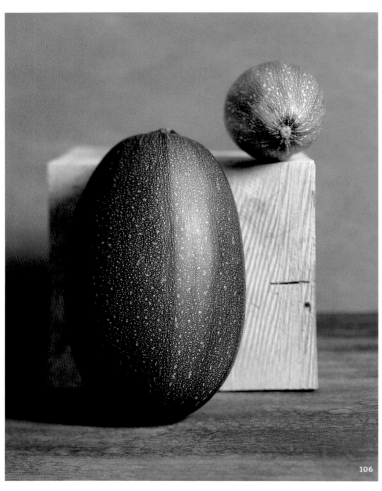

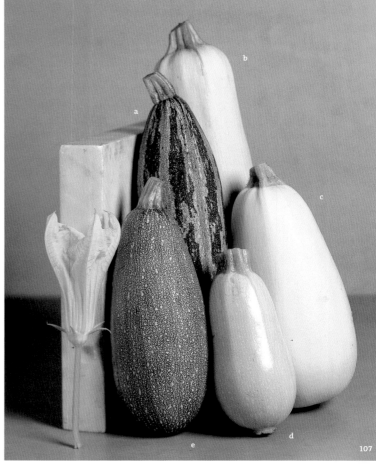

Bolognese *figs. 106, 107e*

Cucurbita pepo Vegetable Marrow Group

SIZE: 4" long by 2½" wide

WEIGHT: 6 ounces

RIND COLOR: deep vermilion green

SYNONYM: Faenza Gardener

SEED SOURCE: Sit

Unusual oval shape. Comes in various shades of green.

Caserta *fig. 107a*

Cucurbita pepo Vegetable Marrow Group

SIZE: 4" long by 1¼" wide

WEIGHT: 2 ounces

RIND COLORS: light olive green and dense olive green

DATE OF INTRODUCTION: 1949 All America Selection (AAS); W. H. Woodruff & Sons, Toledo, Ohio

SEED SOURCES: Loc, Rohr, Ros, Sand, Shaf, Sky, Soc

Developed by Dr. L. C. Curtis at the Connecticut Agricultural Experiment Station. Used as maternal parent of F1 hybrid crosses because it produces a high percentage of female flowers early. Taste and texture similar to Zucchini. Deeply cut leaves make it wind resistant.

Beirut *figs. 72d, 107b*

Cucurbita pepo Vegetable Marrow Group

SIZE: 4" long by 1¾" wide

WEIGHT: 4 ounces

RIND COLOR: toned-down olive green

From Lebanon. Grown for stuffing with meat and rice. Very light green in color.

Verte Petite d'Alger *fig. 107d*

Cucurbita pepo Vegetable Marrow Group

SIZE: 3" long by 2⅛" wide

WEIGHT: 3 ounces

RIND COLOR: toned-down olive green

SYNONYMS: Faentina, French White Bush Zucchini, Grey Zucchini, Small Green Algerian

SEED SOURCES: Bake, Burr, Ers, Heir, Jor, Kil, Lan, Ros, Sese, Set, Shum, Vict, Will

A stuffing marrow from Algeria, light green, softer in texture than Zucchini; large blossom end scar (like Beirut).

FIGURE 107, MARROWS IN JULY: **a.** CASERTA; **b.** BEIRUT; **c.** WHITE VEGETABLE MARROW; **d.** VERTE PETITE D'ALGER; **e.** BOLOGNESE.

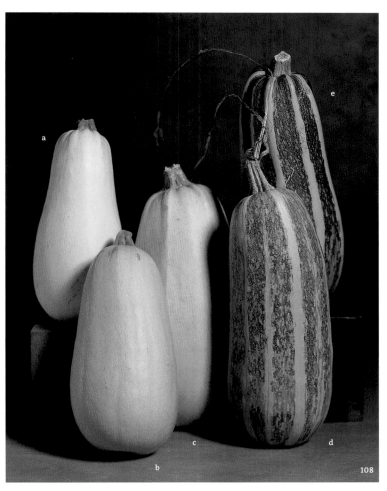

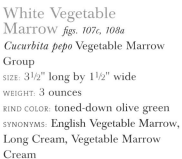

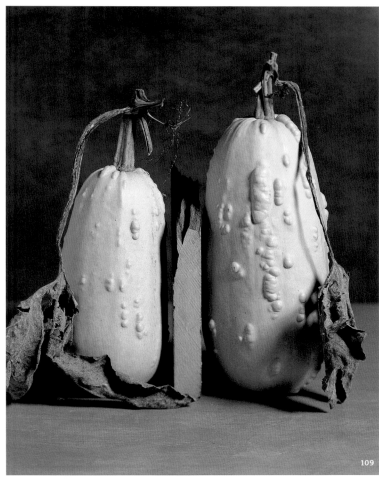

White Vegetable Marrow *figs. 107c, 108a*

Cucurbita pepo Vegetable Marrow Group

SIZE: 3½" long by 1½" wide

WEIGHT: 3 ounces

RIND COLOR: toned-down olive green

SYNONYMS: English Vegetable Marrow, Long Cream, Vegetable Marrow Cream

SEED SOURCE: Hud

Listed by Thorburn in 1824. Standard English fare but not terribly popular in this country.

Long Green Trailing *fig. 108d*

Cucurbita pepo Vegetable Marrow Group

SIZE: 10" long by 4" wide

SYNONYM: Green Vining Vegetable Marrow

SEED SOURCE: Sand

Vines as vigorous as Long White Trailing. Harvest early and often.

Long White Trailing *fig. 109*

Cucurbita pepo Vegetable Marrow Group

SIZE: 13" long by 6" wide

WEIGHT: 6 pounds

Vigorous climber. Fruit turns bright yellow in storage. This specimen is polluted by warts.

FIGURE 108, MARROWS IN SEPTEMBER: **a.** WHITE VEGETABLE MARROW; **b.** YELLOW MARROW (NOT FEATURED IN BOOK); **c.** MARROW (NOT FEATURED IN BOOK); **d.** LONG GREEN TRAILING; **e.** GREEN BUSH (NOT FEATURED IN BOOK).

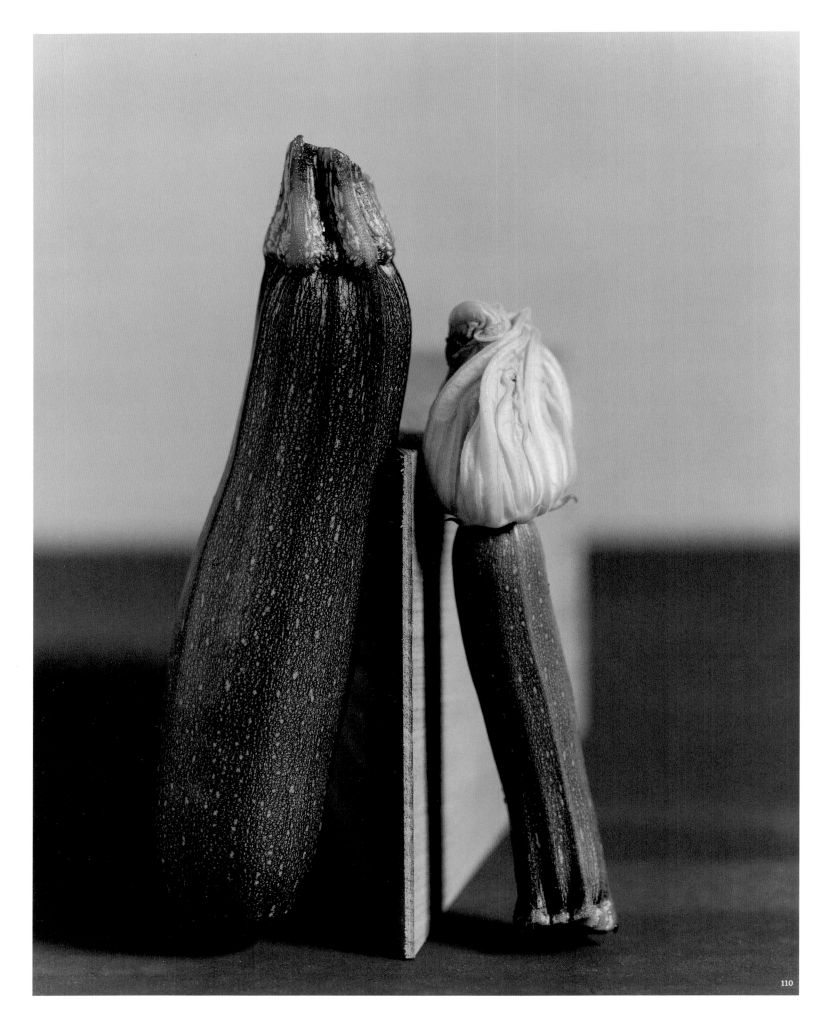

Zucchini Group *Cucurbita pepo*

JUST A LITTLE OVER A HUNDRED YEARS AGO, vegetable lovers knew nothing about Zucchini. Now it's the most popular squash in the world. It makes eating green vegetables a pleasure. Cereals and starchy roots have always had a place at the table, but in the nineteenth century, succulent vegetables, more water than dry matter, were for sissies. At the dawn of the twenty-first century, we Americans are eating tons every year. That's nothing short of a revolution.

Zucchini made its first definitive appearance in the guise of Zucca Quarantina Vera Nana in Milan, Italy, circa 1901. Described by horticulturist D. Tamaro as a long, slender, cylindrical dark green squash borne on a bush plant, this variety appears to be synonymous with Nano Verde di Milano, which does in fact mature in forty days and forty nights, *quarantina* style. According to Harry Paris, don of *Cucurbita pepo*s, Zucchini—and just about all pumpkins and squashes—arose from a combination of serendipitous crossing and selection. In contrast to Zucchini, records of Cocozelles and Vegetable Marrows date back to the Renaissance: Cocozelles spread throughout Italy and to other countries north of the Mediterranean Sea, whereas the Vegetables Marrows became popular south of the Mediterranean.

If you are confused about the differences between Zucchini, Vegetable Marrow, and Cocozelle—some more long and lanky than others—you're not alone. *Everyone* botches this one (everyone except Harry Paris, of course). Here's how to tell when a Zucchini is a Zucchini, and not a Cocozelle or Vegetable Marrow. A Zucchini is uniformly cylindrical with little or no taper; its length to greatest width ratio equals or exceeds 3.5 and usually tops out at 5.0. Simply divide length by greatest width to find your answer. And while we're talking about length, shorter is better when it comes to good eating. Those Zucchinis at the "mature edible stage," ten to twelve inches long, are already over the hill, floppy and flaccid in the pan.

It is likely that the first Zucchini grown in America was imported by Italian immigrants to California. By the time the Germain Seed and Plant Company and Aggeler and Musser of Los Angeles introduced it commercially in 1918 as Italian Squash, local market gardeners who made a specialty of it were already raking in the bucks. The following year, Germain listed it as Italian or Zucchini Squash (with the same catalog copy) and in 1920, a whole page of the catalog, complete with a life-size photo illustrating the actual recommended picking size (five and a half inches), was devoted to Germain's Zucchini. The catalog page also featured both interior and exterior shots of Café Marcell, "Los Angeles' Leading Restaurant Where Zucchini Had Its Birth," as well as recipes for Zucchini Florentine, Mornay, and Julienne (page 186), courtesy of Marcell's chef.

Black Beauty *fig. 110*

Cucurbita pepo Zucchini Group
SIZE: $5^{1}/_{2}$" long by $1^{1}/_{2}$" wide
WEIGHT: 4 ounces
RIND COLOR: deep vermilion green
DATE OF INTRODUCTION: 1957 All America Selection (AAS); John Scarchuk
SEED SOURCES: Bake, Bou, Bunt, Burpee, Com, Cook, Cros, Deat, Deb, East, Ers, Green, High, Hume, Irish, Jor, Jung, Lan, Loc, Mes, Peace, Rohr, Sese, Set, Soc, Sou, Ter, Und, Vesey, Vict, Wet, Will

Not the Black Zucchini listed by Jerome B. Rice Seed Co., Cambridge, New York, in 1931.

GOLDEN ZUCCHINI

TALK ABOUT COLOR! This is *not* mellow yellow. I have no idea why the sky is blue, but I do know why Golden Zucchini is the color of sunshine: It's the work of Dr. Oved Shifriss and the bicolor gene, *B*, which he stabilized within Bicolor Pear gourds and transferred to the genotypes of edible-fruited varieties, including Zucchini. Oved developed some of the first commercial vegetable hybrids in the United States, including the cucumber Burpee Hybrid (1945); he was also the breeder of what is arguably the world's most famous tomato, Burpee's Big Boy Hybrid (1949), named to celebrate the birth of his son. Scarcely anyone knows that Oved, like Harold with his purple crayon, colored the world: More than fifty *B* cultivars in squash have emerged as the result of his groundbreaking research, precocious *B* breeding lines, and sharing of seeds.

It all started quite modestly in 1948 with a single Bicolor Pear gourd plant now known as "plant 168-5." These gourds are as bitter as all get-out—and I mean "get-out" as in "spit-out." Yet there's something here that captures the imagination: the seemingly infinite bicolor variation that is the hallmark of its genetic instability. Look at a Bicolor Pear plant and you'll see all-green fruits coexisting quite happily with bicolor (green and yellow) ones of differing rind color patterns.

The fascinating thing about Bicolor Pears (shown on page 153) is their precocious yellow system of pigmentation. Like clockwork, the nongreen parts of the fruit rind turn yellow early and always before anthesis, or flowering—as opposed to standard squashes, which start out green and change color later. Using traditional plant-breeding techniques such as self-reproduction and selection (*not* genetic engineering), Dr. Shifriss developed a pure breeding line, Precocious Pear, that was genetically stable and more precocious: almost completely yellow. He surmised that gene *B*, for stronger expression and uniformly pigmented yellow fruits, originated from a weak B^W in plant 168-5 via mutation. *B* genes work by replacing chlorophyll development with carotenoid development; and they work in concert with the *L* genes (*L-1* and *L-2* for dark fruit color) to impart an intense yellow fruit color. When stable *B* was transferred by backcrossing from Precocious Pear to Fordhook Zucchini, which bears the two *L* genes, the results were electrifying: Precocious Fordhook Zucchini, the first golden zuke.

Golden Zucchini was developed by Burpee breeders using "genetic material" or seed (presumably the Precocious Fordhook Zucchini breeding line) supplied by Dr. Shifriss. Released in 1973 as the first commercial *B* cultivar and awarded PVP (Plant Variety Protection), which has now expired, Golden Zucchini is an open-pollinated variety in the public domain. That means you are free to save the seeds

and grow, sell, or use it as you'd like. And use it you should, because precocious yellow zukes can be more nutritious (higher carotenoid content) than the "normal" varieties.

Oved died in June 2004. I never met him, but felt I knew him well. He was a brilliant man, as colorful as his squash. We exchanged letters and phone calls for eight years, from the time I trialed some of his precocious squash in my garden. His meticulous handwriting got tinier as he aged, yet on the phone, he was expansive and witty, in his Hebrew-accented English. A man born on Halloween in 1914 in En Gannim ("No Gardens"), Israel, was surely destined to make the world a greener–or a more brilliantly yellow–place. Legend has it that Oved's father, an orange orchardist, walked all the way from Odessa to Israel in 1904. Legend also has it that Oved, which means "work" in Hebrew, committed the entire Old Testament to memory and could recite it by heart. Oved may have mellowed with age, but at nearly ninety he was still growing tons of squash in hopes of elevating it into a more important food crop.

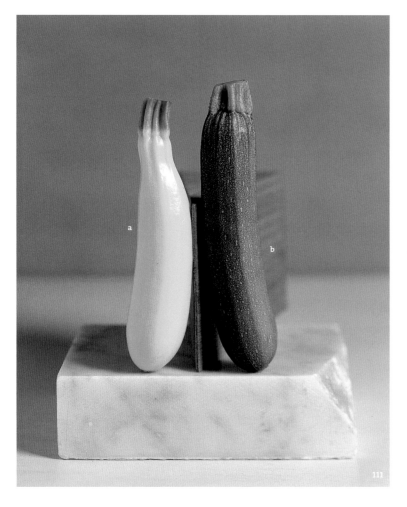

Golden Zucchini *fig. 111a*
Cucurbita pepo Zucchini Group
SIZE: 4¹/₂" long by 1" wide
WEIGHT: 2¹/₂ ounces
RIND COLOR: deep chrome yellow
DATE OF INTRODUCTION: 1973; W. Atlee Burpee Co., Philadelphia
SEED SOURCES: Bake, Burpee

Crisp, mild flavor. Precocious yellow fruits are usually narrower than those of standard sorts and can be malformed because of the *B* gene.

Nano Verde di Milano
figs. 72a, 111b
Cucurbita pepo Zucchini Group
SIZE: 4¹/₂" long by 1" wide
WEIGHT: 3 ounces
RIND COLOR: deep vermilion green
SYNONYMS: Courgette Verte de Milan, Zucca Quarantina Vera Nana

Intensely green and uniformly cylindrical. Fordhook Zucchini is probably a selection out of this one. Decorative plant with big, serrated, silver-mottled leaves.

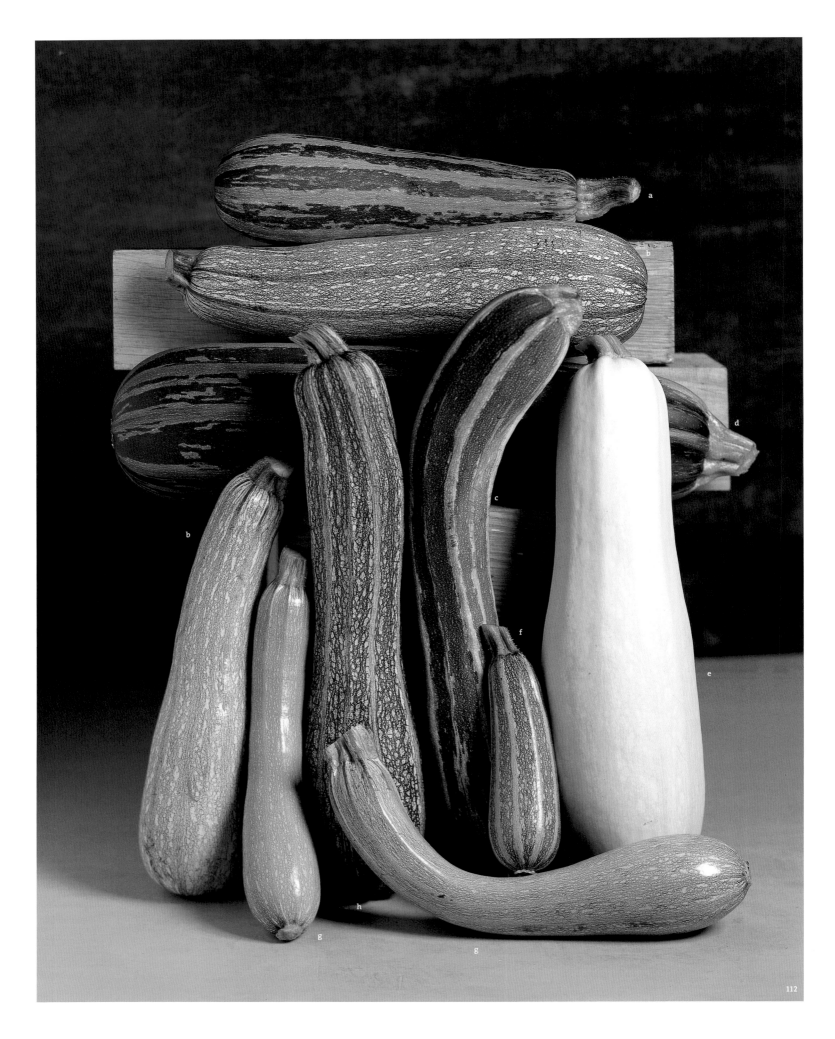

Cocozelle Group *Cucurbita pepo*

"**ALL THROUGH ITALY,** where this Gourd is very commonly grown, the fruit is eaten quite young, when it is hardly the size of a small Cucumber, sometimes even before the flower has opened, when the ovary, which is scarcely as long or as thick as the finger, is gathered for use. The plants, which are thus deprived of their undeveloped fruits, continue to flower for several months most profusely, each producing a great number of young Gourds, which, gathered in that state, are exceedingly tender and delicately flavored."

—The Vegetable Garden, Vilmorin, 1885

Verte Non-coureuse d'Italie *fig. 112a*
Cucurbita pepo Cocozelle Group
SIZE: $3^{1}/_{2}$" long by $^{7}/_{8}$" wide
WEIGHT: 2 ounces
RIND COLORS: deep vermilion green and intense olive green

Stripes are narrow and broken, not broad and contiguous. Often confused with the distinctly different Non-coureuse d'Italie and Verte Non-coureuse. May be the same as Verte d'Italie.

Genovese *fig. 112b*
Cucurbita pepo Cocozelle Group
SIZE: $5^{1}/_{2}$" long by $1^{1}/_{2}$" wide
WEIGHT: 4 ounces
RIND COLOR: dense olive green
SYNONYMS: Chiara di Asti, Di Voghera
SEED SOURCES: Hud, Sit

Grassy taste.

Striato d'Italia *figs. 72l, 112c*
Cucurbita pepo Cocozelle Group
SIZE: 7" long by 1" wide
WEIGHT: 3 ounces
RIND COLORS: dense olive green and deep vermilion green
SEED SOURCES: Bake, Pine, Red, Scheep, Sit

The classic Cocozelle. Green vegetable, spinachy flavor. Fruits have gorgeous longitudinal striping at maturity but are purely decorative at that age and stage.

Merzifon *fig. 112e*
Cucurbita pepo Cocozelle Group
SIZE: $4^{1}/_{2}$" long by 1" wide
WEIGHT: 2 ounces
RIND COLOR: light olive green

Not *striato* (striped or striated). Even lighter green than Alberello di Sarzane. Collected in Merzifon, Amasya, Turkey, and obtained by Harry Paris from the North Central Plant Introduction Station (PI 177370). There are tons of other primitive Cocozelle and Vegetable Marrow cultivars in Turkey.

Costata Romanesco *fig. 112f*
Cucurbita pepo Cocozelle Group
SIZE: $11^{1}/_{2}$" long
WEIGHT: $1^{1}/_{2}$ pounds
RIND COLOR: intense olive green
SEED SOURCES: Bake, Fed, High, Horus, John, Orn, Pea, Peace, Red, Ren, Sand, Sese, Sit, Sou, Tur

Ridgy. "The only summer squash worth bothering with, unless you're just thirsty," according to Will Bonsall of Farmington, Maine.

Alberello di Sarzane *fig. 112g*
Cucurbita pepo Cocozelle Group
SIZE: $5^{1}/_{2}$" long by $1^{1}/_{4}$" wide
WEIGHT: 3 ounces
RIND COLOR: dense olive green
SEED SOURCES: Hud, Sit

A Cocozelle without the dark stripes. Represents a market type in Italy. From an Italian seed cooperative with offices in Cesena.

Lunga di Toscana *fig. 112h*
Cucurbita pepo Cocozelle Group
SIZE: $7^{1}/_{2}$" long by $1^{1}/_{2}$" wide
WEIGHT: $6^{1}/_{2}$ ounces
RIND COLORS: light olive green and dense olive green

Similar to Costata Romanesco but longer. A distinct market type in Italy, harvested before it's even out of the cradle, with the flower attached.

FIGURE 112, YOUNG COCOZELLES GROW WITH ALACRITY: **a.** VERTE NON-COUREUSE D'ITALIE; **b.** GENOVESE; **c.** STRIATO D'ITALIA; **d.** COCOZELLE; **e.** MERZIFON; **f.** COSTATA ROMANESCO; **g.** ALBERELLO DI SARZANE; **h.** LUNGA DI TOSCANA.

Lungo Bianco di Sicilia *fig. 113*

Cucurbita pepo Cocozelle Group

SIZE: 14" long by 3¼" wide

WEIGHT: 2 pounds

RIND COLOR: transparent olive green

SEED SOURCES: Bake, Red

A market type in Italy, from an Italian seed cooperative. A bit prickly.

Cocozelle *figs. 112d, 114*

Cucurbita pepo Cocozelle Group

SIZE: 5" long by 1" wide

WEIGHT: 2½ ounces

RIND COLORS: deep vermilion green and intense olive green

SYNONYMS: Italian Vegetable Marrow, Long

SEED SOURCES: Allen, Bake, Burpee, Com, Cros, Down, Fed, Ger, Heir, High, Horus, Irish, Kil, Nic, Pea, Sed, Sese, Sew, Shaf, Soc, Sow, Syn, Wet

Forerunner described in the early 1600s. Traditionally harvested when as long as a strand of spaghetti.

115

Ornamental Gourds *Cucurbita pepo*

NEST EGG

REMEMBER LAZY MAYZIE, THE BIRD that flew the coop and left Horton the Elephant sitting on her egg? An elephant "faithful 100 percent" or a surrogate mother is, of course, one way to go; Nest Egg gourds is another. Backyard poultrymen have understood the value of Nest Egg gourds for centuries. These days the poultry industry puts a premium on egg production. A hen setting on a clutch of eggs is out of commission for weeks–and that means less profit. So, modern industrial-strength fowl have had their maternal instincts bred right out of them. Incubators and brooders, the tools of industry, are marvelous mechanisms, no doubt. But they've also made the mother hen nearly obsolete.

Not in my backyard. I have just joined the ranks of a new subculture: chicken fanciers and practical poultrymen who are keeping the rarest of the feathered tribes alive. Glenn Drowns of Sandhill Preservation Center in Calamus, Iowa, recently sent me twenty-five Cuckoo Marans, an endangered breed with a French pedigree, said to be paragons of motherhood and superb layers of large, dark brown eggs. Soon the pullets will start laying, and I'll have my daily dose for poaching with plenty left over for brooding or breeding.

When that day comes, I'll be ready with Nest Egg gourds in hand to . . . well, egg the young hens on. Nest Eggs are used in two ways. To make daily egg collection easy, the gourds are slipped into the nest or under the bird to induce egg laying in a circumscribed place. If new chicks are desired–if you want your hen to learn to be a mommy–let her set on the decoys and then introduce the real thing (fertilized eggs). An uneven number of Nest Eggs should bring good luck and induce the hen to feather her nest and cluck in that special motherly way. Nest Egg gourds have been often imitated but never equaled; though it's true that hens will sit on most anything that vaguely resembles an egg, golf balls and plastic Easter eggs are a bit tacky. Better to grow and use your own Nest Egg gourds. Just remember to snap off the stems–or you'll risk goosing your chickens.

Nest Egg *figs. 115, 116e*
Cucurbita pepo
SIZE: 3" long by 2⅛" wide
WEIGHT: 4 ounces
RIND COLOR: thin olive green
FIBER: unacceptable
SYNONYMS: Egg Squash, Japanese Nest Egg, Nest Egg Improved
SEED SOURCES: Bake, Burr, Clif, Gurn, Hori, Lan, Pepp, Pine, Rohr, Sand, Shaf, Sou, Sto, Twi, Will

From the 1898 Child's (Floral Park, New York) catalog: "A striking vine when hanging full of its pretty curious fruit that so clearly resembles smooth well-shaped hen's eggs that a hen might well be excused from claiming them as her own production." Called "egg semlins" in Smoky Mountains. Bland.

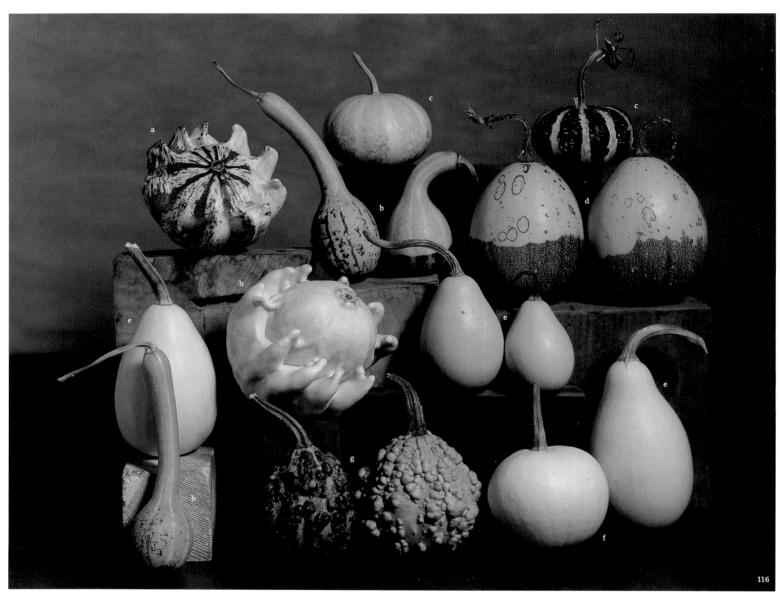

FIGURE 116, GOURD MEDLEY: **a.** SHENOT CROWN OF THORNS; **b.** BICOLOR SPOON; **c.** FLAT STRIPED; **d.** ABOBRINHA; **e.** NEST EGG; **f.** WHITE BALL; **g.** WARTY ORANGE HARDHEAD; **h.** WHITE CROWN OF THORNS.

Shenot Crown of Thorns *figs. 72b, 116a*
Cucurbita pepo
SIZE: 2" long by 1¹/₂" wide
WEIGHT: 1¹/₂ ounces (mini)
RIND COLORS: deep chrome yellow and deep vermilion green
FLESH COLOR: light chrome yellow
FIBER: acceptable only when young
SYNONYMS: Colored Crown, Finger Gourd, Striped Crown
SEED SOURCES: Burpee, Burr, Fed, Gurn, John, Jor, Jung, Mor, Nic, Rohr, Sto, Twi, Ver, Vesey

A mixture of types and colors containing bicolor and striped gourds. Can eat as a mini summer squash; stunning on a crudité platter. Very vigorous plants grow even in floodplains. Some are precociously yellow.

White Crown of Thorns *fig. 116h*
Cucurbita pepo
SIZE: 4" long by 4¹/₄" wide
WEIGHT: 1 pound
RIND COLOR: toned-down chrome yellow
FLESH COLOR: light chrome yellow
FIBER: unacceptable
SYNONYMS: Finger Gourd, Fingered Gourd, Holy Gourd, Gourd of the Ten Commandments, Sugar Bowl
SEED SOURCE: Bunt, Clif, Ers, Jor, Pepp, Pine, Shaf, Sse, Sto, Tho

Bland and as fibrous as can be.

Abobrinha *fig. 116d*
Cucurbita pepo
SIZE: 4" long by 3¹/₂" wide
WEIGHT: 11 ounces
RIND COLORS: dense golden yellow and intense olive green
FLESH COLOR: light golden yellow
FIBER: unacceptable

Loses its glorious green rings and specks very quickly in storage. Bland.

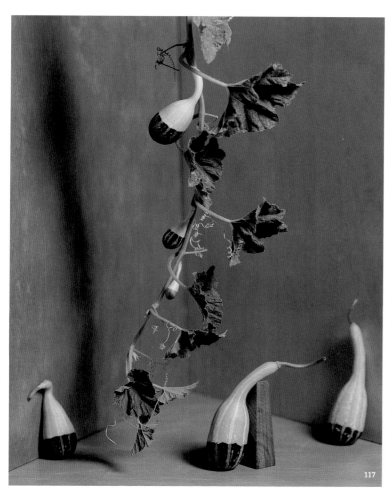

Bicolor Spoon *figs. 72h, 116b, 117*

Cucurbita pepo

SIZE: 2¹/₂" long by 1" wide

WEIGHT: 1 ounce

RIND COLORS: deep chrome yellow and deep vermilion green

FIBER: acceptable only when young

SEED SOURCES: Bake, Clif, Ers, Jor, Nic, Pepp, Pine, Sese, Shaf, Shum, Sto, Twi, Will

Can fashion spoons from dried specimens. Edible as a mini but not sweet. Precociously yellow. Illustrated by Bailey (1937).

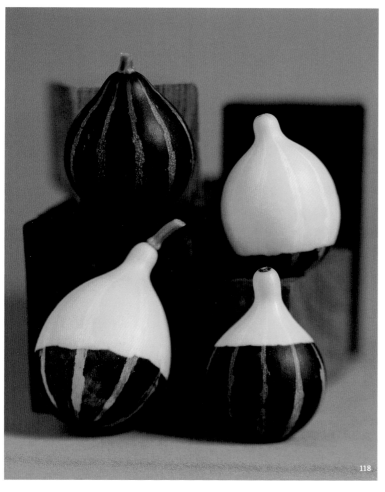

Bicolor Pear *fig. 118*

Cucurbita pepo

SIZE: 3" long by 1⁷/₈" wide

WEIGHT: 2¹/₂ ounces

RIND COLORS: wet chrome yellow and deep vermilion green

FLESH COLOR: thin vermilion green

FIBER: unacceptable

SYNONYM: Coloquinte Poire

SEED SOURCES: Bunt, Clif, Ers, Jor, Mor, Nic, Pepp, Rohr, Shaf, Sto, Twi

Source of gene *B*. Bitter. Gloriously illustrated by Duchesne in the eighteenth century.

Pawnee Orange *fig. 119*

Cucurbita pepo

SIZE: 5¹/₂" long by 7" wide

WEIGHT: 3¹/₂ pounds

RIND COLOR: transparent golden ocher

FLESH COLOR: subdued golden ocher

FIBER: unacceptable

Projectile spitter: a bitter, wild thing.

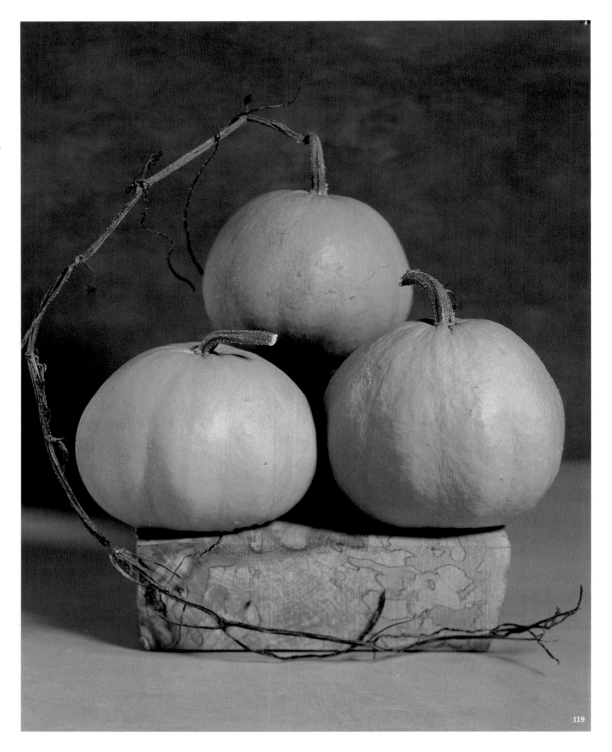

119

Flat Striped *figs. 116c, 120*
Cucurbita pepo
SIZE: 1³/₄" long by 3" wide
WEIGHT: 4 ounces
RIND COLORS: deep bluish black
and subdued yellow ocher
FIBER: unacceptable
SYNONYMS: Flat, Plate et Rayée,
Pomegranate
SEED SOURCES: Clif, Jor, Pepp, Shaf, Twi

Very small and very bitter.

Miniature Ball *figs. 72e, 121a*
Cucurbita pepo
SIZE: 2¹/₂" long by 2³/₄" wide
WEIGHT: 3 ounces
RIND COLOR: light yellow ocher
FLESH COLOR: subdued yellow ocher
FIBER: unacceptable
SEED SOURCE: Sto

Distinctly smaller than other
ornamental gourds. Seems to be
ancestral *C. pepo*. A bitter spitter.
Plant is incredibly vigorous and
prolific; frogs cavort therein.

White Ball *figs. 116f, 121b*
Cucurbita pepo
SIZE: 2" long by 2¹/₄" wide
WEIGHT: 3 ounces
RIND COLOR: dense chrome yellow
FLESH COLOR: light chrome yellow
FIBER: unacceptable
SEED SOURCE: Sto

Small and very bitter. Turns yellow
over time.

Orange Ball *fig.121c*
Cucurbita pepo
SIZE: 2¹/₂" long by 2¹/₂" wide
WEIGHT: 5 ounces
RIND COLOR: light yellow ocher
FLESH COLOR: transparent yellow ocher
FIBER: unacceptable
SYNONYM: Coloquinte Orange
SEED SOURCES: Clif, Jor, Nic, Pepp,
Sse, Sto, Twi

Bitter, seedy, like sawdust. Illustrated
by Duchesne in the eighteenth
century.

Warty Long Orange Hardhead *fig. 122*

Cucurbita pepo

SIZE: 9½" long by 4½" wide
WEIGHT: 2 pounds
RIND COLOR: dense brilliant orange
FLESH COLOR: toned-down brilliant orange
FIBER: unacceptable
SYNONYM: Pimple Yellow
SEED SOURCE: Sto

Unpalatable but not bitter. Similar to Small Tahitian.

Warty Orange Hardhead *figs. 116g, 123*

Cucurbita pepo

SIZE: 5" long by 6" wide
WEIGHT: 1½ pounds
RIND COLOR: medium brilliant orange
FLESH COLOR: toned-down brilliant orange
FIBER: unacceptable
SYNONYMS: Courge Galeuse, Orange Warted
SEED SOURCES: Bake, Sto

Range of sizes with roundish excrescences of various colors. Bitter. Illustrated in Duchesne. Known in France as *barbarines*.

122

123

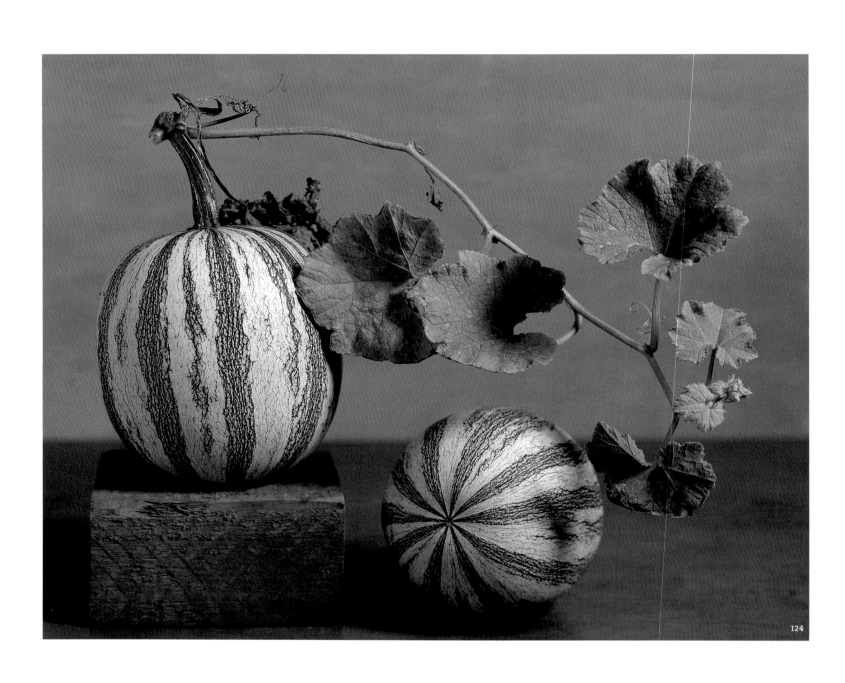

CUCURBITA
ARGYROSPERMA

AFTER I REALIZED that *Cucurbita argyrosperma* had been domesticated primarily for its nutritious seeds, I felt more kindly toward its coarse, thin, pale flesh. The seeds are large, easy to extract and hull, and are an important ingredient in Latin American cuisine. This species was domesticated in Mexico from *C. argyrosperma* ssp. *sororia* and is well adapted to hot and dry conditions. It is not well known in the north; only a handful of varieties are commercially available.

Cucurbita argyrosperma* and *Cucurbita moschata* are regarded as "sister species." Their genetic affinity is evident in allozyme and chloroplast DNA studies, and the two species are partially interfertile. Until the early twentieth century, the two were lumped together in the same species (*C. moschata*); what is now known as *C. argyrosperma* was briefly known as *C. mixta*. *Argyrosperma*'s enlarged, hard, corky stem is diagnostic of the breed; fruits usually have thick necks that are more or less elongated, and the rinds are unfurrowed, solid white, green, or patterned with green on white. My sample of squashes contains two cultivar groups, described by Dr. Laura Merrick.

SILVERSEED: broad seeds have grayish or bluish margins, the flesh is paler than Callicarpa's, and the rind is usually white with green-mottled stripes

CALLICARPA: thick-necked cushaw types with rinds that are green and white, banded and netted; or solid; or blotched with bright orange or yellow. Some cultivars sport ridges of corky tissue

Campeche *fig. 124*

Cucurbita argyrosperma Silverseed Group
SIZE: 7" long by 5½" wide
WEIGHT: 3 pounds
RIND COLORS: thin cadmium beige with wet vermilion green stripes
FLESH COLOR: transparent golden yellow
COLOR RATING: 1
FIBER: unacceptable
BEST USE: seeds
SEED SOURCES: Rev, Sand

Silvery seeds look like shiny fishes gleaming in the bottom of a bowl; they come out easily, at the press of a finger. Unpalatable flesh.

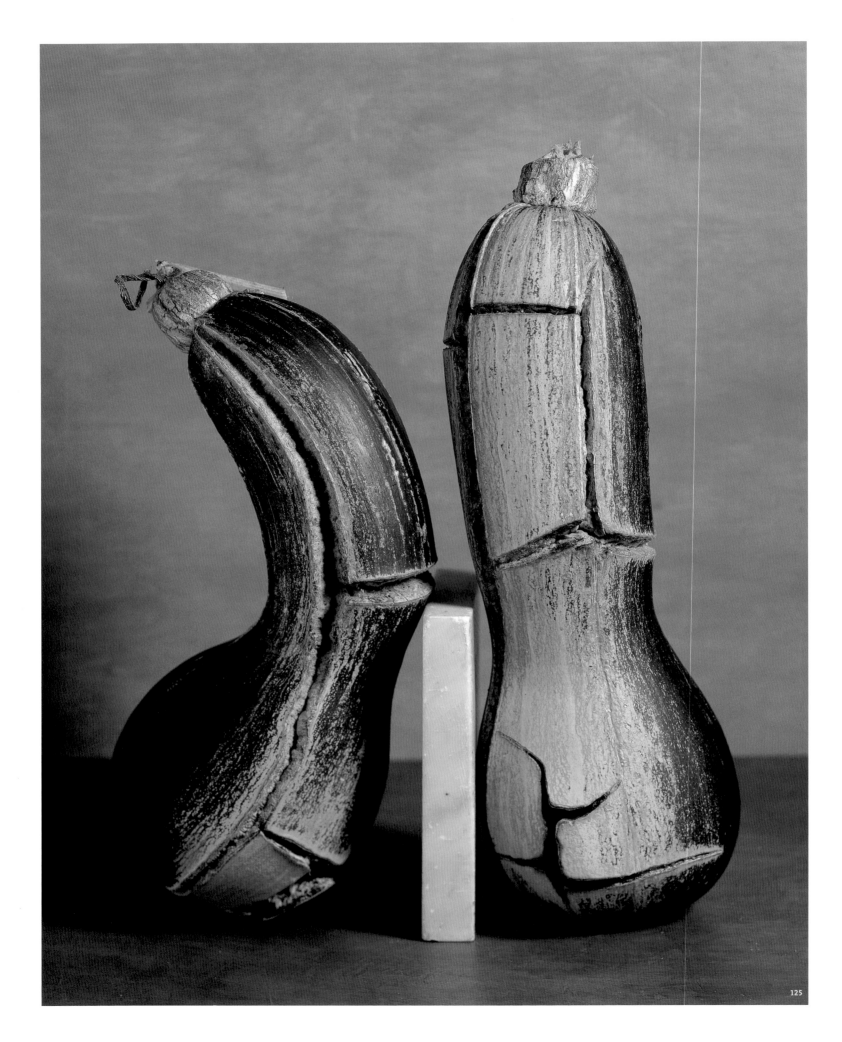

125

Callicarpa Group *Cucurbita argyrosperma*

JAPANESE PIE

JAPANESE PIE NEVER LOOKED AS GOOD as it does in dissolution. The natural balance of curved and straight lines, their very precision and geometry, commands attention. When I allowed Japanese Pie to remain on the vine too long and soak up a bellyful of water, it suddenly and irrevocably burst apart at the seams. Those corky ridges emanating from the stem end, so typical of the callicarpa breed, could be considered an Achilles' heel—or a lucky break.

Even more peculiar than the cracking of Japanese Pie's fruit rind is the crazing of its seeds, described in catalog copy as "curiously marked or sculptured in the manner of Chinese letters." This seed coat characteristic is by no means unique, but it was a novelty when Samuel Wilson of Mechanicsville, Pennsylvania, introduced Japanese Pie to America in 1884. The enigmatic marks captured the popular imagination, as if they were magic symbols or portents. By 1903, seventy-eight American and Canadian mail-order seed houses were cataloging Japanese Pie. Wm. Henry Maule's charming catalog illustration depicted Japanese Pie and its seed calligraphed on strips of bamboo bound into a screen. Japanese Pie eventually fell out of favor—probably because it makes a lousy pie—but I've often thought that "reading" the seeds would be just as enjoyable as interpreting tea leaves or palms.

We may never solve the mystery of Japanese Pie seeds. Without a doubt, though, the fissures and faults on both seed and fruit mimic the basic strokes and ideograms of Japanese and Chinese calligraphy, which themselves were derived from pictorial representations of the natural world. Japanese calligraphy is a direct reflection of *ki*, the life force, in the context of *ma*, or time and space. Talented calligraphers, moved by the spirit of the ink, create such an aesthetic of evanescence.

Seekers of cucurbit wisdom and truth had best leave divination to the soothsayers. Even kings of the Shang Dynasty in China relied on osteomancers with ox scapulas to help predict the future. Over time, tortoiseshells became the preferred medium because the dorsal part symbolized the heavens above and the plastron, or ventral part, evoked life on Earth. Fresh shells were harvested, inscribed, and then heated over a fire to induce cracking. The juxtaposition of cracks and oracular writing (*jiaguwen*) was then read and interpreted. One notable specimen survives intact from the fourteenth century B.C.E., posing the eternal questions: "Will we get a harvest?" and "Will we not get a harvest?"

Japanese Pie *fig. 125*
Cucurbita argyrosperma Callicarpa Group
SIZE: 20" long by 9" wide
WEIGHT: 18 pounds
RIND COLORS: wet vermilion green and intense brilliant orange
FLESH COLOR: transparent golden yellow
COLOR RATING: 1
FIBER: unacceptable
DATE OF INTRODUCTION: 1884; Samuel Wilson, Mechanicsville, Pennsylvania
BEST USES: decorative, divination
SYNONYMS: Alphabet, Chinese Alphabet, Green Cushaw, Japan Crookneck, Japan Pie, Japanese, Japanese Alphabet, Japanese Crookneck, Japanese Pumpkin, New Japanese, Nippon Island
SEED SOURCE: Sed

Cochita Pueblo *fig. 126*

Cucurbita argyrosperma Callicarpa Group

SIZE: 26" long by 12" wide

WEIGHT: 16 pounds

RIND COLORS: wet brilliant orange, medium chrome yellow, and medium olive green

FLESH COLOR: transparent golden yellow

COLOR RATING: 1

FIBER: unacceptable

DATE OF INTRODUCTION: circa 1990

BEST USES: container, decorative, seeds

SYNONYM: Tricolor Cushaw

SEED SOURCE: Bake, Rev, Sed

Amazing Technicolor Cushaw. Grown by the Cochita Pueblo Indians. Not much more than a huge cavity with seeds inside.

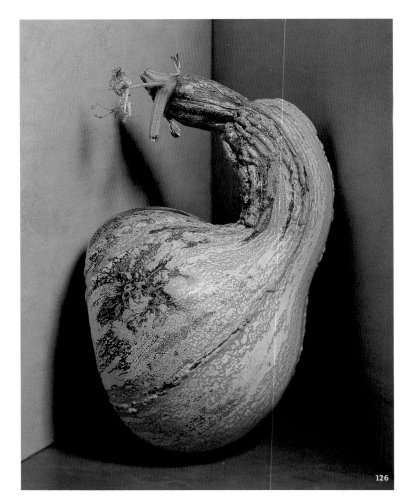

Green Striped Cushaw

fig. 127

Cucurbita argyrosperma Callicarpa Group

SIZE: 15" long by 9½" wide

WEIGHT: 11 pounds

RIND COLORS: subdued golden yellow and deep vermilion green

FLESH COLOR: transparent golden yellow

COLOR RATING: 1

FIBER: unacceptable

BEST USES: container, decorative, seeds

SYNONYMS: Brother Jonathan, Green Crookneck Winter, Hopi Cushaw, Improved Green Striped Cushaw, Improved Winter Crookneck, Pie Melon, Striped Cushaw, Striped Crookneck

SEED SOURCES: Berl, Bunt, Burr, Clif, Com, Ers, Green, Jor, Kil, Lan, Mey, Mor, Old, Rev, Rohr, Ros, Sand, Sese, Sew, Shaf, Shum, Sky, Wet, Will

My daughter is crazy about these; dresses them in costume for vegetable exhibits. Very poor table quality. Seven-thousand-year-old seeds of Green Striped Cushaw or a similar sort have been found in Tehuacán, Mexico.

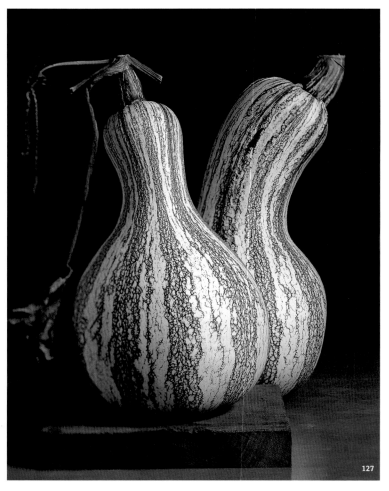

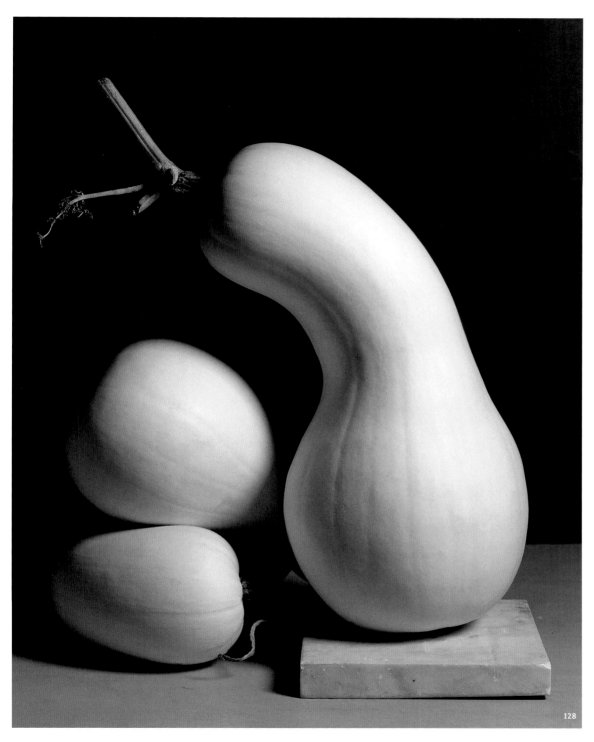

Jonathan *fig. 128*
Cucurbita argyrosperma Callicarpa
Group
SIZE: 20" long by 8" wide
WEIGHT: 13 pounds
RIND COLOR: subdued golden ocher
FLESH COLOR: transparent raw sienna
COLOR RATING: 2
FIBER: unacceptable
DATE OF INTRODUCTION: Offered as early
as 1891 under the name Jonathan by
Livingston
BEST USE: decorative
SYNONYMS: Improved White Cushaw,
Large White Cushaw, Mammoth
White Cushaw, New Jersey,
Trombone, White Crookneck,
White Cushaw, Winter Crookneck
SEED SOURCES: Bake, East, Ers, Green,
Horus, Lan, Rev, Sand, Shum, Sou

Ghostly, marshmallowy. Has no
particular merit. Reminds Tony
Smith, president of The New York
Horticultural Society, of Shmoos,
creatures from *Li'l Abner.*

TENNESSEE SWEET POTATO

FRUITS OF THE SPECIES *Cucurbita argyrosperma* are notoriously worthless. Tennessee Sweet Potato is no exception. The extremely hard shell makes opening one akin to putting a sword to a stone: Banging the squash repeatedly with a two-handled knife wedged inside is about the only way to gain entry. The thick, coarse flesh is somewhat sweet but in no way resembles a sweet potato. Tennessee fails utterly as food.

Nevertheless, Tennessee Sweet Potato is worth growing. The woodiness of the fruit shell allows it to achieve a certain majesty in its dried state, as an objet d'art, that it never had in life. Tennessee is not as durable as bottle gourds (*Lagenaria siceraria*), but it will last for years on the mantelpiece. In addition to collecting these relics–or seed reliquaries–I also collect squash peduncles, or stems. The big, fat, corky peduncle of Tennessee Sweet Potato is my prize specimen, a fascinating object of natural history.

The variety was introduced by Burpee in 1883. It was well adapted and extensively grown in the South, but was only a marginal part of the diet. Frederick Law Olmsted (1822–1903), the landscape architect who designed New York's Central Park, traveled through the backcountry of the south-central states at midcentury and found the locals subsisting largely on a diet of salt pork and corn bread. This was supplemented with occasional turnip greens and sweet potatoes in season, but fruits and vegetables were sorely lacking, particularly those sorts stored for the winter by Yankees: pumpkins, parsnips, potatoes, and cabbage. The hard-shell gourd (*L. siceraria*) was widely grown by early settlers in Tennessee and Kentucky, not to furnish food but rather to supply utensils and containers. Perhaps Tennessee Sweet Potato was used in a similar manner.

Tennessee Sweet Potato and the old Puritan Squash, as described by Fearing Burr Jr. in 1863, appear to be the same variety; both description and illustration conform exactly. Puritan was "long common to gardens in the vicinity of the Old [Plymouth] Colony" and it "retains its distinctive character to a remarkable degree" even when grown "indiscriminately among numerous summer and winter kinds for upwards of twenty years. . . ." That Puritan maintained its genetic purity, even when sympatric (grown in mixed company), makes sense, considering the sterility barriers that prevent gene flow between *C. argyrosperma* and other domesticated squash species.

Tennessee
Sweet Potato *fig. 129*
Cucurbita argyrosperma Callicarpa Group
SIZE: 11" long by 8" wide
WEIGHT: 10 pounds
RIND COLOR: thin raw sienna
FLESH COLOR: transparent golden ocher
COLOR RATING: 2
FIBER: unacceptable
DATE OF INTRODUCTION: 1883; W. Atlee Burpee & Co., Philadelphia
BEST USES: containers, decorative
SYNONYMS: Genesee Sweet Potato, Green Striped Bell, Puritan, Sweet Potato, Tennessee, Virginia Sweet Potato
SEED SOURCES: Horus, Sand, Sed, Sse

In no way, shape, or form like a sweet potato. My prize peduncle measures 3" high, 2$^{1}/_{4}$" wide, and 6$^{3}/_{4}$" in circumference.

Rare Flavors

Heirloom pumpkins and squashes are good old-fashioned, soul-satisfying food. In these golden orbs and myriad rare forms, nature provides the raw materials for a banquet of appetizers, soups, salads, entrées, and desserts.

My advice is to first taste these raw materials raw. Bland varieties can be sweetened by sugar or combined with parsnips. I prefer my squashes dry and starchy, but if you don't, moisten with celery root (celeriac), which also adds a layer of flavor. When squash is too watery, a flaky potato, boiled and mashed, usually helps. Some pumpkins and squashes have texture like sawdust—I label these "spitters." ("Projectile spitters" are the nauseatingly bitter gourds, not used in cooking.) Roasting is the only remedy for spitters—besides aborting the mission altogether.

When you find a pumpkin or squash whose flavor and texture you love, never let it go: Make puree and freeze it. Homemade puree will form the basis of soups, gnocchi, and pies and is more vividly orange and tasty than store-bought. To make this staple, preheat the oven to 350°F. Bake the pumpkin or squash whole (with a few vent holes), or cut in half or quarters and place facedown, until the flesh is easily pierced by a knife. Save the seeds for posterity (or salt and roast them) and scoop the flesh from the rind. Puree the pulp in a blender, adding water if necessary. A five-pound pumpkin will yield approximately two and a half pounds or four cups of pulp. Freeze in two-cup portions, enough for one pie.

FAVORITE PUMPKINS AND SQUASHES

I would be bereft without these squashes in my life. As a group, they make a fabulous collection for the cook, home gardener, and all those who appreciate food history. There's great diversity here in size, shape, and appearance. Every last one is DELICIOUS.

BUTTERCUP Sets the standard of excellence, but we take it for granted. CROOKNECK AND STRAIGHT-NECK These summer squashes, an American institution in the days before Zucchini ruled the roost, are now ready for a comeback. HUBBARD Proves that bigger is better. Includes red-, blue-, and green-rinded varieties. JACK BE LITTLE A palm-size pipsqueak, undeniably fanciful, not just for ornament. MARINA DI CHIOGGIA A bump-rinded squash from Venice that is oddball but *deliziosa*. MUSQUÉE DE PROVENCE Magnificent fluted pumpkin, the color of milk chocolate and just as addictive. SEMINOLE An irreplaceable pumpkin, on an irrespressible plant, from the Seminole Indians. SIBLEY Also known as Pike's Peak. Best of the Banana squashes—and that's saying a lot. THELMA SANDERS An Acorn squash of a different color, flavor, and texture. TRIAMBLE The blue squash that started it all for me: an art form in nature with wall-to-wall goodness inside. VEGETABLE SPAGHETTI The closest thing to pasta since durum wheat. WINTER LUXURY PIE My favorite pie pumpkin; so beautiful that it hurts to cut one open.

SQUASH BLOSSOMS, FRESH AND FRIED.

Stuffed Squash Blossom Tempura

SERVES 4 TO 6, *photograph on page 168*

Most recipes recommend stuffing and frying male blossoms only, but—for me—eating a squash blossom with no immature fruit attached is like eating an artichoke without the heart. If possible, go for the meaty females, those with an ovary at the base of the flower. I don't recommend rinsing the blossoms with water, but do pick them over for hidden bugs.

4 ounces whole milk ricotta cheese
1 large egg, lightly beaten
Salt and freshly ground black pepper
12 squash blossoms, male or female, cleaned
Vegetable oil
3/4 cup all-purpose flour
1 cup cold beer or club soda

Mix the ricotta and beaten egg in a small bowl; add salt and pepper to taste. Gently open the petals of each blossom and spoon in a teaspoonful or more of the filling, carefully twisting the ends of the petals to close. Cover with a damp paper towel and refrigerate until ready to use.

Pour 2 inches of oil into a large skillet and heat to 350°F.

In a small bowl, whisk together the flour and cold beer or club soda to make a thin batter. Working in batches of three or four, dip the stuffed blossoms into the batter and allow the excess to drip off before carefully dropping them into the hot oil.

Fry for 1 or 2 minutes until the batter puffs and becomes crisp and golden. Remove with a slotted spoon and drain on paper towels. Repeat with the remaining blossoms. Sprinkle with a little salt and serve immediately.

Berrichon Pumpkin Pastry

SERVES 2 AS AN ENTRÉE OR 4 AS AN APPETIZER

This traditional recipe from the Berry region of France has been reformulated by local preservationist Jacques Aubourg; it is most authentically made with Sucrine du Berry squash (page 83). Lucky fairgoers get to taste these savory pastries at the annual pumpkin festival in Tranzault, France, on the second Sunday of October. (If this is the French version of fast food, I'm sold.) Instead of parsley, I sometimes use a smaller amount of lovage from a plant Jacques gave me years ago.

2 ready-to-bake frozen puff pastry sheets, thawed
* at room temperature*
1 1/2 pounds Sucrine du Berry or Butternut squash,
* finely minced*
1 small onion, finely minced
1/2 cup chopped parsley
Salt and freshly ground black pepper
1 egg, beaten, for egg wash
Crème fraîche (optional)

Preheat the oven to 400°F.

Unfold the puff pastry onto a lightly floured surface and cut each sheet into 4 equal parts; this will yield 4 pastries for appetizers. Two

THE NAKED SEEDS OF OILSEED PUMPKINS (*CUCURBITA PEPO*, UPPER RIGHT) PRODUCE A DARK, RICH, AROMATIC OIL (IN SPOON) THAT'S MARVELOUS AS A SALAD DRESSING. WOULDN'T IT BE WONDERFUL IF BREEDERS COULD COMBINE THE NAKED-SEEDED TRAIT FROM *C. PEPO* WITH THE LARGE SIZE OF *C. MAXIMA* SEEDS (UPPER AND LOWER LEFT) TO YIELD BIGGER SEEDS WITH MORE OIL?

entrée-size portions can be made by simply dividing the pastry sheets in half. Mound the squash generously onto half the pastry pieces. Top with the onion and parsley and sprinkle with salt and pepper, leaving a ¼-inch border around the edges. Roll out the remaining rectangles or squares to enlarge them for the top crusts and drape them over the mounded mixtures. Fold the edges under or press them together, using a few drops of water to seal them. Prick 3 small holes in the top crusts to let steam escape and brush with the egg wash.

Place on a baking sheet and bake for 30 minutes or until brown. Slit open the top of each packet, insert a dollop of crème fraîche if desired, and serve immediately.

Foie Gras–Stuffed Jack Be Littles

SERVES 4

The recipe for this perfect pairing comes from chef Bill Telepan. The foie gras flavors the squash inside and the squash cooks the terrine perfectly. You might do a double-take when you read how Bill uses plastic wrap, but it works: The plastic helps steam the stuffed Jack Be Littles (JBLs), and the foil secures the plastic, preventing a meltdown. The kosher salt steadies the JBLs and absorbs fat.

4 Jack Be Littles
1 teaspoon finely ground salt
Pinch of finely ground white pepper
10 ounces duck foie gras
Pinch of sugar
4 tablespoons Sauternes or similar dessert wine
Kosher salt
1 large brioche, toasted

Preheat the oven to 450°F.

Remove the tops of the JBLs by cutting a circle into the middle of the squash at an angle with a paring knife. Scoop out the pulp and seeds with a spoon, taking care to keep the shells intact.

Season the seed cavities with salt and pepper, replace the tops, and place the JBLs in a pan with a bit of water, and cover with foil. Bake for about 15 minutes, just until the pumpkins start to soften. Remove from the oven and allow to cool. Lower the oven temperature to 325°F.

Devein the foie gras and season with salt, pepper, and sugar. Place a tablespoon of wine in each JBL. Divide the foie gras into four equal parts and stuff them into the seed cavities.

Cover the bottom of a small roasting pan with kosher salt. Place the JBLs on the salt and cover with the lids. Wrap the pan first with plastic wrap and then aluminum foil; make sure the plastic is completely covered with foil.

Place in the oven and bake 35 to 40 minutes or until the foie gras is warm to the touch. Remove the pumpkins and place them in the refrigerator for 24 hours. Bring the JBLs to room temperature and serve with toasted brioche.

Roasted Pumpkin Seeds

photograph on page 170

All squash seeds are edible, including those from the bitterest gourds, if the cucurbitacins (bitter compounds) are washed away. The next time you're cooking with squash or pumpkin, try saving the seeds and roasting them. Even Acorn squash seeds and those from mature summer Crooknecks, though small, are delectable. Thomas C. Andres, plant explorer and founder of The Cucurbit Network, an organization

dedicated to conservation and understanding of the Cucurbitaceae, is biased toward the naked-seeded pumpkins of *C. pepo* (see page 105) because the seeds require no shelling—and so am I. I just wish someone would make a home dehuller for the rest of the lot.

Preheat the oven to 350°F.

Cut open the pumpkin or squash, scoop out and pick through the seeds, and remove the stringy fibers. Rinse the seeds with water in a colander; shake and blot them with paper towels to remove excess moisture and any residue.

Spread the seeds on a baking sheet, toss with a little vegetable oil (optional) and kosher salt, and roast in the oven, stirring occasionally, until lightly colored, 20 to 30 minutes, depending upon the size of the seed and thickness of the hull. Allow to cool before snacking. Pumpkin seeds are at their best soon after roasting.

Summer Squash Crudités Platter with Red Pepper Dip

SERVES 6 TO 8

Everyone has favorite summer squashes; I prefer the crispness of tiny Zucchinis, Crooknecks, Straightnecks, and Pattypans. Vegetable Marrows and Cocozelles make my mouth pucker, at least when they're raw, so I avoid them for crudités.

RED PEPPER DIP
4 red bell peppers
6 to 8 cloves garlic
2 tablespoons olive oil
Dash of cayenne pepper

CRUDITÉS
1 to 1½ pounds (4 to 5 squashes) young summer squashes

Preheat the oven to 450°F.

Brush the peppers and garlic with a little olive oil and place them in separate shallow roasting pans. Roast the peppers for 15 to 20 minutes, turning them from time to time so that they get charred on all sides. Remove the peppers from the pan and set aside to cool. The garlic may take a few minutes longer in the oven. Remove when the cloves are easily pierced with a knife. Peel the charred skin from the peppers and discard it with the stem, core, and seeds. Squeeze out the soft roasted garlic. In a food processor, puree all the ingredients. Makes about 1 cup of dip.

Slice the squashes into rounds or spears; baby squashes can be used whole or cut in half. Arrange artfully on a platter and serve with the dip at room temperature.

Pumpkin Chestnut Soup

SERVES 8 TO 10, *photograph on page 166*

I have a lifetime supply of canned, whole peeled chestnuts thanks to my mother's generosity. These golden nuggets invariably find their way into my pumpkin soup, adding flavor and structure—especially if the squash is too watery. You can make gallons of this soup and squirrel it away in the freezer for up to one year. If freezing, do not add the cream. Wait until after thawing the soup and reheating it to add the cream.

2 onions, chopped
4 tablespoons unsalted butter
8 cups chicken or vegetable stock
4 pounds pumpkin or squash, roasted and cubed
6 potatoes, peeled and cubed
One 15-ounce jar whole peeled chestnuts
Salt and freshly ground black pepper
½ cup or more heavy cream (optional)

In a large saucepan, sauté the onions in butter until translucent, about 5 minutes. Add the stock, squash, potatoes, chestnuts, season with salt and pepper, and cook until the vegetables are tender, about 45 minutes. Puree in a food processor until smooth, adding extra stock as needed, and season with salt and pepper. Stir in heavy cream to taste just before serving.

Southwestern Winter Squash Chowder

SERVES 8, *photograph at right*

You'll never miss having clams in this thick, hearty, and pungent chowder. To reduce the calorie count, use milk in place of half-and-half and eliminate the cheese.

2 tablespoons olive oil
2 tablespoons unsalted butter
3 cups coarsely chopped onions
1 large red bell pepper, finely chopped
1 large green bell pepper, finely chopped
2 tablespoons seeded and minced jalapeño pepper
½ cup all-purpose flour
1 teaspoon kosher salt
1 teaspoon red pepper flakes (optional)
8 cups chicken or vegetable broth
3 cups peeled, seeded, and diced squash,
 cut into medium dice
2 cups peeled and diced potatoes,
 cut into medium dice
3 cups fresh or frozen corn kernels
1½ cups half-and-half
2½ cups grated cheddar cheese
½ cup chopped fresh coriander, for garnish
Croutons

Heat the oil and butter in a large, heavy-bottomed stockpot over medium high heat. Add the onions and peppers and sauté until the onions are transparent, about 5 minutes. Add the flour, salt, and red pepper flakes and stir until blended. Stir in the broth, squash, and potatoes. Bring to a boil and then reduce the heat to low

and simmer, covered, until the potatoes and squash are tender, about 20 minutes.

Add the corn, half-and-half, and cheddar cheese to the chowder and stir them in; cook for a few minutes until the cheese has melted. Adjust the seasonings to taste, garnish, and serve with croutons.

Garbure

SERVES 8 AS A MAIN COURSE

Garbure is a fabulous main course soup from the Bordeaux region of France. In this recipe, generously provided by Mona Talbott, Galeuse d'Eysines squash—native to Bordeaux—takes the place of the usual white beans. Serve with a hearty *vin du terroir* and toasted bread that is brushed with duck fat and rubbed with garlic cloves.

2 leeks, trimmed, well rinsed, and cut into thin rings
1 large onion, cut into medium dice
8 cloves garlic, finely chopped
4 stalks celery, cut into medium dice
2 tablespoons duck fat
5 quarts homemade duck or chicken stock
1 bouquet garni (2 sprigs parsley, 1 bay leaf,
 2 sprigs thyme, tied in a bundle with string)
1 small cabbage, cored and chopped into large pieces
Duck confit (with 4 legs)
2 medium turnips, peeled and cut into large cubes
3 medium Yukon Gold potatoes,
 peeled and cut into large cubes
Salt and freshly ground black pepper
2 pounds Galeuse d'Eysines or other pumpkin,
 peeled, seeded, and cut into 2-inch cubes

Sweat the leeks, onion, garlic, and celery in duck fat over medium-low heat in a sturdy 2-gallon stockpot until the vegetables are fragrant and cooked through.

Add the stock and bouquet garni to the pot and bring to a boil. Skim off any impurities and then reduce the heat to a simmer. Add the cabbage, duck confit, turnips, and potatoes. Season the soup with salt and pepper. Let the soup simmer for 1 hour over low heat, skimming off the melted duck fat as it rises to the surface. The potatoes and turnips will break down, adding body to the soup.

Carefully remove the duck legs from the soup; the meat will be meltingly tender. Separate and add the meat to the soup, discarding the skin and bones. Add water to the soup if too much of the broth has evaporated.

Add the cubed pumpkin to the soup and return to a simmer. Continue cooking until the pumpkin is soft, approximately 15 minutes. Take out the bouquet garni and add the duck meat to the soup. Season with salt and pepper.

MAIN COURSES

Rustic Zucchini Crust Pizza

MAKES TWO 8-INCH PIZZAS
photograph opposite, upper left

This rustic repast is something like a frittata but not quite as eggy; it is cooked in the oven like a pizza rather than on top of the stove. My daughter won't eat Zucchini in any other form.

4 cups coarsely grated unpeeled Zucchini
 or summer squash
Kosher salt
Olive oil
Cornmeal for sprinkling
4 eggs
½ cup all-purpose flour
2 cups grated mozzarella cheese
20 niçoise olives, pitted and chopped
4 scallions, thinly sliced
2 teaspoons dried oregano
2 or 3 tomatoes, thinly sliced
½ cup fresh basil leaves, cut into strips

Place the grated squash in a colander, salt generously, and set it aside for 30 minutes. Squeeze out the excess moisture with your hands.

Preheat the oven to 425°F. Lightly coat two 11- by 17-inch cookie sheets with olive oil and sprinkle with cornmeal.

Beat the eggs in a large bowl. Add the Zucchini and flour. The mixture should have the consistency of cooked oatmeal; if it's too sticky, add a little more flour.

Spread half the mixture on one prepared cookie sheet and half on the other. Bake for 15 to 20 minutes until puffed and slightly brown; remove from the oven and reduce the temperature to 350°F.

Combine the mozzarella, olives, and scallions and sprinkle the mixture over each pizza, leaving a ½-inch margin along the edge. Sprinkle with oregano and arrange the tomato slices on top. Scatter fresh basil on top and drizzle with a little olive oil.

Return to the oven and bake for 15 minutes or until the cheese is melted. Serve hot or at room temperature.

Zucchini Quiche

SERVES 4, *photograph opposite, lower left*

Zucchini or summer squash quiche is the perfect entrée for brunch or a light supper. Prebaking the pie shell, and salting and wringing all of the water out of the squash before cooking, prevent this excellent quiche from turning into a sodden mess.

FOR THE PASTRY SHELL
1⅔ cups all-purpose flour
Pinch of salt
4 tablespoons unsalted butter, well chilled
 and cut into ½-inch cubes
1 lightly beaten egg yolk
4 to 6 tablespoons ice water

Preheat the oven to 375°F.

Combine the flour and salt in the bowl of a food processor fitted with a metal blade; pulse for 2 seconds to mix. Add the butter and pulse 10 to 12 times until the mixture resembles coarse meal.

In a separate bowl, combine the egg yolk and 4 tablespoons water. With the food processor running, slowly add the egg mixture through

the feed tube. Pulse until the dough just holds together. More water can be added, a tablespoonful at a time, if the dough is too crumbly. Remove the dough from the processor, form into a flattened round, wrap in plastic wrap, and refrigerate for at least 30 minutes.

Roll the chilled dough into a 12-inch circle on a lightly floured surface. Gently fold the dough in half to transfer it into an 8-inch pie pan or straight-sided cake pan, then unfold the dough and firmly press it into the pan. Trim the edges of the dough, leaving a ½-inch overhang; fold excess dough inside the pan and press it into the sides to reinforce the edge of the crust. Refrigerate for 20 minutes.

Prick the bottom and sides of the dough with the tines of a fork and line the chilled shell with aluminum foil or parchment paper; add uncooked dried beans, rice, or pie weights and bake for 15 to 20 minutes. Carefully remove the pie weights and foil and continue baking another 5 to 10 minutes, until the crust is golden brown. Remove the pastry shell from the oven and allow it to cool.

NOTE: To make a sweet pastry shell for pumpkin pie, add two tablespoons of sugar to the above pastry shell recipe, roll the dough a bit larger, and bake in a 9-inch pie or tart pan.

FOR THE FILLING

Kosher salt
1 pound baby Zucchini or summer squash, unpeeled, and diced into ¼-inch pieces or thin slices
2 tablespoons unsalted butter
2 large eggs
2 large egg yolks
1 cup heavy cream
¼ cup milk
Salt and freshly ground black pepper
Freshly grated nutmeg
1 cup grated Gruyère or Swiss cheese

Salt the diced squash, place it in a colander for 30 minutes, and then press it between paper towels to remove excess moisture.

Heat the butter in a heavy-bottomed skillet, add the squash, and sauté until tender and translucent. Remove the squash from the skillet with a slotted spoon and drain on paper towels.

Lightly beat the eggs and yolks with a wire whisk. Pour in the cream and milk and combine, adding a dash of salt, pepper, and nutmeg.

Sprinkle ½ cup grated cheese on the bottom of the prebaked pastry shell. Layer the sautéed squash over the cheese and cover with the remaining cheese. Place the pan on a baking sheet and pour the egg and cream mixture over the cheese until the pan is three-quarters filled.

Bake until just set in the center, puffed, and lightly browned, 25 to 30 minutes. Cool on a wire rack for 10 minutes before serving.

Marina di Chioggia Gnocchi with Walnut Sage Pesto

SERVES 6 AS A MAIN COURSE
OR 8 AS AN APPETIZER,
photograph on page 176, lower right

To make gnocchi as they do in Venice, use Marina di Chioggia (see page 59). If you don't have a Chioggia Sea Pumpkin on hand, substitute any dry, flaky *maxima* squash such as Buttercup or Hubbard. "Dry" and "flaky" are the operative words for the potato, too. This formula makes a light, soft gnocchi with a delicate flavor.

1½ cups all-purpose flour, plus additional
 as needed
1 cup well-drained puree of Marina di Chioggia
 or other maxima *or* moschata *squash*
2 cups riced or mashed potatoes
¼ teaspoon freshly grated nutmeg
1 teaspoon salt
Pinch of white pepper
Walnut Sage Pesto
2 tablespoons olive oil (optional)
Shaved or grated Parmesan cheese for serving

Dust an 11- by 17-inch baking sheet with flour and set aside.

In a large bowl, using your hands, mix the squash puree, potato, and spices. Gradually add ¼ cup flour at a time, only enough to form a soft and slightly sticky dough. Turn the dough out onto a floured surface and knead briefly. Divide the dough into 8 pieces and dust with flour. Using the floured palms of both hands, roll the dough into 1-inch-diameter ropes. Cut each rope into ¾-inch pieces, and with a floured thumb, press each piece of dough onto the tines of a floured fork. Push the dough up and off the fork onto the floured baking sheet. Repeat with the remaining pieces of dough. Cook immediately or freeze.

To freeze, place the uncovered baking sheet in the freezer. After the gnocchi harden, transfer them to an airtight container and store in the freezer. Cooking time for frozen gnocchi is about the same as for fresh gnocchi.

To cook the gnocchi, bring 4 quarts of water to a boil in a large pot with 2 teaspoons salt and reduce to a simmer. Working in small batches, add the gnocchi to the simmering water. They will float to the top after a couple of minutes.

Continue cooking for about 30 seconds or until the centers are cooked through. With a slotted spoon, remove the gnocchi, drain, and keep warm while cooking the rest of the dumplings. Toss the gnocchi with a small amount of pesto, divide into individual servings, lightly toss with olive oil if desired, and top with Parmesan cheese. Serve immediately.

FOR THE WALNUT SAGE PESTO

¾ cup walnuts
½ cup pine nuts
2 cloves garlic
1 teaspoon salt
½ cup chopped parsley
3 to 4 tablespoons chopped fresh sage leaves
½ cup olive oil
½ cup grated Parmesan cheese

Heat a large skillet over medium high heat. Add the walnuts, stirring frequently, until they begin to brown and become fragrant, about 5 minutes. Toast the pine nuts separately, since they take a shorter time to brown (about 2 minutes) and will burn if toasted with the walnuts. Remove the nuts from the heat and allow to cool.

Put the garlic and salt in a food processor fitted with a metal blade. Pulse to chop. Add the parsley and sage and process until blended; add the toasted nuts and pulse until finely chopped. Slowly add the olive oil through the feed tube with the motor running. Then turn off the motor, add the cheese, and pulse to combine.

The pesto can be made well in advance. If stored in a mason jar, covered with ¼ inch of olive oil, it will keep in the refrigerator for several weeks. In the freezer, the pesto will remain good for up to one year.

Shrimp Kebabs
with Summer Squash

SERVES 2, *photograph on page 176, upper right*

There's hardly an ounce of fat in this simple-to-prepare grilled dish. Serve with lemon or lime wedges.

*2 pounds small or mini Pattypan or Acorn
 squashes or Zucchini*
1 red bell pepper
1 green bell pepper
1 onion
*12 medium shrimp (about ½ pound),
 cleaned and deveined*
1 to 2 tablespoons virgin olive oil
2 cups cooked white long-grain rice

Soak 4 bamboo skewers in water for 30 minutes to prevent scorching.

Preheat a gas grill to high.

Cut the squashes into 1-inch cubes; leave minis intact. Slice the peppers and onion into 1-inch squares. Thread the ingredients onto the skewers using 3 shrimps per skewer, alternating them with vegetables; brush with olive oil.

Grill the kebabs for 5 minutes on each side or until the shrimps are pink and the vegetables are slightly charred. Serve on a bed of rice.

Winter Squash Chicken Pot Pie

SERVES 6 TO 8

There's no shame in using frozen commercial puff pastry to jazz up your own homemade stew—in fact, I'd say it's a blessing.

*6 tablespoons unsalted butter, plus extra for
 greasing the baking dish*
1 sheet frozen puff pastry, thawed
2 cups frozen pearl onions
1 cup frozen peas
2 large carrots, peeled and sliced
*2 large parsnips, peeled and sliced
 (about 3 cups carrots and parsnips in total)*
*3 cups peeled, seeded, cubed winter squash,
 cut into bite-size pieces*
6 tablespoons all-purpose flour
2 cups chicken stock
2 cups plus 2 tablespoons half-and-half
1½ teaspoons dried chopped sage leaves
1 teaspoon kosher salt
1 teaspoon freshly ground black pepper
*3 to 4 cups cubed cooked chicken, cut into
 bite-size pieces*
½ cup chopped parsley

Butter a 3-quart ovenproof bowl or baking dish and set it aside.

On a lightly floured surface, roll the dough into a square or rectangle large enough to cover the top of the bowl or baking dish, with a 1½-inch overhang all around. Transfer to a parchment-covered baking sheet and refrigerate until ready to use.

Melt the butter in a large skillet over medium high heat. Add the onions and sauté for about 5 minutes or until they begin to brown; add the peas, carrots, parsnips, and winter squash and continue cooking for several more minutes.

Remove all of the vegetables from the skillet with a slotted spoon and set aside.

Make a roux by adding the flour to the skillet and cooking the mixture over low heat, stirring, until it starts to color, and then quickly whisking in the stock and 2 cups of the half-and-half. Return the vegetables to the skillet and season with sage, salt, and pepper.

Preheat the oven to 400°F and bring the mixture to a boil, reduce the heat, and simmer, stirring frequently, until the liquid is thick and smooth and the vegetables are fork tender but still slightly firm, 10 to 15 minutes. Add the chicken and parsley.

To assemble the pot pie, pour the filling into the buttered dish to within an inch of the top and drape the chilled puff pastry over the dish, pressing the dough to the outside edge of the dish to secure it. Make slits in the pastry to allow steam to escape and brush the pastry with the remaining 2 tablespoons half-and-half. Place the dish on a baking sheet and bake for 15 or 20 minutes, until the pastry is puffed and golden. Serve immediately.

Yafa's Potted Pumpkin and Beef

SERVES 8 TO 10

Pumpkin prepared in this way is an essential part of the ritual Rosh Hashanah (New Year's) meal of Jews from Iran. Each of the vegetables is linked to a specific prayer in Hebrew. For example, the Hebrew word for bottle gourd, *gara,* is connected to the entreaty *Qera' roa' gezar dinenu,* meaning "tear up our evil punishment." Pumpkin is used today instead of bottle gourd (*Lagenaria siceraria*) because it tastes better. The salting, rinsing, and draining of the meat the night before cooking is part of the koshering process (to remove the blood and cleanse the meat). The recipe comes from Mrs. Harry Paris, who advises it is not just for Rosh Hashanah.

3 pounds boneless beef (shoulder or brisket)
Kosher salt
1/2 pound dried garbanzo beans
2 large beets, peeled and left intact
1/2 teaspoon baking soda
1 leek, whole, white and pale green part only, trimmed
3 pounds Winter Luxury Pie or moschata *pumpkin, cut into 1-inch chunks*
1/2 pound green beans, cut into 1-inch segments
6 stalks Swiss chard, chopped
1 or 2 Knorr chicken bouillon cubes
Pepper to taste
Cumin to taste
Turmeric to taste
4 to 5 cups cooked white long-grain rice

The evening before serving, rinse the beef and soak it in cold water for 1 hour. Drain off the water, sprinkle the beef with kosher salt, and let it stand for 30 minutes. Rinse the meat thoroughly and soak it for another 30 minutes. Rinse the beef once more and boil it in a pot of water for 2 hours. Let it cool, wrap it in foil, and refrigerate it overnight. Place the garbanzos in a bowl with 4 cups cold water and soak overnight. Soak the peeled beets with the baking soda overnight in a separate bowl of cold water.

The next morning, place the beef and the leek in a large soup pot, adding enough water to barely cover the meat. Cook for about 1 hour. Add the garbanzos and simmer till they soften. Add the pumpkin, beets, and green vegetables. Cook the mixture for an additional hour, adding water as needed. Season to taste with bouillon cubes, salt, pepper, cumin, and turmeric. Transfer to a large serving plate. Serve with rice.

SALADS, SIDE DISHES & CONDIMENTS

Richard's *Insalata di Farro*

SERVES 4 TO 6, *photograph opposite, upper right*

This is my friend Richard Friedhoff's rendition of a marvelous lunch he had in an *enoteca* in Rome one summer day. He discovered that *farro* was used by the ancient Romans, who found it delicious with honey and wine mixed with thistles, fermented fish, and so many other delicacies that, unlike *farro*, have not withstood the test of time.

2 cups farro or spelt
Olive oil
Dried oregano
Kosher salt
1 pound young Zucchini or other summer squash,
 cut into thin rounds
One 6-ounce jar marinated artichoke hearts
2 tablespoons capers
One 8-ounce can small sweet peas
12 cherry tomatoes, halved

Toast the *farro* in a saucepan over medium high heat until it browns; attend to it carefully so that it doesn't burn. Soak the toasted *farro* in 3 cups water in a saucepan for 1 hour. Then bring it to a boil and simmer, covered, for 45 minutes or until tender. The texture will be chewy, like wild rice. Toss with a little olive oil, oregano, and kosher salt to taste.

 Sauté the squash in olive oil. Meanwhile, drain the artichoke hearts and capers, reserving the liquid. Drain the peas and discard the liquid.

 Mound the *farro* on individual plates; divvy up the squash, tomatoes, artichoke hearts, peas, and capers and place them on top of the *farro*. Season with a little caper juice, artichoke marinade, olive oil, and kosher salt. Sprinkle with oregano and serve.

Faux Cucumber Salad

SERVES 4, *photograph opposite, lower left*

Two of the first lessons my mother taught me in the kitchen were how to clean a blackened pot (boil it with sour salt, i.e., citric acid crystals) and how to slice cucumbers as thin as paper (it's all in the wrist) for her Hungarian cucumber salad. This is her recipe applied to Zucchini.

¼ cup sugar
½ cup water
⅔ cup white vinegar
1 pound tender Zucchini or summer squash, cut
 into very thin rounds, salted, and drained
1 small white onion, sliced into thin rings
Salt and freshly ground white pepper
Fresh dill, chopped
Paprika for garnish

Cook the sugar, water, and vinegar in a small saucepan over medium high heat, stirring to dissolve the sugar. Bring to a boil and then turn off the heat and let cool.

 Combine the vegetables in a bowl with the vinegar solution and mix thoroughly to marinate. Add salt, white pepper, and chopped dill to taste. Sprinkle individual servings with a dash of paprika.

Radish and Zucchini Salad

photograph opposite, upper left

This salad is one of my favorite breakfasts. Don't use a food processor—chopping vegetables is almost as therapeutic as weeding them.

Mince equal amounts of red radishes and summer squash and combine them in a bowl. Serve with sour cream.

Roasted Vegetables

photograph opposite, upper left

I steamed, sautéed, and roasted my way through 150 varieties of squash for this book. One thing I know for sure: Roasting brings out the best in any winter squash.

Winter squash or pumpkin
Parsnips
Carrots
Olive oil
Kosher salt

Preheat the oven to 400°F.

Dice equal amounts of winter squash, parsnips, and carrots into a roasting pan. Sprinkle with olive oil and kosher salt and toss. Roast for one hour or until lightly browned and serve.

Summer Garden Sauté

SERVES 4 TO 6, *photograph opposite, upper right*

This vegetable medley should be made only in summer when fresh summer squash, corn, and tomatoes are in season and most flavorful. It makes a great side dish for a barbecue.

2 tablespoons olive oil
3 scallions, thinly sliced
3 medium Zucchini or summer squash,
 cut into 1½-inch matchsticks
Corn kernels cut from 6 ears of fresh corn
2 medium red tomatoes, diced
⅓ cup chopped parsley
Salt and freshly ground black pepper

Heat the olive oil in a skillet over medium heat. Add the scallions and sauté until translucent. Stir in the squash and corn and cook until barely tender, about 5 minutes. Add the tomatoes and parsley and cook until just heated through. Remove from the heat, season with salt and pepper to taste, and serve.

Sautéed Squash Shoots and Tendrils

photograph on page 182, lower right

Lots of people serve up plates of pea shoots and tendrils, but I love sautéed squash shoots and tendrils. This wonderful dish is reminiscent of escarole or broccoli rabe *aglio olio*.

Harvest the growing tips or young shoots, including small leaves and tendrils, from a squash plant with a vining–not bush–habit. Wash carefully and steam in a pot for 1 minute.

In a skillet, heat olive oil over medium heat. Add chopped garlic to taste. Sauté for 1 minute. Add the shoots and tendrils and sauté for a few minutes until tender.

James J. H. Gregory's 1873 Squash Pudding

SERVES 6 TO 8, *photograph opposite, lower right*

A favorite recipe from the man who brought us the Hubbard squash (see page 49). Turn this into a pie, rather than a pudding, by eliminating one egg and adding a prebaked bottom crust.

Preheat the oven to 350°F.

"To a scant pint of squash, cooked and sifted, allow one quart of milk. Heat the milk to a boiling point and pour it on to the squash, then add two eggs, well beaten, with sugar, salt and nutmeg to taste, and stir. . . . Bake in a deep pudding dish without any crust. To be baked about two hours."

Ratatouille with Baked Vegetable Spaghetti

SERVES 4 TO 6, *photograph on page 185, lower left*

This combination of summer and winter squash is scrumptious.

1 large (1-pound) eggplant
1 green bell pepper
1 red bell pepper
5 tablespoons olive oil
4 onions, coarsely chopped
2 cups Zucchini or summer squash
 cut in 1-inch segments
One 28-ounce can peeled tomatoes,
 drained and chopped
Salt and freshly ground black pepper
5 garlic cloves, minced
2 teaspoons herbes de Provence
1 large (3- to 4-pound) Vegetable Spaghetti squash

Preheat the oven to 350°F.

Cut the eggplant and peppers into 1-inch pieces. Toss the eggplant with 2 tablespoons of the olive oil and roast on a baking sheet for 30 minutes.

Sauté the onions in 3 tablespoons of the olive oil in a large pan over medium heat until translucent. Add the peppers and cook until softened. Add the squash, tomatoes, and eggplant. Season with salt, pepper, garlic, and herbs. Place in an ovenproof casserole and bake for 1 hour. Remove the ratatouille and set it aside.

Increase the oven heat to 400°F.

Puncture the Vegetable Spaghetti first to allow the steam to escape; then roast it whole at 400°F for 1 hour or until browned and softened. Cut the squash open, discard the seeds, and remove the strands of spaghettilike flesh. This method is far superior to steaming, boiling, or cutting the squash in two and roasting, since it yields sweeter, more caramelized squash. Toss the squash with a little olive oil or butter and serve with the ratatouille.

Marcell's Zucchini Florentine, Mornay, and Julienne

The following three recipes, by the chef at Café Marcell, "Los Angeles' Leading Restaurant Where Zucchini Had Its Birth," were originally published in 1920 in the Germain Seed and Plant Company catalog.

FLORENTINE: Cut zucchini into $\frac{1}{4}$-inch dice. Season with salt and pepper. Dip in flour and then raw egg. Fry in a skillet with olive oil and serve with drawn butter.

MORNAY: Cut zucchini into 1-inch cubes. Boil for about 1 minute in salted water. Drain in a colander. Put in a baking dish. Cover with cream sauce and a little Parmesan cheese and butter. Bake in oven until done.

JULIENNE: Cut zucchini in julienne [matchstick slices, much like French fried potatoes], dip in milk, and then in flour. Fry in very hot grease. Season and serve.

Chowchow

MAKES 3 TO 4 PINTS, *photograph on page 187, jar on left*

There seems to be as much confusion about the difference between chowchow and piccalilli as there is about pumpkin and squash. Both relishes consist of chopped pickled vegetables, but chowchow (the word is pidgin English, probably derived from Chinese) tends to be more mustardy and sweeter. Both relishes are wonderful with hamburgers, hot dogs, and any cold meat.

4 cups minced Zucchini or summer squash
1½ cups chopped onion
¾ cup minced red bell pepper
¾ cup minced green bell pepper
1½ tablespoons pickling salt
¾ cup sugar
2 cups apple cider vinegar
1 teaspoon celery seed
1 teaspoon mustard seed
1 teaspoon dry mustard
1 teaspoon ground ginger
1 teaspoon turmeric

Combine the vegetables with the salt in a large glass or ceramic bowl; cover and allow to stand for several hours at room temperature. Drain the excess liquid, rinse thoroughly, and drain again.

Combine the sugar, vinegar, and spices in a large stainless steel pot, add the vegetables, and bring to a boil. Reduce the heat and simmer for 20 minutes. Fill sterilized 1-pint canning jars with the hot vegetable mixture and refrigerate. It can keep for up to 3 months in the refrigerator.

Piccalilli

MAKES ABOUT 6 PINTS, *jar on right*

Piccalilli, formerly known as Indian pickle, is a play on the word *pickle*, which dates from before Victorian times.

8 cups chopped Zucchini or summer squash
1 cup chopped sweet red and orange peppers
1 cup chopped celery
2 large onions, chopped
2 cups fresh corn kernels
⅓ cup pickling salt
2 cups cider vinegar
1 cup sugar
½ cup light brown sugar

1 tablespoon peeled, chopped fresh ginger
1 teaspoon ground ginger
1 teaspoon dry mustard
1 teaspoon celery seeds
1 teaspoon red pepper flakes
1 teaspoon turmeric

Combine the vegetables with the salt in a glass or ceramic bowl; cover and allow to stand at room temperature for several hours. Drain the vegetables, rinse thoroughly with cold water, and drain again.

Combine the vegetables with the remaining ingredients in a large stainless steel pot. Bring the mixture to a boil over medium heat, stirring constantly. Reduce the heat and simmer, uncovered, for 30 minutes, stirring occasionally.

Fill 1-pint sterilized canning jars with the hot relish and refrigerate. It can keep for up to 3 months in the refrigerator.

BREADS & SPREADS

Spicy Zucchini Corn Muffins

MAKES 12 LARGE MUFFINS, *photograph opposite*

You can use any summer squash; it is there to add texture and moisture, not flavor. The muffins are best served warm with lots of butter.

2 cups yellow corn meal
2 cups all-purpose flour
¼ cup sugar
1½ teaspoons baking powder
1 teaspoon baking soda
1 teaspoon salt
3 large eggs
⅔ cup corn oil
1 cup sour cream
⅔ cup milk
1 cup fresh or frozen corn kernels
2 cups coarsely grated Zucchini
3 thinly sliced scallions
2 tablespoons minced jalapeño pepper
1½ cups grated sharp cheddar cheese

Preheat the oven to 375°F. Line a standard 12-muffin pan (½ cup per muffin) with paper cups. Use vegetable spray on the top surface of the pan to prevent sticking.

In a large bowl, whisk together the dry ingredients and set aside. In another bowl, whisk together the eggs, oil, sour cream, and milk. Stir in the corn, Zucchini, scallions, jalapeño, and cheese. Make a well in the center of the dry ingredients, pour the liquid mixture into the well, and stir until just blended.

Divide the batter evenly and generously among the muffin cups. Bake until a tester inserted into the center of the muffins comes out clean, and muffins are just starting to brown, about 25 minutes; turn the pan around halfway through the baking time so the muffins bake evenly. Allow the muffins to cool for a few minutes in the pan on a wire rack.

Pumpkin-Apple Butter

MAKES ABOUT 4 CUPS

When I was a kid, one of my favorite destinations was Mrs. Herbst's bakery on Third Avenue in New York. I've dreamed about her apricot jam (and her apple strudel) for years–ever since the shop went out of business. At long last, I've found a suitable substitute.

2 quarts applesauce
2 quarts homemade pumpkin puree
Sugar
Lemon juice

Preheat the oven to 300°F.

In a large bowl, combine the applesauce and pumpkin puree until well blended to make a vivid orange sauce. Fill a roasting pan with the mixture and bake for 6 or more hours, stirring it at least once an hour. When the consistency is to your liking, remove the pan from the oven. Discard any burned particles and mash the mixture with a potato masher to break up any remnants of hard crust. Add sugar and lemon juice to taste and mix well. Pumpkin-apple butter will keep in the refrigerator for months and in the freezer for a year or more.

DESSERTS

Pumpkin Crème Brûlée

MAKES 6, *photograph opposite, upper right*

Pumpkin adds an inspired flavor to traditional crème brûlée.

1 cup pumpkin puree
½ teaspoon ground cinnamon
¼ teaspoon ground ginger
¼ teaspoon ground allspice
Pinch of salt
8 large egg yolks
½ cup granulated sugar
4 cups heavy cream
1 vanilla bean, split
Light brown sugar or Pumpkin Seed Crackle,
 pulverized (recipe follows)

Position a rack in the center of the oven and preheat the oven to 350°F. Arrange six 4-inch ovenproof ramekins or custard cups snugly in a roasting pan and set aside.

Mix the pumpkin puree, spices, and salt in a bowl. With an electric mixer, beat the egg yolks and granulated sugar on high speed, using the balloon whisk attachment, until the mixture thickens and turns a pale yellow. Stir in the puree.

Combine the heavy cream and vanilla bean in a heavy-bottomed saucepan and bring to a boil over high heat; remove from the heat and discard the vanilla bean. Whisk one-third of the hot vanilla cream into the pumpkin/egg mixture so the yolks don't curdle. Then add the rest of the cream mixture, whisking constantly.

Ladle the custard into the ramekins. Pour enough boiling water into the roasting pan to reach two-thirds of the way up the ramekins.

Bake for 45 minutes or until the custard is barely set and the centers are still slightly soft. Remove from the oven and transfer to a wire rack to cool. Refrigerate at least 6 hours.

Sprinkle the brown sugar or crackle over the custards. Caramelize with a propane torch, or place the ramekins in a roasting pan with ice cubes surrounding them and broil for 2 or 3 minutes. The sugar will bubble and melt. Remove from the oven and refrigerate the custards again for several hours before serving.

Pumpkin Seed Crackle

MAKES ABOUT 2 POUNDS,
photograph opposite, upper left

Not only does this crackle taste better than any peanut brittle I know (and is not as hard on the teeth), but it is as beautiful as amber fossil resin. Put the candy in tins, wrap them, and give them as gifts.

2 cups hulled pumpkin seeds
½ teaspoon vegetable oil
1 teaspoon salt
2 cups sugar
1⅓ cups water
1 cup dark corn syrup
1½ tablespoons unsalted butter

Butter an 11- by 17-inch baking sheet and set aside. Toss the pumpkin seeds with vegetable oil and then transfer them to a large, heavy-bottomed skillet. Toast over medium heat, stirring constantly, until the seeds crackle and pop and become light golden, about 10 minutes. Stir in the salt. Cool on a clean baking sheet.

continued

In a large, heavy saucepan over medium heat, mix the sugar, water, and corn syrup, stirring until the sugar dissolves, about 3 minutes. Increase the heat to high and boil without stirring until the mixture registers 260°F on a candy thermometer, 30 to 45 minutes.

Remove from the heat and quickly stir in the toasted pumpkin seeds and butter until just combined and the butter melts. Immediately pour the mixture onto the buttered baking sheet and spread evenly with the back of a spoon. Allow the candy to cool on a rack until hard.

Flex the baking sheet, loosen and remove the candy, break it into pieces, and store in an airtight container in a cool place or in the freezer.

Chewy Pumpkin Bars with Caramel Drizzle

MAKES 3 DOZEN, *photograph on page 190, lower left*

It's a wonder I ever have any pumpkin bars at all–I'm perfectly content to eat the raw batter and scarf the caramel right from the pan. (Even better: If left to harden by itself, the drizzle becomes fudge.)

8 tablespoons (1 stick) unsalted butter, softened, plus extra for buttering the pan
2 cups all-purpose flour
1½ teaspoons baking powder
1 teaspoon baking soda
½ teaspoon salt
2 teaspoons ground cinnamon
1 teaspoon ground ginger
½ teaspoon freshly grated nutmeg
¼ teaspoon ground cloves
1¼ cups packed dark brown sugar
1 cup pumpkin puree

2 large eggs
1 cup raisins or dried cranberries
Caramel Drizzle (recipe follows)

Preheat the oven to 350°F. Butter a 15- by 10-inch baking pan and line it with buttered parchment paper.

Whisk together the flour, baking powder, baking soda, salt, and spices in a large bowl. Cream the 8 tablespoons butter and sugar until light and fluffy in the bowl of an electric mixer, using the paddle attachment on medium speed. Blend in the pumpkin puree and then the eggs, one at a time. Slowly add the dry ingredients and the raisins, beating until just blended. Spread the batter thinly in the prepared pan and bake for about 40 minutes or until a cake tester inserted into the middle comes out clean. Cool completely before applying the caramel drizzle.

Caramel Drizzle

MAKES ¾ CUP

4 tablespoons unsalted butter
⅓ cup packed light brown sugar
1 teaspoon vanilla extract
1 cup sifted confectioners' sugar
3 tablespoons half-and-half

Melt the butter in a medium saucepan over low heat. Add the brown sugar and stir until it has dissolved; whisk in the vanilla, confectioners' sugar, and half-and-half. Add a little more half-and-half if the consistency is too thick; if it is too thin, add more confectioners' sugar. Drizzle the caramel in a diagonal plaid pattern over the cooled pumpkin base. Cut the base into 3-inch by 1-inch bars. Serve or put into a cookie tin, separating the layers with parchment paper or waxed paper. These bars can be frozen for up to six months.

1 prebaked 9-inch flaky pie crust
(see pastry shell recipe under Zucchini
Quiche, page 177)

Preheat the oven to 400°F.

In a large bowl, combine the pumpkin puree, sugar, salt, and spices. Stir in the eggs and heavy cream until well blended. Pour the custard mixture into the prebaked pie shell and bake for 50 to 60 minutes until the outside edge of the custard is puffed and the center is almost set. The edge of the crust may need to be covered with foil to prevent burning.

FOR THE PRALINE TOPPING

1½ cups hazelnuts
Vegetable oil
2 cups sugar
⅓ cup water

Preheat the oven to 350°F.

Roast the hazelnuts on a baking sheet for 15 to 20 minutes until fragrant; be careful not to burn them. Place the hazelnuts on a dish towel while still hot and roll them around to help remove their skins. Oil the baking sheet and set it aside.

Combine the sugar and water in a small saucepan over medium high heat and stir to dissolve. Cook the liquid until it turns a medium caramel color and then remove from the heat. Add the hazelnuts to the syrup and, working quickly and carefully, pour the nut mixture onto the oiled baking sheet and let it harden. Remove the nut brittle from the baking sheet and process in the blender until very fine and powdery. Apply the praline in a thin layer to the top of the pumpkin pie. Use a propane torch to brown the topping. Do not refrigerate; serve immediately.

Praline Pumpkin Pie

SERVES 4 TO 6

Instead of using the praline as a topping, it can be pressed into the bottom of the prebaked pie shell, using the back of a spoon, as in the pie shown here.

FOR THE PUMPKIN PIE

2 cups pumpkin puree
½ cup light brown sugar
½ teaspoon salt
1½ teaspoons ground cinnamon
¼ teaspoon ground ginger
¼ teaspoon ground cloves
¼ teaspoon ground mace
¼ teaspoon ground nutmeg
3 large eggs, lightly beaten
2 cups heavy cream
Praline Topping

Pumpkin Eggnog Ice Cream

MAKES 1 QUART

Daniele Gespert's ice cream has proved that sometimes canned pumpkin puree is better than homemade. This is the most delicious ice cream I've ever had.

2 cups heavy cream
2/3 cup milk
1/2 cup sugar
3 large egg yolks, lightly beaten
1 teaspoon pumpkin pie spice
1 teaspoon vanilla extract
1 1/2 cups canned pumpkin puree
1 tablespoon dark rum

As with a crème anglaise (see page 197), combine the cream, milk, and sugar in a saucepan and cook over low heat, stirring constantly in a figure eight to distribute the heat. When the mixture warms, add about a cup of it to the beaten egg yolks to temper them so they don't curdle; then pour the egg mixture into the pan and continue cooking, stirring constantly, until the mixture coats the back of a spoon, about 10 minutes.

Strain the mixture into a bowl and whisk in the pie spice and vanilla. Cool the mixture to room temperature before adding the puree and rum. Refrigerate until cold and then freeze in an ice cream machine for 35 minutes.

Individual Pumpkin Cheesecakes

MAKES 6, *photograph on page 190, lower right*

This pumpkin cheesecake is so rich that it's best to take it in small doses; one individual cake can easily serve two people.

FOR THE CRUST
6 ounces gingersnaps
1 teaspoon ground cinnamon
1/3 cup sugar
4 tablespoons unsalted butter, melted

Preheat the oven to 350°F. Butter the bottoms of six 4 1/2-inch springform pans.

Break the gingersnaps into pieces. Grind them with the cinnamon and sugar in the bowl of a food processor until very fine; add the melted butter and pulse until blended. Press about 1/3 cup of the crust mixture onto the bottom of each springform pan and bake for about 10 minutes until lightly toasted. Transfer to a wire rack to cool. Keep the oven on.

FOR THE FILLING
Four 8-ounce packages cream cheese
1/3 cup heavy cream
1 2/3 cups sugar
2 cups pumpkin puree
3 tablespoons all-purpose flour
1 teaspoon ground cinnamon
1 teaspoon allspice
4 large eggs
1 tablespoon vanilla extract
Mascarpone cheese, for garnish
Candied ginger, for garnish

Beat the cream cheese, cream, and sugar together in the bowl of an electric mixer, using the paddle attachment, until light and fluffy. Add the pumpkin puree, flour, and spices and mix until just combined. Then add the eggs, one at a time, and vanilla extract. Pour the mixture into the cooled crusts, filling the pans nearly to the top.

Bake until puffed and slightly brown around the edges, with the centers almost set, 30 to 35 minutes. Transfer to a wire rack and cool completely. Refrigerate overnight.

When ready to serve, release the pan sides and slide the cakes onto individual plates. Garnish with a dollop of mascarpone cheese and pieces of candied ginger.

Pumpkin *Palacsinta*

SERVES 4 TO 6

These Hungarian crepes, traditionally filled with *lekvár* (apricot or prune butter or cherry, apricot, or strawberry jam), are equally delicious with pumpkin-applesauce—and Pumpkin-Apple Butter (page 189), too.

FOR THE FILLING
Prepare a pint of pumpkin-applesauce by combining 1 cup each of well-drained pumpkin puree and applesauce.

FOR THE CREPES
1 cup all-purpose flour
2 large eggs
Pinch of salt
½ cup milk
Vegetable oil
Confectioners' sugar, for garnish

Mix the flour and eggs together in a bowl. Stir in the salt and then slowly add the milk. Transfer to the bowl of a food processor and pulse a few times to remove any lumps. The consistency should be like runny pancake batter; add more milk if necessary.

For each crepe, coat the crepe pan with vegetable oil and heat over a high flame. Pour in a scant ¼ cup of batter, and swirl it around to coat the bottom of the pan. Cook the batter until the edges brown, about 2 minutes. Turn the crepe over, cook it for less than 1 minute on the second side, and remove it to a warm plate. Keep the crepes warm until you are ready to fill them.

Spoon a few tablespoons of pumpkin-applesauce into the center of the crepe, roll the crepe, and sprinkle with confectioners' sugar. Repeat with the remaining crepes and serve.

continued

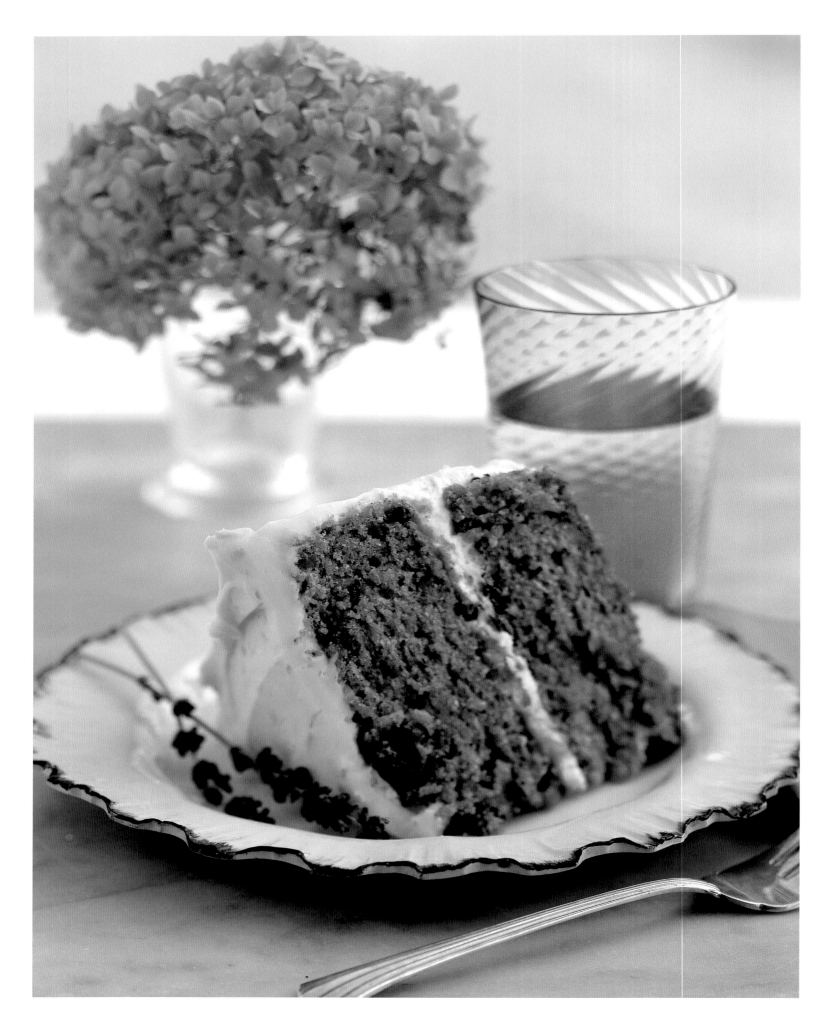

Palacsinta can also be served with crème anglaise on the side:

FOR THE CRÈME ANGLAISE
1 cup milk
1 cup heavy cream
1 vanilla bean, split
6 egg yolks
1/2 cup sugar

Scald the milk and cream with the vanilla bean in a saucepan, then remove the pan from the heat. In a bowl, beat the egg yolks and sugar until lemon colored. Temper the eggs by adding a cup of scalded cream mixture to them and stirring thoroughly; then add the egg mixture to the saucepan. Cook until the mixture thickens and coats the back of a spoon. Strain and serve with *palacsinta*.

Zucchini Spice Layer Cake with Lemon Cream Cheese Frosting

SERVES 12

If you're tired of making the same old chocolate cake for parties, try this aromatic creation, topped with lemon cream cheese frosting.

1 cup unsalted butter, softened, plus extra for
 buttering the pan
2 1/2 cups all-purpose flour
2 teaspoons ground cinnamon
1 teaspoon ground nutmeg
1/2 teaspoon ground cloves
1/2 teaspoon ground ginger
1 teaspoon of salt
1 teaspoon baking powder
1 teaspoon baking soda
1 1/2 cups sugar
4 large eggs

1 cup buttermilk
2 cups grated unpeeled Zucchini, squeezed
1 cup coarsely chopped walnuts
1 cup raisins
Lemon Cream Cheese Frosting (recipe follows)

Preheat the oven to 350°F. Butter the bottom and sides of two 9-inch cake pans. Line the bottoms with buttered parchment paper, then dust the bottoms and sides with flour and shake out any excess.

In a large bowl, whisk the dry ingredients together and set aside. In the bowl of an electric mixer, cream the butter and sugar, using the paddle attachment on high, until light and fluffy. Beat in the eggs, one at a time. Decrease the mixer speed to low and beat in one-third of the flour mixture and then one-half of the buttermilk. Add the remaining flour and buttermilk and then fold in the grated Zucchini, walnuts, and raisins.

Pour half the batter into each of the two prepared baking pans. Bake until golden brown and a toothpick inserted into the middle comes out clean, 35 to 40 minutes. Transfer the cakes to wire racks and remove the parchment. Allow to cool completely before frosting.

Lemon Cream Cheese Frosting

MAKES 2 CUPS

16 ounces cream cheese, softened
1/4 cup confectioners' sugar
Zest of 1 lemon
4 tablespoons lemon juice

Beat all of the ingredients together in the bowl of an electric mixer on medium speed until smooth.

To assemble the cake, place one layer upside down on a serving plate and spread frosting over the top. Top with the second layer right side up and spread the remainder of the frosting over the entire cake.

SEED SOURCES

Allen

Allen, Sterling and Lothrop
191 U.S. Route 1
Falmouth, ME 04105
Fax: 207-781-4143
$1 for catalog, refundable. Specializes in vegetable seeds adapted to northern New England. Company founded in 1911. Retail only.

Bake

Baker Creek Heirloom Seeds
www.rareseeds.com and
www.theheirloomgardener.com
2278 Baker Creek Road
Mansfield, MO 65704
Phone: 417-924-8917
Fax: 417-924-8887
seeds@rareseeds.com
Free catalog. Sells only nonhybrid seeds. One of the largest selections of heirlooms. More than 725 varieties of vegetables, herbs, and flowers, including many rare types and Asian and European varieties. Mainly retail, but catalog includes a page of wholesale offerings.

Berl

Berlin Seeds
3628 State Route 39
Millersburg, OH 44654
Phone: 330-893-2091
Free catalog. Retail only.

Bou

Bountiful Gardens
www.bountifulgardens.org
18001 Shafer Ranch Road
Willits, CA 95490
Free catalog in the United States. Retail and wholesale varieties are listed in the same catalog. Sole U.S. distributor for Chase Seeds of England. Offers open-pollinated, untreated heirloom varieties that are adapted to varied conditions.

Bunt

Bunton Seed Company
www.buntonseed.com
939 East Jefferson Street
Louisville, KY 40206
Phone: 800-757-7179
info@buntonseed.com
Online catalog only since 2000. Offers quality vegetable, herb, and flower seeds for nearly eighty years. Retail and wholesale prices.

Burg

Burgess Seed & Plant Company
www.eburgess.com
905 Four Seasons Road
Bloomington, IL 61701
Phone: 309-662-7761
customerservice@eburgess.com
Free catalog. Unique and popular vegetable seeds and plants since 1913.

Burpee

W. Atlee Burpee & Company
www.burpee.com
300 Park Avenue
Warminster, PA 18991
Phone: 800-888-1447
Fax: 800-487-5530
Free catalog. Separate wholesale and retail catalogs. Extensive selection, including many original introductions.

Burr

D. V. Burrell Seed Growers Company
P. O. Box 150
Rocky Ford, CO 81067
Phone: 719-254-3318
Fax: 719-254-3319
burrellseeds@rmi.net
Free catalog. Family-owned business founded in 1900. Fine collection of cantaloupe, watermelon, vegetable, flower, and herb seeds. Retail and commercial prices are listed in the same catalog.

But

Butterbrooke Farm
78 Barry Road
Oxford, CT 06478
Phone: 203-888-2000
Seed coop. Specializes in open-pollinated, chemically untreated, old-type hardy vegetable strains. Send SASE for price list and membership information.

Clif

Clifton Seed Company
www.cliftonseed.com
2586 NC 403 West
P. O. Box 206
Faison, NC 28341
Phone: 910-267-2690
Fax: 910-267-2692
Free catalog. Family business founded in 1928. Separate but identical retail and wholesale catalogs.

Com

Comstock, Ferre & Company
www.comstockferre.com
263 Main Street
Wethersfield, CT 06109
Phone: 860-571-6590
Fax: 860-571-6595
Free catalog. Established in 1820, incorporated in 1853. "From packets to pounds." Offers 320 vegetable varieties, numerous heirlooms, annuals, herbs, and perennials. Retail and wholesale prices are listed in the same catalog.

Cook

The Cook's Garden
www.cooksgarden.com
P. O. Box 1889
Southhampton, PA 18966-0895
Phone: 800-457-9703
Fax: 800-457-9705
info@cooksgarden.com
Free catalog lists a wide variety of heirloom seeds from around the world, many organic. Great lettuce

selections. Retail only. Many herbs, cut flowers, and annual vines, plus some seed-saving books and supplies.

Cros

Crosman Seed Corp.
www.crosmanseed.com
511 West Commercial Street
P. O. Box 110
East Rochester, NY 14445
Phone: 585-586-1928
Fax: 585-586-6093
Free catalog. Specializes in "tried and true" varieties for the home gardener. Retail only.

Dan

Dan's Garden Shop
www.dansgardenshop.com
5821 Woodwinds Circle
Frederick, MD 21703
Phone: 301-695-5966
Fax: 301-662-3572
info@dansgardenshop.com
No printed catalog; online sales only. Sells vegetable, flower, herb, and sprouting seeds from NK Lawn & Garden.

Deat

Deatriste Seeds
P. O. Box 293897
Sacramento, CA 95829
deatristebay@aol.com
Online catalog only. Open-pollinated, unusual seeds.

Deb

De Bruyn Seed Company, Inc.
www.debruynseed.com
101 East Washington Avenue
Zeeland, MI 49464
Phone: 616-772-2316
Fax: 616-772-0011
debruynseed@egl.com
Free catalog. Specializes in sweet corn and pumpkins. Retail and wholesale.

Down

Down on the Farm Seed
P. O. Box 184
Hiram, OH 44234
$1 for catalog, refundable with order. Specializes in heirloom, open-pollinated, untreated seeds. Retail only.

East

Eastern Native Seed Conservancy
www.enscseeds.org
P. O. Box 451
Great Barrington, MA 01230
Phone: 413-229-8316
natseeds@aol.com
Online seed listing. Endeavors to preserve rare genetic seed stock.

Eden

Eden Organic Nursery Services, Inc.
www.eonseed.com
E.O.N.S., Inc.
P. O. Box 4604
Hallandale, FL 33008
Phone: 954-455-0229
Fax: 954-458-5976
info@eonseed.com
Free catalog. Family-owned and -operated business providing a diversity of seeds, many open-pollinated and organically produced. Separate retail and wholesale catalogs; not all available wholesale.

Ers

E & R Seed
1356 East 200 Street
Monroe, IN 46772
Phone: 260-692-6071
Free catalog. Separate retail and wholesale catalogs, each offering more than 1,000 varieties of vegetable and flower seeds, including many open-pollinated and heirloom varieties.

Ever

Evergreen Y. H. Enterprises
www.evergreenseeds.com
P. O. Box 17538
Anaheim, CA 92817
Phone: 714-637-5769
Fax: 714-637-5769
eeseedsyh@aol.com
Online catalog only. Specializes in more than 230 varieties of oriental vegetable seeds. Retail and wholesale.

Farm

Farmer Seed and Nursery
Division of Plantron, Inc.
www.farmerseed.com
818 Northwest 4th Street
Faribault, MN 55021
Phone: 309-663-9551
Free catalog. Offering hardy northern-grown plants and vegetable seeds for 115 consecutive years. Retail only.

Fed

Fedco Seeds
www.fedcoseeds.com
P. O. Box 520
Waterville, ME 04903
Phone: 207-873-7333
Fax: 207-872-8317
$2 for catalog. Specializes in selections for cold climates and short growing seasons. Offers vegetable, herb, flower, cover crop, and green manure seeds. All seeds are untreated. Retail and wholesale prices are listed in the same catalog.

Field

Henry Field's Seed & Nursery Company
www.henryfields.com
P. O. Box 397
Aurora, IN 47001-0397
Phone: 513-354-1495
Fax: 513-354-1496
service@henryfields.com
Free catalog. Offers a full line of vegetable seeds. Founded in 1893.

Fish

Fisher's Garden Store
20750 East Frontage Road
P. O. Box 236
Belgrade, MT 59714
Phone: 406-388-6052
Free catalog. Breeders and growers of vegetable and flower seeds for high altitudes and short growing seasons. Established in 1923.

Fox

Fox Hollow Seed Company
www.foxhollowseed.com
204 Arch Street
Kittanning, PA 16201
Phone: 724-548-7333
Fax: 724-548-7333
seeds@alltel.net
Online catalog only. Specializes in open-pollinated, heirloom, untreated varieties, including many vegetable seeds that are certified organic. Retail only.

Ger

Germania Seed Company
www.germaniaseed.com
5978 North Northwest Highway
P. O. Box 31787
Chicago, IL 60631
Phone: 800-380-4721
Fax: 800-410-4721
$15 for catalog, refundable with initial order of $50 or more. Offers thousands of varieties of seeds and plugs.

Gour

The Gourmet Gardener
www.gourmetgardener.com
12287 117th Drive
Live Oak, FL 32060
Fax: 407-650-2691
information@gourmetgardener.com
Formerly Herb Gathering.
Online catalog only. Offers unique, exceptional seeds, many from leading importers. Specializes in gourmet vegetables. Retail only.

Green

Green Thumb Seeds
17011 West 280th Street
Bethany, MO 64424
Phone: 660-425-8377
Formerly Yoder Greenhouse. Free catalog. Separate retail and wholesale catalogs, each containing varieties not in the other.

Gurn

Gurney's Seed & Nursery Company
www.gurneys.com
P. O. Box 4178
Greendale, IN 47025-4178
Phone: 513-354-1491
Fax: 513-354-1493
Free catalog. Retail only. Specializes in garden seed and nursery items.

Har

Harris Seeds
www.harrisseeds.com
355 Paul Road
P. O. Box 24966
Rochester, NY 14692-2690
Phone: 800-514-4441
Fax: 877-892-9197
kmcguire@harrisseeds.com
Free catalog. Offers treated, untreated, and organic seed. Separate retail and wholesale catalogs, each containing varieties not in the other.

Heir

Heirloom Seeds
www.heirloomseeds.com
P. O. Box 245
West Elizabeth, PA 15088–0245
Phone: 412-384-0852
mail@heirloomseeds.com
$1 for catalog, refundable with order. Small family-run seed house selling only open-pollinated vegetable and flower seeds, many first introduced in the 1700s and 1800s.

High

High Mowing Seeds
www.highmowingseeds.com
813 Brook Road
Wolcott, VT 05680
Phone: 802-888-1800
Fax: 802-888-8446
Free catalog. Formerly The Good Seed Company of Vermont. Specializes in rare New England heirlooms, 100 percent certified organic, grown by a network of growers, most of them in Vermont; only open-pollinated and especially suited to the northeast United States. Retail and wholesale prices are listed in the same catalog.

Hori

Horizon Herbs
P. O. Box 69
Williams, OR 97544
Phone: 541-846-6704
Fax: 541-846-6233
$2 for "Strictly Medicinal" catalog and growing guide. Offers certified organically grown and sustainably wild-harvested seeds, organically grown plants (250 new species), and organically grown live roots. Retail and wholesale prices are listed in the same catalog.

Horus

Horus Botanicals
341 Mulberry
HCR Route 82, Box 29
Salem, AR 72576
Phone: 870-895-3174
$3 for catalog. Specializes in open-pollinated strains, especially heirlooms and ethnic types. Retail only.

Hud

J. L. Hudson, Seedsman
www.JLHudsonseeds.net
Star Route 2, Box 337
La Honda, CA 94020
JLH@JLHudsonseeds.net

$1 for catalog. Specializes in seeds of rare and unusual plants, Zapotec varieties, and seeds of useful wild and cultivated plants. Established in 1911, successors to Harry Saier. Stresses open-pollinated, nonhybrid, unpatented seeds and preservation of biological and cultural diversity, since 1973.

Hume
Ed Hume Seeds
www.humeseeds.com
P. O. Box 73160
Puyallup, WA 98373
jeff@humeseeds.com
Free price list by mail. Specializes in seeds for cool and short-season climates, with special selections for Alaska and for autumn planting. Retail catalog and wholesale rack sales in Pacific Northwest.

Irish
Irish Eyes & Garden City Seeds
www.irish-eyes.com
P. O. Box 307
Thorp, WA 98946
Phone: 509-964-7000
Fax: 800-964-9210
potatoes@irish-eyes.com
Free catalog. Specializes in vegetables that undergo trials and tasting to ensure quick maturity, good flavor, and vigor. Separate retail and wholesale catalogs; each contains varieties not in the other.

John
Johnny's Selected Seeds
www.johnnyseeds.com
955 Benton Avenue
Winslow, ME 04901
Phone: 207-861-3900
Fax: 800-738-6314
staff@johnnyseeds.com

Free catalog. Vegetable, flower, herb, and farm seed for northern climates. Many heirlooms and new introductions. Extensive trial grounds throughout North America. Satisfaction 100 percent guaranteed. Separate retail and wholesale catalogs.

Jor
Jordan Seeds, Inc.
www.jordanseeds.com
6400 Upper Afton Road
Woodbury, MN 55125-1146
Phone: 651-738-3422
seeds@jordanseeds.com
Free catalog. Offers many untreated seeds for organic growers. Retail and wholesale prices are listed in the same catalog.

Jung
J. W. Jung Seed Company
www.jungseed.com
335 South High Street
Randolph, WI 53957-0001
Phone: 800-297-3123
Fax: 800-692-5864
info@jungseed.com
Free retail catalog; wholesale price information available on request. Quality seeds since 1907. Family owned and operated. Specializes in seeds and nursery stock suitable for northern climates.

Kil
Kilgore Seed Company
P. O. Box 2082
Lake City, FL 32056-2082
Phone: 386-754-1938
Free catalog. Seeds for the Gulf Coast states and tropical and subtropical areas. Retail and bulk prices listed in the same catalog.

Kit
Kitazawa Seed Company
www.kitazawaseed.com
P. O. Box 13220
Oakland, CA 94661-3220
Phone: 510-595-1188
Fax: 510-595-1860
kitaseed@pacbell.net
Free catalog. Specializing in Japanese and other Asian vegetable seeds for commercial growers, wholesalers, and home gardeners since 1917. Separate but identical retail and wholesale catalogs.

Lan
D. Landreth Seed Company
www.landrethseeds.com
180 West Ostend Street
P. O. Box 16380
Baltimore, MD 21210–2229
Phone: 800-654-2407
Free catalog. Founded in 1784, making it the oldest seed house in the United States. Retail and wholesale prices are listed in the same catalog.

Landis
Landis Valley Heirloom Seed Project
www.landisvalleymuseum.org
Landis Valley Museum
2451 Kissel Hill Road
Lancaster, PA 17601
Phone: 717-569-0401
Fax: 717-560-2147
$3 for catalog. Specializes in open-pollinated vegetable varieties with Pennsylvania German origin from 1740 to 1940. Retail and wholesale catalogs contain identical offerings.

Lej

Artistic Gardens & Le Jardin
du Gourmet
P. O. Box 75I, Department 1
St. Johnsbury Center, VT 05863-0075
Phone: 802-748-1446
Fax: 802-748-1446
infodesk@ArtisticGardens.com
Free catalog. Specializes in shallots
and gourmet seeds. Offers $.35
sample packets of herbs, vegetables,
and flowers. Retail only.

Loc

Lockhart Seeds, Inc.
3 North Wilson Way
P. O. Box 1361
Stockton, CA 95205
Phone: 209-466-4401
Fax: 209-466-9766
Sends retail price list upon request.
Main emphasis is commercial
growers, fruit stands, and large
market gardeners.

Mel

Mellinger's, Inc.
www.mellingers.com
2310 West South Range Road
P. O. Box 157
North Lima, OH 44452-9731
Phone: 800-321-7444
Fax: 330-549-3716
mellgarden@aol.com
Sales and free catalog within the
United States only. 4,000 items for
country living, including seeds
(vegetable, tree, herb), bulbs,
perennials, trees, shrubs, and lawn
and garden supplies. Retail and
wholesale prices are listed in the
same catalog.

Mes

Melissa's Seeds
P. O. Box 242
Hastings, MN 55033
Phone: 715-556-1398

Formerly Noel's Seeds. Send two
first-class stamps for catalog. Offers
heirloom, open-pollinated seeds
selected for flavor, quality, and
reliability in short-season home
gardens. Catalog and seed requests
received after August 1 are processed
the following January–February.
Retail only.

Mey

Meyer Seed Company of Baltimore
600 South Caroline Street
Baltimore, MD 21231
Phone: 410-342-4224
Fax: 410-327-1469
Free catalog. Quality seeds since
1911. Retail and wholesale prices are
listed in the same catalog.

Mor

Morgan County Seeds
18761 Kelsay Road
Barnett, MO 65011-3009
Phone: 573-378-2655
Free catalog. Large selection of open-
pollinated seeds, many untreated.
Retail and wholesale prices are listed
in the same catalog.

Nat

Native Seeds/SEARCH
www.nativeseeds.org
526 North 4th Avenue
Tucson, AZ 85705-8450
Phone: 520-622-5561
Fax: 520-622-5591
info@nativeseeds.org
$1 for seed list, $20 for quarterly
newsletter (*The Seedhead News*).
Annual catalog includes packaged
desert foods, crafts from indigenous
farming areas, ethnobotanical books,
gift baskets, and other unique items.
Specializes in vegetables that have
sustained native peoples throughout
the southwestern United States and
northern Mexico. First catalog in 1984.

Nic

Nichols Garden Nursery
www.nicholsgardennursery.com
1190 Old Salem Road Northeast
Albany, OR 97321-4580
Phone: 800-422-3985
Fax: 800-231-5306
Free catalog. Unusual herbs,
elephant garlic, varieties for the
gardener cook, especially Asian
and European specialties, as well
as quality garden varieties. Separate
retail and wholesale catalogs.

Old

Old Sturbridge Village
www.osvgifts.org
One Old Sturbridge Village Road
Sturbridge, MA 01566
Phone: 508-347-0270
Specializes in vegetables, flowers,
and herbs that are appropriate for
gardeners re-creating early nineteenth-
century gardens. Online catalog only.

Orn

Ornamental Edibles
www.ornamentaledibles.com
3272 Fleur De Lis Court
San Jose, CA 95132
Phone: 408-929-7333
Fax: 408-929-5775
info@ornamentaledibles.com
Free catalog. Specializes in an inter-
national selection of seeds for both
"edible landscaping" and "specialty
market" growers. Retail only.

Pap

P & P Seed Company
56 East Union Street
Collins, NY 14034
Phone: 800-449-5681
www.ppseedco.com
Send long SASE for price list. Special-
izes in giant varieties, such as 300-
pound watermelons and 800-pound
pumpkins. Support company for World
Pumpkin Confederation. Retail only.

Park

Park Seed Company
www.parkseed.com
1 Parkton Avenue
Greenwood, SC 29647
Phone: 800-213-0076
info@parkseed.com
Free catalog. Flower seed specialists since 1868. Also offers a full line of vegetables and a number of small fruit varieties. Separate retail and wholesale catalogs; retail catalog contains additional varieties.

Pea

Peace Seeds
2385 Southeast Thompson Street
Corvallis, OR 97333
$1 for annual seed list. Specializes in organically grown vegetable, herb and medicinal seeds; also offers seeds of rare, endangered, and genetically important wild plants.

Peace

Peaceful Valley Farm Supply, Inc.
www.groworganic.com
P. O. Box 2209
Grass Valley, CA 95945
Phone: 888-784-1722
contact@groworganic.com
Tools and supplies for organic gardeners and farmers since 1976. Free 132-page catalog with 2,000 items, including organic and/or open-pollinated seeds, fertilizers, vegetable and cover crop seeds, weed and pest controls, beneficial insects, irrigation, and (in fall) flower bulbs, garlic, onions, potatoes, and fruit trees.

Pepp

Pepper Gal
www.peppergal.com
P. O. Box 23006
Ft. Lauderdale, FL 33307
Phone: 954-537-5540
Fax: 954-566-2208
peppergal@mindspring.com

$2 for catalog. Offers more than 260 hot, sweet, and ornamental peppers, plus tomatoes and gourds. Retail only.

Pete

Peters Seed & Research
P. O. Box 1472
Myrtle Creek, OR 97457-0137
Phone: 541-874-2615
Fax: 541-874-3426
psr@pioneer-net.com
$2 for catalog. Source for unique and high-quality open-pollinated vegetable seeds, many bred at their research facility. Offers many northern varieties; some varieties available to supporting members only. Retail only.

Pine

Pinetree Garden Seeds
www.superseeds.com
P. O. Box 300
New Gloucester, ME 04260
Phone: 207-926-3400
Fax: 888-527-3337
pinetree@superseeds.com
Free catalog. Specializes in flavorful varieties for home gardeners and offers some unique material. "Smaller packets and lower prices." More than 300 gardening books plus tools and bulbs. Retail only.

Plan

Plants of the Southwest
www.plantsofthesouthwest.com
3095 Agua Fria Road
Santa Fe, NM 87507
Phone: 800-788-7333
Fax: 505-438-8800
mark@plantsofthesouthwest.com
Free catalog. Specializes in heirloom and traditional Southwest seeds and native plants, including berry- and nut-producing trees and shrubs. Catalog also includes native grasses, wildflowers, and ancient and drought-tolerant vegetables, including little-known Native American crops.

Retail and wholesale prices are listed in the same catalog.

Red

Redwood City Seed Company
www.ecoseeds.com
P. O. Box 361
Redwood City, CA 94064
Phone: 650-325-7333
Free retail catalog within United States; $2 for catalog to Mexico and Canada. Specializes in seeds of endangered traditional varieties (all open-pollinated or nonhybrid), plus pamphlets and books for the gardener. Two annual catalog supplements online, listing seasonal or rare items in short supply. Retail and wholesale sales; wholesale available online only.

Ren

Renee's Garden Seeds
www.reneesgarden.com
7389 West Zayante Road
Felton, CA 95018
Phone: 888-880-7228
Fax: 831-335-7227
customerservice@reneesgarden.com
Online catalog only. Seeds of gourmet vegetables, kitchen herbs, cottage garden flowers. Personally selected varieties chosen by gardeners for gardeners, including time-tested heirlooms, the best international hybrids, and fine open-pollinated varieties.

Rev

Revolution Seeds
www.walkinginplace.org/seeds
204 North Waverly Street
Homer, IL 61849
Phone: 217-896-3267
bodhi@prairienet.org
$1 for catalog. Heirloom and rare seed catalog new in 2004. Affiliated with The Great Pumpkin Patch, Arthur, Illinois.

Rohr

P. L. Rohrer & Bro. Inc.
www.rohrerseeds.com
2472 Old Philaelphia Pike
P. O. Box 250
Smoketown, PA 17576
Phone: 717-299-2571
Fax: 800-468-4944
info@rohrerseeds.com
Free catalog. Quality farm and garden seeds since 1918. Locally grown by Amish and Mennonite gardeners for their own use as well as organic and heirloom seeds. Retail and wholesale prices in same catalog.

Ros

Roswell Seed Company
115–117 South Main Street
P. O. Box 725
Roswell, NM 88202-0725
Phone: 505-622-7701
Fax: 505-623-2885
Free catalog. Established in 1900. Specializes in New Mexico peppers. Offers vegetable, flower, field, and lawn seeds adapted to the Southwest. Retail and wholesale prices are listed in the same catalog.

Sand

Sand Hill Preservation Center
www.sandhillpreservation.com
Heirloom Seeds & Poultry
1878 230th Street
Calamus, IA 52729
Phone: 563-246-2299
sandhill@fbcom.net
Free catalog. All varieties are open-pollinated and grown on site. Retail only.

Scheep

John Scheepers Kitchen Garden Seeds
www.kitchengardenseeds.com
23 Tulip Drive
P. O. Box 638
Bantam, CT 06750-6086

Phone: 860-567-6086
Fax: 860-567-5323
customerservice@
 kitchengardenseeds.com
Free catalog. Works with growers, farmers, and seed producers from around the world to offer the best new and unique varieties. Retail only.

Sed

Seed Dreams
P. O. Box 1476
Santa Cruz, CA 95061-1476
Phone: 831-234-8668
Fax: 530-496-3221
Free catalog. Specializes in organic, open-pollinated, heirloom vegetables and grains, including many Native American varieties. Retail and bulk prices are listed in the same catalog.

Sese

Southern Exposure Seed Exchange
www.southernexposure.com
P. O. Box 460
Mineral, VA 23117
Phone: 540-894-9480
Fax: 540-894-9481
gardens@southernexposure.com
$2 for catalog. Offers open-pollinated varieties of heirloom and traditional vegetables, flowers, and herbs. Many are suited to hot, humid, and disease-prone areas. Large selection of multiplier onions and garlic. Seed is untreated, and much of it is grown organically. Retail and wholesale prices are listed in the same catalog.

Set

Seeds Trust
www.seedstrust.com
4150-B Black Oak Drive
Hailey, ID 83333-8447
Phone: 208-788-4363
Fax: 208-788-3452
welo@seedstrust.com
$2 for catalog. Small regional seed company specializing in short-season,

open-pollinated, hardy seeds adapted to cold high mountain climates. Separate retail and wholesale catalogs, each containing varieties not in the other.

Sew

Seeds West Garden Seeds
www.seedswestgardenseeds.com
317 14th Street Northwest
Albuquerque, NM 87104
Phone: 505-843-9713
seeds@nmia.com
$2 for catalog; free price list. Specializes in organic and open-pollinated heirloom vegetable seeds and traditional cottage garden annuals; all untreated and many grown regionally. Selected for performance in hot, dry, short-season growing conditions of the West and Southwest. Wholesale and retail.

Shaf

Shaffer Seed & Supply Company
1203 East Tuscarawas Street
Canton, OH 44707
Phone: 330-452-8866
Fax: 330-588-9657
$2 for catalog. Full line of vegetable seeds. Separate retail and wholesale catalogs.

Shum

R. H. Shumway's
www.rhshumway.com
334 West Stroud Street
Randolph, WI 53956
Phone: 800-342-9461
Fax: 888-437-2733
Free catalog. Specializes in heirloom and open-pollinated seeds. Separate retail and wholesale catalogs, each containing varieties not in the other.

Silv

Silver Creek Supply
www.silvercreeksupply.net

R. D. 1, Box 70
Port Trevorton, PA 17864
Phone: 570-374-8010
Fax: 570-374-8071
silcreek@uplink.net
Online catalog. Specializes in greenhouse and gardening supplies. Retail only.

Sit
Seeds from Italy
www.growitalian.com
P. O. Box 149
Winchester, MA 01890
Phone: 781-721-5904
Fax: 612-435-4020
seeds@growitalian.com
Free catalog. Distributes the vegetable, herb, and flower seeds of Italy's second-largest seed company, Franchi Sementi Spa of Bergamo. Family-owned; founded in 1783.

Sky
Skyfire Garden Seeds
www.grapevine.net/~mctaylor
1313 23rd Road
Kanopolis, KS 67454
seedsaver@myvine.com
Free catalog. Open-pollinated, heirloom, and non-GMO-treated seeds. Retail only.

Soc
Seeds of Change
www.seedsofchange.com
P. O. Box 15700
Santa Fe, NM 87592
Phone: 888-762-7333
Fax: 800-392-2587
steve.peters@effem.com
Free catalog. Specializes in vegetables, flowers, and herbs that are 100 percent certified organic, open-pollinated, and public domain varieties. Wide selection of traditional and heirloom varieties. Separate retail and wholesale catalogs, each containing varieties not in the other.

Sou
Sourcepoint Organic Seeds
1220 2640th Road
Hotchkiss, CO 81419-9475
$3 for catalog. Retail only. Offers only organically grown or wild-crafted seeds.

South
South Carolina Foundation Seed Association
www.clemson.edu/seed
1162 Cherry Road
P. O. Box 349952
Clemson, SC 29634
Phone: 864-656-2520
seedw@clemson.edu
Send SASE for price list. Specializes in vegetable varieties developed by state agricultural colleges and U.S.D.A. plant breeders. Retail only.

Sow
Sow Organic Seed
www.organicseed.com
P. O. Box 527
Williams, OR 97544
Phone: 888-709-7333
organic@organicseed.com
Free catalog. Formerly Southern Oregon Organics. Specializes in open-pollinated varieties grown and processed by the company and certified organic by the Oregon Tilth Certified program. Retail and wholesale prices are listed in the same catalog.

Sse
Seed Savers Exchange
www.seedsavers.org
3076 North Winn Road
Decorah, IA 52101
Phone: 563-382-5990
Fax: 563-382-5872
catalog@seedsavers.org
Free 88-page color catalog offers a truly unique selection of outstanding vegetables, flowers, and herbs, including many family heirlooms from the Seed Savers Exchange, and traditional varieties from Eastern Europe and the former Soviet Union. Project-related revenue from seed sales is being used to permanently maintain Heritage Farm's vast seed collections of 24,000 rare varieties. Retail catalog (612-plus varieties) also contains bulk prices (556 varieties) for specialty growers, truck gardeners, CSA growers, and other seed companies. Wholesale price list available on request.

Sto
Stokes Seeds, Limited
www.stokeseeds.com
P. O. Box 548
Buffalo, NY 14240-0548
Phone: 800-396-9238
Fax: 888-834-3334
stokes@stokeseeds.com
Free catalog. Specializes in short-season vegetables. Retail and wholesale prices are listed in the same catalog.

Syn
Synergy Seeds
www.synergyseeds.com
P. O. Box 323
Orleans, CA 95556
Phone: 530-469-3319
george@synergyseeds.com
Online catalog only. Specializes in experimental breeding projects and home-grown family favorites, all grown by sustainable methods.

Ter
The Territorial Seed Company
www.territorialseed.com
P. O. Box 158
Cottage Grove, OR 97424-0061
Phone: 541-942-9547
Fax: 888-657-3131
tetrl@territorial-seed.com
continued

Free catalog. Specializes in varieties for Maritime climate (west of the Cascade Mountains), all grown without chemical pesticides and using only organic fertilizers.

Thomp

Thompson & Morgan, Inc.
www.thompson-morgan.com
P. O. Box 1308
Jackson, NJ 08527-0308
Phone: 800-274-7333
Fax: 888-466-4769
Free full-color catalog. Offers rare and exotic varieties, many unobtainable elsewhere. Retail only.

Tom

Thomas Jefferson Center
for Historic Plants
www.shop.monticello.org
Monticello
P. O. Box 316
Charlottesville, VA 22902
Phone: 800-243-1743
Fax: 434-984-7730
$2 for annual journal and catalog. Retail only. Specializes in vegetables and flowers that were grown by Thomas Jefferson.

Tur

Turtle Tree Seed Farm
Camphill Village
Copake, NY 12516
Phone: 518-329-3038
Fax: 518-329-7955
turtle@taconic.net
Free catalog. Specializes in bio-dynamic vegetables home-grown by Turtle Tree or by other experienced biodynamic growers. Retail only.

Twi

Otis S. Twilley Seed Company, Inc.
www.twilleyseed.com
121 Gary Road
Hodges, SC 29653
Phone: 800-622-7333
Fax: 864-227-5108
Free catalog. Specializes in sweet corn and watermelons. Retail and wholesale prices are listed in the same catalog.

Und

Underwood Gardens
www.grandmasgarden.com
1414 Zimmerman Road
Woodstock, IL 60098
Fax: 888-382-7041
info@underwoodgardens.com
$3 for catalog. Specializes in hard-to-find, untreated, open-pollinated, and heirloom seeds, many of which are grown organically. Retail sales, with bulk seed available depending on harvest.

Ver

Vermont Bean Seed Company
www.vermontbean.com
334 West Stroud Street
Randolph, WI 53956-1274
Phone: 800-349-1071
Fax: 888-500-7333
info@vermontbean.com
Free catalog. Known for having the world's largest selection of beans, plus gourmet specialities and rare and unusual flowers. All seeds are untreated. Retail and wholesale prices are listed in the same catalog.

Vesey

Vesey's Seeds Ltd.
www.veseys.com
P. O. Box 9000
Charlottetown, Prince Edward Island,
C1A 8K6, Canada
Phone: 800-363-7333
Fax: 800-686-0329
Free catalog. Specializes in quality vegetable and flower seeds for short growing season areas. Visitors are welcome to tour their trial gardens. Retail catalog, but offers to commercial customers many varieties that are not in retail catalog.

Vict

Victory Seed Company
P. O. Box 192
Molalla, OR 97038
Phone: 503-829-3126
info@victoryseeds.com
Catalog is available for $2 (refunded with order) or online. Family-owned and -operated retail packet seed company sells only open-pollinated and heirloom varieties.

Wet

Wetsel Seed Company, Inc.
128 West Market
Harrisonburg, VA 22801
Phone: 540-434-6001
Fax: 540-434-4894
hortus@rica.net
Free catalog. Separate retail and wholesale catalogs.

Will

Willhite Seed, Inc.
P. O. Box 23
Poolville, TX 76487
Phone: 800-828-1840
Fax: 817-599-5843
Free color catalog. Family-owned seed company that provides quality open-pollinated and hybrid seed to gardeners and commercial growers; offers more than 450 varieties of vegetable, flower, and herb seeds and accessories. Extensive expertise in watermelon crop production. Separate but identical retail and wholesale catalogs.

ADVOCACY GROUPS

American Horticultural
Society
www.ahs.org
7931 East Boulevard Drive
Alexandria, VA 22308
Phone: 703-768-5700
Fax: 703-768-8700

Center for Food Safety
www.centerforfoodsafety.org
660 Pennsylvania Avenue, SE
Suite 302
Washington, DC 20003
Phone: 202-547-9359
Fax: 202-547-9429

Chefs Collaborative
www.chefscollaborative.org
262 Beacon Street
Boston, MA 02116
Phone: 617-236-5200
Fax: 617-236-5272

The Cucurbit Network
www.cucurbit.org
P. O. Box 560483
Miami, FL 33256

ETC Group (formerly Rural
Advancement Foundation
International)
www.etcgroup.org
118 East Main Street, Room 211
Carrboro, NC 27510
Phone: 919-960-5223
Fax: 919-960-5224

Institute for Agriculture and
Trade Policy
www.iatp.org
2105 First Avenue South
Minneapolis, MN 55404
Phone: 612-870-0453
Fax: 612-870-4846

National Gardening
Association
www.garden.org
1100 Dorset Street
South Burlington, VT 05403
Phone: 800-538-7476
Fax: 802-864-6889

Native Seeds/SEARCH
www.nativeseeds.org
526 North Fourth Avenue
Tucson, AZ 85705
Phone: 520-622-5561
Fax: 520-622-5591

Organic Consumers
Association
www.organicconsumers.org
6101 Cliff Estate Road
Little Marais, MN 55404
Phone: 218-226-4164
Fax: 218-353-7652

Seed Savers Exchange
www.seedsavers.org
3076 North Winn Road
Decorah, IA 52101
Phone: 563-382-5990
Fax: 563-382-5872

Seeds of Diversity
www.seeds.ca
P. O. Box 36
Station Q
Toronto, Ontario,
M4T 2L7 Canada
Phone: 866-509-7333

Slow Food USA
www.slowfoodusa.org
434 Broadway, 6th Floor
New York, NY 10013
Phone: 212-965-5640
Fax: 212-966-8652

Union of Concerned
Scientists
www.ucsusa.org
2 Brattle Square
Cambridge, MA 02238
Phone: 617-547-5552
Fax: 617-864-9405

BIBLIOGRAPHY

Andres, Thomas C. "Diversity in Tropical Pumpkins (*Cucurbita moschata*): Cultivar Origin and History." In *Progress in Cucurbit Genetics and Breeding Research, Proceedings of Eucarpia Cucurbitaceae 2004,* edited by Aleš Lebeda and Harry S. Paris. Forthcoming.

———. "Searching for *Cucurbita* Germplasm: Collecting More Than Seeds." *Acta Horticulturae* 510 (2000): 191–198.

Arthur Yates & Company. *Yates Garden Guide: Australia's Bestselling Practical Gardening Guide.* Sydney: HarperCollins, 2003.

Ashworth, Suzanne. *Seed to Seed: Seed Saving and Growing Techniques for Vegetable Gardeners.* Decorah, IA: Seed Savers Exchange, 2002.

Baggett, James R., and Deborah Kean. "Sugar Loaf and Honey Boat Winter Squashes." *HortScience* 25, no. 3 (1990): 369–370.

Bailey, Liberty Hyde. "The Domesticated *Cucurbitas.*" *Gentes Herbarum* 2, no. 2 (1929): 63–114.

———. *The Garden of Gourds: With Decorations.* New York: Macmillan, 1937.

Baranov, A. I. "Preparation of Dried Vegetable Marrows for Winter Use in North Manchuria." *Economic Botany* 19, no. 1 (1965): 68–69.

Barron's. *Mixing Colors: Watercolor.* Hauppauge, NY: Barron's Educational Series, 1996.

Batson, W. A., ed. *The Cucurbits Illustrated.* Waterloo, NE: J. C. Robinson Seed Co., 1937.

Blazey, Clive. *The Australian Vegetable Garden: What's New Is Old.* Sydney: New Holland, 2001.

Boudonnat, Louise, and Harumi Kushizaki. *Traces of the Brush: The Art of Japanese Calligraphy.* San Francisco: Chronicle Books, 2003.

Bridson, Gavin D. R., and Donald E. Wendel with the assistance of James J. White. *Printmaking in the Service of Botany: Catalogue of an Exhibition.* Pittsburgh: Hunt Institute for Botanical Documentation, 1986.

Burr, Fearing Jr. *The Field and Garden Vegetables of America: Containing Full Descriptions of Nearly Eleven Hundred Species and Varieties; With Directions for Propagation, Culture, and Use.* Boston: Crosby and Nichols, 1863.

Castetter, E. F., and A. T. Erwin. "A Systematic Study of Squashes and Pumpkins." Ames: Iowa State College of Agriculture and Mechanic Arts, Bulletin No. 244, 1927.

Catlin, George. *North American Indians: Being Letters and Notes on Their Manners, Customs and Conditions, Written During Eight Years' Travel Amongst the Wildest Tribes of Indians in North America, 1832–1839.* Edinburgh: John Grant, 1926.

Culpepper, C. W., and H. H. Moon. "Differences in the Composition of the Fruits of *Cucurbita* Varieties at Different Ages in Relation to Culinary Use." *Journal of Agricultural Research* 71, no. 3 (1945): 111–136.

Damerow, Gail. *The Perfect Pumpkin.* Pownal, VT: Storey Communications, 1997.

Darragh, W. H. "Pumpkins and Squashes. Classification and Description of Varieties." *Agricultural Gazette of New South Wales* 43 (1932): 683–690.

Decker, Deena S. "Origin(s), Evolution, and Systematics of *Cucurbita pepo* (Cucurbitaceae)." *Economic Botany* 42, no. 1 (1988): 4–15.

Decker-Walters, Deena S. et al. "Diversity in Free-Living Populations of *Cucurbita pepo* (Cucurbitaceae) as Assessed by Random Amplified Polymorphic DNA." *Systematic Botany* 27, no. 1 (2002): 19–28.

Decker-Walters, Deena S., and Terrence W. Walters. "Squash." Chap. II.C.8 in *The Cambridge World History of Food,* edited by Kenneth F. Kiple and Kriemhild Coneè Ornelas. Cambridge: Cambridge University Press, 2000.

Defay, Bruno. *Trésors de Courges et de Potirons: jardinage et cuisine.* Paris: Terre Vivante, 1993.

Dunthorne, Gordon. *Flower and Fruit Prints of the 18th and Early 19th Centuries: Their History, Makers and Uses, with a Catalogue Raisonné of the Works in Which They Are Found.* 1938; London: Holland Press, 1970.

Earnshaw, Christopher J. *SHO Japanese Calligraphy: An In-Depth Introduction to the Art of Writing Characters.* Boston: Tuttle Publishing, 1988.

Fanton, Michel, and Jude Fanton. *The Seed Savers' Handbook for Australia and New Zealand.* Byron Bay, Australia: The Seed Savers' Network, 1993.

Goff, Emmett S. "Report of the Horticulturist." *New York State Agricultural Experiment Station Annual Report* 6 (1888): 243–273.

Gregory, James J. H. *Squashes. How to Grow Them*. New York: Orange Judd, 1867, 1883.

Haber, E. S. "Inbreeding the Table Queen (Des Moines) Squash." *Proceedings of the American Society for Horticultural Science* (1928): 111–114.

Hayes, Babette. *Two Hundred Years of Australian Cooking*. Sydney: Thomas Nelson, 1976.

Hedrick, U. P. *A History of Horticulture in America to 1860*. Portland, OR: Timber Press, 1988.

_____. *Sturtevant's Notes on Edible Plants*. Albany: J. B. Lyon, 1919.

Heiser, Charles B. Jr. *The Gourd Book*. Norman: University of Oklahoma Press, 1979.

Henderson, Peter. *Gardening for Profit: A Guide to the Successful Cultivation of the Market and Family Garden*. Chillicothe, IL: The American Botanist, 1991.

Hutchins, A. E. "The Rainbow." *The Minnesota Horticulturist* 75, no. 1 (1947): 5–6.

Ibrahim, Aly M. et al. "Orientation, Anatomical, and Breeding Behavior Studies of the Crookneck Rogue Fruit in Butternut Squash." *Journal of the American Society for Horticultural Science* 98, no. 6 (1973): 576–580.

Jahoda, Gloria. *The Trail of Tears: The Story of the American Indian Removals 1813–1855*. New York: Wings Books, 1975.

Jeffrey, Charles. "Cucurbita." In *Mansfeld's Encyclopedia of Agricultural and Horticultural Crops,* edited by Peter Hanelt, 1541–1553. Berlin: Springer, 2000.

Kingsbury, Al. *The Pumpkin King: Howard Dill and the Atlantic Giant*. Hantsport, Nova Scotia: Lancelot Press, 1993.

Lamon, Harry M., and Joseph William Kinghorne. *Practical Poultry Production*. St. Paul: Webb Publishing, 1926.

Langevin, Don. *How-to-Grow World Class Giant Pumpkins*. Rev. ed. Norton, MA: Annedawn Publishing, 1998.

La Quintinie, Jean de. *Instruction pour les jardins fruitiers et potagers, avec un traité des orangers, suivy de quelques réflexions sur l'agriculture*. Amsterdam: Henri Desbordes, 1692.

Lavery, Bernard. *How to Grow Giant Vegetables*. London: HarperCollins, 1995.

McGee, Harold. *On Food and Cooking: The Science and Lore of the Kitchen*. New York: Scribner, 1984.

Merrick, Laura C. "Systematics and Evolution of a Domesticated Squash, *Cucurbita argyrosperma*, and Its Wild and Weedy Relatives." In *Biology and Utilization of the Cucurbitaceae*, edited by David M. Bates, Richard W. Robinson, and Charles Jeffrey. Ithaca: Cornell University Press, 1990.

Moerman, Daniel E. *Native American Ethnobotany*. Portland, OR: Timber Press, 1998.

Morton, Julia F. "The Sturdy Seminole Pumpkin Provides Much Food with Little Effort." *Proceedings of the Florida State Horticultural Society* 88 (1975): 137–142.

Nabhan, Gary Paul. *Gathering the Desert*. Tucson: University of Arizona Press, 1997.

Nee, Michael. "The Domestication of *Cucurbita* (Cucurbitaceae)." *Economic Botany* 44, no. 3 supplement (1990): 56–68.

Nizzoli, Arneo. *The Squash: History, Folklore, Ancient Recipes*. Cologne: Könemann, 1998.

Norrman, Ralf, and Jon Haarberg. *Nature and Language: A Semiotic Study of Cucurbits in Literature*. London: Routledge & Kegan Paul, 1980.

Paris, Harry S. "A Proposed Subspecific Classification for *Cucurbita pepo*." *Phytologia* 61, no. 3 (1986): 133–138.

_____. "Characterization of Reversed Striping in *Cucurbita pepo*." In *Cucurbitaceae 2002,* edited by Donald N. Maynard. Alexandria, VA: ASHS Press, 2002.

_____. "Historical Records, Origins, and Development of the Edible Cultivar Groups of *Cucurbita pepo* (Cucurbitaceae)." *Economic Botany* 43, no. 4 (1989): 423–443.

_____. "History of the Cultivar Groups of *Cucurbita pepo*." In *Horticultural Reviews* 25, edited by Jules Janick. New York: John Wiley and Sons, 2001.

_____. "Paintings (1769–1774) by A. N. Duchesne and the History of *Cucurbita pepo*." *Annals of Botany* 85 (2000): 815–830.

_____. "Some Comments Concerning the Origin and Taxonomy of Old World Pumpkins." *Cucurbit Genetics Cooperative Report* 23 (2000): 99–100.

_____. "Summer Squash: History, Diversity, and Distribution." *HortTechnology* 6, no. 1 (1996): 6–13.

Paris, Harry S. et al. "Assessment of Genetic Relationships in *Cucurbita pepo* (Cucurbitaceae) Using DNA Markers." *Theoretical Applied Genetics* 106 (2003): 971–978.

Pearson, Oscar H. "Unstable Gene Systems in Vegetable Crops and Implications for Selection." *HortScience* 3, no. 4 (1968): 33–36.

Piperno, Dolores R., and Deborah M. Pearsall. *The Origins of Agriculture in the Lowland Neotropics*. San Diego: Academic Press, 1998.

Prades, J. B., N. Prades, and V. Renaud. *Le grand livre des courges*. Paris: Éditions Rustica, 1995.

Riggs, Dale Ila Miles, ed. *Pumpkin Production Guide*. Ithaca: National Research, Agriculture, and Engineering Service, 2003.

Robinson, R. W., and D. S. Decker-Walters. *Cucurbits*. New York: CAB International Publishing, 1997.

Rubatzky, Vincent E., and Mas Yamaguchi. *World Vegetables: Principles, Production, and Nutritive Values*. Gaithersburg, MD: Aspen Publishers, 1999.

Sargent, Steven A., and Donald N. Maynard. "Cucurbits: Postharvest Physiology of Perishable Crops." London: Blackwell Scientific. Forthcoming.

Saunders, Alan. *Australian Food: In Celebration of the New Australian Cuisine*. Berkeley: Ten Speed Press, 1999.

Schneider, Elizabeth. *The Essential Reference: Vegetables from Amaranth to Zucchini*. New York: HarperCollins, 2001.

Shifriss, Oved. "The *B* Genes and Their Phenotypic Expression in *Cucurbita*: An Overview." *Cucurbit Genetics Cooperative Report* 19 (1996): 73–77.

_____. "Developmental Aspects of the *B* Genes in *Cucurbita*." In *Biology and Utilization of the Cucurbitaceae,* edited by David M. Bates, Richard W. Robinson, and Charles Jeffrey. Ithaca: Cornell University Press, 1990.

_____. "On the Emergence of *B* Cultivars in Squash." *HortScience* 23, section 1, no. 2 (1988): 237–238, 431.

_____. "Origin, Expression, and Significance of Gene *B* in *Cucurbita pepo* L." *Journal of the American Society for Horticultural Science* 106, no. 2 (1981): 220–232.

Spector, Sally. *Venice and Food*. Verona, Italy: Arsenale Editrice, 1998.

Tapley, W. T., W. D. Enzie, and G. P. van Eseltine. *The Cucurbits*. Vol. 2, part 4 of *The Vegetables of New York*. Albany: J. B. Lyon, 1937.

Teppner, Herwig. "*Cucurbita pepo* (Cucurbitaceae)–History, Seed Coat Types, Thin Coated Seeds and Their Genetics." *Phyton* (Horn, Austria) 40, no. 1 (2000): 1–42.

Thoreau, Henry David. *Wild Fruits*. New York: W. W. Norton, 2000.

Tracy, W. W. Jr. *List of American Varieties of Vegetables for the Years 1901 and 1902*. Washington, DC: U.S.D.A., Bureau of Plant Industry Bulletin No. 21, 1903.

Tuleja, Tad. "Pumpkins." In *Rooted in America: Foodlore of Popular Fruits and Vegetables,* edited by David Scofield Wilson and Angus Kress Gillespie. Knoxville: University of Tennessee Press, 1999.

Vilmorin-Andrieux. *Description des plantes potagères*. Paris: Vilmorin-Andrieux, 1856.

_____. *Les plantes potagères*. Paris: Vilmorin-Andrieux, 1883, 1891, 1904, 1925.

_____. *The Vegetable Garden: Illustrations, Descriptions, and Culture of the Garden Vegetables of Cold and Temperate Climates,* trans. W. Miller. London: John Murray Ltd., 1885.

Whealy, Kent, ed. *Garden Seed Inventory*. Decorah, IA: Seed Savers Exchange, 1985, 1988, 1992, 1995, 1999.

Whitaker, Thomas W., and Glen N. Davis. *Cucurbits: Botany, Cultivation, and Utilization*. New York: Interscience, 1962.

Whitaker, Thomas W., and G. W. Bohn. "The Taxonomy, Genetics, Production, and Uses of the Cultivated Species of *Cucurbita*." *Economic Botany* 4, no. 1 (1950): 57–81.

Wien, H. C. "The Cucurbits: Cucumber, Melon, Squash, and Pumpkin." In *The Physiology of Vegetable Crops,* edited by H. C. Wien. New York: CAB International Publishing, 1999.

Winkler, Johanna. "Breeding of Hull-less Seeded Pumpkins (*Cucurbita pepo*) for the Use of the Oil." *Acta Horticulturae* 510 (2000): 123–128.

ACKNOWLEDGMENTS

I am eternally grateful to the following cucurbitaceans for their invaluable contributions to this squash oeuvre.

GOLD NUGGETS—Ann Bramson, Pamela Cannon, Glenn Drowns, Richard Friedhoff, Vivian Ghazarian, M. Mark, Donald N. Maynard, Harry S. Paris, Victor Schrager, Emma Sweeney, Kent Whealy

SWEET DUMPLINGS—Thomas C. Andres, Sara Arno, Jacques Aubourg, Clive and Penny Blazey, Steffi Blessing, Bruce Carle, Kit Condill, Keith Crotz, Louise Martin Cutler, Deena Decker-Walters, Danny Dill, Stephen Donahue, Linda Drowns, Kathy Duffy, Eve Felder, Julie Flynn, Susan Fraser, Susan Fugate, Daniele Gespert, Jeremiath Gettle, Dominique Guillet, Hayley Harrison, Christie White Higginbottom, Larry Hollar, Rob Johnston Jr., Addie Juell, Minoru Kanda, Parvine Klein, Tom Knoche, Leslie Land, Camilla Lazzar, Sara Lee, Brent Loy, James McCreight, Carolyn Male, Kenneth Marshall, Barbara Melera, Laura C. Merrick, Tristan Millar, Diane Miller, Rose Marie Morse, Neil Munro, Gary Nabhan, Brian Nedley, Michael Nee, Yafa Paris, Delphine Posson, Margaret Roach, Larry Robertson, Roger Rupp, Kees Sahin, Yoshiteru Sakata, Renée Shepherd, Jordan Shifriss, Oved Shifriss, Mona Talbott, Bill Telepan, Joanne Thuente, Sherry Vance, Aaron Whaley, Diane Whealy

SILVER BELLS—LuEsther T. Mertz Library, New York Botanical Garden; Special Collections, National Agricultural Library, Beltsville, Maryland; Ethel Zoe Bailey Horticultural Catalogue Collection, Bailey Hortorium, Cornell University

INDEX

Page numbers in *italics* refer to photographs

Published by Artisan
A Division of Workman Publishing, Inc.
708 Broadway
New York, New York 10003–9555
www.artisanbooks.com

Library of Congress Cataloging-in-Publication Data
Goldman, Amy.
 The compleat squash: a passionate grower's guide to pumpkins, squashes, and gourds /
 Amy Goldman; photographs by Victor Schrager; foreword by Kent Whealy.
 p. cm.
 ISBN 1-57965-251-4
 Includes bibliographical references (p.) and index.
 1. Squashes. 2. Pumpkin. 3. Gourds. I. Title

SB347.G65 2004
635'.62–dc22

 2004046402

Printed in Singapore
10 9 8 7 6 5 4 3 2 1

Book design by Vivian Ghazarian

This book was set in the following fonts: Baskerville, Escorial, AT Sackers, AT Sackers English Script, and The Serif; flourishes from the 1862 Derriey Typographic Catalog.